STILL-LIFE PAINTING

in the

Museum of Fine Arts, Boston

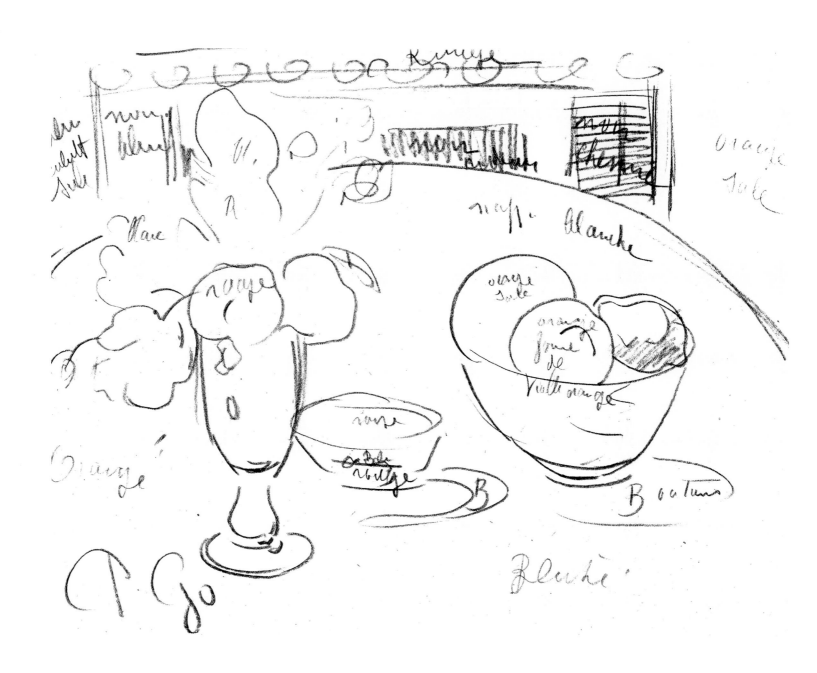

STILL-LIFE PAINTING
in the
Museum of Fine Arts, Boston

KARYN ESIELONIS

Introduction by Theodore E. Stebbins, Jr., and Eric M. Zafran

MUSEUM OF FINE ARTS, BOSTON

ISBN NO. 0-87846-421-2
Library of Congress Catalogue Card No. 94-078152

Typeset by Carl Zahn in Monotype *Dante,*
a typeface designed by Giovanni Mardersteig

Designed by Carl Zahn
Edited by Troy Moss
Printed by Acme Printing Co., Wilmington, Massachusetts
Bound by Acme Bookbinding Co., Charlestown, Massachusetts

Cover illustrations:
Front: Paul Gauguin, French, 1848–1903,
Flowers and a Bowl of Fruit on a Table, 1894;
Back and frontispiece: *Drawing* by Gauguin for the cover painting.

Photographs were supplied by Photographic Services,
Museum of Fine Arts, Boston

CONTENTS

FOREWORD

It is with great pleasure that the Museum of Fine Arts presents this important exhibition of European and American still-life paintings dating from the seventeenth century to the present day. The exhibition traces the development of still life as an independent genre, beginning in Holland, flowering in Italy, Flanders, and Spain during the seventeenth and eighteenth centuries, and culminating in France in the works of Chardin in the eighteenth century and of the French Impressionists a hundred years later. Finally, still life becomes a quintessentially twentieth-century form, represented here by beautiful works of Braque and Metzinger, and of the American modernists, among them Charles Sheeler, Georgia O'Keeffe and Stuart Davis.

Such is the richness of the Museum's permanent collections that all these works – with the exception of two long-term loans for which we are grateful – are drawn from our own holdings. This is a tribute to the far-sighted patronage of the Museum from the earliest gifts of two great still lifes by Chardin, to the most recent acquisition of a Frans Snyders, made possible by income derived from endowed purchase funds. Each painting is a reminder that public-spirited generosity built the Museum of Fine Arts, sustains it today, and will surely secure its role in the future.

This exhibition was conceived by my predecessor as director, Alan Shestack, and by Peter Sutton, formerly Mrs. Russell W. Baker Curator of European Paintings, to whom we are most grateful. It has traveled in slightly different form to three museums in the Sogo chain of department stores in Japan, at Nara, Chiba, and Yokohama, where it was warmly received. For the Boston showing we have added a handful of major works that were too fragile to travel, and a group of contemporary still lifes.

I am especially grateful to Karyn Esielonis, primary author of the catalogue; to Theodore E. Stebbins, Jr., John Moors Cabot Curator of American Paintings, and Eric M. Zafran, Acting Mrs. Russell W. Baker Curator of European Paintings, who have overseen the project, and their colleagues Erica E. Hirshler, Sydney Resendez, and John Loughman. James Wright and his colleagues in the Department of Paintings Conservation have ensured that the pictures are seen at their best; Désirée Caldwell, Assistant Director – Exhibitions, was responsible for the overall administration; Janice Sorkow and her staff in the Department of Photographic Services provided the color transparencies. In addition, I wish to thank Michael Rizzo who has designed the exhibition, Troy Moss for her editing of the text, and Carl Zahn, designer of the catalogue.

Finally, on behalf of the Trustees of the Museum, I want to extend sincere thanks to the Visiting Committee of the Department of Paintings whose contributions have helped to make this publication possible.

MALCOLM ROGERS
Director

INTRODUCTION

This exhibition presents a selection of the best European and American still-life paintings in the collection of the Museum of Fine Arts. This gathering of magnificent Dutch, French, Spanish, American, and other still lifes will come as a surprise even to the most knowledgeable of Museum visitors, for normally these works hang in the Evans Wing galleries mixed with the portraits, landscapes, and history paintings of each national school, and the modesty, delicacy, and relative small scale of the still lifes make them easy to overlook. In bringing these works together for the first time, we demonstrate our belief that paintings of flowers, fruit, and game are as important, and indeed have as much beauty and as much meaning, as any works in the Museum.

This is an exhibition that could not have happened in earlier times. For one thing, the recognition of still lifes is a recent phenomenon. Though there were still-life painters active in Greece as early as the fourth century B.C. (Pliny writes about the painting of foodstuffs, flowers, and illusionistic "trompe l'oeil" subjects that fooled the viewer's eye) and afterwards in Rome, it is only in our own century that the genre has received serious study and admiration. In the eighteenth century, Sir Joshua Reynolds, President of England's Royal Academy, ranked still life as the least worthy of all types of painting, and advised the true painter to "leave the meaner artist servilely to suppose that those are the best pictures, which are most likely to deceive the spectator."[1] At about the same time in France, the encyclopedist Diderot wrote of the Salon in 1767, "I am not unaware that the models of Chardin, those inanimate entities which he imitates, change neither place, nor color, nor shape…Chardin's kind of painting is the easiest."[2] One finds a general disdain for still life continuing even into our own time. The German art historian Max Friedländer, for example, in his important book *Landscape, Portrait, Still-Life* (1947), treats still life last and then devotes only eight pages to the subject. Friedländer observed that a new appreciation of this genre was blossoming, but seemed puzzled by it:

The thoughtful art-lover…may find it astonishing that a lemon, a herring, a wine-glass can be regarded as objects worth painting in themselves. When and how did it happen? What change of artistic sense, of outlook, indeed of social conditions must have come about that production and demand turned to reach simple, insignificant objects?[3]

As Friedländer further notes, still-life painting flowered in some places but not in others. The first great national school of still life prospered in Protestant Holland during the seventeenth century, while Italy produced fewer still lifes. Still lifes became popular in the United States during the nineteenth century, in a society with many parallels to the Dutch one of two centuries before; yet Protestant England during the eighteenth and nineteenth centuries produced inexplicably few still lifes, while Catholic Spain of the seventeenth century – where one might not have expected it – gave birth to a number of extraordinarily talented and original masters.

Just as still-life painting itself developed rather late and occurred sporadically, so both the collecting and the scholarly study of still life remained rare until very recently. The first great American collectors of Old Masters in this country such as P. A. B. Widener, Andrew Mellon, Henry Clay Frick, and Isabella Stewart Gardner, simply had no interest at all in paintings of flowers and fruit. Similarly, the collections of American art that were formed during the nineteenth century by W. W. Corcoran, Thomas B. Clarke and the like, and in the first half of this century by Francis Garvan, Henry F. DuPont, and Abby Aldrich Rockefeller, all generally lacked distinguished still-life paintings. As one would expect, scholarship followed the same pattern. Neither Bernard Berenson, who advised many of the early American collectors, nor the modern founders of the art historical discipline as it came to be practiced in America, including Panofsky, Wölfflin, or Gombrich, had much use for still life. It is not until the 1940s that Ingvar Bergström's studies of Dutch seventeenth-century still life were written, and only in 1952 that Charles Sterling produced the first modern survey of the western still-life tradition. On

the American side, the same years saw the pioneering work of Alfred Frankenstein on Harnett and the trompe l'oeil painters, the specialized collecting of Paul Magriel, and – slightly later – the important survey by William H. Gerdts and Russell Burke entitled *American Still-Life Painting* (1971).[4]

Two more things make it all the more remarkable that the Museum of Fine Arts now finds itself with such a fine collection of still lifes. First is the fact that Boston was even less still-life minded than other American art centers during the nineteenth century, if we can judge from the fact that this city produced no still-life painters of significance before Alexander Pope, who began making his hunting trophy pictures only in 1887.[5] Boston's taste had long been dominated by the idealizing, figurative work of painters from Washington Allston to William Morris Hunt, and it lacked the local still-life tradition of Philadelphia or New York. Secondly, Boston continued to reject modern art and abstraction longer than the other major centers such as New York, Philadelphia, and Chicago, and it was the acceptance of modernism that makes still life seem so relevant to twentieth-century eyes. It is surely no coincidence that the earliest general exhibition of still-life painting was apparently one organized by the Galerie Bernheim-Jeune in Paris in 1907,[6] just as Braque and Picasso were inventing Cubism. Modernism revolutionized both art and taste and still life, for so long a stepchild in the artistic pantheon, now rose to a position central to painting. With the work of Cézanne and then of the Cubists, all painting, whatever its apparent subject, became a form of still life. Forms were painted or were invented, just so the painter could rearrange and recreate them. Traditional landscape, history painting, and portraiture all gave way to this new spirit, and still life's low ranking was turned on its head.

Since the mid-nineteenth century, Jean Siméon Chardin's still lifes have been admired as quintessential examples of the genre. Small, simple, depicting prosaic subjects found in every French kitchen – a jug of wine, a lemon or a peach, a teapot, a half-full glass – these paintings fascinated Manet and Cézanne, and their combination of formal subtlety and spirituality continues to move us today. Many of the families who founded the Museum of Fine Arts in 1870 were enthusiastic collectors of French paintings of the seventeenth, eighteenth, and nineteenth centuries; they are well known for their love

of Barbizon and, later, Impressionist pictures. Two great pastoral subjects by François Boucher were given to the Museum the year after it was founded, and shortly afterwards came the first great still lifes to enter the collection – not surprisingly, works by Chardin. In 1880 Mrs. Peter Chardon Brooks, wife of one of the city's wealthiest men (who a few years later became one of the first Bostonians to collect Monet and Sargent), donated the rich and beautiful *Kitchen Table* (cat. 29). Three years later Martin Brimmer, a founder and first President of the Museum, gave a second Chardin, *Still Life with Tea Pot* (cat. 30), a work which he might well have had in mind when he described the young institution's collecting policy: "The master's hand, expressing the master's mind, gives that which fills the eye and touches the imagination as nothing else can, and no opportunity should be neglected to procure for our museum works of this original and permanent value."[7] The acquisition of these two works was fortuitous indeed, for only one more Chardin still life has come to the Museum, and it is one whose attribution is now doubted.[8] Moreover, Boston's love of Chardin and French painting found reflection in a number of later additions including the three rare still lifes by Jean-François Millet, all gifts from the Quincy Adams Shaw collection in 1917. The small oil, *Pears* (cat. 31) directly quotes a Chardin composition, while the two pastels, *Dandelions* and *Primroses* (cats. 32-33), are exquisite nature studies.

Handsome Northern still lifes were also acquired during the early years. Stanton Blake, another of the founding trustees, had in 1880 purchased a number of fine Dutch and Flemish paintings at the sale of Prince Demidoff's collection in Florence, which were then placed on deposit at the Museum. When he died in 1889, as the *Annual Report* recorded, "Mr. Blake left to the Trustees a legacy of five thousand dollars and the right to purchase at somewhat less than their cost" his valuable collection.[9] His Harvard classmate Francis Bartlett and other friends subscribed to a fund to complete the purchase. In this way the Museum obtained its greatest eighteenth-century Dutch flower painting, Jan van Huysum's *Vase of Flowers in a Niche* (cat. 14), as well as a fine seventeenth-century picture, Verelst's *Still Life with Dead Partridge and Kingfisher* (cat. 22). Two more classic Dutch seventeenth-century still lifes were acquired in 1913 when Mrs. Edward Wheelright

bequeathed her pair of fine breakfast pieces by Pieter Claesz. (cat. 6-7).

During the first years of the twentieth century, Boston's taste turned briefly to large pictures featuring chickens, pigeons, and other living denizens of the barnyard. The traditional scholars including Bergström and Sterling did not consider these works to be within the definition of still life, but today's broader view includes them. Very often these works were painted by artists such as Frans Snyders, who specialized in dead game and other more typical still-life subjects. Three works by or attributed to the Dutch seventeenth-century master Melchior d'Hondecoeter entered the collection in short order, including *Barnyard Fowl and Peacocks* (cat. 20), which was purchased by the Museum at Christie's in 1907. Then just four years later came *Poultry Yard* (cat. 51) by Max Schramm-Zittau, a German Impressionist. It was given by Hugo Reisinger, perhaps in recognition of Boston's taste for Hondecoeter. Reisinger two years earlier had organized an exhibition of contemporary German art in New York, Chicago, and Boston, including several works by Schramm-Zittau, as Karyn Esielonis points out below. The Museum of Fine Arts apparently did not follow up on this gift, for Reisinger and his in-laws, the Busch family, took their collecting interests and their taste for modern German art elsewhere: in 1948 Harvard's Germanic Museum was renamed for them in honor of the family's gifts.

The Museum (and to a lesser extent, the whole Boston community) was slow to embrace the art of the twentieth century. Even now, the collection lacks a still life by perhaps the most important modern painter, Picasso. And when the Museum's first modern still life, Georges Braque's *Peaches, Pears, and Grapes* (cat. 73) was purchased by subscription in 1932, it was put into the "Reserve Collection," which meant that it was here only on a provisional basis and could be easily sold if the Cubist experiment was later thought to have failed (as many in Boston thought would happen). Two other modern still lifes, the playful pair of compositions by Severini (cats. 87-88) were purchased at the same time and under the same provisions.

During the mid-1930s the Museum brought to its staff a knowledgeable team of paintings experts, and a number of important purchases followed. George H. Edgell, a scholar of

Sienese painting who had served briefly as curator of paintings, became director in 1935. W. G. Constable, a specialist in Canaletto and Venetian painting, left the Slade professorship at Cambridge to become curator of paintings, and Charles C. Cunningham, later a distinguished director at Hartford and Chicago, came to work as assistant curator until 1946. The families of Boston and New England have been very generous over the years in giving works by the artists whom they favored – hence the Museum's superb collections of Millet and Monet, of Copley, Allston, and Homer. Since the institution's beginning the trustees and staff have also made purchases that complement the "core" collection, filling its major gaps with paintings of a kind not owned by local collectors. Thus the new curatorial team began in 1935 by recommending the purchase of Charles Sheeler's iconic *View of New York* using the Charles Henry Hayden Fund, a purchase endowment which was the gift of a painter and which has provided funds for many important acquisitions. This highly significant contemporary work, executed just four years earlier, remains one of the anchors of the twentieth-century collection. In 1939 came the purchase of a pair of illusionistic tabletop compositions of extraordinary quality and rarity by the then little-known Spanish eighteenth century painter Luis Meléndez (cats. 27-28). Later that year they bought William M. Harnett's *Old Models* of 1892 (cat. 63) the last work painted by the greatest American master of trompe l'oeil, and now recognized as one of his masterpieces. This highly realistic hard-edged work was designed for a popular audience in Philadelphia and New York, and thus was a work far from Boston's normal taste.

The first important American still lifes to enter the collection were by a favorite Boston painter, John La Farge. In 1920 two sisters, Louise W. and Marian R. Case, donated the very beautiful *Vase of Flowers* (cat. 57) which their father had acquired some years before, William Sturgis Bigelow gave *Hollyhocks and Corn* in 1921, and *Waterlily* was bequeathed by another collector a few years later. Next came the purchase of the Harnett, described above. Then in the 1940s the American collection was transformed through the generosity of the pioneering collector Maxim Karolik. Earlier, Karolik and his wife, Martha Codman Karolik, had given the Museum an important collection of colonial American decorative arts, along with a few early paintings. During the early forties they

turned, in consultation with the director and curators, to American painting of the nineteenth century. Though Karolik's special gift was his eye for landscapes by such then-unknown painters as Fitz Hugh Lane and Martin Johnson Heade, he also had an unusual appreciation of still life. Contained in the unrivaled selection of some thirty works by Heade in the Karolik Collection is a superb group of still lifes including *Vase of Mixed Flowers* (cat. 58), *Orchids and Hummingbird* (cat. 59), with its unusual yellow flowers, *Orchids and Spray Orchids with Hummingbird,* the sensuous *Magnolia Grandiflora,* and a rare vertical composition, *Magnolias.* Karolik also gave two still lifes by John F. Francis, including *Still Life with Apples and Chestnuts* (cat. 54). And because he cared more about quality than name or attribution, Karolik owned and later presented to the Museum several interesting "folk" or non-academic pictures such as *Watermelon* (cat. 56) by an unknown artist. Finally, during the 1950s he began collecting the work of John F. Peto, Harnett's follower, who produced his own evocative brand of trompe l'oeil during the last years of the nineteenth century, and Karolik's 1964 bequest included the famous *Poor Man's Store* (cat. 62), *Old Time Letter Rack* (cat. 61), along with two other examples.

Another extraordinary gift came in 1948, this time from John Taylor Spaulding. He and his brother William in 1921 gave to the Museum what has been called "one of the finest collections of Japanese prints in the world."[10] He then turned to collecting a sensitive and beautiful group of Impressionist, Post-Impressionist, and modern paintings by European and American artists. In keeping with his modernist eye, Spaulding had a special love for still life. The catalogue of the exhibition of his collection, held at the Museum of Fine Arts following his death, reported that this modest collector (he had always declined a trusteeship) had hung his Manet and Cézanne still lifes (cats. 40, 45) "where he could see them from his reading chair", and that "one of Mr. Spaulding's very prized works," his Redon pastel *Large Green Vase with Mixed Flowers* (cat. 47), had "hung in his bedroom over the mantel."[11] Spaulding also gave Renoir's masterpiece, *Mixed Flowers in an Earthenware Pot* (not included in this exhibition due to its being away on loan), as well as magnificent still lifes by Courbet, Fantin-Latour, Sisley, Morisot, Gauguin, and Matisse (cats. 34, 37, 42, 46, 44, 79). There were also fine examples by

the Americans Maurice Prendergast and Stanton Macdonald-Wright (cats. 66, 83), and by S.J. Peploe (cat. 70), who is the only British painter included in this exhibition.

Director George Edgell died in 1954, and was succeeded by another connoisseur of paintings, Perry T. Rathbone, who held the position until 1972. Rathbone served as his own curator of paintings and under his direction the Museum made a series of brilliant acquisitions which included a number of still lifes. Among his first purchases was a marvelous Cubist work of about 1918 by Jean Metzinger, *Fruit and Jug on a Table* (cat. 72) which has become one of the highlights of the modern European collection. Also during Mr. Rathbone's tenure came another Braque still life from the twenties – which unlike its predecessor did not go into the Reserve Collection – and important still lifes by such other modernists as Ensor (cat. 80, the gift of G. Peabody Gardner), Gris (cat. 75, given by the great collector and patron from St. Louis, Joseph Pulitzer, Jr.), and Max Beckmann (cat. 90, the donation of Mrs. Culver Orswell). Perry Rathbone also built the collection of older still lifes, both European and American, acquiring a rare work by the German Isaak Soreau, the *Vanitas Still Life* by the seventeenth century Flemish painter Cornelis Gijsbrechts (cat. 11), the early Italian *Peaches and Pears* by Spadino (cat. 18), and a large floral work by the mid-nineteenth-century American Severin Roesen (cat. 55).

The most recent era in the collecting history of the Museum began with the appointment of Jan Fontein, formerly curator of Asiatic art and a distinguished scholar in that field, to the directorship in 1976. One of Dr. Fontein's aims was to rebuild the Department of Paintings; early in his tenure he appointed John Walsh, Jr., to the newly endowed position of Mrs. Russell W. Baker Curator of European Paintings, and then Theodore E. Stebbins, Jr., as the Museum's first curator of American Paintings. A major accomplishment during the period was the complete renovation (including installation of a climate-control system) of the Evans Wing where the paintings collection is housed; the skylit European galleries were refurbished, and the space for American pictures was more than doubled. Walsh, who went on to become director of the J. Paul Getty Museum in 1983, bought landscapes and religious pictures for the most part, but also made one notable addition to the European still-life collection in his purchase of

the impressive Impressionist painting by Gustave Caillebotte, *Fruit Displayed on a Stand* (cat. 43), at a Paris auction in 1979.

On the American side, on the other hand, the needs were far greater and a major effort was made to acquire still lifes in order to fill many gaps and to bring this part of the collection closer to the great strength already existing in portraiture, landscape, and genre. A search was undertaken for a fine Raphaelle Peale, the first major still-life painter in the United States, but it has been unsuccessful to date. However, two fine Neo-classical still lifes from the early nineteenth century were acquired: in 1978 a rare tabletop composition in the Peale tradition by Charles Bird King (cat. 46) was purchased, and the next year the distinguished Los Angeles collectors JoAnn and Julian Ganz, Jr., donated the fine *A Porcelain Bowl with Fruit* by James Peale (cat. 52). As for the late nineteenth century, a decision was made to build on the strengths already provided by the great trompe l'oeil paintings by Harnett and Peto described above. Thus, small but masterly examples by illusionistic artists John Haberle, De Scott Evans, and Levi Wells Prentice (cats. 35, 24) were purchased with the latter's *Apples in a Tin Pail*, arguably his finest work, being featured shortly afterwards as the cover illustration for William H. Gerdts's second survey of American still life, *Painters of the Humble Truth*.[12] In addition, the Museum's strong holdings of Boston School and American Impressionist paintings were augmented by the purchase of Frank W. Benson's superb *Silver Screen* (cat. 67).

During the same period, the Museum's holdings of American Modernist paintings changed character completely. This effort began quietly, with the purchase of Georgia O'Keeffe's magnificent *White Rose with Larkspur #2* (cat. 84) directly from the painter herself. When the curator visited the legendary figure at her home in Abiquiu, New Mexico, he imagined selecting one picture from numerous possibilities. Instead, after a long, private lunch on the patio, O'Keeffe led him to her darkened bedroom, pointed to the work hanging over the bed and said, "This is my favorite. Don't you think this is the one for Boston?" He quickly agreed.

Then, through the generosity of the extraordinary collectors William H. and Saundra B. Lane, farsighted lovers of early twentieth-century American painting, an area of relative weakness was transformed into one of the great strengths of the Museum. In 1983, the year of the exhibition *The Lane Collection: Twentieth Century Paintings in the American Tradition*, the Lanes gave the important early *Green Bottle* of 1921 (cat. 78) by Hans Hofmann, which the artist himself had given to Mr. Lane in 1953. At the same time, they helped the Museum acquire one of Stuart Davis's greatest works, *Hot Still-Scape for Six Colors – 7th Ave. Style*, which Mr. Lane had long admired. A few years later, in 1990, the gift of the Lane Foundation Collection brought to the Museum a profusion of still lifes of great quality, including Marsden Hartley's *Tinselled Flowers*, 1917, Patrick Henry Bruce's *Forms (Peinture)*, and Charles Demuth's *Longhi on Broadway*, 1927. The Lane gift also added an extensive group of works by Charles Sheeler, including his tender *Spring Interior* of 1931 (cat. 82), several more splendid paintings by Georgia O'Keeffe, particularly *Deer's Skull with Pedernal* (cat. 85), a landscape with a central still-life element, and Mr. Lane's favorite, *Calla Lily on Gray*. The Lane gift also included such additional masterworks by Stuart Davis as *Apples and Jug*, 1923 (cat. 76), the experimental *Egg Beater No. 3*, 1927-28, and *Medium Still Life* from 1953 (cat. 77). All in all, the Lane gifts rank with earlier donations from John Taylor Spaulding and Maxim Karolik in terms of their importance for the Museum's paintings collection in general, and for their great still lifes especially.

Peter C. Sutton, who served as curator of European paintings from 1985 to 1994, not only conceived this exhibition but also presided over the acquisition of several major additions to the collection. Our friends George and Maida Abrams, internationally recognized collectors of Dutch seventeenth-century drawings and paintings, made a generous gift in 1990 of a distinctive *bosstilleven*, or forest still-life, a type previously unrepresented in the Museum's collection, by Otto Marseus van Schrieck, *Still Life with Snake and Lizard* (cat. 13). The most recent purchase for the collection is the exquisite, richly conceived *Fruit Still Life with Squirrel* by Frans Snyders (cat. 3). This is a quintessential seventeenth-century Flemish still life, depicting a lavish display of fruits and objects enlivened by a busy squirrel. Executed on copper, it is in a remarkable state of preservation, and makes an important addition to our now rich, and still growing, collection of European and American still-life paintings.

Finally, we are pleased indeed that the present exhibition

includes eight contemporary still-life paintings and one sculpture; this has been made possible by the Museum's Department of Contemporary Art and its curator, Trevor J. Fairbrother. During the heyday of abstraction in the hands of Kandinsky, Mondrian, and the Abstract Expressionists, it looked as if still life, indeed all realist painting, was doomed to extinction. But contrary to these expectations, still life – practiced in a wide variety of styles – has flourished during the past two decades. Jim Dine's *Hammer Study*, 1962, recalls for us the strength of the Duchampian tradition, carried on by such diverse artists as Joseph Beuys and Jasper Johns; it may be a still life of sorts or it may not be, but in either case, it contains traditional still-life elements and it makes us think about the nature of painting. Quite different is Roy Lichtenstein's three-dimensional *Glass V*, 1973, which can be read either as a Pop parody of the Cubist style or as a work that stems from the inventions of Braque and Picasso and brings them into our own time, or perhaps as both.

The other seven recent paintings would have been recognized as still lifes by seventeenth- or eighteenth-century viewers, though each also has formal elements of composition, cropping, viewpoint, or facture that make each one a work of the late twentieth century. Peter Plamonden and Barnet Rubenstein (the latter a longtime teacher at the School of the Museum of Fine Arts and a master also of still-life drawing), both employ flattened, modernist space. Axel Kasseböhmer and David Bates paint traditional still-life subjects, a skull and magnolia blossom respectively, but dramatically juxtapose them with other elements, while Ken Beck's painterly yet highly illusionistic *Duckbill Hat* suggests its contemporary roots both in its reference to photography and its exaggerated scale. Finally, works are included by two painters long active in western Massachusetts, who are both much admired by the Boston audience, Gregory Gillespie and Frances Cohen Gillespie. In the former's *Purple Gloxinia* and the latter's *Still Life with Eggplants* one finds deep, conscious awareness of the art of the past combined with a flattened space and coloristic intensity that make them modern. Frances Gillespie's work reminds us at times of the tenuous striving of the American folk painter, while having something of the spirit of Italy about it also; Gregory Gillespie's tabletop fruits and vegetables are vivid and weighty, and his picture seems more Spanish than anything else.

Still life thus goes on, alive and well. Having begun as a stepchild of the serious arts, still-life painting today is recognized as one of the purest forms of painting. On behalf of the Museum of Fine Arts, we thank those who have made this great collection possible.

THEODORE E. STEBBINS, JR.
John Moors Cabot Curator of American Paintings

ERIC M. ZAFRAN
Acting Mrs. Russell W. Baker Curator of European Paintings

NOTES:

1. Sir Joshua Reynolds, *Discourses on Art*, ed. Robert R. Wark (New Haven, 1975), p. 50.

2. As quoted in Pierre Rosenberg, *Chardin* (Cleveland, Cleveland Museum of Art, 1979), p. 46. It should also be noted that Diderot on other occasions expressed his admiration for Chardin's work, in one instance writing, "it is the very substance of objects, it is air and light that you take on the tip of your brush and place on the canvas...."

3. Max J. Friedländer, *Landscape. Portrait. Still-Life* (New York, 1963), p. 277. The same point is made in William Gerdts and Russell Burke, *American Still-Life Painting* (New York, 1971).

4. Ibid. H.W. Janson's standard text *History of Art* (3rd ed.; New York, 1986) reproduces just seven still-life paintings, Helen Gardner's *Art through the Ages* only four (see Horst, de la Croix et al., eds., 9th ed., Ft. Worth, 1986).

5. Gerdts and Burke, p. 193.

6. Charles Sterling, *Still Life Painting from Antiquity to the Present* (New York, 1959), p. 152.

7. *The American Architect and Building News*, October 30, 1880, as quoted in Walter Muir Whitehill, *Museum of Fine Arts, Boston: A Centennial History* (Cambridge, MA, 1970), vol. 1, pp. 12-13.

8. Follower of Chardin, *Fruit and a Silver Goblet on a Ledge* (Bequest of John T. Spaulding, 48.526).

9. *Museum of Fine Arts, Fourteenth Annual Report, for the Year Ending December 31, 1889* (Boston, 1890), p. 5.

10. Jan Fontein, "Notes on the History of the Collections," in *Asiatic Art in the Museum of Fine Arts, Boston* (Boston, Museum of Fine Arts, 1982), p. 12.

11. Charles Hovey Pepper, "John T. Spaulding as a Collector," in *The Collection of John Taylor Spaulding, 1870-1948* (Boston, Museum of Fine Arts, 1949) pp. 4-6.

12. William H. Gerdts, *Painters of the Humble Truth* (Columbia and London, 1981).

COLOR PLATES

❧❧❧❧❧❧❧❧❧❧❧❧
❧❧❧❧❧❧❧❧❧❧
❧❧❧❧❧❧❧
❧❧❧❧
❧

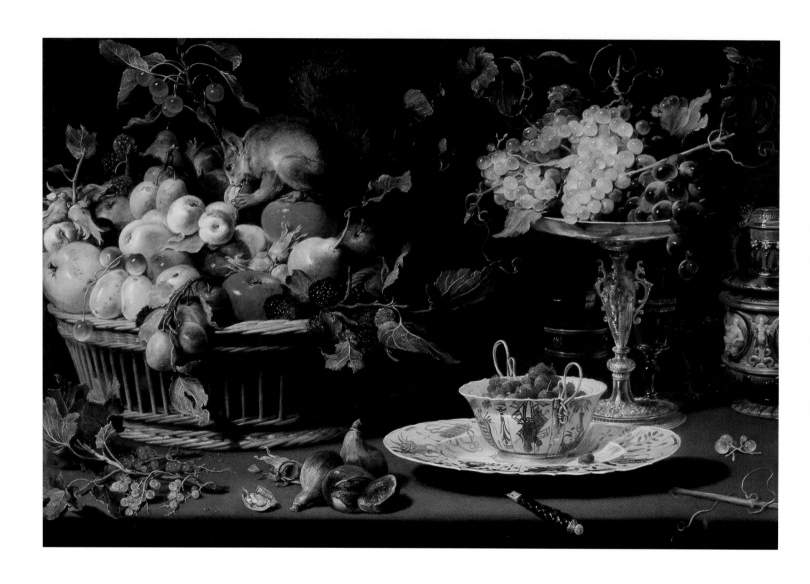

Pl. 1 (cat. 3). FRANS SNYDERS, *Fruit Still Life with Squirrel*, 1616

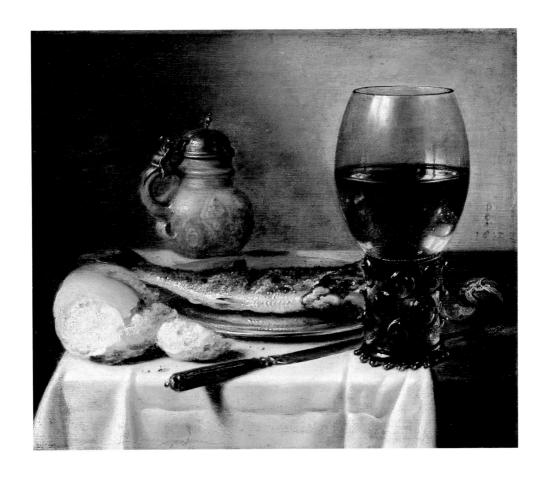

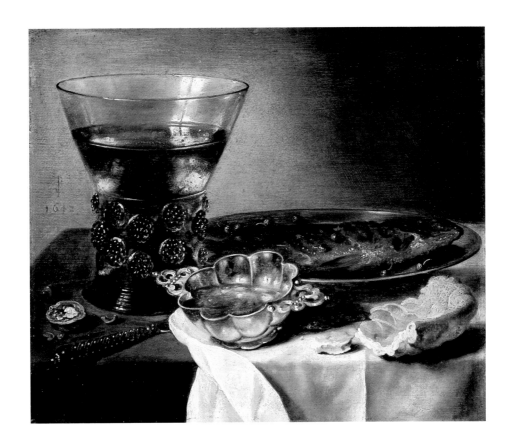

Pl. 2 (cat. 6). PIETER CLAESZ., *Still Life with Stoneware Jug, Wine Glass, Herring, and Bread*, 1642
Pl. 3 (cat. 7). PIETER CLAESZ., *Still Life with Silver Brandy Bowl, Wine Glass, Herring, and Bread*, 1642

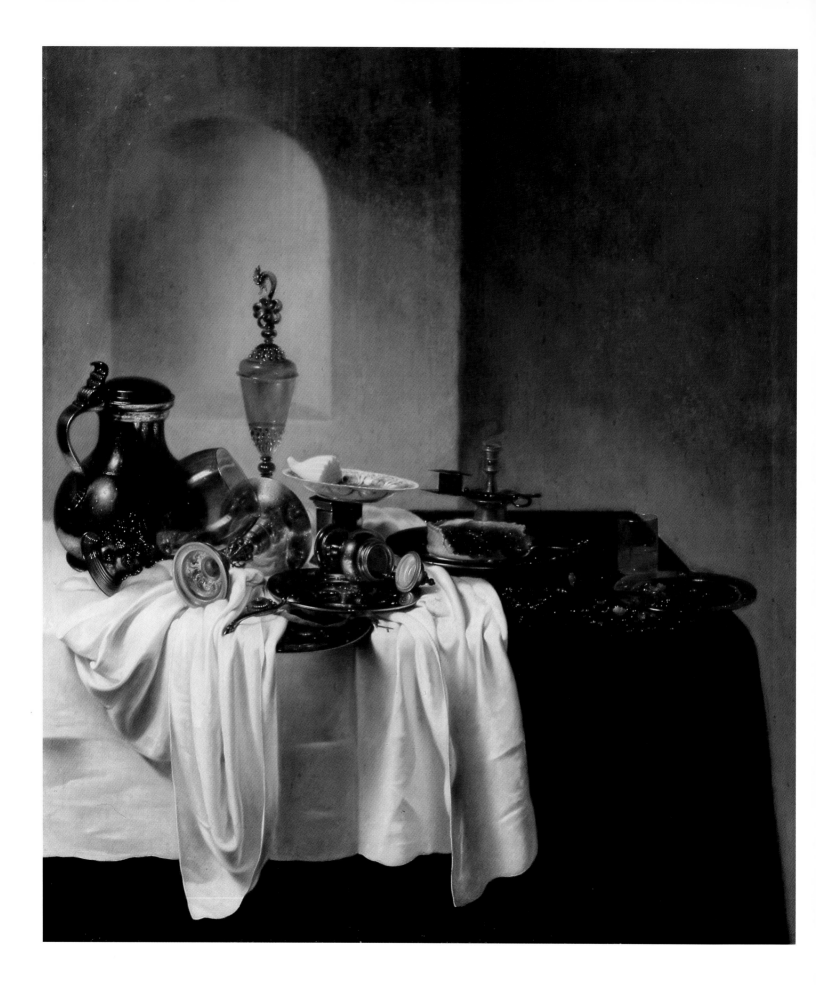

Pl. 4 (cat. 10). JAN JANSZ. DEN UYL, *Breakfast Still Life with Glass and Metalwork*

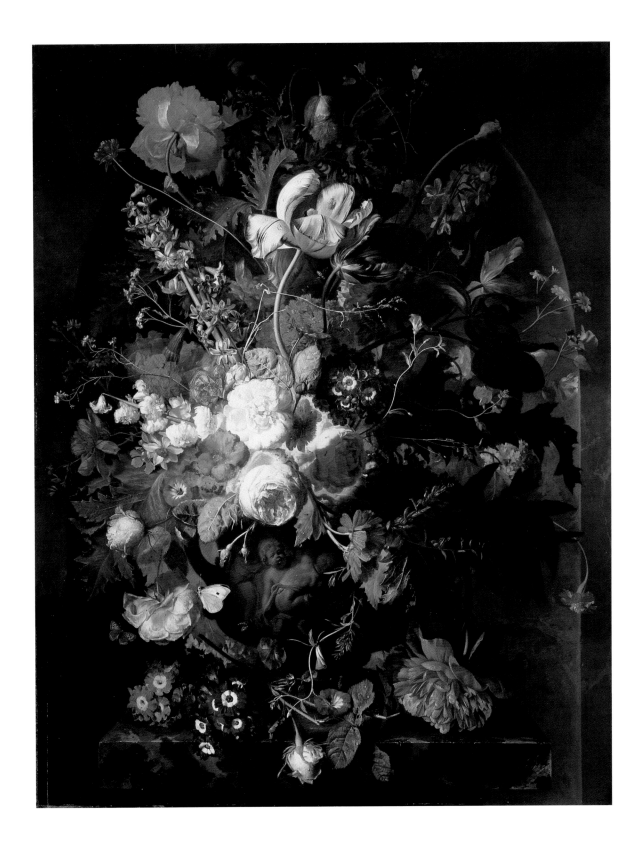

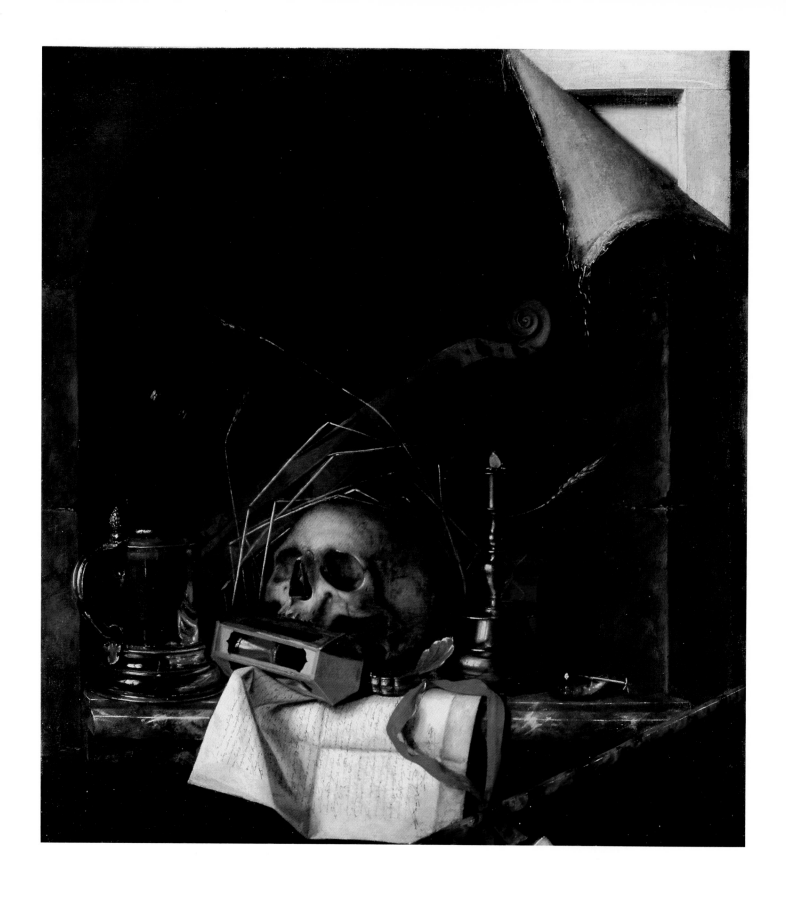

Pl. 6 (cat. 11). CORNELIS NORBERTUS GIJSBRECHTS, *Vanitas Still Life*

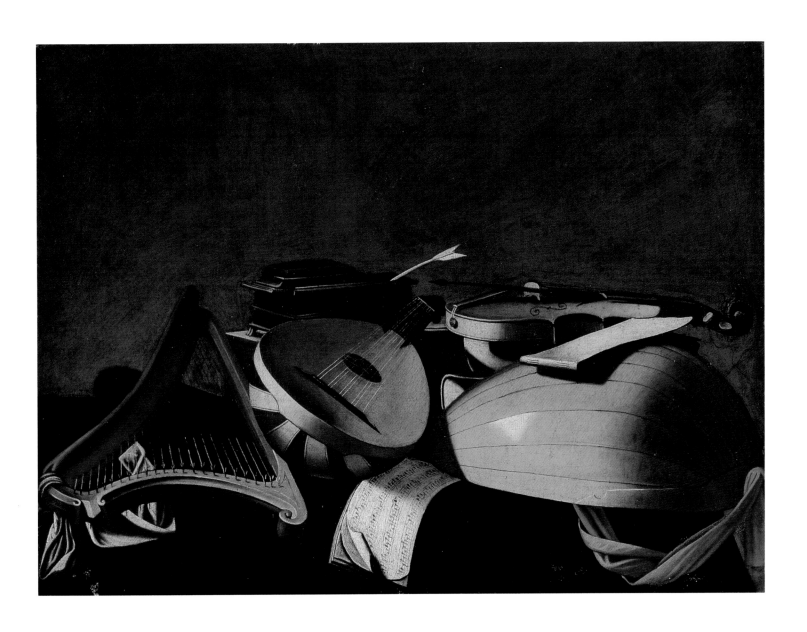

Pl. 7 (cat. 17). Attr. to EVARISTO BASCHENIS, *Musical Instruments*

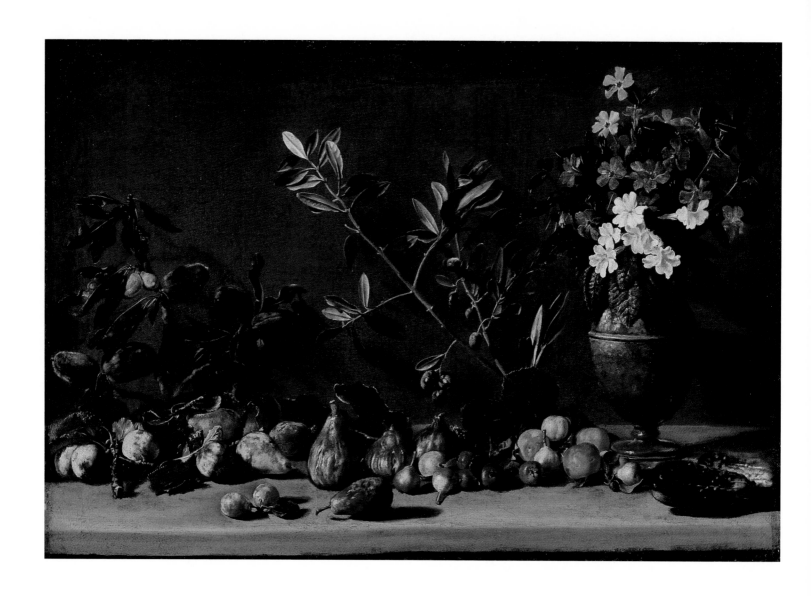

Pl. 8 (cat. 19). Attr. to PIETRO PAOLINI, *Fruit and a Vase of Flowers on a Ledge*

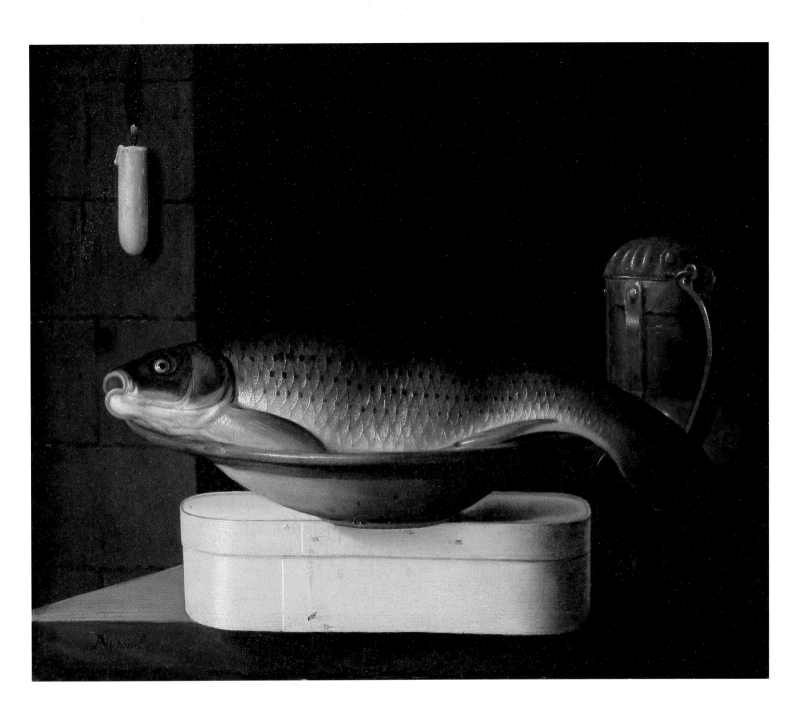

Pl. 9 (cat. 26). PIERRE NICHON, *Still Life with a Dead Carp on a Box*

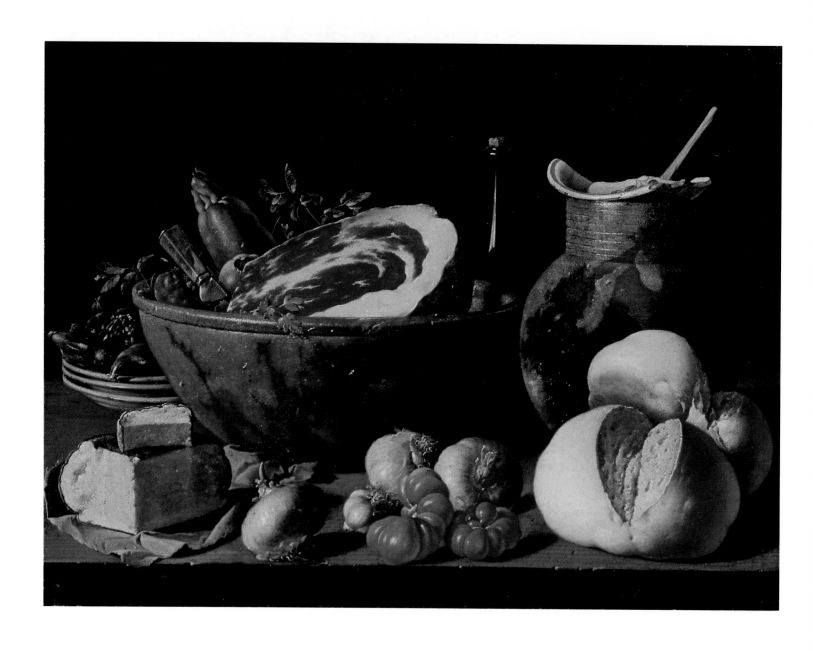

Pl. 10 (cat. 27). LUIS MELÉNDEZ, *Still Life with Bread, Ham, Cheese, and Vegetables*

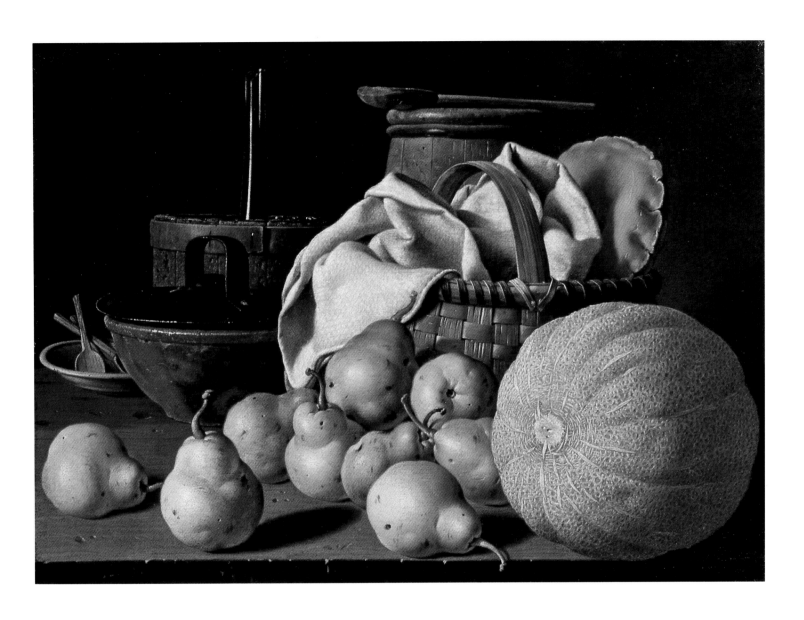

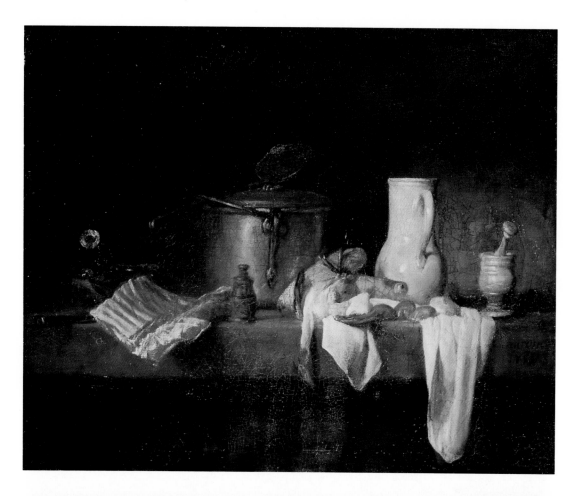

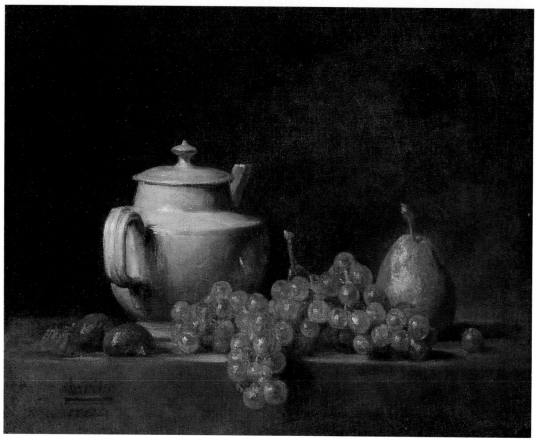

Pl. 12 (cat. 29). JEAN SIMÉON CHARDIN, *Kitchen Table*

Pl. 13 (cat. 30). JEAN SIMÉON CHARDIN, *Still Life with Tea Pot, Grapes, Chestnuts, and a Pear*

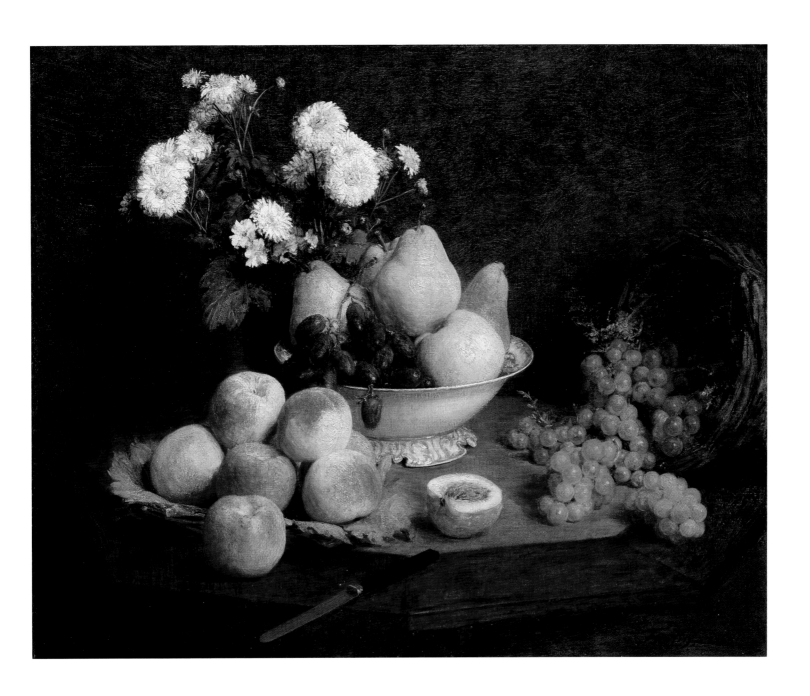

Pl. 14 (cat. 37). IGNACE-HENRI-JEAN-THÉODORE FANTIN-LATOUR, *Flowers and Fruit on a Table*, 1865

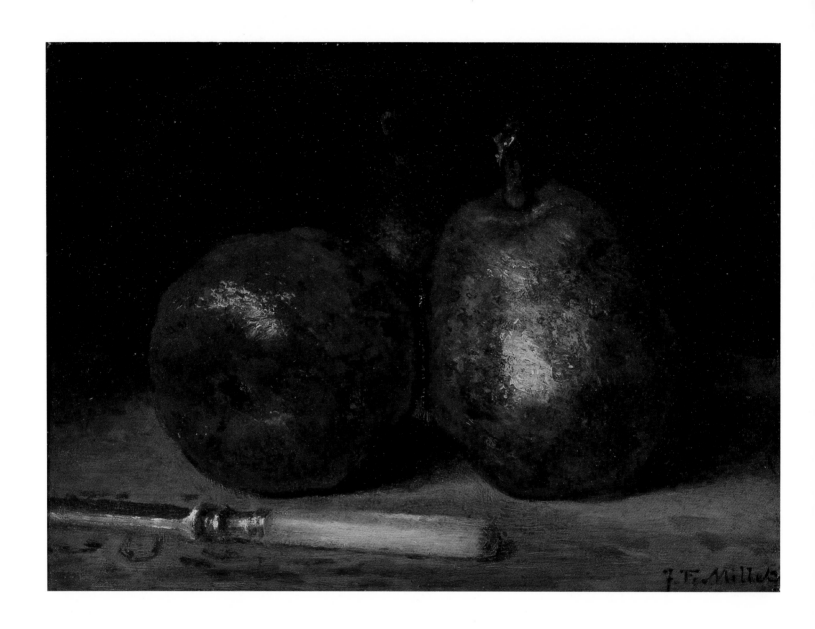

Pl. 15 (cat. 31). JEAN-FRANÇOIS MILLET, *Pears*

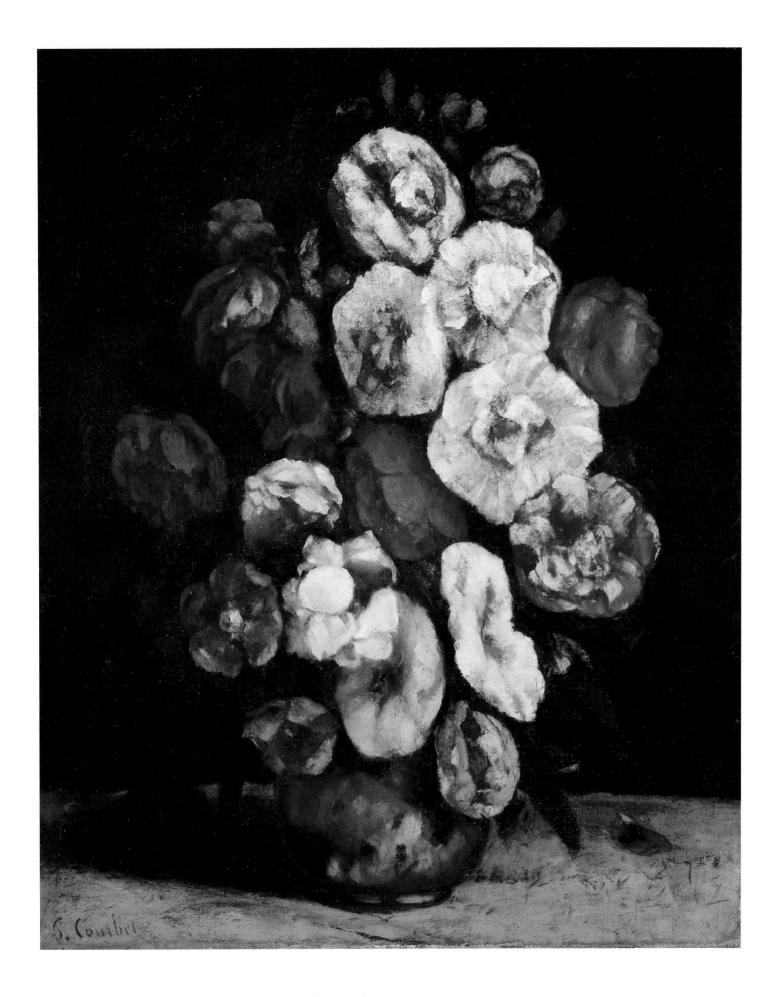

Pl. 16 (cat. 34). Jean Désiré Gustave Courbet, *Hollyhocks in a Copper Bowl*, 1872

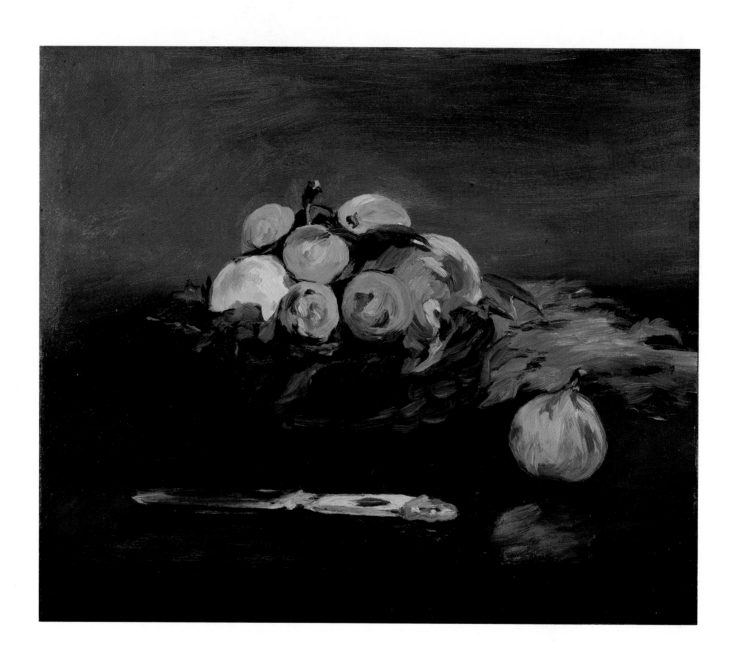

Pl. 17 (cat. 40). EDOUARD MANET, *Basket of Fruit*

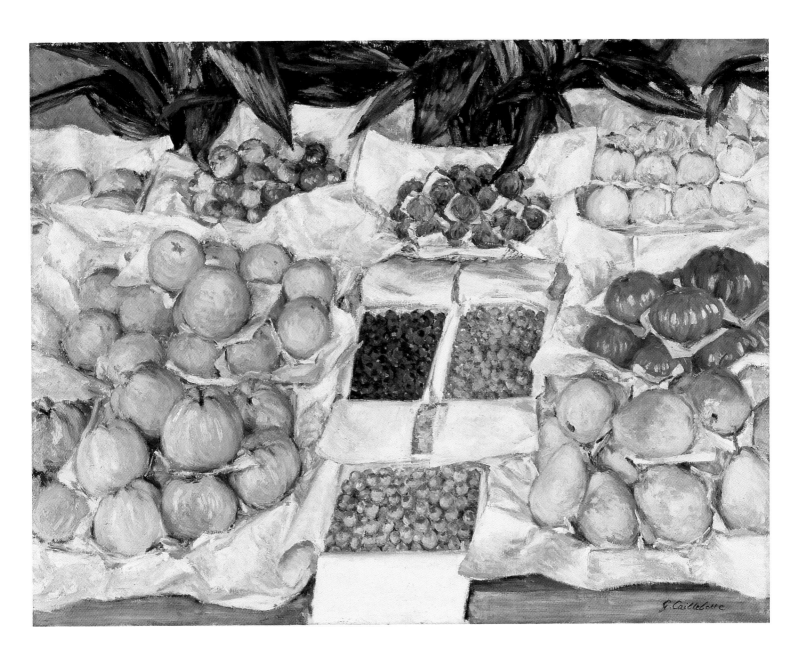

Pl. 18 (cat. 43). GUSTAVE CAILLEBOTTE., *Fruit Displayed on a Stand*, ca. 1881-82

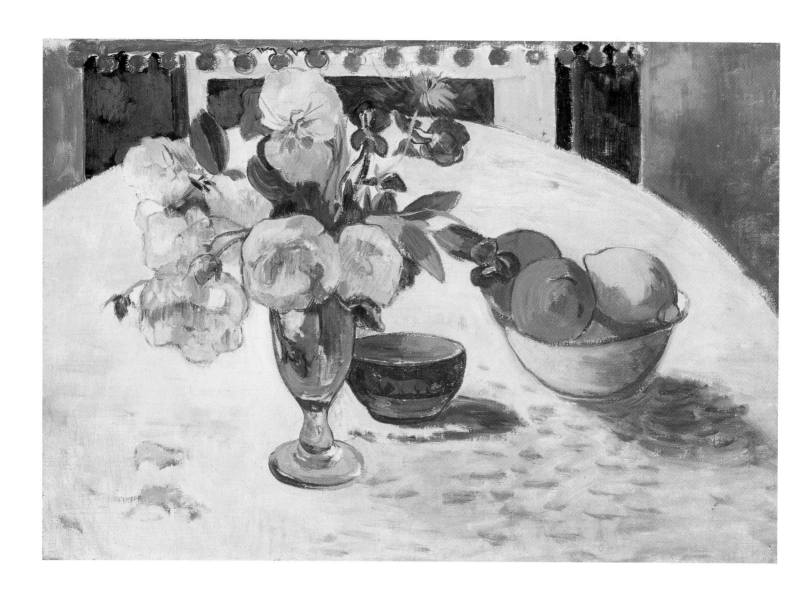

Pl. 19 (cat. 44). PAUL GAUGUIN, *Flowers and Bowl of Fruit on a Table*

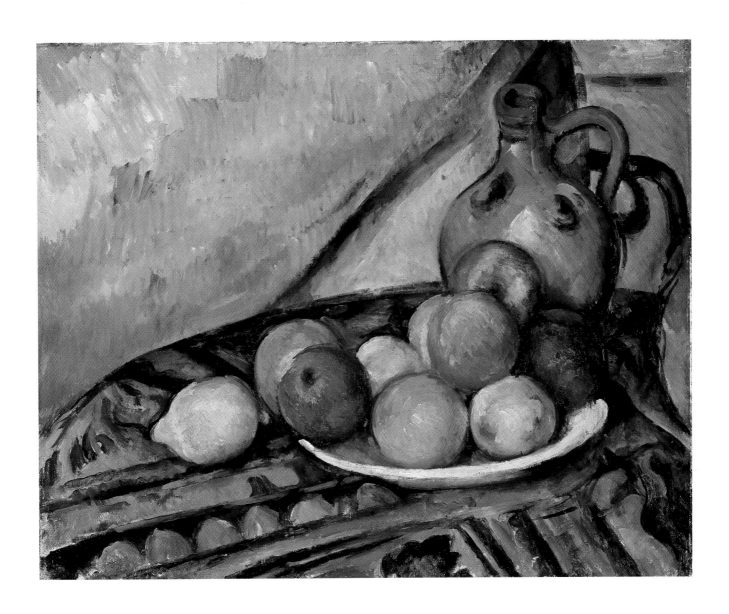

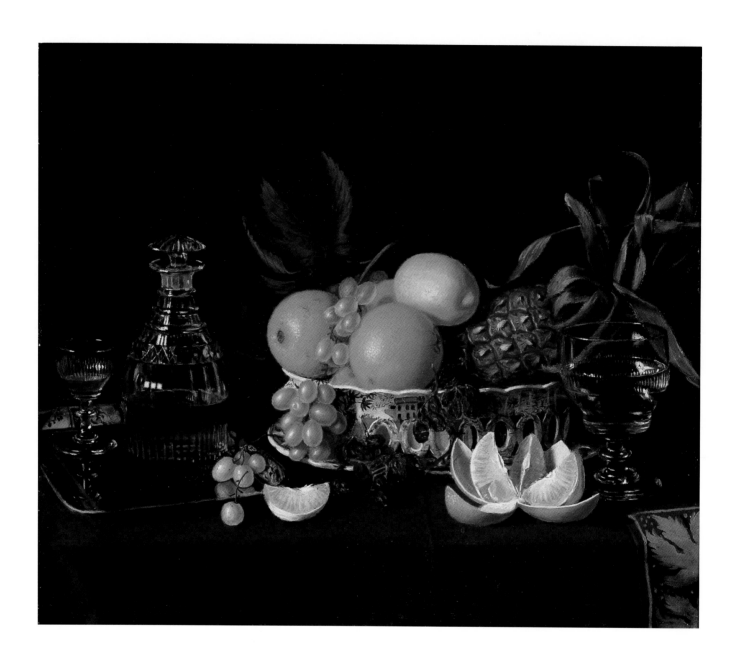

Pl. 21 (cat. 53). CHARLES BIRD KING, *Still Life on Green Tablecloth*, ca. 1815-25

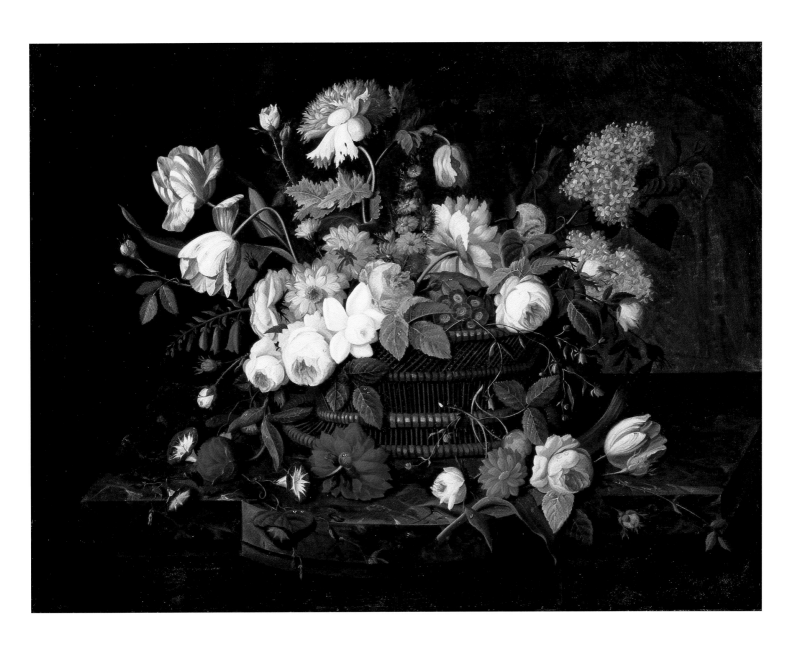

Pl. 22 (cat. 55). Severin Roesen, *Still Life – Flowers in a Basket*

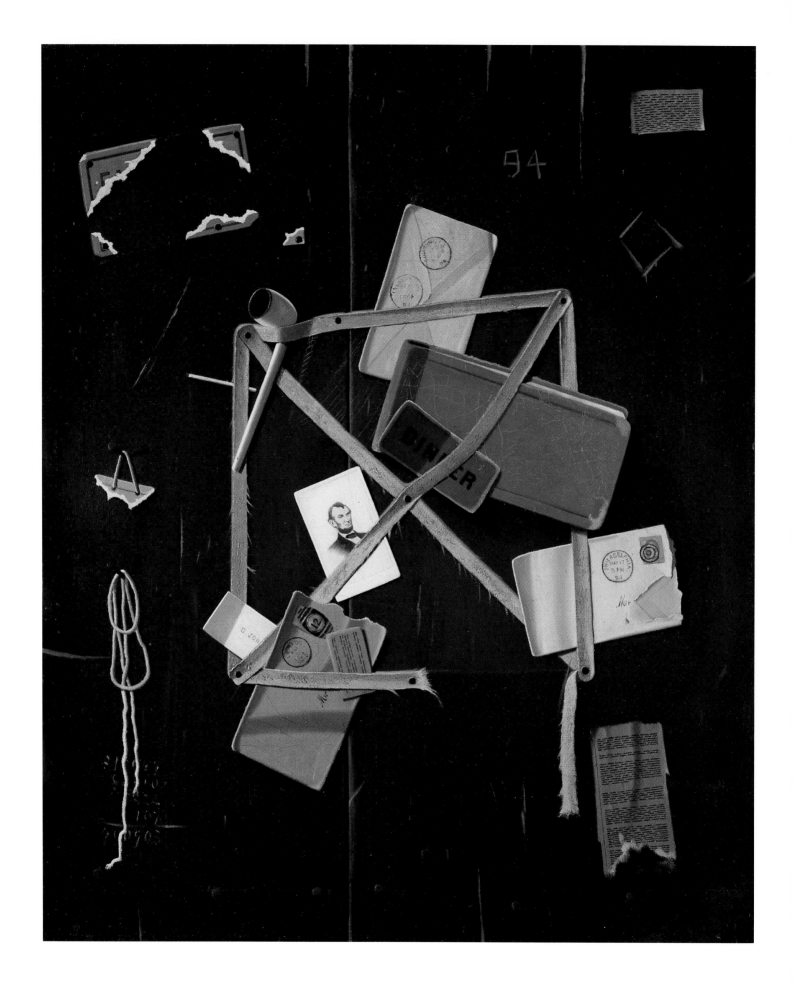

Pl. 23 (cat. 61). JOHN PETO, *Old Time Letter Rack*, 1894

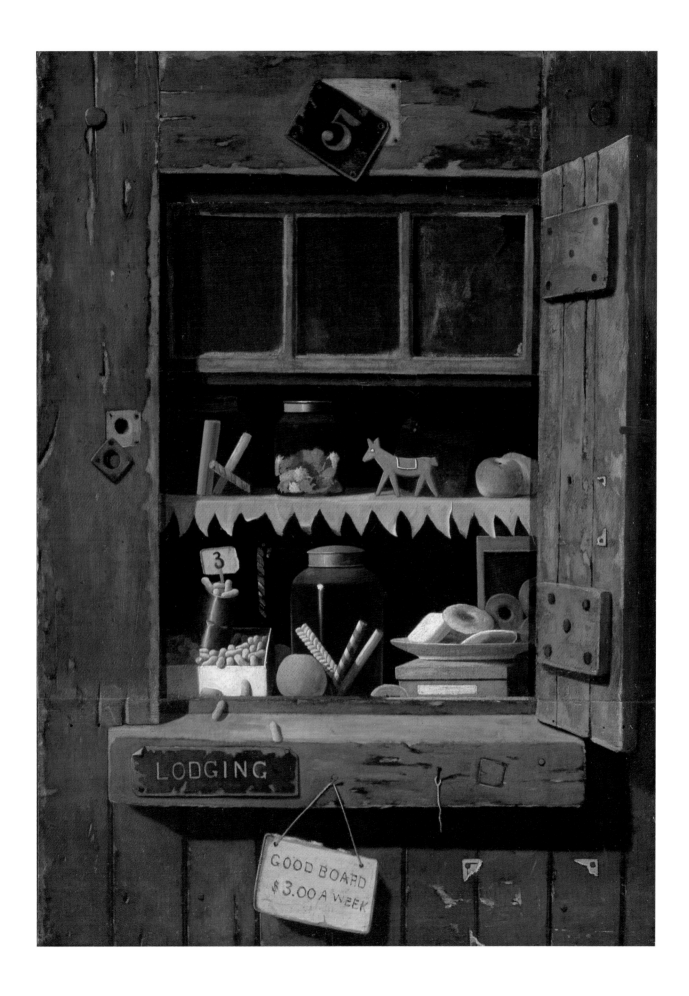

Pl. 24 (cat. 62). JOHN PETO, *The Poor Man's Store*

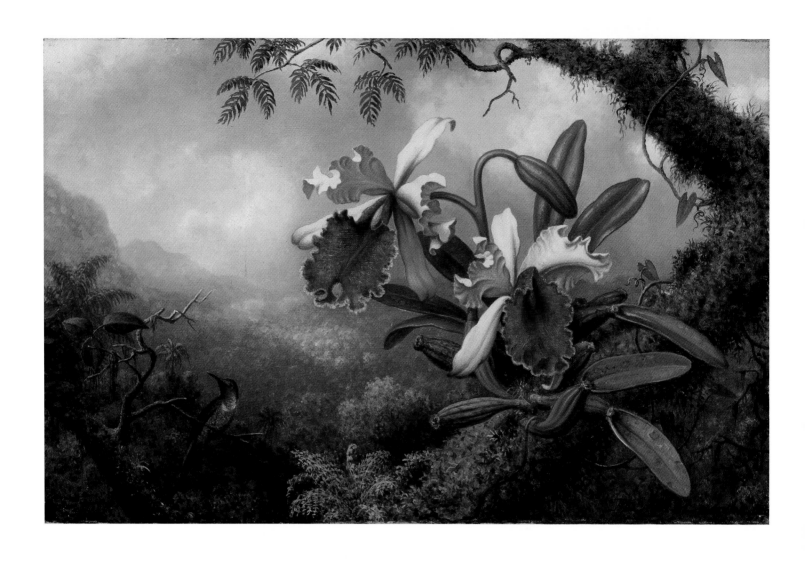

Pl. 25 (cat. 59). Martin Johnson Heade, *Orchids and Hummingbird*, ca. 1875-85

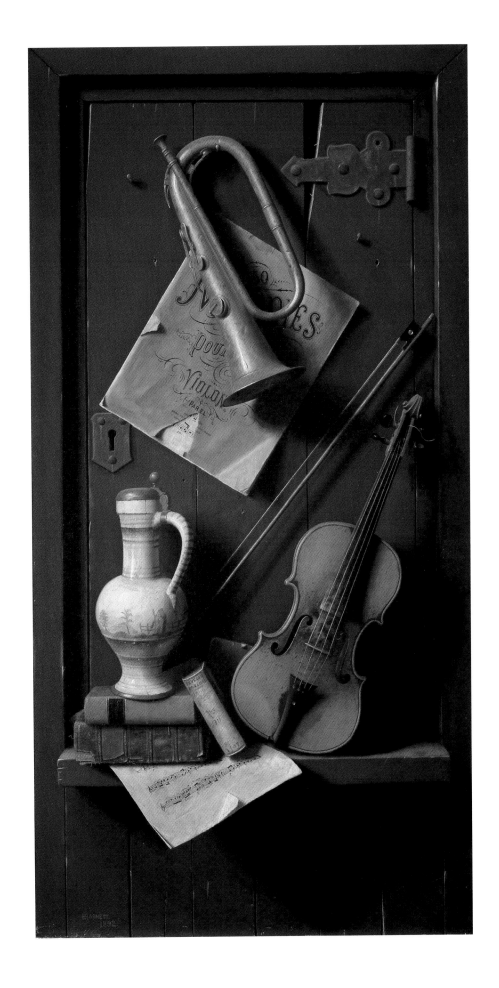

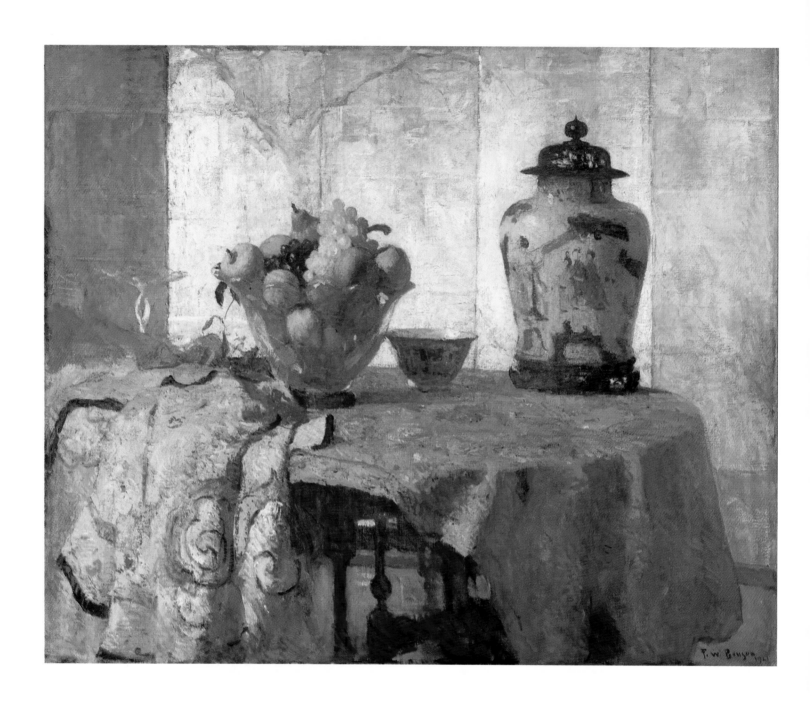

Pl. 27 (cat. 67). FRANK WESTON BENSON, *The Silver Screen*, 1921

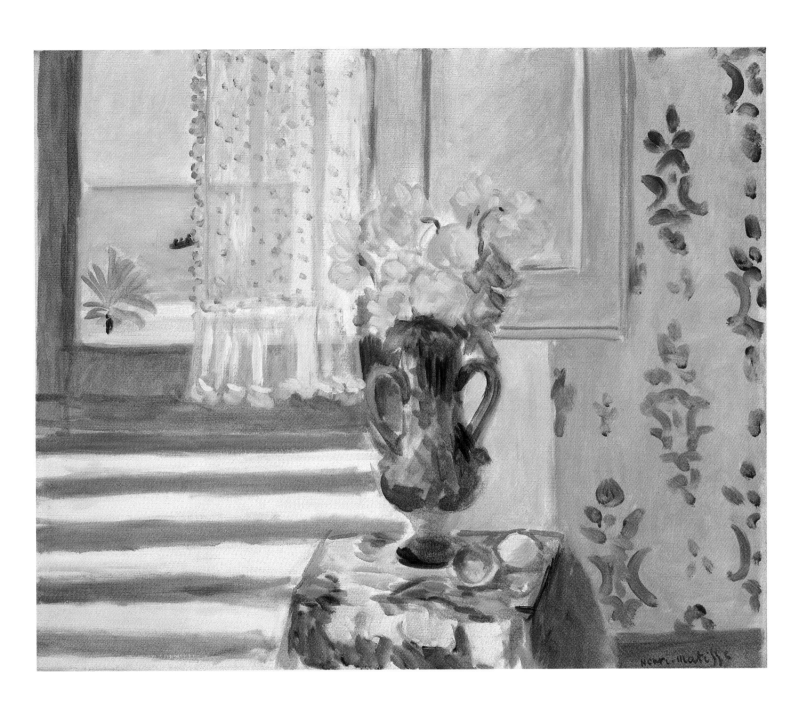

Pl. 28 (cat. 79). HENRI MATISSE, *Vase of Flowers*

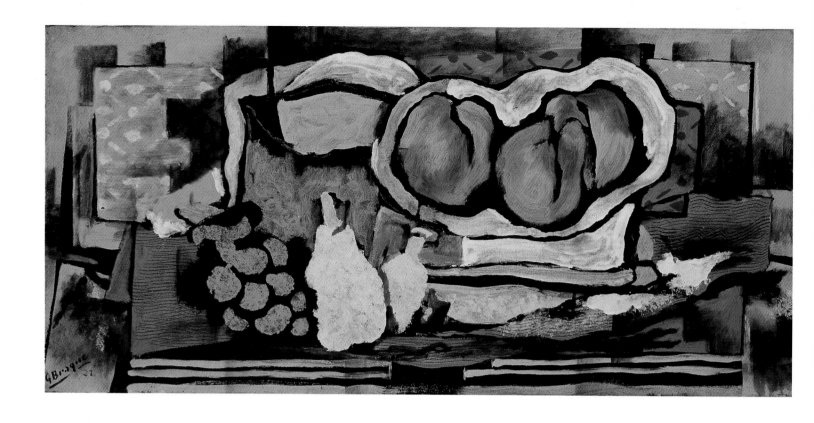

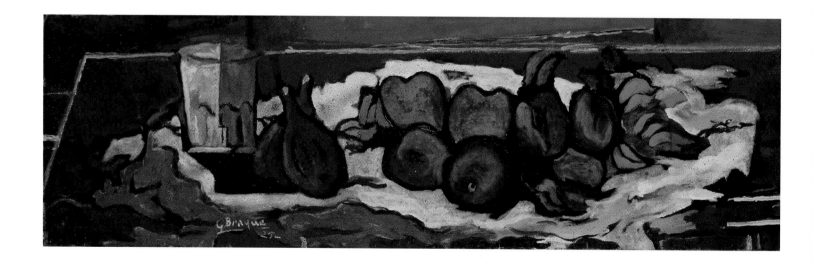

Pl. 29 (cat. 73). GEORGES BRAQUE, *Still Life with Peaches, Pears, and Grapes*, 1921

Pl. 30 (cat. 74). GEORGES BRAQUE, *Still Life with Plums and a Glass of Water*, 1925

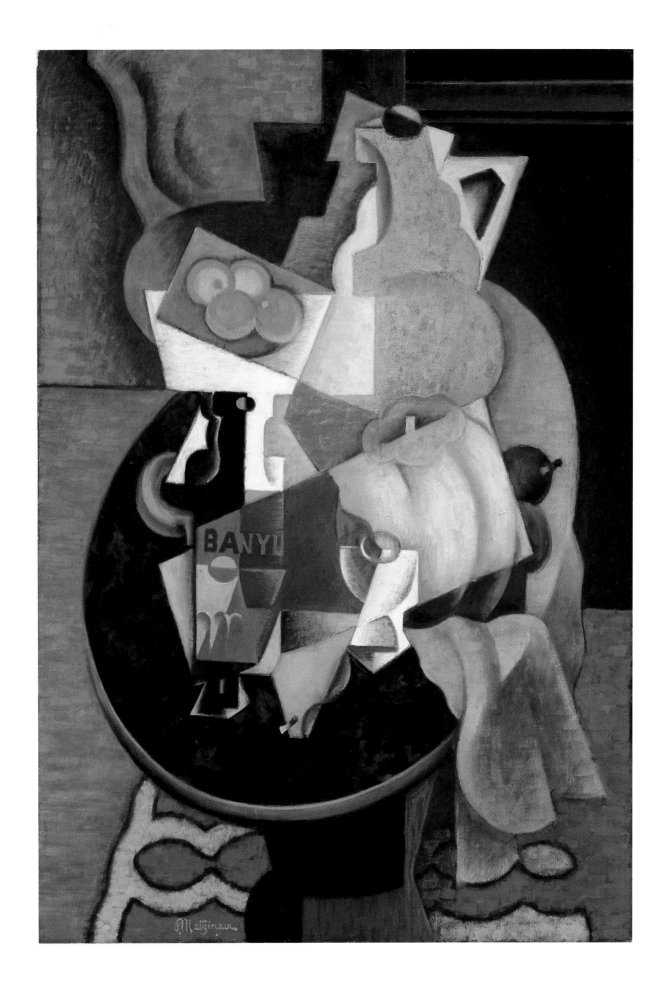

Pl. 31 (cat. 72). JEAN METZINGER, *Fruit and a Jug on a Table*

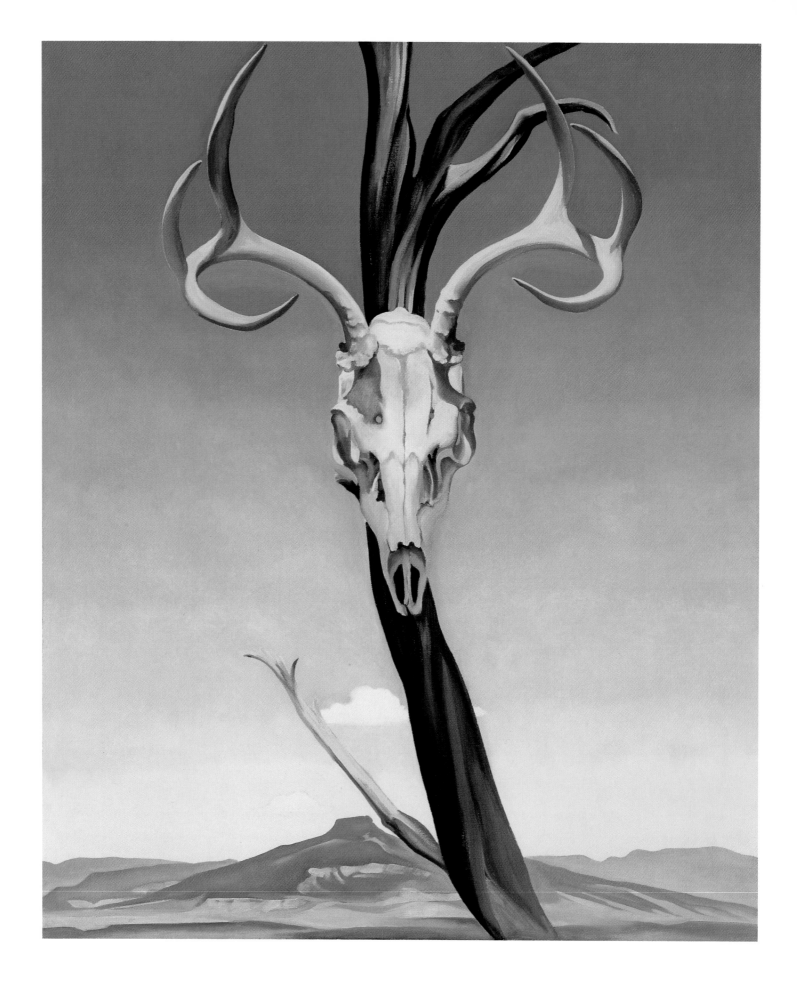

Pl. 32 (cat. 85). GEORGIA O'KEEFFE, *Deer Skull with Pedernal*, 1936

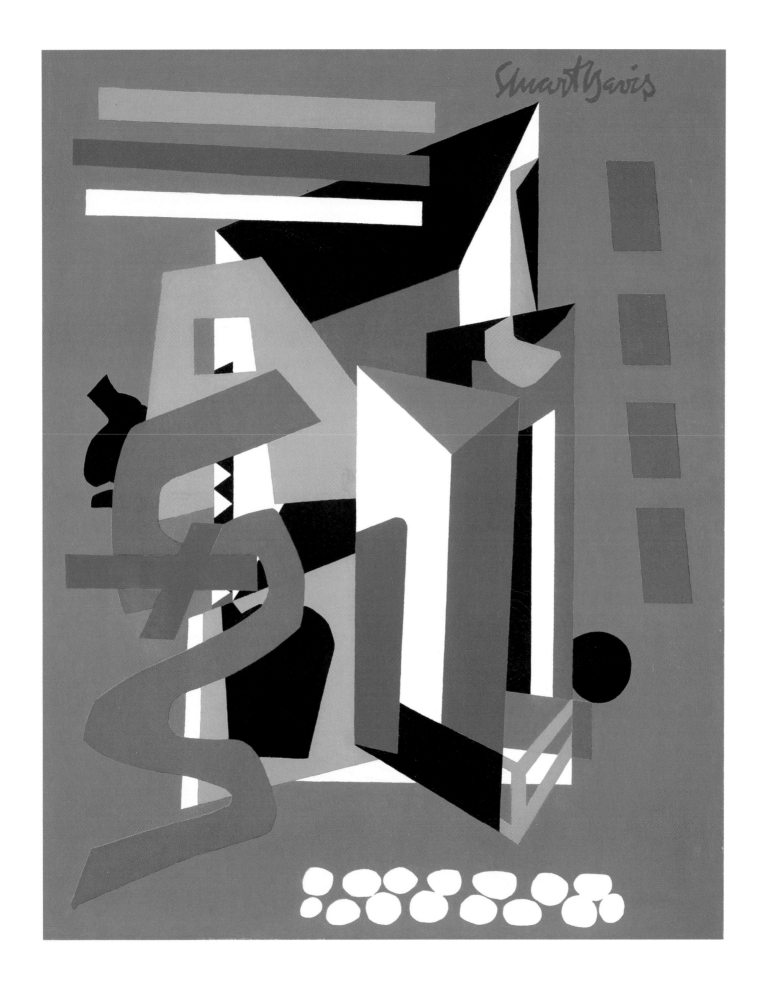

Pl. 33 (cat. 77). STUART DAVIS, *Medium Still Life*, 1953

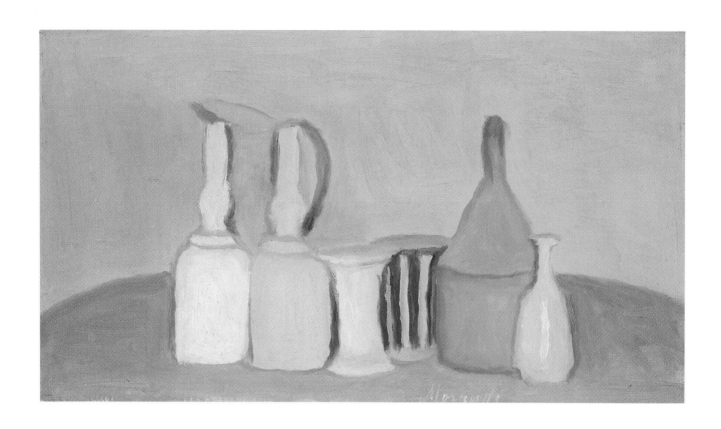

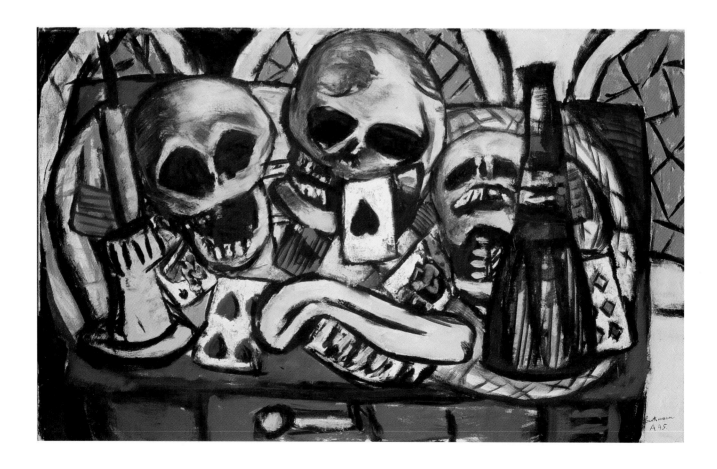

Pl. 34 (cat. 89). GIORGIO MORANDI, *Still Life of Bottles and a Pitcher*, 1946

Pl. 35 (cat. 90). MAX BECKMANN, *Still Life with Three Skulls*, 1945

STILL LIFE PAINTING

"Surely art has come to so great a misfortune that one finds the most famous collections composed mainly of paintings which would be made as a mere diversion or in play by great masters, for example, here a bunch of grapes, a pickled herring, or a lizard, or there a partridge, a game-bag, or something less significant."

— Samuel van Hoogstraten, *Inleyding tot de Hooge Schoole der Schilderkonst* (1678).[1]

Given Hoogstraten's dismissive words, which typify early views of still life, one wonders how he might have reacted to Maurice Denis's *Homage to Cézanne* (1900; Paris, Musée d'Orsay), a painting which explores, among other themes, the importance of still life in avant-garde painting. In *Homage*, Denis depicted some of the prominent painters of the day. While he painted portraits of Cézanne's contemporaries, he represented Cézanne himself with one of the artist's canvases, significantly a still life, which once belonged to Paul Gauguin and in Denis's picture is encircled by the assembled artists.[2] In its arrangement of figures and its style, Denis's *Homage to Cézanne* refers to two other group portraits of painters by Fantin-Latour – *Homage to Eugène Delacroix* (1864; Paris, Musée d'Orsay) and *The Atelier in the Batignolles* (1870; Paris, Musée d'Orsay). Though Fantin-Latour's subjects varied, he was best known during his lifetime for his still lifes. How, then, did still-life painting, which Hoogstraten dismissed, attain the status that Denis directly and indirectly accorded it in his picture? How did the genre develop and why did early writers deride it?

The independent still life first appeared in Northern and Southern European art in the last decades of the sixteenth century.[3] Precedents for the independent still life date to antiquity when, according to Pliny the Elder, Greek artists in the fourth century B.C. – Piraikos was the most famous – painted illusionistic images of foodstuffs on small wooden panels. Images of food, vases of flowers, and skulls, all conven-

tional motifs of European still life, are also found in wall paintings and mosaics from the Roman era. While the medieval period reveals no evidence of still-life painting per se, images of objects in the borders of illuminated manuscripts suggest that a fascination with the material world endured, though it was subordinated to religious issues. Between the fourteenth and sixteenth centuries, the impulse to render mimetic likenesses of material objects grew stronger. Increasing interest in the natural world led artists in the North to observe and record closely the shapes, textures, and properties of physical phenomena – velvet, fur, reflective metal surfaces, woodgrain, and the like. Inspired perhaps by a renewed interest in the trompe l'oeil still lifes of antiquity, which they would have known either from examples from Roman wall paintings or mosaics or from Pliny's descriptions, painters in Italy began to render objects on intarsia panels and gradually to incorporate them into their portraits and religious pictures. Taddeo Gaddi's images of various eucharistic vessels set in trompe l'oeil niches in the Baroncelli Chapel of Santa Croce in Florence (1337-38) and the religious pictures of the late fifteenth-century Venetian painter Carlo Crivelli (fig. 1), which frequently display succulent fruits and vegetables, are instructive examples of this trend. Prominent piles of food and vessels dominate the small religious scenes in the backgrounds of the market and kitchen scenes of the late sixteenth-century Flemish painter Pieter Aertsen, and his student, Joachim Beuckelaer – works which are generally viewed as the immediate precursors of the independent still life. Market and kitchen scenes, derived from the paintings of Aertsen and Beuckelaer, were also painted in the South by Bartolomeo Passerotti of Bologna and Vincenzo Campi of Lombardy whose work is represented in this exhibition by a copy executed by the Flemish artist Scipio Goltzius (cat. 1). While research has convincingly shown that the religious scenes in the works of Aertsen and Beuckelaer were not merely vestiges of an older tradition of image-making but shaped the meaning of the market and kitchen scenes by imbuing them with moral import, Aertsen and Beuckelaer nonetheless gave the objects extraordinary visual importance through placement

and size.[4] Aertsen's contemporaries praised his paintings for their naturalism and in 1588, Hadrianus Junius compared the artist to the ancient Greek painter Piraikos.[5] Caravaggio's majesterial renderings of fruit, flowers, and musical instruments in his genre and religious paintings of the sixteenth century also gave impetus to the independent still life. His fascination with the material world eventually led him to paint an independent still life, *Fruit and Flowers in a Basket* (ca. 1600; Milan, Pinacoteca Ambrosiana), one of the earliest surviving examples of the genre.

While we can locate possible sources for the independent still life and link its evolution to the growth of naturalism, neither the availability of models nor the existence of the naturalistic vision alone explains why painters in the last decades of the sixteenth century no longer felt compelled to render material objects simply as accessories or attributes. The emergence of still life involved a constellation of larger forces at work – economic, social, and intellectual conditions which made pictures composed solely of objects (metalwork, instruments, pieces of food, flowers, ceramic vessels, glasses, books, playing cards, and the like) a viable artistic goal. Some specific factors deserve mention. Surely the independent still life could not have developed apart from the rise of secular humanism, the move away from a theocentric view of the world to a belief in the centrality of man and his power to shape the world. The latter fostered an environment conducive to the execution of paintings focused on objects that individuals had crafted, consumed, cultivated, touched, and admired – objects that gave them physical and emotional sustenance and pleasure. That shift also encouraged the painter to make his somatic sensations – his sense of taste, touch, and smell – a part of the picture.

Still life was not the only kind of painting that gained currency at this time – portraiture, landscape, and genre painting also grew in popularity, all like still life, indicating the emerging primacy of man's experience in the world. The growth of empirical science, the generation of knowledge through observation of physical phenomena, which took root in the seventeenth century, also indicated and helped cultivate a disposition favorable to still life. It is surely not coincidental that the microscope was invented in the last decade of the sixteenth century, that the popularity of the magnifying glass

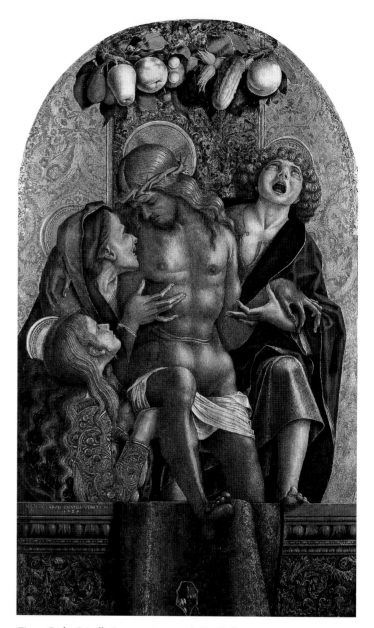

Fig. 1. Carlo Crivelli, *Lamentation over the Dead Christ*, 1485. James Fund and Anonymous Gift. 02.4

grew during that time, or that wealthy nobles built *kunst-* and *wunderkammern* – collections of curiosities, ethnographic, botanical, and zoological specimens, rare and precious gems. All attest to the same desire to scrutinize and categorize objects that one witnesses in still life, especially in its early phases.

In addition to depending upon changing attitudes about man's sense of his own place in the world and his ways of understanding it, the emergence of still life involved a new group of buyers, a shift in the sensibilities of older or established sources of artistic patronage, and new ideas about the function of pictures and where they might be hung. In earlier periods, painters had depicted religious and historical themes and depended largely upon commissions from the church and the ruling elite. By the early seventeenth century, the growth of the middle class increased the pool of people with the means to buy pictures, while the evolution of the private art market gave them the opportunity to do so. Still life, moreover, might be linked to new notions of privacy and the increasing importance of the domestic sphere, tendencies which began to manifest themselves in changes in residential architecture and new conceptions of the family beginning in the seventeenth century. It has been suggested that still life exemplifies the increasing hegemony of the bourgeois conception of the world which emphasized the material and concrete, as well as the formation of an individual's identity in terms of property and possessions.[6] At the same time still lifes also found receptive patrons among the nobility, indicating a change in their world view, their relation to material objects, and their expectations of pictures.

Whether the independent still life originated in the North or the South has been a subject of debate. The earliest surviving still lifes all come from the North, from Holland and Flanders, although literary evidence suggests that artists painted still lifes in Italy during the same period.[7] The debate may, in fact, be a moot point since there was such an active exchange of ideas between artistic centers in the late sixteenth and early seventeenth century. While the independent still life may have been the product of interaction between North and South, painters in each region approached the genre differently. From an early date, Northern painters tended to specialize in certain categories of still life, which were designated with names

derived from the contents of the picture: *ontbijtje* (breakfast piece or light meal), *bloempot* (vase of flowers), *fruitje* (fruit piece), *jachtje* (trophy of the hunt), and *vanitas* (*Memento mori* or a reminder of mortality or human failures or errors). With the exception of the Cremonese artist Evaristo Baschenis, who mainly painted pictures of musical instruments (see cats. 16-17), artists in the South did not specialize in one type of still life over another, but most favored images of fruit and flowers, depicting meals less frequently.

Though painters executed still lifes from the beginning of the seventeenth century, the recognition of still life as a category within art criticism only came somewhat later. In Holland, the general term for these pictures, *stilleven*, meaning still models, came into usage in the middle of the seventeenth century, while the French term, *nature morte*, first appeared in the middle of the eighteenth century. Earlier terms included André Félibien's *choses mortes et sans mouvements*, a phrase he used in setting out the hierarchy of genres in 1669, while Denis Diderot and others preferred *nature inanimée*. Both the Italian term *natura morta* and the Spanish designation *naturaleza muerta* date only to the nineteenth century. Spanish still-life pictures, however, were more commonly known as *bodegones*, a word which initially referred to lower class restaurants, or were described like their Dutch counterparts by their contents – *lienzos de frutas* (paintings of fruit), *lienzo de caza* (painting of game), and so on.[8]

While the number of still lifes executed over the centuries attests to significant and sustained demand, research thus far suggests that theorists and writers well into the nineteenth century usually discouraged artists from paying any special attention to the painting of inanimate objects. Already the terms devised to designate the genre – dead nature and things without movement, for example – signal a negative attitude. Though the comments that follow come from writers of different nationalities and of different periods, their reservations show a remarkable consistency, resulting in large part from the pervasive authority of classical theory. In antiquity, writers distinguished between *rhyparography*, the paintings of small, insignificant, and sordid things, and *megalography*, the painting of more noble subjects, and generally believed that images of objects were inferior to scenes from history and fable, which entailed the exposition of ideas through depictions of the

human form, not the mere imitative record of objects. Alberti in his *Della Pittura* (1436) held to this distinction between invention and imitation and insisted upon the superiority of history painting and the images of the human figure. Sensing perhaps the potential popularity of still-life paintings and concerned that Dutch painters prove themselves the intellectual equals of Italian artists, the Dutch writer Karel van Mander in 1604 echoed Alberti's prescriptions, urging Dutch artists to focus their efforts on figural scenes from history, the Bible, or mythology, and encouraging them to devote less attention to such prosaic objects as pieces of food and flowers.[9]

The text that had perhaps the greatest impact on the way that subsequent writers posed still life was that of the architect and writer André Félibien who in 1669 presented a hierarchy of genres to the Royal Academy of Painting and Sculpture in France, putting into theory what had been observed in the practice of painting for at least several decades. Félibien gave history painting pride of place since it involved the most difficult of subjects: the human figure; the most elevated themes: ancient literature, the Bible, and history; and the most noble purpose: the inculcation of moral and ethical values in the viewer. History painting, most significantly, required the painter to use the faculties which set him apart from the craftsman and aligned him more closely with God: his imagination and intuition.[10] Until the middle of the nineteenth century, a French painter usually made a name for himself at the annual Salon, the state-sponsored exhibition held each May, with a grand history painting involving an ennobling theme and a complex arrangement of figures. The goal of executing a history painting also determined the curriculum at the Ecole des Beaux-Arts where students perfected their abilities to render the idealized human figure.

The power and authority of the Academy in France in determining aesthetic policy and practice perhaps partially explains why still-life painting never enjoyed the same popularity there that it did in, for example, Holland. However, even in seventeenth-century Holland, which boasted some of the greatest concentrations of outstanding still-life painters in the world, still-life painting remained a dubious endeavor in the eyes of art theorists. In his *Inleyding tot de Hooge Schoole der Schilderkonst* of 1678, Samuel van Hoogstraten followed Félibien's hierarchy, relegating still-life images to the lowest eche-

lons and describing such paintings as "common footsoldiers in the army of art, which should not be produced by a good artist except for amusement or a game" – a surprising opinion since Hoogstraten himself painted illusionistic still lifes and acknowledged that some of the most noted collections of art included examples of the genre.[11] Similar sentiments came from Sir Joshua Reynolds in England although he allowed that the genre had some merit:

> Even the painter of still life, whose highest ambition is to give a minute representation of every part of those low objects which he sets before him, deserves praise in proportion to this attainment; because no part of his excellent art, so much the ornament of polished life, is destitute of value and use. These, however, are by no means the views to which the mind of the student ought to be primarily directed.[12]

In the United States, still-life paintings were relatively rare until the mid-nineteenth century because there were few places for painters to exhibit their works publicly, a crucial concern in the case of still-life images which were most often made on speculation not on commission. What little Americans wrote about the genre in the nineteenth century suggests that their ideas derived from European art theory – still-life painting lacked imagination and invention; the still-life painter's work was more mechanical than mental.[13] In an intriguing twist, the critic Daniel Fanshaw condemned still life not only for its lack of invention but also its popularity, writing in 1827 that the chief merit of the genre, its "exactness of imitation," made it "intelligible to all," a quality which given the condescending tone of his remarks, did not recommend it.[14]

Fanshaw's reservations about still life's general intelligibility, of course, involved issues that are peculiar to the history of American culture, specifically the resistance in the United States to endeavors that were not outwardly practical, useful, or widely accessible. Nonetheless it can be suggested that he articulated a sentiment that lay beneath the surface of the commentary of the earlier European theorists. The hierarchy of genres recapitulated a larger hierarchy of social and political values and was intended to maintain a certain order of experience. It is tempting to suggest that critics like Félibien, Hoogstraten, and Fanshaw understood the genre's potential to legitimate – not just recognize – and to explore to discon-

certing and unacceptable degrees certain kinds of experiences, particularly those surrounding the sustenance and gratification of the body and the display of property as an index of status. Though writers might acknowledge the existence of still life, they would not allow the genre – and the experiences that it alluded to – to disrupt a system of values and a cultural order arranged around the spirit and the intellect.

While the writers just cited represent the dominant view of still life, the genre did find supporters. For varied reasons, Diderot and Proust, for example, both lauded Chardin's still lifes and Reynolds and Goethe were moved by Dutch examples.[15] As more research is done on this genre – it is, in fact, one of the least studied – our sense of its reception may change. As for the commentary that is available, we need to understand its limitations. To contend as the early theorists and critics did that still-life painting involved mere technical skills and exacted little from painters in the way of invention and imagination, to insist that the viewer's engagement with a picture turned solely on recognizing and naming the objects in the picture and judging the painter's ability to mimic nature does not do justice to the range of meanings that still-life painters have produced or the variety of factors that have shaped still lifes over the centuries. Surely describing forms and textures of objects in the material world was one aspect of still-life painting well into the nineteenth century. We have only to look at their careful depictions to know that a fascination with the specific physical qualities of various objects came to bear on Pieter Claesz. (cats. 6-8), for example, when he painted pieces of shiny metal and translucent glass, or Luis Meléndez (cats. 27-28) when he rendered the tough veined surface of a melon, or Fantin-Latour (cats. 36-37) when he attempted to capture the soft fuzzy skin of the peach. Today perhaps we tend to underestimate the value that painters and viewers in previous eras placed on mimetic description. Nonetheless, it would be wrong to limit still life's significance to a valorization and imitation of the material world.

The desire to see more in the still life, to understand it within some larger field of meanings is hardly surprising. Meléndez treated his pieces of meat, fruit, and vegetables with such singular devotion and monumentalized them to such a degree that it seems implausible that factors or circumstances beyond the desire to render the specific qualities of the objects did not enter the making of the image. Yet equally unsurprising is our difficulty in explaining what these meanings might be since many still lifes are grounded in a frustrating paradox. Still-life painters often depict objects that are closest to our everyday lives – ones that we use, eat, touch, buy, and admire on a daily basis. These objects are therefore capable of evoking myriad associations and memories from everyday life. As Proust divined while studying Chardin's canvases in the Louvre, still life can prompt us to look more closely at things that we ordinarily neglect because they are so familiar:

> The pleasure his depiction of a room with someone serving gives you, of a pantry, a kitchen, a sideboard, is the pleasure, seized hold of as it passed, released from the moment, made timeless and profound, that seeing a sideboard, a kitchen, a pantry, a room with someone sewing gave to him. So inseparable are they one from the other that if he was unable to confine himself to the first but sought to give himself and to give others the second, you cannot confine yourself to the second but will necessarily return to the first. You had already experienced, unconsciously, the pleasure that the spectacle of modest lives or of still life affords, else it would not have arisen in your heart when Chardin came to summon it with his brilliant and imperative language. Your consciousness was too inert to descend so far. It had to wait until Chardin came to take it up inside you and raise it into consciousness. Then you recognized it and savored it for the first time. If when you look at a Chardin you can say to yourself, this is intimate, is comfortable, is alive like a kitchen, when you walk about a kitchen you will say to yourself, this is interesting, this is grand, this is beautiful like a Chardin.[16]

In Proust's understanding, the still life operates in concert with the world from which it comes, the one enhancing and shaping the apprehension of the other, while the intersection of the two suggests a fluid rather than inviolable boundary between the material and painted realms. Yet as close as still life might come to everyday life, no genre can seem as remote, resistant, unyielding, and mute as still life often does since it involves no story, action, or evident theme. The still life eludes capture in a text composed of characters, events, and relations. Claesz.'s breakfast pieces for example portray the makings of a meal, but the objects are so still, so deliberately placed – the set of the knife so perfectly angled to echo the line of the tablecloth – that it is difficult to imagine an

individual sitting down to eat the bread, cut the fish, or touch his lips to the glass, to intrude, in short, upon this perfectly contained and ordered world.

This particular collection of works and the commentaries included in the individual catalogue entries enable us to see how varied the aims and meanings of still lifes have been over the centuries. The reservations of the earlier theorists aside, still lifes often involve many levels of meaning and invite varied interpretations. We can attempt, for example, to assess the range of expectations, possible responses, or associations that the objects might have evoked in contemporary viewers. We can situate still life in relation to other genres and analyze the ways in which painters resisted or exploited what may have seemed the limitations of the genre, particularly the absence of a story in which the objects played specific roles. We can ask whether the artist envisioned a particular audience or patron when he selected his objects or whether a still life inculcated certain attitudes towards the body, consumption, and physical pleasure. In fairness to earlier writers, it needs to be acknowledged that these kinds of questions are the product of a relatively recent expansion of the kinds of inquiry the art historian or critic might undertake and were not necessarily part of earlier frameworks for analyzing pictures.

Though van Mander, Félibien, van Hoogstraten, and others reduced still life to an act of imitation, at different moments still-life painters have aspired to imbue their works with symbolic meanings and moral import, to lead the viewer to contemplate higher ideas, as in religious or history painting. While the literature on still life has perhaps overstated symbolic content, there are certain cases in which such intent is clear. Some paintings, for example, contain what E. de Jongh has called a "tone-setting" element such as a skull, or they exhibit what might be called a "tone-setting" design, which suggests metaphorical dimensions by configuration and placement.[17] An anagogical aim, for example, goes to the heart of the *vanitas* still life like the one painted by Gijsbrechts (cat. 11) where the hourglass, the curled page, the guttering candle, all signifying the passage of time, admonish the viewer to spend his life wisely and reinforce the emphatic reference to mortality embodied in the prominently placed skull. More than three centuries later, Max Beckmann, a German artist, returned to the *vanitas* image in *Skulls*, which he painted in

Amsterdam at the end of World War II. A combination of dark tones and brighter acidic colors as well as expressionistic brushwork amplify the feelings of doom and cynicism embodied in the lifelike skulls which leer at the viewer. Given the many proverbs, fables, and figures of speech which describe human characteristics in terms of the behavior of animals and birds, viewers of Melchior d'Hondecoeter's *Barnyard* (cat. 20) may have appreciated the scene as a morality play of sorts, or seen Otto Marseus van Schrieck's forest scene with its threatening snake and lizard (cat. 13) as a metaphor of human strife. The stark order and monumentality of the objects as well as the sepulchral lighting of Pierre Nichon's copy of Sébastien Stoskopf's *Still Life with Dead Carp* (cat. 26) might have encouraged contemporary viewers to read the fish and other objects in Christological not just literal terms.

In other instances, the selection and presentation of the objects can be interpreted in terms of the economies and the consumption habits of a particular country and time. While today we might see the seventeenth-century Spanish *Still Life with Sweetmeats* (cat. 15) as a whimsical image reminiscent in some ways of a candyshop window, in its day it might have evoked thoughts of political and economic power, of Spain's position as the leading cultivator of sugar in the early decades of that century and of its colonial possessions where sugarcane grew. With its panoply of rich, expensive objects, Jan Jansz. den Uyl's *Breakfast Still Life with Glass and Metalwork* (cat. 10) celebrated the material wealth of seventeenth-century Holland, but in its jumble of plates and glassware, its half-eaten food, and general disarray, the well-appointed table also appears infused with an anxiety about the effects of indulgence in worldly pleasures.[18] Meléndez's images of natural abundance, in which he magnified the size of the objects to monumental proportions, might be characterized as forms of wish-fulfillment, fantasies of plenitude painted at a time of famine by an artist who made a formal declaration of poverty before his death. In contrast, William H. Gerdts has argued that mid-nineteenth-century Americans were drawn to Severin Roesen's canvases with their abundance of fruit and flowers because such images gave visual form to a sense of well-being, an optimism in their own futures and that of the United States generally.[19]

As several works in this exhibition attest, painters also

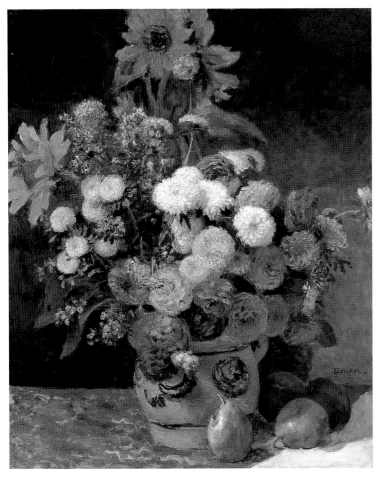

Fig. 2. Pierre Auguste Renoir, *Mixed Flowers in an Earthenware Pot,* 1869.
Bequest of John T. Spaulding. 48.592

used the still life as a vehicle for investigating and meditating upon the act and means of representation. Since it did not necessarily have a public role or a didactic purpose like history painting, or a potentially demanding sitter or client like portraiture, still life lent itself to experiments with paint, light, color, and brushwork. Chardin's canvases, for example, not only reveal a lifelong affinity for simple, humble everyday objects, but also a passion for the liquid consistency and the colors of paint. Conceiving his still lifes as opportunities to experiment and improvise, Renoir in his *Mixed Flowers in an Earthenware Pot* (fig. 2) explored contrasts of light and shade, the minimum amount of paint needed to describe an object in the material world, and the effects of one color upon another.

In allowing paint to stand as paint (rather than manipulating it to describe an object) as he did in numerous canvases such as *Kitchen Table* and *Tea Pot with Grapes* (cats. 29-30), Chardin, intentionally or not, established a barrier between the world inside and the world outside the canvas. No matter how commonplace the objects, there could be no mistaking one sphere for the other. However, given the origins of most still-life objects in the material world, many artists were lured by the temptation to make their canvases appear as extensions of reality. In contrast to artists who asserted the properties of their materials, the seventeenth-century Flemish painter Gijsbrechts concealed the brushstrokes in his *Vanitas*, attempting to craft an illusion that would appear indistinguishable from the world outside the frame. However, the punitive implications of the *vanitas* objects in the niche seemingly compelled him to acknowledge the deceit of the trompe l'oeil since he depicted the artifice underpinning his illusion: the curled edge of the white canvas, the wooden stretcher, and the painter's maulstick. On the other hand, the eighteenth-century Dutch painters Jan Weenix and Simon Verelst, who both painted gamepieces (cats. 21-22), and the late nineteenth-century American painter De Scott Evans (cat. 65), delighted unrepentently in their abilities to rival the real world in paint. Evans's canvas is a particularly curious one. Though he took pains to make his picture appear as if it were an actual material object, even painting the tacking margins to resemble wood grain, Evans paradoxically invented the container in which he displayed the peanuts, tricking the viewer into accepting the materiality of a purely fictional object.

Usually the objects featured in still lifes are widely known and have widely shared public meanings, but painters consciously or not have also used objects of common currency as vehicles to explore, displace, or neutralize personal concerns. John Frederick Peto's *Old Time Letter Rack* (cat. 61) appears at first glance as a trompe l'oeil painting in which the artist has painted generic objects – a calling card, ticket, mass-produced photograph of Lincoln, envelopes, and newspaper clippings – all linked by their common function of communicating, providing information, or facilitating interaction. It has been argued that Peto identified his father with Lincoln and been shown that the envelopes all bear postmarks of places that Peto had lived or visited. Yet the torn and faded condition of the objects, their filmy, dream-like edges, their recurrence in his other still lifes as well as the illegibility of the name on the calling card and the absence of addresses on the envelopes suggest that at some point their significance exceeded the artist's desire to paint them clearly and neutrally. Here as in other canvases, the common, prosaic objects become sites for revery, nostalgia, and introspection rather than for the dissemination of information and the creation of community. The same might be said of Ensor's *Seashells* (cat. 80). While painters in the North particularly had featured shells and chinoiserie in their still lifes since the seventeenth century, it can be argued that these objects not only link Ensor's work to the history of the genre, but that they also had personal meaning for the painter. In all likelihood, they embodied memories of his childhood since his parents sold such items to tourists in their shop in the seaside resort of Ostende. However, given their appearance in other canvases and the way that they have been painted, juxtaposed, and positioned in space in this particular work, we also suspect that they had taken on erotic associations.

While Ensor's and Peto's canvases prompt us to investigate the aims, ambitions, and private concerns of the artist, in other still lifes, the objects or style of the painting may tell us something of the client that the painter envisioned for his work. Weenix and Verelst probably hoped noble patrons or socially ambitious burghers would be drawn to their game-pieces since hunting in Holland was a privilege reserved for the aristocracy. The seventeenth-century Spanish *Still Life with Sweetmeats* probably attracted similar clients because sug-

ar was a rare and therefore expensive commodity that only the wealthy could afford. The nineteenth-century American image, *The Watermelon* (cat. 56), by contrast, was probably bought by a middle-class client of moderate means who wanted to invest in and adorn his home with pictures, but could not afford the works of a more technically skilled painter. Lest, however, we insist on a direct connection between the objects or the style in which they are portrayed and the intended client, we have only to consider Chardin's *Kitchen Table*. Though a scullery maid or cook would probably have greater familiarity with the pieces of food and vessels in the picture, it was first owned by Ange-Laurent de La Live de Jully, a learned and wealthy aristocrat who added it to his collection of important works by many of the greatest European masters. Sometimes still-life painters catered to a particular market. Fantin-Latour followed trends in British horticulture and changed his pictures in order to maintain the market for them in England. When England became the world leader in rose production in the 1870s, he featured different varieties of the bloom in canvas after canvas. As letters indicate, those flower pieces eventually became a millstone around Fantin's neck. Bored by the routine exercise of painting them and free of the financial worries that had forced him to churn out the pictures, he all but abandoned flower pieces in the 1890s.

✤✤✤

One of the striking aspects of still life is the consistency of the objects that are depicted and the formats that are used though the painting styles of the canvases vary widely according to the period and country in which they originated. The *vanitas* image, for example, retained enough resonance that Beckmann would use it three centuries after Gijsbrechts. During the early 1920s, Stuart Davis (cat. 76) would paint a jug and apple, time-honored still-life objects, in a style derived in parts from modern advertising and from synthetic Cubism. As Norman Bryson has observed, the consistency of the objects and formats of still life derives in part from the consistency of the habits and rituals to which they allude.[20] However the consistency of the genre can be as deceptive as it is significant. While there appears to be some visual kinship between the still lifes of the eighteenth-century Spanish painter Meléndez, and, for example, the nineteenth-century American John F. Francis (cat. 54), the circumstances in which each painted their fruits and vegetables and rustic vessels differed markedly. As more research is done on the genre, we will undoubtedly see that the artists' intentions, the meanings contemporary viewers attributed to the pictures, and the roles those pictures played in framing certain cultural, psychological, and economic issues varied more than has been thought.

Moreover, the consistency of still life and insistence of art theorists on the separation of the genres should not overshadow those instances in which painters have sought to modify the formats of still life and broaden its boundaries. Weenix, following earlier Flemish artists, set his still-life objects in a landscape. So too did Otto Marseus van Schrieck, who also introduced a narrative of sorts – the imminent battle between snake and lizard – into a painting type usually defined by the absence of a story. Van Schrieck also sought to wed the objective eye of the botanist and herpetologist and the poet's sense of evocation, striking a balance between exact description and suggestive mood. In the *Sitting Room* (cat. 48), the nineteenth-century French painter Vollon situated the still life in a setting customarily used in genre pictures, substituting the objects for their human owners. As if he were quoting a section of the market scenes of Aertsen and Beuckelaer, Gustave Caillebotte in a highly unusual work depicted pieces of fruit and vegetables in a market stand (cat. 43). In selecting a fragment of a

larger scene and subjecting it to the focused gaze typical of still life, Caillebotte, like Vollon, explored the boundaries ordinarily separating still life and genre painting. Given the evidence that the images in Peto's *Old Time Letter Rack* held personal meanings for the artist, his picture might be construed not only as a still life but also as a kind of self-portrait, in which he constructed an image of himself with objects of private significance instead of painting his physical appearance. As more research is done on still life, we will gain a better understanding of what these attempts to change the parameters of the genre indicate.

Perhaps the most dramatic change in still life occurred in the late nineteenth century and early twentieth century. As we can see from looking at the works of Manet, Morisot, Vuillard, and others (cats. 40, 46, 49), painters at that time began attenuating the image's relation to the material world by schematizing and abbreviating its forms in search of the minimum amount of information needed to maintain the painted shape's relation to a known object. Though the canvases from Manet to Morandi (cat. 89) retain the focused gaze and tight cropping of still-life painting, that gaze yields little specific information, so that intimacy paradoxically produces distance. The knowability of the world through its surfaces – a knowability that still life's gaze had promised and depended upon – is subject to question.

The forces that shaped and changed painting in general in the late-nineteenth and twentieth centuries are complex, but two factors can be singled out for the challenges that they posed for still-life painting in particular. Manufactured, assembly-line objects with their anonymous surfaces, industrial materials, and standardized forms deflected a way of seeing accustomed to searching out unique details and delighting in rich, variegated textures, shapes, and substances. In addition, the visual procedures required under mass visual culture – scanning, skimming and other means of rapidly processing information – were antithetical to a kind of vision rooted in reflection, contemplation, and careful analysis.

Yet neither the new objects or ways of viewing spelled the end of still life. In fact, of the genres that Félibien codified in 1669 – history painting, landscape, portraiture, scenes of everyday life, and the painting of objects – still life was arguably the one that best survived as a coherent category of

painting in the modern period. It played a dominant role in the work of many painters who were central to avant-garde art such as Cézanne and the Cubist painters. The significance of still life in the formation of late nineteenth- and twentieth-century avant-garde painting needs more investigation. Here, however, it can be proposed that the quality that rankled earlier writers – still life's grounding in the things of everyday life as well as the aspect that makes still life so hard to interpret – its lack of narrative and its resistance to formulation as a text featuring protagonists who perform nameable actions – were the very traits that not only enabled it to survive but also rec-ommended it as a vehicle for developing a new visual order. On the one hand, still life remained rooted in and engaged with the world of material reality through its objects. On the other, the muteness of the genre, the absence of a storyline which might shape or dictate the meanings and reception of the objects it displayed, gave still life a degree of immunity to the often reductive and manipulative languages and strategies of mass culture. In some senses, then, the genre that early critics had dismissed in terms that resembled those that would later be used to describe the products and effects of mass culture, was the genre best equipped to resist it.

KARYN ESIELONIS

NOTES:

1. Samuel van Hoogstraten, *Inleyding tot de Hooge Schoole der Schilderkonst* (Rotterdam, 1678), pp. 75-76. Translation from Albert Blankert, "General Introduction," *Gods, Saints and Heroes: Dutch Painting in the Age of Rembrandt* (Washington D.C., National Gallery of Art, 1980), pp. 17-18. 107-111.

2. On Cézanne's still life and Gauguin's collection, see Merete Bodelsen, "Gauguin, the Collector," *Burlington Magazine* 112/810 (September 1970), p. 606.

3. The discussion of the roots of still life is based primarily on that of Charles Sterling, *Still Life Painting from Antiquity to the Twentieth Century* (2nd rev. ed.; New York, 1981) and Ingvar Bergström, *Dutch Still Life Painting in the Seventeenth Century*, trans. Christina Hedström and Gerald Taylor (New York, 1956). Sterling's work, which was initially published in 1952, was the first comprehensive treatment of the genre and remains in use today though many of its assertions are now dated. Bergström's work is still the standard history of the genre, although it has been supplanted by the research for example of E. de Jongh and Sam Segal.

4. For the relevant bibliography on Aertsen and Beuckalaer, see cat. no. 1.

5. For a translation of Hadrianus Junius's passage on Aertsen in his *Batavia* (Antwerp, 1588, pp. 239-240), see Keith P. F. Moxey, *Pieter Aertsen, Joachim Beuckelaer, and the Rise of Secular Painting in the Context of the Reformation* (New York, 1977), p. 28.

6. Meyer Schapiro, "The Apples of Cézanne," in *Modern Art* (London, 1978), pp. 20-21.

7. See for example, Jacopo de Barbari, *Still Life with Partridge and Iron Gloves* (1504; Munich, Alte Pinakothek). De Barbari's picture, however, was probably originally used as part of a cupboard and thus does not technically qualify as an independent picture; Hans Memling, *Flower Piece* (ca. 1490; Lugano, Thyssen-Bornemisza Collection). The Westphalian artist Ludger tom Ring the Younger is also known to have painted flower pieces in the 1560s. On the literary evidence for still-life painting in Italy, see John Spike, *Italian Still Life Paintings from Three Centuries* (New York, 1983), p. 12.

8. On the various meanings and sources of terms for still life in France and Holland, see Sterling, pp. 63-64; On Spanish designations for the genre, see William B. Jordan, *Spanish Still Life in the Golden Age, 1600-1650* (Fort Worth, Kimbell Art Museum, 1985), pp. 16-17.

9. Karel van Mander, *Het Schilder-Boeck* (Haarlem, 1603-04), n.p. Good surveys of the early criticism of still life can be found in Scott A. Sullivan, *The Dutch Gamepiece* (Totowa and Montclair, 1984), pp. 2-4 and Andrea Gasten, "Dutch Still-Life Painting: Judgements and Appreciation," in *Still Life in the Age of Rembrandt* (Auckland, Auckland City Art Gallery, 1982), pp. 13-25.

10. André Félibien, *Conférences de l'Académie Royale de Peinture et de Sculpture* (Paris, 1669) reprinted in *Entretiens sur les vies et sur les ouvrages des plus excellens pentres*, vol. 5 (Trevoux, 1725; reprinted Farnborough, 1967), p. 310.

11. Van Hoogstraten, pp. 75-76. Trans. Blankert, pp. 17-18. On the seemingly contradictory relation between Hoogstraten's own trompe l'oeil paintings and his support of history painting, see Arthur K. Wheelock, Jr., "Trompe l'Oeil Painting: Visual Deceptions or Natural Truths?" in *The Age of the Marvelous*, Joy Kenseth ed. (Hanover, NH, Hood Museum of Art, 1991), pp. 179-191.

12. Sir Joshua Reynolds, *Discourses on Art*, Robert B. Wark ed. (San Francisco, 1959), Discourse XI, December 10, 1782, pp. 196-197.

13. On American views of the genre, see William H. Gerdts, *Painters of the Humble Truth* (Columbia and London, 1981), pp. 21-28

14. Daniel Fanshaw, "The Exhibition of the National Academy of Design, 1827," *The United States Review and Literary Gazette* (July 1827), pp. 241-263. The passages relevant to still life are quoted in Gerdts, pp. 22-23.

15. On Diderot's views of Chardin, see Philip Conisbee, *Chardin* (Lewisburg, 1985), pp. 11, 195-196, 210; Marcel Proust, "Chardin and Rembrandt," in *Against Sainte-Beuve and Other Essays*, trans. John Sturrock (London, 1988) pp. 125-136; Henry William Beechey ed., *The Literary Works of Sir Joshua Reynolds*, vol. 2: *Journey to Flanders and Holland* (London, 1852), p. 225; Johann Wolfgang von Goethe, *Gedenkausgabe der Werke, Briefe, und Gespräche*, vol. 10: *Dichtung and Wahrheit* (Zurich, 1948), p. 685. For more on Goethe's appreciation of Northern still lifes, see Sullivan, p. 65.

16. Proust, pp. 123-124.

17. E. de Jongh, "The Interpretation of Still-Life Paintings: Possibilities and Limits," in *Still Life in the Age of Rembrandt*, pp. 27-37.

18. On Dutch anxieties about consumption, see Simon Schama, *The Embarrassment of Riches: An Interpretation of Dutch Culture in the Golden Age* (New York, 1987), pp. 129-220.

19. Gerdts, p. 87.

20. Norman Bryson, *Looking at the Overlooked*, (Cambridge, 1990), pp. 12-13. Bryson's is the most stimulating work on still life to date. For an insightful review of *Looking at the Overlooked*, see Paul Taylor, "Looking and Overlooking," *Art History* 15/1 (March 1992), pp. 107-111.

CATALOGUE

❧❧❧❧❧❧❧❧❧❧❧❧❧
❧❧❧❧❧❧❧❧❧❧
❧❧❧❧❧❧❧
❧❧❧❧
❧

Catalogue entries by KARYN ESIELONIS,
except nos. 3 – 5 by JOHN LOUGHMAN,
and no. 25 by SYDNEY RESENDEZ

Dimensions are given in inches and centimeters, height preceding width.

ABBREVIATIONS

Boston 1979
Atlanta, High Museum of Art, *Corot to Braque, French Paintings from the
Museum of Fine Arts, Boston,* April 21 – June 17, 1979; Denver Colorado, The
Denver Art Museum, February 13 – April 20, 1980; Tulsa, Oklahoma, The
Philbrook Art Center, May 25 – July 25, 1980; Phoenix, Arizona, The
Phoenix Art Musuem, September 19 – November 23, 1980.

Japan 1983
Tokyo, Isetan Museum of Art, *Masterpieces of European Painting from the
Museum of Fine Arts, Boston,* October 21 – December 4, 1983; Fukuoka,
Fukuoka Art Musuem, January 6-29, 1984; Kyoto, Kyoto Municipal Museum
of Art, February 25 – April 8, 1984.

Japan 1989
Kyoto, Kyoto Municipal Art Museum, *From Neoclassicism to Impressionism:
French Art from the Boston Museum of Fine Arts,* May 30 – July 2, 1989;
Hokkaido, Musuem of Modern Art, July 15 – August 20, 1989; Yokohama,
Sogo Museum of Art, August 30 – October 10, 1989.

Japan 1993
Tokyo, The Bunkamura Museum of Art, *Monet and His Contemporaries from
the Musuem of Fine Arts, Boston,* October 17 – January 17, 1993;
Hyogo, The Hyogo Prefectural Museum of Modern Art, Kobe,
January 23 – March 21, 1993.

Murphy 1985
Alexandra R. Murphy, *European Paintings in the Museum of Fine Arts, Boston*
(Boston, 1985)

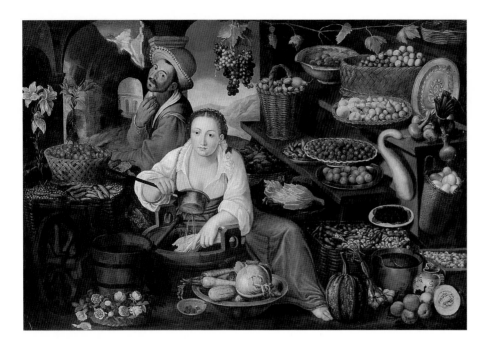

I

SCIPIO GOLTZIUS
(Flemish, late sixteenth century)

Fruit and Vegetable Vendors, 1577

Oil on canvas, 54⅜ x 80 in. (138.2 x 203.3 cm)
Signed lower left on the scale: *SCIPIO GOLTZ.
ANTWERPIENSIS. FECIT 1.5.7.7.*
Gift of Mr. and Mrs. Robert L. Henderson. 67.752

Provenance: Mr. and Mrs. Robert L. Henderson,
Brookline MA.

Literature: Murphy 1985, p. 121 ill.

In an outdoor market an array of produce, much of it neatly piled in various vessels, surrounds a male and female vendor. She stares out at the viewer while washing some vegetables. A jug, an example of Italian maiolica or tin-glazed earthenware, sits in the lower right corner. The golden basin in the upper right corner is probably made of brass and is of a type produced in the late 1570s, making it contemporary with the picture.[1] A landscape scene composed of antique ruins fills the upper left corner.

We know little about Scipio Goltzius save that he was the son of Hubert Goltzius, the cousin of Hendrick Goltzius, and like them an engraver.[2] *Fruit and Vegetable Vendors* appears to be his only extant painting. Goltzius's canvas derives from the market scenes of the Cremonese painter Vincenzo Campi. Campi, who came from a family of artists, was trained by his brother Giulio; he painted mainly religious scenes, which hung in the

Duomo in Cremona as well as churches in Pavia and Milan.[3] Typically displaying one or two figures sitting amidst an array of poultry and fish or fruit and vegetables, his market scenes descend from the market and kitchen scenes of the Flemish painters Pieter Aertsen and his nephew and student Joachim Beuckelaer.[4] Campi might have seen those pictures, which were executed mainly in the 1550s and 1560s, during his travels in Emilia in the later 1570s. Campi's scenes differ from those of Aertsen and Beuckelaer in several respects. His designs are generally more geometric, the gestures of his figures more artificial, and the relation between figure and setting more forced. Moreover, Campi did not include religious scenes in the background as Aertsen and Beuckelaer usually did.

The market and kitchen scenes of Aertsen, Beuckelaer, and Campi occupy a prominent place in the history of still life. Because the everyday, inanimate objects are emphasized as much as and sometimes even more than the figures and landscape, these pictures are generally seen as one of the precursors of the independent still life in which the objects become the sole focus of attention.[5] The Lombard region where Campi painted became a center for Italian still life. Caravaggio, whose *Basket of Fruit* (ca. 1600; Milan, Pinacoteca Ambrosiana) is often viewed as the first independent still life, came from that area as did Evaristo Baschenis (see cat. 17).

Fruit and Vegetable Vendors is related to a canvas entitled *Fruit Stall* (1601; Hartford,

Wadsworth Atheneum).[6] Believed to be the work of a Northern Italian artist though it has not been attributed to a specific painter, the Hartford canvas differs from the Boston picture only in minor details. There are slight variations in the kinds of fruits and vegetables displayed. The woman in the Hartford canvas turns her head to the left and she and the man whose hat is adorned with a peacock feather wear slightly more animated expressions. There is also an orange lily standing next to the white one in the Boston canvas. Both pictures strongly resemble several of Campi's works. The pair of figures in the Boston and Hartford canvases parallel those of the fruit vendors in a painting dated 1583 which was with the Galleria Previtali in Bergamo in 1989 and another picture formerly with Colnaghi in New York. The female figure compares with the female fruit seller in pictures in the Accademia di Brera and in one of the paintings commissioned by Hans Fugger, banker to the Hapsburg monarchy, for his castle in Kirchheim where they remain today.[7] Although Jean Cadogan conceives the Hartford canvas as a variation on Campi's work, its similarity with the Boston canvas suggests that the two are based on the same lost canvas by Campi. While Goltzius's canvas is earlier than the Hartford picture, it seems unlikely, given the Flemish artist's obscurity, that the painter of the Hartford work derived it from Goltzius's canvas. Since we know so little about Goltzius, it is impossible to say when and where he saw Campi's work. Antwerp was a center for the import and export of paintings and some of Campi's works may have passed through the city. It is also possible that Goltzius visited Cremona which was linked to Antwerp by Hapsburg rule.

The market pictures of Aertsen, Beuckelaer, and perhaps Campi often carried allegorical or symbolic meanings,[8] and in that vein, Cadogan has argued that the Hartford picture is replete with erotic symbolism. In her interpretation, the apples and onions signify love and lust and the cherries, libidinousness while the lily was thought to have aphrodisiacal powers. The phallic-shaped beans, squash, and cucumbers might have had erotic associations, and the grapes suspended over the woman's head could have referred to the woman's chastity or alternatively her carnal desires since grapes were associated with wine and hence lasciviousness.[9] To this list might be added the roses,

time-honored symbols of love, and the unbroken eggs, traditional signs of virginity. Together these references would suggest some more intimate relation between the two figures beyond a professional one or perhaps the man's sexual designs on the unsuspecting maiden. Whether Cadogan's theory applies is not clear. On the one hand, the position of the lilies and the grapes, the one improbably sprouting from the baskets of fruit and the other directly over the woman's head, seem contrived enough to suggest some symbolic intent as does the surfeit of objects conventionally associated with love and lust. On the other hand, there is nothing overtly erotic either in the relation between the male and female figures or in their expressions though both might be attributed to Goltzius's stolid rendering of Campi's original figures or later restorations, particularly to the woman's face.

1. My thanks to Jeffrey H. Munger, associate curator of European Decorative Arts, for identifying the piece of pottery and basin and providing the following references. On Italian maiolica jugs similar to the one in the painting see Timothy Wilson, *Ceramic Art of the Italian Renaissance* (Austin, 1987), pp. 86-87 and Carola Fiocco and Gagriella Gherardi, *Ceramiche umbre dal medioevo all storicismo*, vol. 1 (Faenza, Museo Internazionale delle Ceramiche, 1988), p. 291.

2. On Goltzius see Ulrich Thieme and Felix Becker, eds., *Allgemeines Lexikon der Bildenden Künstler* (Leipzig, 1921), vol. 15, p. 355.

3. On Campi see S. Zamboni, "Vincenzo Campi," *Arte antica e moderna* 1965/30, pp. 134-137 and 144-145; *I Campi e la cultura artistica cremonese del cinquecento* (Milan, 1985), pp. 197-211.

4. On Campi's fruit sellers see Mina Gregori, *La fruttivendola di Vincenzo Campi* (Bergamo, 1989); On Aertsen and Beuckelaer's market scenes see Keith Moxey, *Pieter Aertsen and Joachim Beuckelaer and the Rise of Secular Painting in the Context of the Reformation* (New York and London, 1977), pp. 26ff. and 72ff. See also note 8.

5. On the importance of Aertsen's, Beuckelaer's, and Campi's works in the history of still life see Ingvar Bergström, *Dutch Still-Life Painting in the Seventeenth Century*, trans. Christina Hedström and Gerald Taylor (New York, 1956), and Charles Sterling, *Still-Life Painting from Antiquity to the Twentieth Century* (2nd rev. ed.; New York, 1981), pp. 16-24, 61-63.

6. On the Atheneum's *Fruit Stall* see Jean K. Cadogan, *Wadsworth Atheneum Paintings II* (Hartford, 1991), pp. 266-268.

7. For the related works see Cadogan 1991, pp. 267, 268 n. 9.

8. On the allegorical meanings of Aertsen's and Beuckelaer's paintings see J. A. Emmens, "Eins aber ist nötig – Zu Inhalt und Bedeutung von Markt- und Küchenstück-en des 16. Jahrhunderts,"in *Album Amicorum J.G. van Gelder* (The Hague, 1973), pp. 93-101; Ardis Grosjean, "Toward an Interpretation of Pieter Aertsen's Profane Iconography," *Konsthistorik tidskrift* 43/3-4 (December 1974), pp. 121-143; K. Craig, "Pieter Aertsen and the Meat Stall," *Oud Holland* 96 (1982), pp. 1-15; Keith Moxey, "Interpreting Pieter Aertsen: The Problem of 'Hidden Symbolism,'" and Ethan Matt Kavaler, "Pieter Aertsen's 'Meat Stall.' Diverse Aspects of the Market Piece," in *Nederlands Kunsthistorisch Jaarboek* 40 (1989), pp. 29-40 and pp. 67-92. For additional bibliography on the market and kitchen pictures, see Peter C. Sutton, "Painting in the Age of Rubens," in *The Age of Rubens* (Boston, Museum of Fine Arts, 1993), p. 101 n. 241; On the allegorical reading of Campi's market scenes see Barry Wind, "Vincenzo Campi and Hans Fugger: A Peep at Late Cinquecento Bawdy Humor," *Arte Lombarda* 47/48 (1977), pp. 108-114.

9. Cadogan 1991, p. 267.

2

Italian, first quarter of the seventeenth century

Poppies in a Wine Flask

Oil on canvas, 25⅝ x 22¼ in.
(65 x 56.5 cm)
Falsely signed lower right: *Ma¹ Cariva ... i fe*
Charles Potter Kling Fund. 50.651

Provenance: Earl of Leicester, Penshurst Place, Kent, England until 1698; Robert Sydney, 4th Earl of Leicester, Penshurst Place, Kent, England until 1702; Philip Sydney, 5th Earl of Leicester, Penshurst Place, Kent, England until 1705; John Sydney, 6th Earl of Leicester, Penshurst Place, Kent, England until 1737; Jocelyn Sydney, 7th Earl of Leicester, Penshurst Place, Kent, England until 1743; Elizabeth Sidney Perry, Wormington Gloucestershire and Penshurst Place, Kent, England until 1783 (?); Sir John Shelley-Sidney, Penshurst Place, Kent, England until 1835; Philip Charles Sidney, 1st Baron de l'Isle and Dudley, Penshurst Place, Kent, England until 1851; Philip Sidney, 2nd Baron de l'Isle and Dudley, Penshurst Place, Kent, England until 1898; Philip Sidney, 3rd Baron de l'Isle and Dudley, Penshurst Place, Kent, England until 1902; Algernon Sidney, 4th Baron de l'Isle and Dudley, Penshurst Place, Kent, England until 1945; William Sidney, 5th Baron de l'Isle and Dudley, Penshurst Place, Kent, England until 1945; William Philip Sidney, 6th Baron de l'Isle and Dudley, Penshurst Place, Kent, England until 1950; Paul Cassirer, Ltd., London, 1950.

Exhibitions: Naples, Palazzo Reale, *La Natura morta italiana*, October - November 1964, no. 43; Zurich, Kunsthaus, *Das Italienische Stilleben*, December 1964 - February 1965 and Rotterdam, Museum Boymans-Van Beuningen, March - April 1965, no. 44.

Literature: Bernard Berenson, *Caravaggio* (New York, 1953), p. 2 and pl. 3; Hanns Swarzenski, "Caravaggio and Still-Life Painting," *Bulletin of the Museum of Fine Arts* 52/288 (June 1954), pp. 22-38 ill.; Carlyle Burrows, "Art: New Light on Caravaggio," *New York Herald Tribune*, August 8, 1954, p. 15 ill.; F. E. Baumgart, *Caravaggio* (Berlin, 1955), p. 111; Francesco Arcangeli et al., *Maestri della pittura del seicento emiliano* (Bologna, 1959), pp. 279-280; R. Jullian, *Caravage* (Lyon, 1961), pp. 48, 231 and pl. xxxvii; Giuseppe de Logu, *Natura morta italiana* (Bergamo, 1962), p. 179; Alfred Moir, *The Italian Followers of Caravaggio* (Cambridge MA, 1967), vol. 1, p. 249 and vol. 2, p. 37 and fig. 25; Charles Sterling, *Still-Life Painting from Antiquity to the Twentieth Century* (2nd rev. ed.; New York, 1981), pp. 88, 166; *European and American Works of Art in the Putnam Foundation Collection* (San Diego, Timken Art Gallery, 1983), p. 22; Luigi Salerno, *Natura morta italiana* (Florence, 1984), p. 66; Luigi Salerno, *Still-Life Painting in Italy, 1560-1805* (Rome, 1984), pp. 80, 82 ill.; Murphy 1985, p. 145 ill.

Hanns Swarzenski originally attributed the work to Caravaggio on the basis of its subject, naturalist style, and fragmentary signature which, according to initial conservation reports, was contemporary with the painting.¹ Challenging that attribution in 1959, Francesco Arcangeli gave the work to Guido Cagnacci on the basis of its similarity to a work in the museum in Forlì which Arcangeli had also assigned to Cagnacci.² Like the present work, the Forlì picture displays a bouquet of flowers in a chianti bottle with an unraveling raffia wrap. In the Forlì picture, however, the flowers form a tight bouquet and the loose rope a neat coil in front of the bottle whose stem is broken. Mina Gregori sustained the attribution of the Boston picture to Cagnacci when it was displayed in an exhibition of Italian still life mounted in Naples in 1964, but in the catalogue for the Zurich and Rotterdam showings of that exhibition, gave the picture to an anonymous follower of Caravaggio, since comparison of the two paintings when they hung together in Naples suggested that they were by different hands.³

The Boston picture also resembles a picture provisionally given to Cagnacci in the Putnam Foundation Collection which displays a chianti bottle with a broken covering filled with flowers. The two pictures, however, differ in certain respects. The Putnam canvas includes a number of small animals and insects and its tight arrangement of flowers and neat coil are closer to the Forlì than to the Boston picture.[4]

Only one still life, *Basket of Fruit* (ca. 1600; Milan, Pinacoteca Ambrosiana), has been firmly attributed to Caravaggio. However the painter's many genre and religious scenes frequently display groupings of carefully observed objects, including flowers arranged in flasks or bottles intended for other purposes such as holding water or wine.[5] These motifs are consistent with Caravaggio's general emphasis on the everyday world and quotidien subjects, a focus, which along with his robust, earthy style, insistently plastic forms, and dynamic structure (all characteristics more or less present in the Boston picture) shaped one strain of early seventeenth-century Italian still-life painting. While the missing petals of the poppy, the flowerless stem, the gray withering pods, and the loose coil are clearly products of Caravaggesque naturalism, it is possible that contemporary viewers conceived those features allegorically as signs of decay and perhaps death.[6] Those associations might have been underscored by the poppy, which traditionally symbolized night, sleep, and dreams because its pods produced opium. Such an interpretation, however, can be advanced only tentatively in the absence of contemporary evidence to support it.

1. Hanns Swarzenski, "Caravaggio and Still-Life Painting," *Bulletin of the Museum of Fine Arts* 52 / 288 (June 1954), pp. 22-38. There are no extant paintings with Caravaggio's signature. That the signature shows pigments similar to those of the painting does not mean that it is contemporary, only that it is not a modern addition. As Swarzenski noted, collectors often added signatures in order to increase the value of the works.

2. Francesco Arcangeli, *Maestri della pittura del seicento emiliano* (Bologna, 1959), p. 279. The Forlì picture is illustrated as no. 145. Cagnacci studied with Guido Reni in Bologna and painted in Rome and Vienna where he worked for the Emperor Leopold I. The attribution to Cagnacci was accepted by Giuseppe de Logu. See De Logu, *Natura morta italiana* (Bergamo, 1962), p. 178.

3. See Mina Gregori's catalogue entry in *La Natura morta italiana* (Naples, Palazzo Reale, 1964), p. 37 and *Das italienische Stilleben* (Zurich, Kunsthaus and Rotterdam, Museum Boymans-Van Beuningen, 1965), p. 37.

4. For an illustration, see *European and American Works of Art in the Putnam Foundation Collection* (San Diego, Timken Art Gallery, 1983), p. 23. In the 1964 show of Italian still life held in Naples, Zurich, and Rotterdam, the Boston painting was also related to two still lifes then in the Benedetelli Collection in Milan which also display flowers in bottles. See *La Natura morta italiana*, p. 37 and *Das italienische Stilleben*, p. 37. The comparison seems forced since the bottles in the Milan still lifes are decorated with metalwork and the flower arrangements are much more static than that of the Boston picture. Luigi Salerno has compared the Boston picture to two still lifes in the Lodi Collection. In those pictures, wildflowers have been arranged in flasks that are only partially covered with a few pieces of rope which form a star on the body of the bottle. See Luigi Salerno, *Natura morta italiana* (Florence, 1984), p. 66 and p. 67 for illustrations of the two works.

5. See for example, *The Lute Player* in the Hermitage.

6. Cecil Gould has argued for such symbolic content in the still life by Cagnacci in the Putnam Foundation Collection. In addition to withering flowers and an unraveling coil, that still life includes moths and butterflies as well as a locust and a lizard, all of which, Gould argues, have allegorical meanings relating to death and destruction. See *European and American Works of Art in the Putnam Foundation Collection*, p. 22.

3 (plate 1, page 18)

FRANS SNYDERS
(1579 Antwerp – 1657 Antwerp)

Fruit Still Life with Squirrel, 1616

Oil on copper, 22 x 38⅛ in. (56 x 84 cm)
Signed: 1616
M. and M. Karolik Fund, Frank B. Bemis Fund, and other funds. 1993.566

Provenance: Schaumburg-Lippe collection; sale Regine Charles, Brussels (Galerie Fierez), December 16, 1929, no. 90; dealer A. G. Luzern, 1934; Edward Meert, Saint-Nicholas-Waas; with Edward Speelman Ltd., London, 1972; Private Collection, Washington, D.C.

Exhibitions: Boston, Museum of Fine Arts, *The Age of Rubens*, September 22, 1993-January 2, 1994 and Toledo, Toledo Museum of Art, February 2-April 24, 1994, no 114.

Literature: E.Greindl, *Les Peintres flamands de nature morte au XVIIe siècle* (Brussels, 1956), pp. 54, 181; H. Gerson and E. H. ter Kuile, *Art and Architecture in Belgium: 1600-1800* (Harmondsworth, 1960), p. 159; E. Greindl, *Les Pientres flamands de nature morte au XVIIe siècle* (Drogenbos [Brussels], 1983), pp. 73, 74, no. 44 ill. p. 293, no. 199; D. F. Lusingh Scheureleer, *Chinesiches und japanisches Porzellan in europäischen Fassungen* (Braunschweig, 1980), pp. 30, 197, fig. 57; Sam Segal, *A Prosperous Past: The Sumptuous Still Life in the Netherlands, 1600-1700*, William B. Jordan, ed. (The Hague, 1988), pp.75-76 ill. and n. 61; H. Robels, *Frans Snijders, Stilleben- und Tiermaler 1579-1657* (Munich, 1989), p. 79, no. 125, ill.

Born at Antwerp in 1579, Frans Snyders studied with Pieter Brueghel the Younger, and probably later with Hendrick Van Balen. He registered as a master with the guild of St. Luke in 1602. In the spring of 1608, he traveled to Rome and susequently to Milan where he had been recommended to Cardinal Federigo Borromeo by his fellow painter and friend Jan Brueghel the Elder. By July 1609, Snyders had returned to Antwerp where two years later he married a sister of the artists Cornelis and Paulus de Vos. He joined the Confraternity of Romanists in 1619 and was later elected their dean. Various testaments describing Snyders's estate indicate that he was an extremely wealthy man; he lived in a large house on the affluent Keizersgracht. Snyders died in August 1657 and was buried in the Minderbroederskerk in Antwerp.

In addition to his own independent paintings, Snyders frequently collaborated with Rubens among others, adding the animals, fowl, fruit, flowers, and landscape elements to his colleagues' figural compositions. Snyders was a versatile still-life painter: his work ranges from large-scale kitchen pieces that combine the overlapping forms of game, fruit, vegetables, and utensils, to more intimate representations of garlands of flowers. With his dynamic compositions and love of ornament, he breathed new vitality into the pioneering tabletop still lifes of Hieronymus Francken and Gillis Francken, and paved the way for later painters of the "sumptuous" still life – the so-called *pronkstilleven* – like Jan Davidsz. de Heem and Willem Kalf.

The present painting is an exceptionally well preserved example of a type of cabinet-sized still life that Snyders produced during the second decade of the seventeenth century. It combines a conventional depiction of a heavily laden basket of fruit, familiar from the work of early fruit and flower painters such as Ambrosius Bosschaert the Elder, with a group of finely wrought objects of tableware on the right which includes a Chinese porcelain cup and dish, a golden tazza, and a ceramic jug in the style of Palissy. The artist attempts to re-fashion in paint the textual peculiarities of each component, from the fur-like sheen that covers the plums to the smooth and highly polished surfaces of the porcelain. Not only does he emphasize the technical virtuosity of his craft in this way, but he also resorts to compositional means that could be regarded (anachronistically) as proto-cinematic: the strong spotlighting from the left, the cutting-off of objects along the periphery of the picture field, the severe fore-

shortening of the knife which protrudes illusionistically into the viewer's space. With the sense of movement generated by his vibrant design, there is little need for the additional animation offered by the nibbling squirrel perched atop the fruit.

Snyders's impressive display of tight, barely perceptible brushwork and the brilliance of his colors was greatly aided by the copper support. Copper plate was more expensive than either canvas or wooden panel and was valued by painters like Bosschaert for the high state of finish that it allowed.[1] A major determinant of cost in the seventeenth century was the amount of time an artist had to spend on a given work and smaller meticulously executed still lifes with their enamel-like surfaces were obviously more labor-intensive.[2] Consequently many specialists in this genre were often highly remunerated for their efforts. Although extensive information on the prices commanded by Snyders's paintings is lacking, they had certainly earned him vast riches; Snyders's own works were among the most expensive when his collection was auctioned two years after his death.[3] Another measure of his success is the number of copies after his work which are listed in contemporary inventories.[4]

1. More than half of Ambrosius I Bosschaert's work was painted on copper. See L.J. Bol, *The Bosschaert Dynasty: Painters of Flowers and Fruit* (Leigh-on-Sea, 1960), pp. 58-68. Snyders used this support only on rare occasions. See H. Robels, *Frans Snijders, Stilleben- und Tiermaler 1597-1657* (Munich, 1989), cat. nos. 1821 and 115.

2. The influence of economic factors on the style and appearance of Northern Netherlandish paintings has been considered by J. M. Montias "Cost and Value in Seventeenth-Century Dutch Art," *Art History* 10 (1987), pp. 455-460.

3. Among the paintings listed by Snyders were "a wolf hunt" (50 guilders), "a canvas with parrots" (50 guilders), "6 originals of hunts" (1200 guilders), and "a small fruit" (50 guilders). See Jan Denucé, *Na Pieter Pauwel Rubens: Documenten uit den Kunsthandel te Antwerpen in de XVIIe eeuw van Matthijs Musson* (Antwerp/The Hague, 1949), pp. 188-190.

4. See, for example, four unspecified copies after Snyders assessed at 150 guilders in the 1643-44 inventory of Arnold Lunden, director of the Antwerp mint (E. Duverger, *Antwerpse Kunstinventarissen uit de zeventiende eeuw* [Brussels, 1991], vol. 5, p. 58). The same inventory contained an original fruit painting by Snyders which carried an estimate of 180 guilders. Copies are also mentioned in the 1659 sale of Snyders's collection. See Denucé, pp. 188-190.

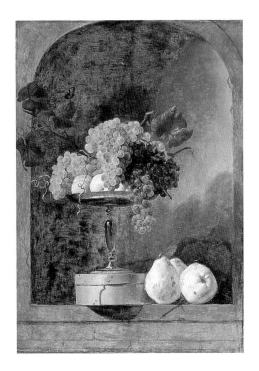

4

FRANS SNYDERS
(1579 Antwerp – 1657 Antwerp)

Grapes, Peaches, and Quinces in a Niche

Oil on panel, 29⅝ x 21⅜ in. (75.1 x 54.2 cm)
Charles Edward French Fund. 46.59

Provenance: with A. Mondschein, New York.

Exhibitions: Boston, Museum of Fine Arts, *Seventeenth Century Dutch and Flemish Still-Life Paintings,* October 7 - November 30, 1980.

Literature: Edith Greindl, *Les Peintres flamands de nature morte au XVIIe siècle* (Drogenbos, [Brussels] 1983), p. 376, no. 128; Murphy 1985, p. 265 ill.; Hella Robels, *Frans Snyders, Stilleben- und Tiermaler 1579 - 1657* (Munich, 1989), pp. 277-278, no. 156

In a shallow niche, a tazza of grapes and peaches is placed on an elliptical wooden box. Three quinces nestle to the right. This simple design is enlivened by a butterfly fluttering among the vine leaves above, while a small insect crawls on top of one of the foreground quinces. Hella Robels dates this painting to the 1630s or 1640s.[1]

The unusual sketchy manner in which Snyders has indicated the interior of the niche has led some scholars to speculate on the painting's state of finish. Both Michael Jaffé and Robels agree that it is an unfinished piece, the former even suggesting that a drapery was originally intended to the right. Seymour Slive rejected this notion.[2]

A striking aspect of the painting's composition is its low viewpoint. This still life must have been intended to be hung high, perhaps over a door or fireplace.[3] The direction of the shadows cast by the overhanging box and the twig of the quince furthest to the right, also suggest that the painting should be viewed from below. Indeed, when placed at a certain height, the impressionistically rendered background would have been optically corrected.

Following the example of Sam Segal,[4] Robels has suggested that this work may be read as a Christian allegory: the grapes and the box (in her view a receptacle for consecrated hosts) alluding to the Eucharist, the peaches to the Redemption, and the butterfly to the Resurrection. However, since Synders has not chosen any overtly Christian objects, such as a crucifix or chalice, or used any Christian symbols, and since there are no seventeenth-century texts that refer to intentionally concealed meanings in still life, such an interpretation is at best tentative. Indeed, the marked illusionism of this painting indicates that Snyders was more concerned with visual than iconographic deception.

1. Hella Robels, *Frans Snyders, Stilleben- und Tiermaler 1579 - 1657* (Munich, 1989), p. 277.

2. On Jaffé's and Slive's opinions, see memo to file, August 7, 1961, and on Robels's opinion, see memo to file, April 17, 1979.

3. Two Antwerp household inventories from 1668 and 1686 refer to paintings by Snyders (one done in collaboration with Rubens) that functioned as overmantels. See J. Denucé, *De Antwerpsche "konstkamers." Inventarissen van kunstverzamelingen te Antwerpen in de 16e en 17e eeuwen* (Antwerp, 1932), pp. 255 and 341. Other works by Snyders depicting niche still lifes also have low horizons. See, for example, Robels nos. 119 and 120.

4. S. Segal, *A Fruitful Past: A Survey of the Fruit Still Lifes of the Northern and Southern Netherlands from Bruegel to Van Gogh* (Amsterdam, 1983).

5

Attributed to FRANS SNYDERS
(1579 Antwerp – 1657 Antwerp)

Vegetables and a Basket of Fruit on a Table

Oil on canvas, 33 x 37¾ in. (83.8 x 95.9 cm)
Bequest of Sidney Bartlett. 89.499

Provenance: Prince Demidoff, Florence; sale Demidoff collection, Palace of San Donato, Florence, 15 March 1880 and subsequent days, no. 1050; Stanton Blake, Boston.

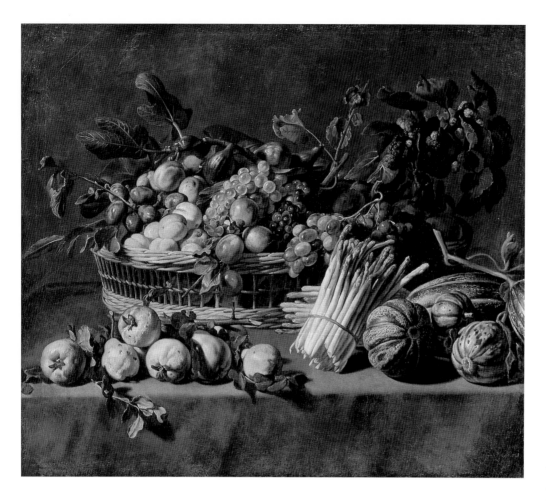

Exhibitions: New Orleans, Isaac Delgado Museum of Art, *Fêtes de la Palette*, November 16 - January 7, 1963, no. 59.

Literature: F. Harck, "Berichte und Mittheilungen aus Sammlungen und Museen, über staatliche Kunstpflege und Restaurationen neue Funde," *Repertorium für Kunstwissenschaft* 11 (1888), p. 78; Murphy 1985, p. 265 ill.

While many of Frans Snyders's larger still lifes and particularly his kitchen-pieces are characterized by their stage-like settings, sweeping diagonals, and vibrancy of color, the exhibited work is less ostentatious. Filling almost one half of the entire picture space is a large wickerwork basket of fruit and foliage. In the foreground are a cluster of seven pears, two bundles of asparagus, and to the right various watermelons and gourds. Unlike other tabletop still lifes by Snyders that contain opulent and finely painted silver and porcelain objects and that are enlivened by creatures such as nibbling squirrels and monkeys (see cat. 3), the pictorial elements are confined here to closely studied representations of fruit and vegetables. The appeal of

this painting lies in the quiet and harmonious disposition of the forms and in the fluid brushwork which convincingly evokes the different textures.

The attribution of this canvas to Frans Snyders has been questioned, most notably by the author of a recent monograph on the artist, Hella Robels. While admitting that certain details resemble Snyders's manner, Robels found the composition atypical. She also rejected alternative attributions to Adriaen van Utrecht and Pieter de Boel.[1] The painting does, however, share a number of similarities with a signed still life by Snyders in the Bode-Museum, Berlin, particularly in the way in which both are cropped.[2]

1. Memo to file, April 4, 1979.

2. Illustrated in Lee Irena Geismeier, *Malerei 14. – 18. Jahrhundert im Bode-Museum* (Berlin, 1978), p. 65, no. 155.

6 and **7** (plates 2 and 3, page 19)
PIETER CLAESZ.
(1597/98 Burgsteinfurt – 1661 Haarlem)

Still Life with Stoneware Jug, Wine Glass, Herring, and Bread, 1642

Oil on panel, 11¾ x 14⅛ in. (30 x 35.8 cm)
Signed with mongram, "PC" and dated [16]42
Bequest of Mrs. Edward Wheelwright. 13.458

Provenance: Mrs. Edward Wheelwright.

Exhibitions: Burlington VT, Fleming Museum, November - December 1936; Boston, Museum of Fine Arts, *Seventeenth-Century Dutch and Flemish Still-Life Paintings*, October 7 - November 30, 1980.

Literature: John Walsh, Jr., and Cynthia P. Schneider, "Little-Known Dutch Paintings in the Museum of Fine Arts, Boston," *Apollo* 110/214 (December 1979), p. 500; Murphy 1985, p. 52 ill.; Simon Schama, *The Embarrassment of Riches* (New York, 1987), pp. 82-83 ill.; Norman Bryson, *Looking at the Overlooked* (Cambridge MA, 1990), p. 134 ill.

Still Life with Silver Brandy Bowl, Wine Glass, Herring, and Bread, 1642

Oil on panel, 11¾ x 14⅛ in. (29.9 x 35.9 cm)
Signed with monogram, "PC" and dated [16]42
Bequest of Mrs. Edward Wheelwright. 13.459

Provenance: Mrs. Edward Wheelwright.

Exhibitions: Andover MA, Addison Gallery of American Art, February - March 1936; Boston, Museum of Fine Arts, *Seventeenth-Century Dutch and Flemish Still-Life Paintings*, October 7 - November 30, 1980.

Literature: John Walsh, Jr., and Cynthia P. Schneider, "Little-Known Dutch Paintings in the Museum of Fine Arts, Boston," *Apollo* 110/214 (December 1979), p. 500; Murphy 1985, p. 52 ill.

Bearing the artist's monogram, "PC," and the date [16]42, these works constitute a pair. Both display similar compositions, and are painted on panels of the same size.

Although the Museum's panels date to the 1640s when Claesz. generally crafted richer, more ornate, and colorful works, they typify the style of the monochrome breakfast piece that he had perfected in the previous decade. Claesz. has united a small selection of objects with closely keyed colors and created depth in the picture by overlapping the pieces of food and tableware and blurring the edges of those objects that appear in the background. As in so many of his works, the handle of the knife extends over the edge of the table to suggest space in the foreground and provide momentary animation – the possibility that it might drop off. For the most part, the brushwork in both panels is smooth, but the wal-

nuts and *roemers* in both compositions show passages of the loose painterly strokes that Claesz. adopted in the 1640s. The silver brandy cup with its delicately wrought handles also reflects Claesz.'s new predilection for more luxurious objects. The works from the late 1620s through the 1630s, in contrast, display more prosaic articles like spare earthenware jugs and plain pewter vessels.

What Claesz. intended the seventeenth-century viewer to see, or what meaning the viewer might have drawn from these works and the other *ontbijte* in this show, is open to question. Certain pious viewers, steeped in a metaphoric language and emblem books then popular among the educated classes in seventeenth-century Holland, might well have interpreted the fish as a symbol of Christ, the cracked walnut as a sign of his Passion, and the bread and wine as a reference to the Eucharist.[1] Yet neither work exhibits what Eddie de Jongh has called a "tone-setting element,"[2] such as the skulls or time pieces of *vanitas* still lifes, which suggest that the painter intended to evoke moral or conceptual meanings beyond what is literally depicted. Others, however, might have seen the works as essays in visual description, as examples of the culture's commitment to acquiring knowledge of the world and the way it worked by closely observing visual phenomena. Claesz., in this view, scrutinized and recorded the textures and physical properties of various objects and substances – the translucency of glass, the fluidity of liquid, the glint of metal, and the matte surface of the earthenware jug. The painter's delight in describing objects led him to reveal, for example, the inside of the brandy cup by tipping it and to disclose the lightly colored core of the walnut by cracking it.

Neither interpretation can be entirely rejected, yet both overlook the deliberate arrangement of the objects in a composition whose concerns go beyond mere empirical description, but stop short of alluding to ideas beyond what is seen. Neither mere scientific exposition nor emblematic essay, the image represents the objects – vessels, utensils, and food – that viewers of all classes encountered daily. Claesz., however, strikes a balance in these panels between appealing to the viewer's familiarity with the taste and textures of these objects – the crunchiness of the bread, the tang of the herring, and the cool surfaces of glass and metal – and his appreciation of an exquisitely simple arrangement of

surfaces and textures. In both works, Claesz. deploys the objects to create visual rhythms. In one panel, the *roemer* reiterates the earthenware jug, the globular bowl and cylindrical base of the one countering the bulbous body and spherical top of the other. The curvilinear edge of the flat white bread repeats the curved lines of the handles and rims of the brandy cup whose rounded form echoes the fold of the table cloth. The oval of the herring mimics that of the plate on which it rests, and both food and vessel reiterate the diagonal lines of the knife. Those rhythms, in tandem with the closely keyed colors and simple shapes, counter the threat of disorder which is intimated in the haphazardly tipped brandy cup, the casually folded cloths, and the knives which hang precipitously over the edge of the tables. At the same time, the size of the panels, which are among Claesz.'s smallest, lend the objects, particularly the *roemers*, a sense of monumentality that allows them to transcend their status as objects of everyday life.

1. For a discussion of this approach and some cautionary remarks, see E. de Jongh, "The Interpretation of Still Life Paintings: Possibilities and Limits," in *Still Life in the Age of Rembrandt* (Auckland, Auckland City Art Gallery, 1982), pp. 27-37.

2. Ibid., p. 28.

8

PIETER CLAESZ.
(1597/98 Burgsteinfurt – 1661 Haarlem)

Still Life with Wine Goblet and Oysters

Oil on panel, 19¾ x 27⅝ in. (50.2 x 70.1 cm)
Signed with monogram, *"PC"* and dated *163[?]*
Gift of Mrs. H. P. Ahrnke in Memory of her great-aunt, Mrs. Francis B. Greene. 56.883

Provenance: Galerie Sedelmeyer, Paris; Mrs. Francis B. Greene; Mrs. H. P. Ahrnke (1938-1956).

Exhibitions: Miami, Miami Art Center, *The Artist and the Sea*, March 20 - April 18, 1969, no. 11; Boston, Museum of Fine Arts, *Masterpieces of Dutch Silver*, May 14 - June 22, 1980; Boston, Museum of Fine Arts, *Seventeenth-Century Dutch and Flemish Still-Life Paintings*, October 7 - November 30, 1980.

Literature: John Walsh, Jr., and Cynthia P. Schneider, "Little-Known Dutch Paintings in the Museum of Fine Arts, Boston," *Apollo* 110/214 (December 1979), pp. 499-500; Murphy 1985, p. 52 ill.

On a table partially covered with white linen, Claesz. has painted a *roemer* of white wine, a silver tazza tipped on its side, pewter plates containing a sliced lemon, oysters, and olives, as well as a knife, a roll, tobacco spilling from a cone of paper, and a saltcellar.

The panel, which is signed with the artist's monogram "PC" and shows the date 163[?], is an example of the monochrome *banketje*,[1] or

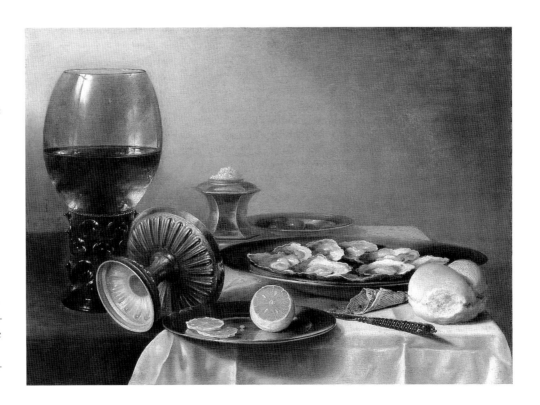

breakfast piece, a term referring to any still life showing the makings of a small meal painted mainly in shades of green, gray, and brown. Claesz., along with Willem Claesz. Heda, is credited with developing the monochrome breakfast piece in the late 1620s. Amsterdam and Haarlem, where Claesz. practiced until his death in 1661, were centers for the production of such compositions, which were popular through the 1640s when a taste emerged for more colorful, elaborate arrangements with costlier objects.

Since dated paintings exist from 1621 to 1660, Claesz.'s development is easily followed. Before he began painting the monochrome pieces, Claesz. worked in the manner of Floris Van Dyck, Nicolaes Gillis, and Floris Van Schooten, all Haarlem artists, assembling numerous objects, often on a tabletop, observed from a high view point, and painted in varied colors. These additive compositions permitted the artist to offer as full a descriptive account of each object as possible.[2] Although Claesz. occasionally painted *vanitas* and fish still lifes, he specialized in the breakfast piece, and like many still-life painters of his time, favored certain objects: simply shaped glasses, pewter or silver vessels, and plain foods like bread, fruit, oysters, and herring. These kinds of wares and foods were common to the tables of most classes, save for the peasantry, in seventeenth-century Holland where the taste of even the very prosperous ran to a simple palate.[3]

In its design and selection of objects, the panel is typical of Claesz.'s monochrome period. The objects are seen from a low viewpoint. Closely keyed tonal shades bind the forms together as does the light which washes gently over them. Claesz. developed the space of the picture by superimposing objects and softening the edges of those farther back. Diagonal lines, one leading from the tazza to the plate of olives and the other, running from the roll to the saltcellar, subtly draw the viewer's eye back in space. The rim of the plate and the handle of the knife hang over the front edge of the table, creating the illusion of space and foreground. Although the last digit of the date is illegible, the panel's similarity to works of the late 1630s suggests a date in the last years of the decade.[4]

1. The term *ontbijte* is also used.

2. On the phases in Claesz.'s still lifes, see Ingvar Bergström, *Dutch Still-Life Painting in the Seventeenth Century*, trans. Christina Hedström and Gerald Taylor (New York, 1956), pp. 114-123.

3. Simon Schama, *The Embarrassment of Riches: An Interpretation of Dutch Culture in the Golden Age* (New York, 1987), p. 150.

4. In particular, a panel in a private collection in Copenhagen, and another in the Staatliche Gemäldegalerie Schloss Wilhelmshöhe in Kassel. Both these works are signed with Claesz.'s monogram and dated 1638. These are illustrated in N.R.A. Vroom, *A Modest Message as intimated by the painters of the "Monochrome Banketje"*, (Schiedam, 1980),vol. 2, nos. 85 and 87.

9

JAN JANSZ. VAN DE VELDE

(1619/20 Haarlem – 1663 [?] Amsterdam)

Still Life with Goblet and Fruit, 1656

Oil on canvas, 14¾ x 13¾ in. (37.6 x 34.8 cm)
Signed lower right: *Jan Vande Velde A^no 1656/fecit*
Gift by exchange. 27.465

Provenance: Dr. H. S. Bigelow; William Sturgis Bigelow, Boston until 1926; George K. Harrington.

Literature: Murphy 1985, p. 291 ill.

Van de Velde came from a family of distinguished artists. His grandfather Jan Jansz. van de Velde I, a renowned calligrapher, designed *Deliciae variarum insigniumque scripturarum* (1604) and *Spiegel der schrift-Konste* (1605), while his father, Jan II, pioneered new styles and subjects of landscape drawing and engraving. Among his cousins, Esaias van de Velde II executed landscape drawings and engravings and Willem I and II van de Velde specialized in marine subjects.[1]
Fifty works by Van de Velde, many of them signed and dated, are known with the

earliest dating to 1639 and the latest to 1663. Whether the artist died around that time or just stopped painting is not known. Though he painted a few monumental works to hang in the large houses built by Amsterdam's wealthy patricians, his finest images are, like the present picture, small cabinet-sized paintings devoted to a few objects which are simply arranged and imbued with a quiet monumentality. Van de Velde's works are clearly indebted to those of Pieter Claesz. who painted monochrome banquet pieces (see cats. 6-8) in Haarlem where Van de Velde was born and raised.

The exact date of Van de Velde's move to Amsterdam is not known, though he married there in 1643. While a number of artists in Amsterdam including Jan Jansz. Treck painted intimate still lifes, Van de Velde was arguably the most accomplished. Amsterdam was not known as a center of still-life painting in the first half of the seventeenth century, but the situation changed when Willem Kalf arrived in 1650. Inspired by Kalf, Van de Velde's still lifes after 1650 began to display warmer, more glowing tones and heightened light effects. However he never adopted Kalf's more complex arrangements and ornate objects, preferring instead to create a rich effect with an economy of means.

While Van de Velde's still lifes frequently featured smoking requisites, the pieces of fruit, costly wan-li dish, and *roemer* of wine in the present work were among his favored objects. The Boston picture resembles another picture of 1656 in the National Gallery in London which also displays a glittering *roemer* set slightly to the left with objects discretely placed to either side forming a subtle pyramidal shape.[2]

1. On Van de Velde, see Ingvar Bergström, *Dutch Still-Life Painting in the Seventeenth Century*, trans. Christina Hedström and Gerald Taylor (New York, 1956), p. 144; N. R. A. Vroom, *A Modest Message as intimated by the painters of the 'Monochrome Banketje'* (Shiedam, 1980), vol. 1, pp. 222-230, vol. 2, pp. 131-137, and Peter C. Sutton, *Dutch and Flemish Seventeenth-Century Paintings: the Harold Samuel Collection* (London, 1992), pp. 223-224. Sutton includes full bibliography.

2. The work is illustrated in Vroom, vol. 2, p. 134.

10 (plate 4, page 20)

JAN JANSZ. DEN UYL
(1595/6 Leiden - ca. 1640 Amsterdam)

Breakfast Still Life with Glass and Metalwork

Oil on panel, 51⅜ x 45½ in.
(130.5 x 115.5 cm)
Signed with owl ideogram on the upper lip of the tazza
Anonymous Gift. 54.1606

Provenance; Linnartz Collection, Berlin; Berlin, Lepke auction, March 23, 1926, no. 117; J. Goudstikker, Amsterdam; Julius Bohler, Munich; Charles B. Hoyt, Untenberg; Rowland Burdon-Muller, Boston.

Exhibitions: Brussels, Palais des Beaux-Arts, *La Nature Morte Hollandaise*, 1929, no. 50; Boston, Museum of Fine Arts, *Masterpieces of Dutch Silver*, May 14 - June 22, 1980; Boston, Museum of Fine Arts, *Seventeenth-Century Dutch and Flemish Still-Life Painting*, October 7 - November 30, 1980.

Literature: Beschreibendes Verzeichnis de Gemälde im Kaiser Friedrich-Museum im Deutschen Museum (Berlin, 1931), p. 208; A. P. A.Vorenkamp, *Bijdrage tot de Geschiednis van het Hollandsch Stilleven in de Zenvetiende Eeuw* (Leiden, 1933), p. 42; Pieter de Boer, "Jan Janz. den Uyl," *Oud Holland* 52 (1940), p. 62; N. R. A. Vroom, *De Schildes van het Monochrome Banketje* (Amsterdam, 1949), pp. 159-160, 218, fig. 140; Ingvar Bergström, *Dutch Still-Life Painting in the Seventeenth Century* , trans. Christina Hedström and Gerald Taylor (New York, 1956), p. 306 fn. 78; Laurens J. Bol, *Holländische Maler des 17. Jahrhunderts, nahe den grossen Meistern* (Braunschweig, 1969), p. 71, fig. 59; Walther Bernt, *The Netherlandish Painters of the Seventeenth Century,* (New York, 1969) vol. 3, p. 119, pl. 1203; Bob Haak, *Rembrandt, His Life, His Work, His Time* (New York, 1969), p. 69 ill.; Irene Beismeier, *Holländische und flämische Gemälde des siebzehnten Jahrhunderts im Bode-Museum* (Berlin, 1976), p. 84; N. R. A. Vroom, *A Modest Message as intimated by the painters of the "Monochrome Banketje"* (Schiedam, 1980), vol. 1, p. 219 ill. and vol. 2, p. 128; Murphy 1985, p. 287 ill.

Before a niche on a wall, Den Uyl has painted a table, partially covered with white linen, strewn with objects including a pewter flagon, a *roemer* lying atop a gold-plated tazza next to a jumble of silver plates and an overturned pitcher. A half-eaten meat pie sits next to a candle holder and snuffer.

The panel came to the Museum as the work of Den Uyl's contemporary Willem Claesz. Heda.[1] In 1933, Vorenkamp assigned it to Den Uyl's brother-in-law, Jan Jansz. Treck, who imitated his style and technique in the 1640s and early 1650s.[2] Despite Den Uyl's reputation among his contemporaries – Rubens, for example, owned three of his paintings[3] – it was assumed that none of his works had survived. In the early 1940s, Pieter

de Boer proposed that Den Uyl signed his works with the image of an owl; a painting in Hartford signed with both the owl and his name confirmed his thesis.[4] The Boston work's resemblance in style and subject to a panel in Berlin bearing the owl ideogram prompted de Boer to assign it to Den Uyl.[5] Unconvinced by de Boer's comparison, N.R.A. Vroom termed the Boston panel a copy of the Berlin picture and gave it to the artist's son, Jan Jansz. Den Uyl de Jonge.[6] The panel was definitively attributed to Den Uyl in 1962 when de Boer discovered an owl on the lip of the gold tazza.[7]

The panel can be tentatively dated to the early 1630s on the basis of its resemblance to a panel of 1633 in a private collection in Copenhagen,[8] one of two dated works by Den Uyl.[9] In both the Boston and Copenhagen panels, the artist concentrated a number of objects on the left before a niche in a beige wall. In the later years of the decade until his death in early 1640, Den Uyl reduced the number of objects in his paintings and brought them closer to the viewer.[10]

Some drawings suggest that Den Uyl depicted landscapes and animals, but all of his extant works are examples of the monochrome breakfast piece,[11] which usually displays the makings of a meal described in closely keyed tonal shades. While Haarlem artists Pieter Claesz. and Willem Claesz. Heda receive credit for developing the monochrome breakfast piece in the late 1620s, Den Uyl of Amsterdam took it in new directions. Anticipating the *pronk* still lifes that became popular in the 1640s, he enriched Heda's delicacy and Claesz.'s economy with complex, dramatic arrangements and deep rich colors. Unlike Claesz. who generally favored simple vessels common to the modest daily tables of the middle classes, Den Uyl preferred finely crafted wares made of costly materials. Despite the Dutchman's reputation for frugality, these opulent objects attest to the increasing taste for elegant cosmopolitan things among the wealthier strata of Dutch society. The porcelain plate, an example of Chinese export ware of the late Ming dynasty, reminds us of Holland's vast trade network in the seventeenth century. Glass flutes like the one in the picture originated in Venice, but their popularity prompted Dutch glass makers to produce them in Holland using Venetian models.

The picture simultaneously suggests and denies a story. Since the objects have been

used and left in disarray, we assume that they document the aftermath of a meal, the jumbled detritus of some lavish feast, which the sated participants have left behind. The realization, however, that these objects have not been randomly scattered but deliberately organized into a tight, balanced arrangement checks the impulse to imagine the larger scenario of which the scene depicted in the Boston canvas is only an episode. The tipped and fallen objects form a circle around the *façon de venise* glass. A diagonal runs from the flute to the saltcellar through the plate to the half-eaten pie and spoon and continues through another plate, ending in a small glass surrounded by crumbs of food. That diagonal together with the one connecting the flagon and flute creates a triangle. The dish of butter, though improbably placed, sits securely atop the saltcellar. Smooth finished surfaces of exquisitely controlled brushwork and subtle harmonic colors complement the carefully orchestrated design. A scene that initially seemed chaotic, appears on further reflection tranquil and serene. The disjunction between apparent disarray and underlying order may evidence a cultural conflict about the deleterious effects of excess. Thus the moderation and restraint of the composition counteracts the theme of indulgence manifested in the objects.[12] Alternatively Den Uyl's chaotic arrangement might be seen as a form of empiricism because it allows him to describe the various properties of different materials and their interaction – the translu-cency of glass, the opacity of pewter, the reflectivity of liquid. By tipping, overturning, and skewing the vessels, Den Uyl is able to display their various parts and fine craftsmanship.[13] The orderly design, for its part, encourages the viewer to study these qualities carefully and contemplatively.

1. *Catalogue des nouvelles acquisitions de la collection Goudstikker exposées à Amsterdam* (Amsterdam, 1927), no. 65; *La Nature Morte* (Brussels, Palais des Beaux Arts, 1929), no. 50.

2. A. P. A. Vorenkamp, *Bijdrage tot de Geschiedenis van het Hollandsche Stilleven in de Zenvetiende Eeuw* (Leiden, 1933), p. 42.

3. J. Denucé, *De Antwerpsche 'Konstkamers'* (Amsterdam, 1932), p. 69.

4. Pieter de Boer, "Jan Jansz. den Uyl," *Oud Holland* 52 (1940), pp. 49-64. De Boer assigned twelve paintings to den Uyl. He followed Vorenkamp's suggestion that den Uyl might have used the owl ideogram for his signature. See Vorenkamp, p. 43.

5. Ibid., pp. 7, 14. The Boston panel is de Boer no. 6.

6. N. R. A. Vroom, *De Schilders van het Monochrome Banketje* (Amsterdam, 1945), pp. 159-160, 218.

7. Memo dated August 31, 1962, in curatorial file of the Museum of Fine Arts. On the basis of that evidence, Vroom subsequently gave it to den Uyl. N. R. A. Vroom, *A Modest Message as intimated by the painters of the "Monochrome Banketje"*, (Schiedam, 1980), vol. 1, p. 219 and vol. 2, p. 128.

8. The painting is illustrated in Ingvar Bergström, *Dutch Still-Life Painting in the Seventeenth Century*, trans. Christina Hedström and Gerald Taylor (New York, 1956) pl. IV and Vroom 1980, vol 2, p. 127.

9. The second panel (Laren, Private Collection) dated 1637 is illustrated in Bergström, p. 147. The Boston and Berlin panels also compare with a panel in Groningen. De Boer called the Groningen panel a copy of the Berlin picture, while Vroom attributed it to Den Uyl's son. See de Boer, p. 61 and Vroom 1945, pp. 159, 218 and Vroom 1980, vol. 2, p. 130.

10. On Den Uyl's style, see Bergström, pp. 146-151 and Laurens J.Bol, *Holländische Maler des 17. Jahrhunderts, nahe den grossen Meistern* (Braunschweig, 1969), pp. 71-72. Bergström dated the Boston panel to the early 1630s.

11. Vroom 1980, vol. 1, p. 217.

12. On this conflict, see Simon Schama, *The Embarrassment of Riches* (New York, 1987), pp. 129-220.

13. On Dutch art and empiricism, see Svetlana Alpers, *The Art of Describing* (Chicago, 1983).

11 (plate 6, page 22)

CORNELIS NORBERTUS GIJSBRECHTS
(Flemish, active 1659 – 1678)

Vanitas Still Life

Oil on canvas, 33¼ x 30¾ in. (84.4 x 78 cm)
Abbott Lawrence Fund. 58.357

Provenance: Mortimer S. Brandt, New York by 1953; Jan Nicholas Streep, New York.

Literature: Murphy 1985, p. 117 ill.

On a marble slab inside a niche, the painter has depicted a silver tankard, an hourglass before a skull encircled by sheaves of wheat, a watch with a vivid red ribbon, and a guttering candle. A violin resting on a box in the background creates a strong diagonal which is echoed by the painter's maulstick in the foreground. A letter lies creased and crumpled beneath the objects on the shelf while a soap bubble floats above the silver flagon.

Little is known of Gijsbrechts's life. He was admitted to the guild of St. Luke in Antwerp in November 1659 but by the early 1660s he was living in Germany. He settled in Hamburg from 1665 to 1668 when he left for Copenhagen where he served as court painter to Frederick III and Christian V until 1672. Parallels between his canvases and contemporary Dutch works by van Hoogstraten and others as well as the presence of Dutch words in some of his pictures suggest he may have spent time in Holland. His last known canvas dates to 1678. Whether he continued to paint or died soon after that is not known.[1]

The Boston canvas exemplifies the *vanitas* still life which originated in Leiden and Utrecht in the 1620s and 1630s but soon gained popularity throughout Europe.[2] Gijsbrechts provides a veritable catalogue of common *vanitas* images that symbolize the emphemerality of life. The large, prominently placed skull, an obvious reference to death, sets the tone and inflects the meaning of the other images.[3] To informed viewers, the sheaves of wheat symbolized the Resurrection and the idea of redemption,[4] and encircling the skull as they do, they also recall the crown of thorns from Christ's Passion. The hourglass, watch, and guttering candle evoke thoughts of the passage of time, a theme reinforced by the delicate bubble which will soon burst and the violin which produces notes of music, which like time are fleeting and transitory. The violin may also allude to the common analogy between making music and making love and that reference along with the allusion to drinking embodied in the silver tankard are subtle reminders perhaps that physical pleasures are best enjoyed in moderation. The work's predominantly somber colors befit the admonitory tone of the objects.

Gijsbrechts painted a number of *vanitas* images, placing many of the same objects found in the Boston canvas on a similar shelf inside a niche. The Boston canvas, however, is one of a few still lifes in which Gijsbrechts combined a fairly standard *vanitas* image with a meditation on the nature of artistic representation.[5] The two themes appear cleverly connected. Using the trompe l'oeil technique, highly regarded at the time, Gijsbrechts seeks to bewitch the viewer into believing that the objects are real. He conceals his brushwork, insists on the three-dimensionality of the objects, and makes the pictorial space appear continuous with the viewer's. In the painter's illusion, the ephemeral becomes permanent: the fragile bubble will never burst, the candle will burn forever, and the niche will remain intact despite its cracks. Against the reminders of human weakness and frailty, the artist asserts a superhuman ability to arrest time and to transform paint into bone, silver, gold, marble, and cloth. But a confessional impulse, in keeping with the cautionary message of the objects, tempers the artist's desire to dazzle and deceive with his virtuoso technical skills. He displays his maulstick, peals back the cloth canvas to reveal the picture's wooden support, and paints the threads from which the canvas has been woven. His claims to affect permanence and attain perfection notwithstanding, the threads indicate the canvas is as ephemeral as the delicate bubble, the diminishing flame, and human life itself.

1. On Gijsbrechts, see Poul Gammelbo, "Cornelius Norbertus Gijsbrechts og Franciskus Gijsbrechts," *Kunstmuseets Arsskrift 1952-1955* (Copenhagen, 1956), pp. 125-156 and Dorota Folga-Januszewska, "Trompe-l'oeil de C. N. Gijsbrechts dans les collections du Musée National de Varsovie," *Bulletin du Musée National de Varsovie* 22/2-3 (1981), pp. 52-72.

2. On the *vanitas* still life, see Ingvar Bergström, *Dutch Still-Life Painting in the Seventeenth Century* trans. Christina Hedström and Gerald Taylor (New York, 1956), pp. 154-190; Christian Klemm, "Weltdeutung – Allegorien and Symbole in Stilleben," in *Stilleben in Europa* (Münster, Wesfälisches Landesmuseum für Kunst und Kulturgeschichte and Baden-Baden, Staatliche Kunsthalle, 1980), pp. 190-217; On the popularity of the theme, see *Les vanités dans la peinture au XVIIe siècle* (Caen, Musée des Beaux-Arts, 1990).

3. On the skull as a "tone-setting" element that determines the meaning of the objects around it, see E. de Jongh, "The Interpretation of Still-Life Paintings: Possibilities and Limits," in *Still Life in the Age of Rembrandt* (Auckland, Auckland City Art Gallery, 1982) pp. 28, 31.

4. On the symbolism of the sheaves of wheat, see *Still Life in the Age of Rembrandt*, p. 206.

5. See Gammelbo no. 5, fig. 1 and no. 16, fig. 2. The absence of cusping around the edge of the canvas and the odd cropping of the picture – particularly on the right side where the maulstick is strangely truncated – suggest that the picture was cut down before it came to the Museum. Gammelbo no. 16 shows virtually the same trompe l'oeil canvas as the Boston *Vanitas* does, but it is shown on a trompe l'oeil easel. The maulstick, moreover, continues beneath the "canvas" to rest on the easel's tray.

70 ❧ STILL-LIFE PAINTING

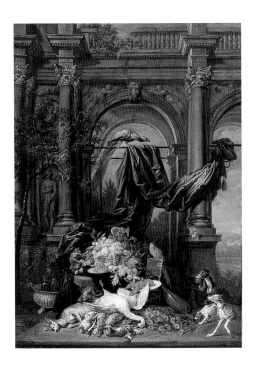

12

Attributed to
JAN-ERASMUS QUELLINUS (1634-1715),
JAN PAUWEL GILLEMANS THE
YOUNGER (1651-1704), and
JAN VAN KESSEL I (1641/2-1680), or
PEETER GYSELS (1621-1690/1)

Still Life with Architecture

Oil on canvas, 44¼ x 32⅝ in. (112.3 x 82.9 cm)
Ernest Wadsworth Longfellow Fund. 50.2728

Provenance: sale H.J. Stier d'Aertselaer, Antwerp, July 29-
30, 1822, no. 25; Puthon collection ; sale Comte S. Fes-
tetit, Vienna, April 11, 1859, no. 101; sale F. J. Gsell, Vien-
na, March 14, 1872, no. 30; acquired from dealers Rosen-
berg and Stiebel, New York, 1950.

Exhibitions: Boston, Museum of Fine Arts, *Seventeenth-
Century Dutch and Flemish Still-Life Paintings*, October 7 -
November 30, 1980; Japan, 1983, cat. no. 13; Boston,
Museum of Fine Arts, *The Age of Rubens*, September 22 -
January 2, 1994 and Toledo, Toledo Museum of Art, Feb-
ruary 2 - April 24, 1994, no. 117.

Literature: E. Greindl, *Les Pientres flamands de nature
morte auXVIIe siècle* (Brussels, 1956), p. 80; E. Greindl,
Les Pientres flamands de nature morte au XVIIe siècle
(Drogenbos [Brussels], 1983), p. 106; M. Vandenven, in
W.A. Liedtke et al., *Flemish Paintings in America: A Survey
of Early Netherlandish and Flemish Paintings in the Public
Collections of North America (Flandria Extra Muros)*
(Antwerp, 1992), pp. 310-311 ill.

A classical portico forms the backdrop for an
elaborate still life staged on a table and chair
before a swag of rich drapery which enhances
the picture's theatrical presentation of luxuri-
ous excess. As if they are offering a pictorial
encyclopedia of the still-life elements favored
by seventeenth-century Dutch and Flemish
painters, the artists have depicted an array of
exotic fruits, imported Chinese porcelain, a
lute, and a lobster with a berry perfectly bal-
anced on its back. A pile of dead game before
the table includes a roebuck, rabbits, a boar,
and a peacock topped by a swan splayed on
its back with its wings thrust dramatically to
either side. A cast of live animals completes
the tableau: a monkey climbing mischievous-
ly toward the basket of fruit, two parrots
perched on a chair and the base of the col-
umn, and a peacock stretched beneath the
arch. Finally, two greyhounds and a spaniel
eye the pile of dead game.

Modern art historians have termed this
kind of arrangement a *pronkstilleven*, a type
popular in the Northern and Southern
Netherlands beginning in the early 1640s.
The word "pronk" means not only beautiful
and rare, adjectives that describe the objects,
but also showy and ostentatious, terms that
account for the manner of presentation.
Various details of this still life have their
antecedents in earlier Flemish still-life paint-
ing. Frans Snyders and Jan Davidsz. de
Heem, for example, both set elaborate still
lifes in architectural settings before land-
scapes. While the grandiose subject of this
picture befits a magnificent banqueting hall,
the small size of the canvas implies a more
intimate, even domestic setting. The disjunc-
tion between the scale and the subject sug-
gests that aristocratic tastes had been adapted
for haute bourgeois collectors in the late-sev-
enteeth century.

Collaboration between painters was not
unusual in Renaissance and Baroque studios.
Rubens, for example, oversaw a large contin-
gent of assistants and students who were
assigned to paint various sections of large
commissions depending upon their specialty:
figures, architectural features, still lifes, ani-
mals, and so on. While it is generally accept-
ed that at least two painters worked on the
canvas, their identities are in some doubt.
The picture was acquired by the Museum as
the joint work of Jan Fyt, who painted
Rubensian figures and architectural settings
and Erasmus Quellinus II, but that attribu-
tion has recently been questioned. While
documents linking Fyt and Quellinus exist,
no paintings produced by the two have been
identified. Moreover, as Peter Sutton argues,
the style of the painting displays no evidence
of Fyt's broad, loose touch or more muted
colors.[1] Marc Vandenven has also cast doubt
on the attribution to Erasmus Quellinus II
and suggested the work is closer in handling
and composition to that of Erasmus II's son,
Jan Erasmus.[2] Other possible collaborators
include Jan Pauwel Gillemans II, a late fol-
lower of Jan Davidsz. de Heem, and Jan van
Kessel I or Peeter Gysels who painted elabo-
rate still lifes before porticos in a manner sim-
ilar in conception if not technique to the
Boston canvas. Sutton, however, cautions that
a firm attribution awaits better understanding
of the work of those artists who have been
linked to the painting and their place in the
development of late-seventeeth century Flem-
ish still-life painting.[3]

1. For an in-depth discussion of the attribution problems,
see Peter C. Sutton, *The Age of Rubens* (Boston, Museum
of Fine Arts, 1993), p. 556.

2. Marc Vandenven in Walter A. Liedtke et al., *Flemish
Paintings in America: A Survey of Early Netherlandish and
Flemish Paintings in the Public Collections of North Ameri-
ca (Flandria Extra Muros)* (Antwerp, 1992), p. 310.

3. Sutton, pp. 556-558.

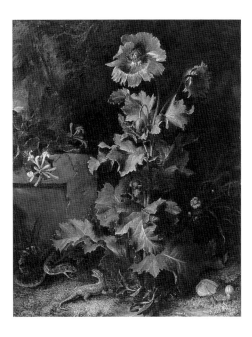

13

OTTO MARSEUS VAN SCHRIECK
(Nijmegen 1619 – 1678 Amsterdam)

Still Life with Snake and Lizard, ca. 1670

Oil on panel, 24¾ x 19½ in. (62.9 x 49.5 cm)
Gift of Maida and George S. Abrams in Memory
of Matilda and Samuel Abrams. 1990.622

Provenance: Schaeffer Galleries, Inc., New York, 1975.

Literature: Peter Sutton in "Curatorial Departments: Acquisitions," *The 115th Annual Report of the Museum of Fine Arts, Boston 1990 - 91* (Boston, Museum of Fine Arts, 1991), p. 39 ill.

Most of what is known about Marseus's life comes from Arnold Houbraken, the painter and biographer who interviewed the artist's widow.[1] Marseus worked in the Dutch Republic, England, France (for the Queen Mother), and Italy where he traveled in 1648 with his student Mathias Withoos. Between 1652 and 1663, the two worked in Florence for Grand Duke Ferdinand II de' Medici and his brother, Cardinal Leopold de' Medici. The Medicis had supported other Dutch painters, but it may have been their fascination with science – both patronized the Accademia del Cimento, an organization committed to empirical experimentation – that drew them to Marseus. The painter was also active in Naples and Rome where he associated with the *Bentvogelen* ("Birds of a Feather"), a brotherhood of Netherlandish painters. He returned to the Dutch Republic in 1657.

Early on in his career, he painted vases of flowers set on ledges in an indeterminate space, following the conventions established by Ambrosius Bosschaert the Elder and Balthasar van der Ast. He is best known, however, for his nocturnal woodland still lifes (*bosstilleven*), a subcategory of still life that he invented. In those still lifes, in which he depicted the plants and animals of the forest's undergrowth, Marseus expands the boundaries of still life by conflating the genre with landscape and often introducing an explicit narrative action to the scene.

Marseus's fascination with the woody nether regions intrigued his contemporaries. It prompted the *Bentvogelen* to nickname him, *de Snuffelaar* (the sniffer) because he "sniffed around everywhere for strange colored or speckled snakes, lizards, caterpillars, spiders, butterflies, and strange plants and herbs."[2] Samuel van Hoogstraten, the artist and theoretician from Dordrecht who visited Marseus in Rome in 1652, reported that the artist kept a menagerie of various snakes and lizards with which he appeared to share a remarkable emotional rapport.[3] According to the French traveler de Monconys, Marseus bred reptiles at his house, Wateryk, in Diemen after he returned to the Netherlands.[4] He also kept a cottage outside Amsterdam, which he used when collecting specimens in the countryside.[5] Though it seems far-fetched, Houbraken nonetheless related the widow's claim that her husband had trained the snakes to hold poses that he set for them with his maulstick.[6]

Marseus brought his naturalist's eye to the depiction of plants and animals. In the present work, he records the various colors of the poppy's petals, the shapes of the different leaves, the crystalline dew drops that rest on the foliage, and the pattern of scales on the skins of the snake and lizard. Marseus, however, was not simply a detached scientist. In this and other *bosstilleven*, the gaze of the botanist and herpetologist defers to the imagination of the storyteller and poet who combines and arranges the objects to produce rich mysterious overtones. The poppy, evoking visions of sleep, the night, and opium-induced hallucinations, dominates the image. Shades of blue, gray, and black give its red petals a sickly, sinister cast. The coiled snake hisses and unfurls its slender tongue at the lizard who gives his antagonist a vexing look. Honeysuckle with their spikey stamens and pistals creep over a rectangular stone, a pedestal or socle. The loosely painted moonlit area in the background adds a dreamy quality to the composition.

1. Arnold Houbraken, *De Groote Schouburg*, (Amsterdam, 1753; reprinted Amsterdam, 1976), vol. 1, pp. 357-358. Other contemporary sources are listed below. For modern literature on Marseus, see A. D. de Vries, "Otto Marseus," *Oud Holland* 1 (1883), pp. 166-168; F. F. Guelfi, "Otto Marseus van Schrieck a Firenze: Contributo all storia dei rapporti fra scienza e arte figurative nel seicento Toscano," *Antichità viva* 16/2 (1977), pp. 15-26 and 16/4 (1977), pp. 13-21; L. Bol," Schilders van Flora en Fauna en Bos en Struweel," in *Goede Onbekenden* (Utrecht, 1982), pp. 97-105. See also Bernard Barryte's discussion of Marseus in *In Medusa's Gaze* (Rochester, Memorial Art Gallery, 1991), pp. 54-55.

2. Houbraken, p. 358. Translation by Barryte, p. 54.

3. Samuel van Hoogstraten, *Inleyding tot de Hooge Schoole der Schilderkonst* (Rotterdam, 1678; reprinted Soest, 1970), p. 169.

4. B. de Monconys, *Journal des Voyages* (Lyon, 1666), vol. 2, p. 161.

5. Houbraken, p. 358.

6. Ibid.

14 (plate 5, page 21)

JAN VAN HUYSUM

(1682 Amsterdam – 1749 Amsterdam)

Vase of Flowers in a Niche

Oil on panel, 35 x 27⅛ in. (88.9 x 70.0 cm)
Signed lower right, on marble slab:
Jan Van Huysum fecit
Bequest of Stanton Blake. 89.503

Provenance: (Possibly) Schönborn collection, Pommersfelden; sale Paris, May 17-24, 1867, no. 62; bought by Comte de L'Epine; sale Paris ["Comte de L'***" collection], April 15, 1868, no. 33; bought by Nieuwenhuys.

Exhibitions: Boston, Museum of Fine Arts, *Seventeenth-Century Dutch and Flemish Still-Life Paintings*, October 7-November 30, 1980; Boston, Museum of Fine Arts, *The Great Boston Collectors: Paintings from the Museum of Fine Arts*, February 13-June 2, 1985, no. 9.

Literature: C. Blanc, "Une Visite à San Donato," *Gazette des Beaux-Arts* 16 (1877), p. 420; H. Janitschek, *Repertorium für Kunstwissenschaft*, vol. XI (Berlin and Stuttgart, 1888), p. 79, no. 321; Cornelis Hofstede de Groot, *Beschreibendes und kritisches Verzeichnis der Werke der hervorragendsten holländischen Maler des XVII Jahrhunderts*, vol. 10 (Stuttgart and Paris, 1928), p. 368, no. 146; M. H. Grant, *Jan Van Huysum 1682-1749* (Leigh-on-Sea, 1954), p. 24, no. 107; Murphy 1985, p. 135 ill.; Theodore E. Stebbins, Jr., and Peter C. Sutton, *Masterpiece Paintings from the Museum of Fine Arts, Boston* (New York, 1986), p. 47 ill.; C. Vogel, "Double Dutch," *New York Times*, Friday, April 23, 1993, p. C20 ill.

Van Huysum, who trained with his father, Justus van Huysum, also a flower painter, made several hundred paintings over the course of his career, most of them fruit and flower pieces, though he also painted numerous arcadian landscapes. His earliest flower pieces feature compact bouquets set against dark backgrounds, but later in his career, he loosened the bouquets, made them more luxurious, and placed them against softer, more open backgrounds, including some landscapes.

The independent flowerpiece, which came into being in the seventeenth century, served many purposes. It offered a means of displaying and permanently recording prize blooms like the ones Van Huysum has depicted in the Boston picture: the hybrid striped tulip; hyacinths; and the yellow rose, a "rosa huysumiana," named after Van Huysum and known only from his paintings. Detailed renderings of flowers also satisfied the desire for empirical knowledge of the natural world. Finally, flowerpieces were apposite vehicles for symbolic, particularly *vanitas* themes. Not only was the beauty of the flower subject to the vicissitudes of time, but moralizing types

deemed the cultivation of flowers, particularly rare and costly ones, a waste of time and money and therefore an exercise in human folly.[1]

Whether Van Huysum intended his paintings to communicate symbolic meanings is difficult to say. He explicitly invoked the *vanitas* theme in a few of his works,[2] and given the withering petals and wilting stems as well as the cycle of growth and decay illustrated in the three poppies of the bouquet's apex, he hints perhaps at notions of transience in the Boston canvas. By the eighteenth century, however, *vanitas* imagery was less popular and flowerpieces like Van Huysum's technical masterpieces sold for very high prices: they were valued as luxury objects. Moreover, the richness of Van Huysum's bouquet overwhelms the signs of deterioration, suggesting he was more intent on celebrating the beauty of the flowers than subjecting them to moral scrutiny. Clearly reveling in their different shapes, textures, and colors, he renders the flowers with extraordinary skill and sensitivity. In contrast to earlier flower painters who tended to paint each flower individually, Van Huysum delights in the expressive lines and forms of the flowers, joining them to form grand sweeping rhythms and twisting and turning their stems and blooms to create an image of floral exuberance.

Van Huysum combined species that grew at different times of the year – the springtime auriculus and the late-blooming morning glory, for example, in the Boston canvas – making it impossible to re-create his bouquets with actual flowers.[3] While some flower painters used studies of flowers to free themselves from the vagaries of the floral timetable, Van Huysum preferred to base his pictures on live specimens, a practice which sometimes delayed a painting's completion as we know from a letter to a patron in 1742.[4] (Paintings produced over two growing seasons appropriately bear two dates.) Notoriously circumspect about his working methods, Van Huysum refused visitors to his studio, fearing they would steal his colors. Though his works exerted enormous influence over successive generations of flower painters, he had only one student, Margaretha Havermann, during his lifetime.

1. On the history of flowerpieces, see Ingvar Bergström, *Dutch Still-Life Painting in the Seventeenth Century*, trans. Christina Hedström and Gerald Taylor (New York, 1956),

pp. 42-97; Sam Segal, *A Flowery Past – A Survey of Dutch and Flemish Flower Painting from 1600 to the Present* (Amsterdam, Gallery P. de Boer, 1983), and Segal, *A Prosperous Past: The Sumptuous Still Life in the Netherlands 1600-1700*, William B. Jordan, ed. (The Hague, 1988), pp. 93-120, and Elizabeth B. MacDougall, "Flower Importation and Dutch Flower Painting 1600-1700," in *Still Lifes of the Golden Age*, Arthur K. Wheelock, Jr., ed. (Washington, National Gallery of Art, 1989), pp. 27-33.

2. His *Still Life with Flowers* (Amsterdam, Amsterdams Historisch Museum), for example, bears an inscription from Matthew 7:28-29. On that inscription and its meaning see Titia van Leeuwen, "Jan van Huysum," in *Still Life in the Age of Rembrandt* (Auckland, Auckland City Art Gallery, 1982), p. 171.

3. The flowers are identified in Theodore E. Stebbins, Jr., and Peter C. Sutton, *Masterpiece Paintings from the Museum of Fine Arts, Boston* (New York, 1986), p. 47.

4. In a letter dated July 17, 1742, to A. N. van Haften, agent of the duke of Mecklenburg, Van Huysum wrote: "the flower-piece is very far advanced; last year I couldn't get hold of a yellow rose, otherwise it would have been completed." For the letter, see F. Schlie, "Sieben Briefe und eine Quittung von Jan Van Huysum," *Oud Holland* 18 (1900), p. 141. The translation is from van Leeuwen, p. 171.

15
Spanish School, seventeenth century
Still Life with Sweetmeats

Oil on canvas, 15⅝ x 28⅜ in. (39.7 x 72.2 cm)
M. Theresa B. Hopkins Fund. 62.172

Provenance: Frederick Mont, New York.

Literature: "Accessions of American and Canadian Museums, April - June, 1962," *Art Quarterly* 25/3 (Autumn 1962), p. 264, 268 ill.; Murphy 1985, p. 129 ill.

To the left, the artist has depicted a wooden box filled with pieces of glazed fruit and candy in a nest of blue and pink paper, and on the right, a smaller box containing sticks of brown sugar. In the center, a piece of gingerbread is placed before two boxes, which, stacked one on top of the other, support a ring of bread and two pieces of yellowish-brown fruit. A dark bottle stands to the left. All of the objects are set on a greenish-gray table against a dark background. The frieze-like arrangement of tipped and propped confections invites comparison with a bake shop window display.[1]

At present the painter of this work is unknown. On the basis of its subject, it was originally given to Juan van der Hamen y Léon, who along with Blas de Prado and Juan Sánchez Cotán, is considered one of the greatest still-life artists that seventeenth-century Spain produced. Although he painted other still-life objects, portraits, and religious themes, according to Pacheco, Velásquez's teacher, Van der Hamen's contemporaries knew him primarily for his paintings of candy and other confections.[2] William Jordan, however, has rejected that attribution because the technique and composition differ from Van der Hamen's. Pointing to the liquid application of paint, he believes that the picture may have been executed at a later date, possibly the 1630s by an artist influenced by Velásquez. The still-life painters Francisco de Burgos Mantilla and Francisco Palacios are possible candidates, but so few of their still lifes are

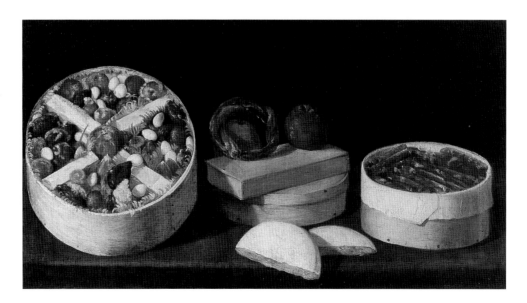

extant – they are best known from literary documents – it is difficult to make a firm attribution to either one.[3]

Images of candy and sweetmeats seem a natural subject for a Spaniard since Spain pioneered the cultivation of sugar cane and the manufacture of sugar. Its cost and rarity, however, made sugar the preserve of the Spanish aristocracy, and Lope de Vega reported that even they reserved it for special occasions.[4] Presumably images of candy attracted mainly noble clients and perhaps the well-to-do bourgeoisie, individuals who might have valued these images not only as symbols of their status and wealth – or their aspirations thereto – but also as reminders of Spain's political, economic, and colonial power. Sugar was produced mainly in the Spanish territories in the Atlantic Islands and the Caribbean, and at the time this picture was painted, Spain led the world in the production and export of sugar, though it would cede that distinction to Britain and France by mid-century.[5]

1. The description is suggested by Jutta Held, "Verzicht and Zeremoniell," in *Stilleben in Europa* (Münster, Westfälisches Landesmuseum für Kunst und Kulturgeschichte and Baden-Baden, Staatliche Kunsthalle, 1980), p. 392.

2. F. Pacheco, *Arte de la pintura* (Seville, 1649; reprinted Madrid, 1956), vol. 2, p. 126.

3. Letter in Museum files from William B. Jordan, April 15, 1993.

4. Quoted in William B. Jordan, *Spanish Still-Life in the Golden Age* (Fort Worth, Kimbell Art Museum, 1985), pp. 112-113.

5. On the history of the production and consumption of sugar, see Sidney W. Mintz, *Sweetness and Power* (New York, 1985).

16
Workshop of EVARISTO BASCHENIS
(Italian, 1617– 1677)

Musical Instruments

Oil on canvas, 13¾ x 21⅜ in. (34.8 x 54.4 cm)
Gift of Arthur Wiesenberger. 49.1789

Provenance: Arthur Wiesenberger, New York.

Literature: Marco Rosci, *Baschenis Bettera & Co.* (Milan, 1971), p. 48; Marco Rosci, "Evaristo Baschenis," in *I Pittori bergamaschi dal XIII al XIX secolo*, vol. 3, *Il Siecento* (Bergamo, 1985), p. 87 no. 92; Murphy 1985, p. 12 ill.

The picture displays an embossed guitar case supporting a book and hourglass, an over-

turned lute atop a virginal or clavichord and two pages of a score. The scrolled key cheeks and carved key front indicate that the virginal or clavichord was made in Italy.[1]

Baschenis, a priest as well as an artist, known to his contemporaries as *Prevarisco (Prete Evaristo)*, specialized in still lifes composed mostly of musical instruments, among the earliest known examples of this type of image. Credited with reviving still-life painting in his native Lombardy, which is often viewed as the birthplace of Italian still-life painting, Baschenis spent his life in Bergamo, but his pictures were known throughout Italy. By 1675, they had already entered noble collections in Florence, Rome, Venice, and Turin.

His realistic style with its strong chiaroscuro and precise forms parallels that of his fellow Lombard Caravaggio, whose extraordinary renderings of musical instruments in paintings like *Victorious Amor* (Berlin-Dahlem, Staatliche Museen Preussischer Kulturbesitz) probably inspired the younger painter. His subject matter was also influenced, no doubt, by the fine instruments crafted in the towns surrounding Bergamo, among them Cremona where the Amati family produced their renowned violins and lutes and trained Antonio Stradivari whose own violins would set the standard for that instrument.

Boston's canvas was originally attributed to Bartolomeo Bettera, but on the basis of its

similarity to three of Baschenis's canvases, Marco Rosci assigned it to Baschenis's workshop which the master had established by 1647 to produce copies and variants of his pictures.[2] The Museum's canvas and the three related pictures exhibit part of a spinet to the right, next to various instruments and objects. The Boston canvas is cropped more tightly than the others, minimizing the space around the objects, and its design of pronounced horizontals and verticals is more static than the compositions of the related pictures. While Baschenis probably oversaw the execution of the canvas, the instruments are not rendered with the same attention to detail characteristic of his autograph works. The virginal, for example, is missing some keys, and the relation between the instrument's case and its playing parts is not clearly delineated.[3]

The instruments depicted here are among those played by chamber ensembles which performed in private homes for invited guests in this era before the public concert and full-scale orchestra. In all probability, however, these instruments would not have been played together since all produce very soft sounds. The hourglass, in any event, suggests not the performance, but the practice of music, although as the dusty lute indicates no one has used the instruments for some time. Symbolic intent is obvious. The curled pages of the score indicating age and use, the dust on the lute, and the hourglass all allude to

the passage of time, a common metaphorical reference in seventeenth-century still life.

1. My thanks to Darcy Kuronen, curatorial assistant in the Collection of Musical Instruments, for his help in identifying the instruments. It is not clear from its exterior whether the keyboard instrument is a virginal or clavichord. The virginal is a small form of harpsichord which uses a plucking mechanism to activate the strings, while the clavichord's strings are struck by slips of brass.

2. Marco Rosci, *Baschenis Bettera & Co.* (Milan, 1971), p. 48 and Rosci, "Evaristo Baschenis" in *I Pittori bergamaschi dal XIII al XIX Secolo*, vol. 3: *Il Seicento* (Bergamo, 1985), p. 87. Of the three related paintings of musical instruments, two belong to private collections in Milan and the third to Milan's Museo Teatrale della Scala. For illustrations, see Rosci 1985, nos. 51, 57, and 105a.

3. Memo in Museum files, January 12, 1950.

17 (plate 7, page 23)

Attributed to EVARISTO BASCHENIS
(1617 Bergamo - 1677 Bergamo)

Musical Instruments

Oil on canvas, 28⅛ x 38⅝ in. (72.5 x 98.0 cm)
Charles Potter Kling Fund. 64.1947

Provenance: Bruno Lorenzelli, Bergamo, Italy.

Exhibitions: Miami, Miami Art Center, *Art in Italy*, October 23 - November 30, 1969, no. 12.

Literature: Angelo Geddo, *Evaristo Baschenis* (Bergamo, 1965), fig. 16; Marco Rosci, *Baschenis Bettera & Co.* (Milan, 1971), pp. 43, 49, fig. 76; Gisela D. Mueller, "Evaristo Baschenis – der Initiator von Musikstilleben – und sein Kreis," *Kunst in Hessen und am Mittelrhein*, p. 19, n. 26; Marco Rosci, *I Pittori bergamaschi dal XIII al XIX Secolo*, vol. 3: *Il Seicento* (Bergamo, 1985), p. 92, fig. 136; Murphy 1985, p. 12 ill.

In this canvas a harp rests against an overturned theorbo or chittarone, types of archlutes developed in the early seventeenth century, while a small lute, probably a mandora, gives the picture a strong central focus. A violin, whose short fingerboard and thick neck indicate its early design, lies atop a book next to a box supporting an inkwell and quill. A lute tablature hangs over the edge of the table while another, inside its cover, rests on the large lute.[1]

In the selection and arrangement of instruments, the Boston canvas is directly related to three other paintings by Baschenis, two of them in private collections in Monza and Milan and a third in the Accademia Carrara in Bergamo.[2] Those canvases, however, display a variety of other objects in addition to the instruments, as well as a curtain in the foreground. The works in Monza and Milan

also include indications of a room in which the table and instruments are placed. Marco Rosci has questioned the Boston canvas's attribution to Baschenis,[3] and indeed, with its overall blond tonality, it lacks the rich warm colors and subtle chiaroscuro characteristic of Baschenis's canvases. The instruments are, by and large, accurately rendered, although the f-holes of the violin are perhaps too thin compared to those of an actual instrument.[4]

Baschenis's canvases were widely copied during his life time, and so great was his legacy that artists in Bergamo painted still lifes of musical instruments well into the eighteenth century, making the town the center for such scenes. In addition to the influence of Caravaggio's depictions of musical instruments and of the actual lutes and violins produced in the area around Bergamo, Baschenis may have been inspired by illustrated perspective manuals which often encouraged artists to practice challenging forms like those of the lute. In his 1596 treatise on perspective, Sirigatti warned "it is held a most difficult thing to put into foreshortening regular bodies and above all those composed of curved lines such as the viola and lute."[5] Scenes of musical instruments on intarsia panels, which often put the manuals' advice into practice, offer another possible source for Baschenis's still lifes.[6] The obvious perspectival arrangement of the instruments in the Boston canvas and the related works not only demonstrates the painter's technical skill, but also underscores a fundamental difference between painting and music. One is an art that develops in space while the other unfolds in time.

By the seventeenth century music was rich in symbolic meanings. A viewer steeped in that symbolism might have appreciated the still life in allegorical terms. Many of the elements that Cesare Ripa, for example, designated for the depiction of music are present in this image: the harp, possibly alluding to the lyre of Apollo, god of music; the musical score, which imparts music and harmony to others through their eyes; a lute and a quill, which in figure scenes are played and held respectively by a putto and a young woman, personifying Music, who writes notes on a score.[7] Noting the inherent temporality of music, John Spike has argued that most scenes of musical instruments invoke a *vanitas* theme, and in this particular canvas, the curled, aged pages of the score and the shadows cast by the instruments might well allude to the passage of time, reminding the

viewer to use his days wisely.[8] As an expedient to and source of sensual pleasure, music was – and remains – intimately linked to the experience of love. "Love is born of music and from music love never departs," Vasari wrote in 1568.[9] The relationship between love and music was, of course, the theme of several of Caravaggio's paintings, notably his *Lute Player* (St. Petersburg, State Hermitage Museum) and *Musicians* (New York, Metropolitan Museum of Art). The lute was the instrument par excellence of love, due not only to the amorous songs composed for its strings, but also to its resemblance to the female body. There is perhaps some reference in this still life to Cupid's bow in the harp and to the god's arrow in the violin's bow and the quill whose stiffly feathered tip resembles an arrow's fret.

1. My thanks to Darcy Kuronen, curatorial assistant in the Collection of Musical Instruments, for his help in identifying the instruments.

2. For illustrations of these canvases, see Marco Rosci, *I Pittori bergamaschi dal XIII al XIX secolo*, vol. 3: *Il Seicento* (Bergamo, 1985), nos. 3, 139a, 144.

3. Ibid., p. 92.

4. As noted by Darcy Kuronen.

5. Quoted in Marco Rosci, *Baschenis Bettera & Co.* (Milan, 1971), p. 34. On the significance of these manuals for Baschenis's work, see pp. 34-36.

6. Keith Christiansen, *A Caravaggio Rediscovered, The Lute Player* (New York, The Metropolitan Museum of Art, 1990), p. 78.

7. Cesare Ripa, *Baroque and Rococo Pictorial Imagery*, introd. and trans. Edward A. Maser (New York, 1971), no. 192. This is a translation of the 1758-60 Hertel edition of Ripa's *Iconologia*. In the *Iconologia*, of course, the objects are attributes of configurations or personifications.

8. John T. Spike, *Italian Still-Life Paintings from Three Centuries* (New York, 1983), p. 72.

9. Quoted in Donald Posner, "Caravaggio's Homo-erotic Early Works," *Art Quarterly* 34, p. 303. On the subject of love and music generally, see A. P. de Mirimonde, "La Musique dans les allegories de l'amour," *Gazette des Beaux-Arts* 68/1174 (November 1966), pp. 265-290; 69/1175 (December 1966), pp. 319-346.

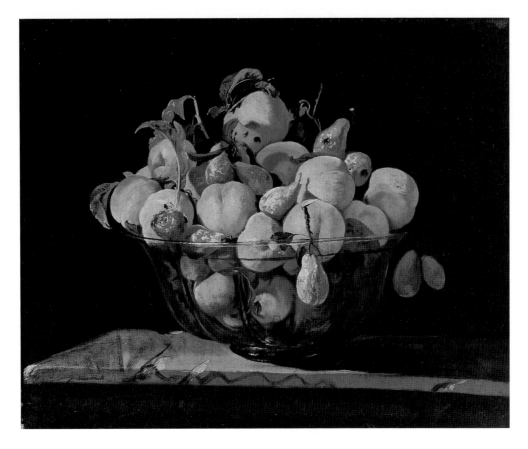

1. John Spike, however, does not believe that any more specific attribution than Roman, second half of the seventeenth century is possible given the quality of the picture. Letter dated February 23, 1983, in Museum files from John Spike to John Walsh, Jr.

2. On Spadino, see Luigi Salerno, *Italian Still-Life Painting from Three Centuries: The Silvano Lodi Collection* (Florence, 1984), pp. 146-149.

3. See in particular *Glass Bowl with Fruit* which is in a private collection and *Fruit in a Garden with a Parrot* in the Musée Fesch in Ajaccio. The shape of the bowl in the Boston canvas is particularly close to that in the Ajaccio still life. For illustrations of these pictures, see Luigi Salerno, *Still-Life Painting in Italy, 1560 - 1805* (Rome, 1984), figs. 73.3-4.

4. Spike, p. 110.

19 (plate 8, page 24)

Attributed to PIETRO PAOLINI

(1603 Lucca – 1680 Lucca)

Fruit and a Vase of Flowers on a Ledge

Oil on canvas, 21⅛ x 30¾ in. (53.6 x 78.2 cm)
Ernest Wadsworth Longfellow Fund. 39.42

Provenance: Matthiesen Ltd., London, until 1938; Knoedler Gallery, New York.

Exhibitions: Toledo, Toledo Museum of Art, *Spanish Painting*, March 16 - April 27, 1941, no. 83; New York, Mortimer Brandt Gallery, 1961 benefit for the National Cancer Foundation.

Literature: Juan J. Luna, *Luis Meléndez* (Madrid, Museo del Prado, 1982), p. 37 ill.; Murphy 1985, p. 143 ill.

With its lyrical composition and emphasis on botanical accuracy, *Fruit and Flowers in a Vase* combines elegance and empiricism. Suspended between nature and artifice, the pieces of fruit seem to lie haphazardly on the table, but are, it is obvious, carefully arranged. Closely keyed colors knit the forms together and reinforce the work's decorative quality. The spare setting, devoid of any signs of a specific location and the contrived placement of the branches contrast with the careful depiction of the objects' natural appearance and the deliberate references to their natural origins in the branches and leaves whose twisted, expressive forms oppose the neat bunch of flowers placed in their prim vase.

The attribution of the canvas is not secure. It was originally given to Luis Meléndez, but it lacks the Spanish master's monumental forms and robust modeling. The combination of natural detail and decorative style are more characteristic of seventeenth-century

18

GIOVANNI PAOLO SPADINO

(1659 Rome – ca. 1730 Rome)

Peaches and Pears in a Glass Bowl

Oil on canvas, 24⅛ x 29⅞ in. (61.2 x 76 cm)
M. Theresa B. Hopkins Fund. 59.193

Provenance: Barberini collection, Palazzo Barberini, Tagliacozzo; Corsini collection, Rome; Albrighi, Florence in 1959.

Exhibitions: Allentown, PA, Allentown Art Museum, *Four Centuries of Still Life*, December 12, 1959 - January 31, 1960, no. 18; Paris, Mme. Anne Wertheimer, 24 avenue Matignon, *Nature Morte*, April 15 - May 15, 1960.

Literature: Murphy 1985, p. 146 ill.

Laurence Kanter has attributed the work to Spadino who painted in Rome and was the neighbor of Abraham Breughel, the Flemish expatriate artist, from 1671-74.[1] When his older brother Bartolomeo died in 1686, Spadino inherited his unfinished canvases and his clients. Though foreigners such as Breughel and Christian Berentz dominated still-life painting in late seventeenth-century Rome, Spadino's work was highly acclaimed and patronized by a number of important individuals. Moreover, the appearance of his name in the 1715 inventory of Prince Giacomo Capece Zurlo of Naples indicates that he was also respected outside of Rome.[2]

Glass bowls filled with fruit, a motif probably made popular by Brueghel, appear in a number of Spadino's canvases, sometimes displayed alone and sometimes in tandem with other objects in a landscape.[3] In the monumentality and weightiness accorded the fruit, this work is rooted in the Roman school of still-life painting, but it also displays qualities characteristic of the late Baroque generally, particularly the looser brushwork and the tendency to bring the objects forward rather than setting them back in space. In contrast to earlier Roman still-life painters – particularly those influenced by Caravaggio – Spadino was generally less interested in recording the specific textures of different objects. His work therefore typically displays a consistency of handling across the picture. John Spike observed that Spadino's work also exhibits a playful quality embodied, for example, in his predilection for over-sized white highlights, which are much in evidence in this canvas.[4]

Italian still lifes. It has been suggested that the canvas belongs to the Neapolitan painter Luca Forte,[1] yet Forte's still lifes display more compact compositions, brighter colors, and form-defining chiaroscuro. With its shallow space, modulated light, and brownish background, it more nearly resembles the still lifes that have been tentatively assigned to Pietro Paolini.[2] Paolini studied in Rome with Angelo Caroselli, a follower of Caravaggio. After working in Venice for several years, he returned to his native Lucca in 1640 where he founded an academy of painting whose students included Simone del Tintore (cat. 24).

1. Pierre Rosenberg suggested Forte during a visit to the Museum of Fine Arts in September 1979, note in Museum files.

2. Examples of still lifes that have been assigned to Paolini can be found in Luigi Salerno, *Still-Life Painting in Italy, 1560-1805*, trans. Robert Erich Wolf (Rome, 1984), figs. 22.3-22.5 and 22.7. *Fruit and Flowers in a Vase* also bears comparison with two still lifes formerly given to Simone del Tintore, Paolini's student, which Salerno has reattributed to Bernardo Strozzi during his stay in Rome in 1625 when, Salerno believes, he came in contact with Paolini. See Salerno, pp. 139-142 and figs. 35.3-35.4. Those two still lifes, now in private collections in New York, display a bunch of flowers in a vase as well as a branch of fruit and leaves set diagonally in, or near, the center of the canvas. In both, moreover, there is space between the objects as there is in *Fruit and Flowers in a Vase*.

20

MELCHIOR D'HONDECOETER

(1636 Utrecht – 1695 Amsterdam)

Barnyard Fowl and Peacocks

Oil on canvas, 48 x 61⅝ in. (122 x 156.5 cm)
Signed upper center on stone wall: *Melchior d hondecoeter*
James Fund. 07.501

Provenance: Edward Balfour, sold Christie's, London, May 31, 1907, lot 138.

Literature: Murphy 1985, p. 133 ill.

A peacock and a peahen approach two chickens and a rooster assembled before stone socles. A pigeon perched on one of the socles looks back over its shoulder while a mother duck in the foreground tends her flock. The scene opens onto a landscape.

The grandson of Gillis Claesz. de Hondecoeter, the landscapist, and son of Gysbert Gillisz. de Hondecoeter, the landscape and animal painter, Melchior d'Hondecoeter studied with his father until the latter's death in

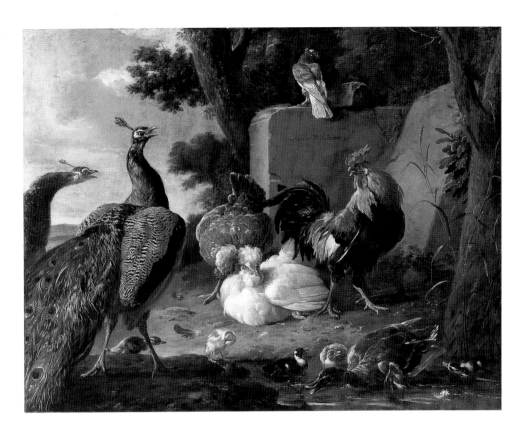

1653 when he entered the studio of his uncle Jan Baptist Weenix, who specialized in gamepieces. By 1659, he was working in The Hague and by 1662 was the leader of the *Confreria Pictura*, or painters' confraternity, in that city. By 1663, he had moved to Amsterdam where he married and remained until his death.[1]

Hondecoeter painted gamepieces, which display the influence of Weenix and by the mid-1660s Willem van Aelst as well as fish still lifes in the manner of Abraham van Beyeren, but he is best known for his images of live domestic and exotic birds set in barnyards or imaginary landscapes. His works, which range in size from cabinet pictures to murals, attracted important patrons including Willem III who commissioned him to paint a portrait of his private zoo on the walls of his country residence Het Loo. His skill earned him the nickname, "the Raphael of animals," in the nineteenth century.

While Hondecoeter invented many of the buildings and vistas that appear in his landscapes, he rendered the fowl with noteworthy attention to realistic detail, faithfully describing their particular postures and markings. It is likely that he worked from a set of studies since he repeats many of the same birds in different combinations in his canvases.

Though Hondecoeter's paintings are distinguished by their ornithological accuracy, they may also have carried emblematic meanings for contemporary viewers familiar with proverbs and figures of speech which likened human character traits to the behavior of various birds. Even today we sense a story unfolding as the proud peacock and bold rooster suspiciously eye one another, the hens congregate in the center of the canvas and the mother duck minds her flock of ducklings.

Though for unknown reasons Hondecoeter died in poverty, his bird pictures were extremely popular during his lifetime and often imitated. A small copy of the Boston still life entitled *Poultry* can be found in the Bowdoin College Museum of Art.[2]

1. The best sources on Hondecoeter's life and work are *Melchior de Hondecoeter (1636 - 1695): Katalog der XVI Sonderausstellung* (Vienna, Akademie der bildenden Künste, 1968); Scott A. Sullivan, *The Dutch Gamepiece* (Totowa and Montclair NJ, 1984), pp. 54-55 and Peter C. Sutton, *Northern European Paintings in the Philadelphia Museum of Art* (Philadelphia, Philadelphia Museum of Art, 1990), pp. 124-129.

2. The copy, which measures 13 x 18¼ inches, differs in certain details. The artist has deleted the peahen and painted the entire body of the peacock which is closer to the birds in the center, included a drake behind the

mother duck, and reduced the number of ducklings. The landscape is also less elaborate. The Bowdoin painting does not appear as skilled or confident in its execution as the Boston picture.

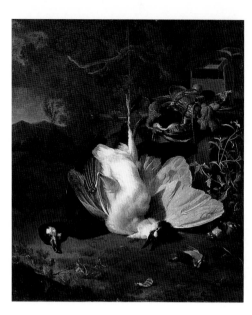

21

JAN WEENIX

(1642 Amsterdam – 1719 Amsterdam)

Dead Birds and Hunting Equipment in a Landscape

Oil on canvas, 38½ x 33 in. (97.8 x 83.7 cm)
Signed lower right: *JW*
Gift of Mrs. Roger Merriman. 41.744

Provenance: Mrs. Daniel Merriman by 1901 through 1902; Mrs. Roger B. Merriman by inheritance 1902.

Exhibitions: Worcester, Worcester Art Museum, 1901 - 1902; Cambridge, Germanic Museum, 1933 - 1941; Winchester MA, Winchester Art Association, 1946; Boston, Museum of Fine Arts, *Seventeenth-Century Dutch and Flemish Still-Life Paintings,* October 7 - November 30, 1980.

Literature: Murphy 1985, p. 299 ill.

Five dead birds, the two larger ones arranged in a pyramid in the center, and a cache of hunting equipment are set in a romantically lit landscape.

The gamepiece only appeared in sizeable numbers beginning in the 1650s. The earliest examples probably depended in part on images of dead game in market and kitchen pictures and on Flemish gamepieces, though Dutch painters initially eschewed the opulent trappings, dynamic space, and rich colors favored in the South.

The son of Jan Baptist Weenix and cousin

of Melchior d'Hondecoeter, Jan Weenix was the foremost painter of the late decorative gamepiece in Holland. Weenix's family left Amsterdam for Utrecht in the early 1650s. He probably remained in that city throughout the 1660s since he is listed among the painters belonging to the local chapter of the guild of St. Luke in 1664 and 1668. During the 1660s he painted genre scenes in the manner of his father. He devised his basic approach to the gamepiece by the early 1680s by which time he had returned to Amsterdam where he married in 1679 and attracted a number of important patrons including the Elector Palatin, Johann Wilhelm, who commissioned a series of hunting scenes for the Bensberg Castle in Düsseldorf. Though he also painted portraits, genre scenes, and flower pieces, Weenix devoted himself primarily to gamepieces.[1]

Inspired perhaps by the vogue for French culture which shaped Dutch taste in the last decades of the seventeenth century, Weenix eschewed the simple niche or plain table favored by painters of gamepieces in previous decades, setting the dead animals in elaborate landscapes decorated with various objects, including antique urns, statuary, occasionally the facade of a classical building, displays of food, and sometimes a live squirrel, hunting dog, monkey, or bird to animate the scene. The images, which are often suffused with soft crepuscular light, also display rare species of game like peacocks, swans, and deer. While the present work is noticeably simpler than many of Weenix's gamepieces, it nonetheless features some of his signature characteristics: the prized birds in the foreground, the rich hunting accessories, the warmly lit landscape, and the vista to the left.

Hunting in the United Provinces was largely restricted to the nobility well into the eighteenth century. The laws not only regulated who could hunt but also what animals could be hunted, when, and in what quantities. Bannered nobles and members of the court, for example, were permitted to bag one deer per year. All nobles were allowed to shoot two rabbits or one hare per week between September 15 and February 2. While only the nobility could hunt larger birds – swans, geese, pheasants, and the like – any individual could shoot smaller species.[2] Noting that the number of gamepieces painted far exceeded the number of nobles in Holland, Scott Sullivan has argued that this kind of still life was bought not only by the aris-

tocracy but also by the bourgeoisie seeking to emulate noble manners and fashion. Though they could not hunt, these pictures enabled the burghers, whose wealth increased dramatically in the second half of the seventeenth century, to enjoy vicariously the social prestige that hunting implied.[3]

1. On Weenix see Scott A. Sullivan, *The Dutch Gamepiece* (Totowa and Montclair, NJ, 1984), pp. 61-66 and Peter C. Sutton, *Northern European Paintings in the Philadelphia Museum of Art* (Philadelphia, Philadelphia Museum of Art, 1990), pp. 357-359.

2. Sullivan, pp. 32-45.

3. Ibid.

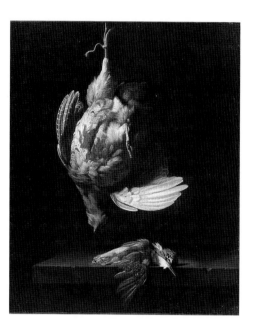

22

SIMON PIETERSZ. VERELST

(1644 The Hague – 1721 London)

Still Life with Dead Partridge and Kingfisher

Oil on canvas, 29⅜ x 24¾ in. (74.7 x 62.9 cm)
Signed lower left on stone ledge: *S. verelst F.*
Gift by Subscription. 90.202

Provenance: Paul Pavlovich Demidoff, Florence, Italy until 1880; Demidoff Sale, Florence, March 15, 1880; Stanton Blake, Boston, from Demidoff Sale.

Exhibitions: Westport CT, Westport Library, *Still Life Paintings,* May 22 - June 7, 1958; Boston, Museum of Fine Arts, *Seventeenth-Century Dutch and Flemish Still-Life Paintings,* October 7 - November 30, 1980.

Literature: Laurens J. Bol, *Holländische Maler des 17. Jahrhunderts nahe den Grossen Meistern* (Braunschweig, 1973), p. 286; Frank Lewis, *Simon Pietersz. Verelst* (Leigh-

on-Sea, 1979), p. 29; Scott A. Sullivan, *The Dutch Game-piece* (Totawa and Montclair, NJ, 1984), p. 72 ill.; Murphy 1985, p. 291 ill.

Verelst, who probably trained with his father, Pieter Harmensz. Verelst, moved to London in 1669 where he established his reputation painting flowerpieces and portraits for King Charles II and members of the court, including the Duchess of Portsmouth and the Earl of Shaftesbury. Possessed of a colorful personality, he drew the attention of contemporary writers, notably Samuel Pepys.[1]

In his gamepieces, which are rare, Verelst generally depicted a partridge hanging before a niche or a plain wall sometimes with hunting accessories or some fruit on the ledge below, a format popular in Holland from the 1650s until the early 1680s. Scott Sullivan has suggested that the present work derives from Melchior d'Hondecoeter's *Still Life with Birds* (ca. 1678; Toledo, Toledo Museum of Art), which also shows a brightly colored kingfisher lying on the ledge below a partridge hanging by its right leg with its left leg extended to reiterate the line of the open left wing.[2] Sullivan has theorized that Verelst saw Hondecoeter's canvas in Amsterdam, where he, in all likelihood, stopped before visiting Paris in 1680. Not only did Verelst use the same motifs as Hondecoeter, but he also displayed the same sensitivity to detail – note, for example, how carefully he has rendered each kind of feather on the birds' bodies – and attempted to paint in a trompe l'oeil style, though the results are perhaps less compelling than Hondecoeter's. Yet the two canvases also differ in important respects. By placing the birds along a right angle and allowing the partridge's beak to touch the breast of the kingfisher, Melchior created a tight geometric design. He, in addition, flooded the scene with light. Verelst, by contrast, placed the kingfisher slightly to the right of the partridge's beak, thus producing a looser structure, and in keeping with the format he favored in his flowerpieces, he gave the canvas a more dramatic tone by setting the brightly lit objects before a dark background. Where Melchior painted the kingfisher lying stiffly on its back as if rigor mortis had set in, Verelst depicted the bird stretched on its stomach with its head falling limply over the stone ledge much as he often painted a single bloom resting forlornly to the side of the main bouquet or spray in his flower pieces.

Sullivan observed that dead animals hanging from the wall were a common sight in Dutch kitchens and markets,[3] yet both Hondecoeter and Verelst conspicuously avoid references to any context, domestic, commercial, or otherwise. Verelst probably painted the work with a noble patron in mind or a wealthy burgher aspiring to aristocratic status since Dutch law restricted partridge hunting to titled individuals.[4] Partridge, moreover, was a delicacy, which only the privileged could afford. As the author-physician Johan van Beverwijck mused, "You won't find partridge often on our poor table, / That meat is fare for lords, food for the epicure."[5]

1. On Verelst, see Frank Lewis, *Simon Pietersz. Verelst* (Leigh-on-Sea, 1979), pp. 15-18 and Scott A. Sullivan, *The Dutch Gamepiece* (Totawa and Montclair, NJ, 1984), pp. 71-72, 105.

2. Sullivan, p. 72.

3. Ibid., p. 69.

4. Ibid., pp. 32-45. For more on these regulations see cat. no. 21.

5. Johan van Beverwijk, *Schat der Gesontheyt* (Utrecht, 1651), p. 131, cited in E. de Jongh et al., *Still-Life in the Age of Rembrandt* (Auckland, Auckland City Art Gallery, 1982), p. 140.

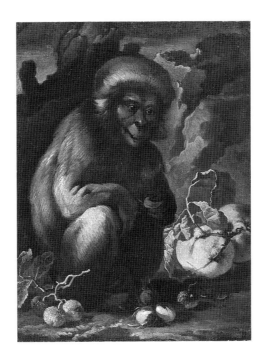

23

Italian (Roman), early eighteenth century

Monkey with Fruit

Oil on canvas, 17⅞ x 13¾ in. (45.4 x 34.8 cm)
Gift of the firm of Jacob Heimann. 44.585

Provenance: Jacob M. Heimann, New York.

Exhibitions: Portland OR, Portland Art Museum, *Primates in Art*, August 1 - 27, 1972.

Literature: Murphy 1985, p. 144 ill.

This canvas came to the Museum as the work of the seventeenth-century Neapolitan painter Paolo Barbieri. John Spike, however, suggested that the painting was executed in Rome around 1700 because the monkey has been copied from a still life, *Fruit and Animals in a Park*, in the Musée Fesch in Ajaccio, Corsica. That still life was formerly attributed to Michelangelo Pace, called Michelangelo da Campidoglio, but has now been given to David De Koninck.[1] A Fleming active in Rome in the late seventeenth century, De Koninck was a pupil of Pieter Boel. Best known for his gamepieces and animal pictures painted in the style of Boel, Frans Snyders, and Jan Fyt, he traveled to Italy in 1670 and stayed for seventeen years.[2]

In De Koninck's painting, the monkey sits to the right of an opulent arrangement of fruit, flowers, and live rabbits set before a fountain in a lush landscape with a vista to the right. The Roman painter uses softer, more blended brushwork than De Koninck so that the animal's fur appears smoother and the features of the landscape less distinct.

While monkeys sometimes satirized human folly or symbolically alluded to, for example, the animal passions, or that human ape of nature, the artist himself, nothing in De Koninck's painting or in the Roman copy suggests that either artist intended the animal to carry emblematic meanings.[3] De Koninck probably included the animal, who sits upright and stares out at the viewer, to enliven the scene. Its exotic origins, moreover, made the monkey, which the wealthy sometimes kept as pets, a luxury object akin to the rich profusion of objects to its right. The Roman artist, for his part, gave the monkey a more contemplative cast than De Koninck did, producing a sensitive rendering of this human-like creature. Self-composed and introspective, it differs from the more typical depictions of monkeys as playful creatures like those that appear in Frans Snyders's *Mischievous Monkeys* (Edinburgh, National Gallery of Scotland) where the scheming animals impishly disassemble the still-life arrangement.

1. Letter from John T. Spike dated May 1, 1993, in Museum files. De Koninck's still life is reproduced in John T. Spike, *Italian Still Life Paintings from Three Centuries* (New York, 1983), p. 131, no. 34.

2. On De Koninck, see Walther Bernt, *Die Niederländischen Maler und Zeichner des 17. Jahrhunderts*, (Munich, 1980), vol, 1, p. 43.

3. On the symbolism of the monkey in earlier periods, see H. W. Janson, *Apes and Ape Lore in the Middle Ages and the Renaissance* (New York, 1952).

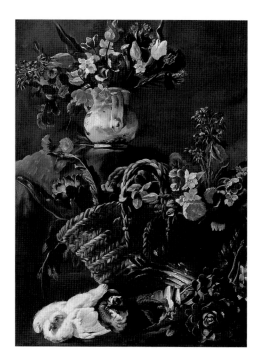

24

SIMONE DEL TINTORE
(1630 Lucca – 1708 Lucca)

Still Life with Flowers, Vegetables, and Pigeons

Oil on canvas, 46½ x 34⅜ in. (118.1 x 87.8 cm)
Lucy Dalbiac Luard Fund. 69.1059

Provenance: Frederick Mont Inc., New York.

Literature: Murphy 1985, p. 264 ill.

The Boston canvas came to the Museum as the work of Tommaso Salini but was subsequently given to Simone del Tintore. Tintore is a somewhat mysterious figure in the history of Italian still-life painting. Though Lanzi praised his skill in rendering birds and fruit, only one canvas had been attributed to him until 1964.[1] At that time, Mina Gregori assigned several works, originally attributed to Pietro Paolini and to Salini, to Tintore.[2]

Little is known of Tintore's life. Baptismal documents establish that he was born on May 7, 1630.[3] He studied at the academy in Lucca founded by Pietro Paolini (see cat. 19), who had worked for several years in Rome where he studied with Angelo Caroselli, a follower of Caravaggio, before returning to his native city around 1640.

Although the scattered arrangement of vegetables and fruit seems more natural than formal, the over-all effect of the canvas is picturesque and decorative, not realist. The Boston picture resembles those generally viewed to be by Tintore in its loose arrangement of fruits and vegetables, painterly handling, tendency to crowd the visual field, and to bind the elements together rather than emphasize their individuality.[4] An identical basket appears in still lifes in the Lodi collection and in the Museo del Castello Sforzesco in Milan.[5]

1. L. Lanzi, *Storia pittorica dell'Italia dal risorgimento delle belle arti fin presso la fine del XVIII secolo* (Bassano, 1789) quoted in Luigi Salerno, *Italian Still-Life Painting from Three Centuries: the Silvano Lodi Collection* (Florence, 1984), p. 122; In 1962, de Logu gave a still life in the Gregori Collection in Florence to Tintore. See Giuseppe de Logu, *Natura morta italiana* (Bergamo, 1962), pp. 187-188.

2. Mina Gregori, *La Natura morta italiana* (Naples, Palazzo Reale, 1964), p. 86. During restoration, two still lifes in the Mazzarosa collection in Lucca originally given to Paolini revealed the monogram, "ST," as well as a date of 1645. That signature had appeared on other paintings and was generally believed to belong to Tommaso Salini. Since Salini died in 1645, he could not have painted the works in the Mazzarosa collection. Gregori proposed, then, to read the "ST" monogram as that of Tintore and to reassign not only the Mazzarosa still lifes to him but also several others formerly given to Salini.

3. The documents were found in the archives of San Frediano at Lucca. See C. Del Bravo, "Lettera perta sulla natura morta," *Annali della Scuola Normale Superiore di Pisa* 3 (1974), p. 1566 n. 5.

4. The oeuvre of Tintore is still disputed. For a consideration of the various arguments and a selection of works tentatively assigned to Tintore, see Luigi Salerno, *Still-Life Painting in Italy, 1560-1805*, trans. by Robert Erich Wolf (Rome, 1984), pp. 282-285.

5. For an illustration of the Lodi still life, see Salerno, *Italian Still-Life Painting*, p. 123 and Salerno, *Still-Life Painting in Italy*, p. 285. For an illustration of the Museo del Castello Sforzesco still life, see Salerno, *Still-Life Painting in Italy*, p. 283. While Gregori attributed the second still life to Tintore, Salerno disputes that attribution and believes the work is related to two pictures by Bernardo Strozzi.

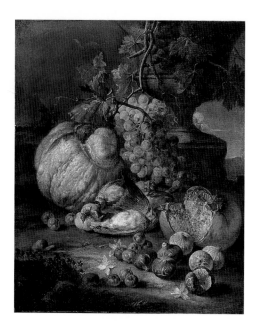

25

GIOVANNI BATTISTA RUOPPOLO
(1629 Rome – 1693 Rome)

Still Life with Fruit and Dead Birds in a Landscape

Oil on canvas, 29½ x 24⅜ in. (75 x 62 cm)
Bequest of Mrs. Henry Edwards. 90.82

Provenance: Anonymous collection or dealer, Rome; Mrs. Henry Edwards by 1890.

Literature: Murphy 1985, p. 143 ill.

From the upper right, grapevines cascade down the side of a large stone urn, surrounding the base with bunches of green and deep blue-red grapes. The urn rises up beyond the picture space. A light green melon split open at its end is nestled against the grapes. Three (or perhaps originally four) small game birds are grouped in the center foreground. To their right a burst pomegranate, three light green and four bluish figs fill the foreground. Smaller red fruits and a few delicate white blossoms are scattered about these dominant forms. A soft light originating from the upper left draws a diagonal path across the arrangement, while the distant background is lit by a sunset sky. Emerging from the bottom right corner and spreading across almost the entire edge of the painting is an outcropping of rocks, grasses, and ground cover dotted with tiny crimson flowers.

The painting was given to the Museum as a Neapolitan work from the second half of the seventeenth century. Hanns Swarzenski

later attributed this work to Giovanni Battista Ruoppolo on the basis of its similarity in subject and style to a still life by Ruoppolo in the Naples Pinacoteca.[1] Fredricksen and Zeri accepted that attribution.[2] The details of Giovanni Battista Ruoppolo's life are told briefly in modern secondary sources. He was born in Naples in 1629 and probably began his training with his father who painted maiolica. Married in 1655, Ruoppolo lived his entire life in Naples,[3] leaving behind a sizeable school of followers when he died in 1693. In his own time Ruoppolo was one of only two still-life specialists to be distinguished by separate chapters in Bernardo de Dominici's seminal biography of the Neapolitan school published in 1742. Even Giuseppe Recco (1634-95) who with Ruoppolo dominated the still-life market in Naples, was not accorded such treatment. De Dominici discussed him within the context of Ruoppolo's biography.[4] Ruoppolo's paintings appear in an inventory of the Van den Eynden collection and were included in a show for the Viceroy Marchese Del Carpio (Naples), organized by Luca Giordano, the great Neapolitan painter of vast decorative religious programs.[5]

Many aspects of *Still Life with Fruit and Birds* confirm the attribution to Ruoppolo whose art was informed both by existing Neapolitan traditions as well as the realist influence of Caravaggio and the Roman still-life school. Figs, burst pomegranates, delicate white blossoms, but especially the grapes, reaching down from the mouth of the urn, and the bumpy melon beside them, all figure in numerous paintings by him. The squash reveals Ruoppolo's sensuous modeling of form, using layers of blues, greens, and white highlights. All of the forms appear solid and well defined yet pliant; their edges are tempered by a pervasive warm light. Despite serious losses to the paint surface in the background areas, the remains of a fading sun are still evident in the distance, bringing to mind a late summer evening, when the perfume of dropping blossoms lingers in the air.

The Boston painting is currently undated. The condition of the painting is problematic. There are numerous small paint losses and missing glazes. These combined with layers of discolored and uneven varnish hinder a proper reading of the painting.[6] However, some indication of *Still Life with Fruit and Birds*'s place within Ruoppolo's oeuvre can be established through the composition. The placement of the urn so that it rises out of

view was a particularly striking device, unique even among the majority of Ruoppolo's vessels, which are typically fully illustrated. Here the urn serves to anchor the objects that wind lazily toward the foreground without asserting its own decorative function. This quiet but masterful use of Baroque dynamism unites a seemingly free placement of objects and bestows a sultry grace upon the whole image. Based on these observations it would be safe to venture that the painting was made after the mid-1670s. By that time, Ruoppolo's paintings reveal a greater Baroque theatricality in presentation (paralleling a similar transition in the Roman school, seen in the work of Cerquozzi), while his earlier work (as exemplified by *Celery and Hydrangeas* in the Ashmolean Museum, Oxford) is more contemplative and lit by a stark Caravaggist light.[7]

1. Manuscript note in Museum files. A. de Rinaldis, *Neapolitan Painting of the Seicento* (Florence, 1929), pl. 173.

2. B. B. Fredericksen and F. Zeri, *Census of Pre-Nineteenth-Century Italian Paintings in North American Collections* (Cambridge MA, 1972), p. 179.

3. John T. Spike, *Italian Still-Life Paintings from Three Centuries*, (New York, 1983), p. 87.

4. B. de Dominici, *Le vite de pittori, degli scultori et architetti napolitani*, 3 vols., [Naples, 1742/43]. Salerno discusses the probability that the exhibition occurred between 1680 and 1687, when the viceroy died. See L. Salerno, *Still-Life Painting in Italy 1560-1805*, trans. Robert Erich Wolf (Rome, 1984), p. 201.

5. Spike, p. 88.

6. This author thanks Jean Woodward, associate conservator of paintings, Museum of Fine Arts, Boston, for discussing the state of conservation of the painting with her.

7. Attributions to Ruoppolo have been complicated by the presence of still-life painters who share versions of his initials. Giuseppe Recco's older brother was Giovanni Battista Recco (1630-75), and Giovanni Battista's own nephew, Giuseppe Ruoppolo (1631-1710), can in turn be confused with the elder Ruoppolo or the elder Recco (Salerno 1984, p. 222). Giovanni Battista Recco's art more consistently evidences a capability for "metaphysical abstraction" typical in Spanish *bodegones* (Salerno 1984, p. 116). Indeed, Ruoppolo's amber-colored offerings make their appeal instead to our basic sensibilities.

26 (plate 9, page 25)

PIERRE NICHON
(French, seventeenth century)

Still Life with a Dead Carp on a Box

Oil on canvas, 19⅜ x 23⅜ in. (49.2 x 59.3 cm)
Signed at lower left: *P Nichon.f*
Francis Welch Fund. 63.1628

Provenance: R. Payelle, Paris by 1951; Paris, Heim Gallery by 1963.

Exhibitions: Paris, Galerie Charpentier, *Natures mortes françaises du XVIIe siècle à nos jours*, December 1951, no. 129; Miami, Miami Art Center, *The Artist and the Sea*, March - April 1969, no. 29; Boston, Boston Museum of Fine Arts, *French Paintings from the Storeroom*, 1978; Paris, Grand Palais, *France in the Golden Age, Seventeenth-Century French Paintings in American Collections*, January 29 - April 26, 1982, and New York, Metropolitan Museum of Art, May 26 - August 22, 1982, Chicago, The Art Institute of Chicago, September 18 - November 28, 1982, no. 75.

Literature: Anon., "L'Epoque archaïque de la nature morte," *Connaissance des Arts* 23/23 (January 15, 1954), p. 19 ill.; P. Jouffroy, "Un Farceur nommé Nichon," *Connaissance des Arts* 23/26 (April 15, 1954), p. 19; Idem, "Les Carpes de Nichon," *Connaissance des Arts* 23/28 (June 15, 1954), p. 17; Zurich, Kunsthaus, *Unbekannte Schönheit*, June 9 - July 31, 1956, pp. 41-42; H. Haug, "Sébastien Stosskopf," *L'Oeil* 76 (April 1961), p. 30; M. Faré, *La Nature Morte en France*, (Geneva, 1962), vol. 1, pp. 46, 104; "Accessions of American and Canadian Museums, October - December 1963," *Art Quarterly* 28/1 (1964), p. 107; H. Haug, "Une Nature morte de Sébastien Stosskopf," *Bulletin des musées et monuments lyonnais* 3/4 (1965), p. 313; D. Hannema, *Beschrijvende Catalogus van de Schilderijen uit de Kunstverzameling Stichting Willem van der Vorm* (Rotterdam, 1967), p. 23; Michel Faré, *Le Grand Siècle de la nature morte en France* (Fribourg, 1974), pp. 134-135 ill.; Sylvain Laveissière, "Pierre Nichon Identified," *The Burlington Magazine* 124/956 (November 1982), p. 704; Christopher Wright, *The French Painters of the Seventeenth Century* (Boston, 1985), p. 237; Murphy 1985, p. 271 ill.

A dead carp rests in a ceramic plate placed atop a wooden box before a water jug or a *coquemard*, a special jug for heating water.[1]

The Boston canvas is a copy of a work in the collection of Pierre Joffroy, Montbéliard, signed by Sébastien Stosskopf of Strasbourg who was active in Paris between 1619 and 1640.[2] There are numerous copies of the work including one by Stosskopf himself which was in the collection of S. Lodi, Munich, and another signed by Nichon which was sold in Paris in 1989.[3] The Boston canvas differs from the original only in minor details. Stosskopf indicated a ledge to the right and depicted a stone rather than plain wall. Little is known about Nichon. Michel Faré originally suggested that he was the Parisian painter Antoine Michon who is

known through contemporary documents,[4] but Sylvain Laveissière has identified him as Pierre Nichon, an artist active in Dijon between 1626 and 1655 who painted a large *Calvary* for the Cathedral of Nôtre-Dame in Dijon.[5]

The simple commonplace objects and realistic style of Stosskopf's original and Nichon's fine copy reflect the naturalist impulse in French seventeenth-century painting exemplified by such artists as Georges de La Tour and the three Le Nain brothers. That style and kind of subject contrasted with the other currents that shaped French art in the period: the intellectual classicism of Poussin and Claude and the mannered elegance of the School of Fontainebleau. Despite the artist's choice of prosaic household objects and his attention to the smallest details – the scales of the fish and the pegs of the box, for example – the design is highly contrived and arresting in its simplicity. Pierre Rosenberg has argued that the fish alludes to Christ, the guttering candle to the emphemerality of life – both were common symbols – and the box to the sacred casket.[6] Given the highly artificial placement and size of the objects, the care with which they have been rendered, and the dramatic, sepulchral lighting, Rosenberg's contention that the artist intended more than just an arrangement of ordinary objects seems plausible.

1. My thanks to Jeffrey H. Munger, associate curator of European Decorative Arts, for identifying the jug.

2. Illustrated in Michel Faré, *Le Grand Siècle de la nature morte en France* (Fribourg, 1974), p. 126. On Stosskopf see H. Haug, "Une Nature morte de Sébastien Stosskopf," *Bulletin des musées et monuments lyonnais* 3/4 (1965), pp. 75-78.

3. Paris, Hôtel Drouot, June 27, 1989, no. 27. The painting which measures 46.5 x 60 cm is given the same provenance as the Boston canvas and is signed *Nichon fec.* For other versions of the composition see Pierre Rosenberg, *France in the Golden Age, Seventeenth-Century French Paintings in American Collections* (Paris, Grand Palais and Chicago, The Art Institute of Chicago, 1982), p. 294.

4. Faré, pp. 134-135.

5. Sylvain Laveissière, "Pierre Nichon Identified," *The Burlington Magazine* 124/956 (November 1982), p. 704.

6. Rosenberg, p. 294.

27 (plate 10, page 26)

LUIS MELÉNDEZ

(1716 Naples – 1780 Madrid)

Still Life with Bread, Ham, Cheese, and Vegetables

Oil on canvas, 24⅜ x 33½ in. (62 x 85.2 cm)
Signed lower right: *L. EGIDIO M*
Margaret Curry Wyman Fund. 39.40

Provenance: R. F. Ratcliff collection, England; Matthiesen Gallery, London (sold as a pair with *Still Life with Melon and Pears*).

Exhibitions: London, Matthiesen Gallery, *Still Life and Flower Paintings*, 1938, no. 98; Toledo, Toledo Museum of Art, *Five Centuries of Realism*, 1939; New York World's Fair, *Masterpieces of Art*, 1940, no. 123; New London, Lyman Allyn Museum, *Spanish Paintings of the XVI to XX Centuries*, 1948, no. 14; London, Royal Academy, *European Masters of the Eighteenth Century*, 1954, no. 353; Paris, Galerie André Weil, *Nature Morte*, 1960, no. 41; New York, Metropolitan Museum of Art, *Masterpieces of Painting from the Museum of Fine Arts, Boston*, 1970, no. 31; Raleigh, North Carolina Museum of Art, *Luis Meléndez: Spanish Still-Life Painter of the Eighteenth Century*, January 12 - March 10, 1985 and Dallas, Meadows Museum of Art and University Gallery, March 22 - May 19, 1985, no. 21; London, National Gallery, *Painting in Spain during the Later Eighteenth Century*, March 14 - May 31, 1989, no. 21.

Literature: J. A. Gaya Nuño, *Pintura española fuera de España* (Madrid, 1958), p. 235 ill.; George Kubler and Martin Soria, *Art and Architecture in Spain and Portugal and Their American Dominions* (Baltimore, 1959), p. 299 ill.; Juan J. Luna, *Luis Meléndez* (Madrid, Museo del Prado, 1982), p. 36 ill.; Eleanor Tufts, "Luis Meléndez: Still-Life Painter sans pareil," *Gazette des Beaux-Arts* 100/1366 (November 1982), p. 178-179 ill.; E. Tufts, *Luis Meléndez: Eighteenth-Century Master of the Spanish Still Life with a Catalogue Raisonné* (Columbia MO, 1985), no. 58; Murphy 1985, p. 187 ill.

Along with *Still Life with Melon and Pears* (cat. 28), this canvas is among Meléndez's largest works. In the foreground are cheese, onions, tomatoes, and bread, and in the middle distance stands a bowl containing a large ham, cucumber, a knife, and sausage next to an earthenware pitcher. In the background, Meléndez has painted figs resting on a stack of plates and a bottle with a window reflected on its neck.

Meléndez, considered the greatest eighteenth-century Spanish still-life painter, studied with his father, Francisco Meléndez, and for six years assisted Jean-Michel van Loo, the principal painter to the Court of Philip V, with portraits of the royal family. He ranked first in his class at the Royal Academy of San Fernando in 1745, but his father's public quarrel with the institution he helped found led to his son's expulsion in 1748. After spending sev-eral years in Rome and Naples, Meléndez returned to Madrid to help his father illustrate choirbooks for the Royal Chapel. The inanimate objects that he painted in the borders of the illustrated pages augur the penchant for firmly constructed forms that characterized his still lifes. Although forty-five of his still lifes hung in the king's dining room at the royal residence at Aranjuez by 1818,[1] both his petitions (1760 and 1772) to serve as court painter to Charles III were rejected.[2]

Meléndez painted most of his still lifes, which comprise the majority of his extant works, in the last twenty years of his life. Expertly modeled and crisply contoured forms, usually lit from the left distinguish his *bodegones*, a word originally designating a lower-class restaurant but applied to pictures of food by 1700. In this, as in many of his canvases, Meléndez prefers round objects placed on a surface which is slightly tipped to afford a clear view of each object. Despite the size and profusion of his objects – he usually minimized the amount of empty space in his canvases – his works convey a sense of balance and measure, due, in large part, to his insistently geometric designs. Meléndez's preference for humble objects in spare settings evokes comparisons with Chardin (cats. 29-30), but unlike his French contemporary who painted some objects distinctively while sketchily indicating others, Meléndez depicts each form with the same degree of clarity.

Although in some canvases Meléndez did not indicate the function of the food and vessels, here the knife in the bowl, the utensil in the pitcher, and the combination of meat, vegetables, and cheese point to the preparation and consumption of a meal. At the same time, however, Meléndez distances the scene from everyday life. Though the selection and placement intimate a story and function for the objects, it proves difficult to conceive a human intruding upon this perfectly ordered world, which has been rendered with the grandeur and respect normally accorded more elevated subjects like the human figure.

1. Eleanor Tufts, "Luis Meléndez, Documents on His Life and Work," *Art Bulletin* 54/1 (March 1972), p. 65.

2. The best source of information on Meléndez is Eleanor Tufts, *Luis Meléndez, Eighteenth-Century Master of the Spanish Still Life with a Catalogue Raisonné* (Columbia MO, 1985).

28 (plate 11, page 27)

L U I S M E L É N D E Z

(1716 Naples – 1780 Madrid)

Still Life with Melon and Pears

Oil on canvas, 25⅛ x 33½ in. (63.8 x 85 cm)
Signed lower right: *EG.Lˢ.M�z.Dᵒsᵀᵒ.Pᶜ.* [Egidius
Ludovicus Meléndez de Ribera Durazo y Santo
Padre]
Margaret Curry Wyman Fund. 39.41

Provenance: R.F. Ratcliff collection, England; Matthiesen
Gallery, London.

Exhibitions: London, Matthiesen Gallery, *Still Life and
Flower Paintings*, 1938, p. 97; Winchester MA, Winchester
Art Association, February 1946; Cambridge, Fogg Art
Museum, *Still Life Exhibition*, April - May 1947; New Lon-
don CT, Lyman Allyn Museum, *Spanish Paintings of the
XVI to XX Centuries*, March - April 1948, no. 14; Paris,
Musée de L'Orangerie, *La Nature Morte*, April-June 1952,
no. 84; London, Royal Academy, *European Masters of the
Eighteenth Century*, November 1954 - February 1955, no.
357; Zurich, Kunsthaus, *Unbekannte Schönheit*, June - July
1956, no. 170; Allentown PA, Allentown Art Museum,
Four Centuries of Still Life, December 12, 1959 - January 31,
1960, no. 23; Dallas, Meadows Museum of Art and Uni-
versity Gallery, *Goya and the Art of His Time*, December
1982 - February 1983, no. I-37; Raleigh, North Carolina
Museum of Art, *Luis Meléndez: Spanish Still Life Painter of
the Eighteenth Century*, January 12 - March 10, 1985 and
Dallas, Meadows Museum of Art and University Gallery,
March 22 - May 19, 1985, New York, National Academy
of Design, May 30 - September 1, 1985, no. 22; London,
National Gallery, *Painting in Spain during the Later Eigh-
teenth Century*, March 14 - May 31, 1989, no. 22.

Literature: Martin Soria, "Firmas de Luis Egidio Melén-
dez (Menendez)," *Archivo Espanol de Arte* 21/83 (1948), p.
201; Jacques Lassaigne, *Spanish Painting from Velásquez to
Picasso* (Geneva, 1952), p. 75; Allan Gwynne-Jones, *Intro-
duction to Still Life* (London, 1954), pp. 71-72 ill.; Georges
de Lastic Saint-Jal, "Rustic Fare for the Spanish Court,"
in Georges and Rosamond Bernier eds., *The Selective Eye*
(New York, 1955), p. 42; Alfonso Pinto, "La obra maestra
desconocida," *Goya* 14 (1956), pp. 122-123; J. A. Gaya
Nuño, *Pintura española fuera de España* (Madrid, 1958), p.
234; Charles Sterling, *Still Life Painting* (New York, 1959),
p. 114 ill.; Giuseppe de Logu, *Natura morta italiana* (Berg-
amo, 1962), p. 199 ill.; Terisio Pignatti, *La Pittura del sette-
cento in Inghilterra e in Spagna* (Milan, 1966), pl. 30;
Michael Levey, *Seventeenth and Eighteenth Century Painting*
(New York, 1968), p. 186 ill.; Eleanor Tufts, "Luis Melén-
dez: Still-Life Painter sans pareil" *Gazette des Beaux-Arts*
100/1366 (November 1982), p. 156; Juan J. Luna, *Luis
Meléndez, Bodegonista espanol del siglo XVIII* (Madrid, Pra-
do Museum, 1982), p. 36 ill.; Enrique Garcia-Harraiz,
"Las Tres Grande Exposiciones de Arte Espanol en Dal-
las-Forth Worth," *Goya* 172 (1983), pp. 253-254; Eleanor
Tufts, *Luis Meléndez, Eighteenth-Century Master of the
Spanish Still Life with a Catalogue Raisonné* (Columbia
MO, 1985), no. 59; Murphy 1985, p. 187 ill.

A large melon and a group of pears fill the
foreground space. A reed basket in the mid-
dleground containing a piece of flat bread

and a napkin sits next to a covered earthen-
ware bowl and before a small wooden barrel
supporting a spoon. To the left, a bottle of
wine cools in a cork bucket.

It is not known what specifically motivat-
ed Meléndez's turn to still life, but the bril-
liant examples of such seventeenth-century
masters as Francisco Zurbarán, Juan Sánchez
Cotán, Juan van der Hamen, and Blas de
Ledesma were, no doubt, influential.[1]
Meléndez's fascination with the things of
everyday life has also been linked to the
prominence of similar themes in contempo-
rary Spanish theater and music, and his pre-
cise rendering of pieces of fruit and vegeta-
bles to the interest in botany in eighteenth-
century Spain.[2]

Meléndez's robust realism and earthy
palette contrast with the style of many of his
contemporaries who preferred more painter-
ly forms and delicate colors, following the
examples of the French and Italian artists
favored by the Spanish court. Treating each
object individually, he savored its unique
shape, features, and textures – the varied col-
ors composing the burnished skin of the
pears, the mottled surface of the pottery, and
the tough webbed rind of the melon. So
great is Meléndez's commitment to render-
ing the character of his objects that he
records the knicks and knots in the wooden
table, the chips on the rim of the bowl, and
the blemishes that mar the pears. Meléndez's
still lifes celebrate fertility and natural abun-
dance, but, paradoxically, he painted many of
them at a time when a series of bad harvests
had produced severe food shortages in
Madrid.[3] The plentiful array of foods was
also at odds with the realities of the painter's
own life. In his petition to serve as court
painter in 1772, he wrote that he had no mon-
ey to feed himself and claimed his brush as
his only asset,[4] and twenty days before he
died, he filed a declaration of poverty.[5]

1. On the various sources of Melendez's work, see
Eleanor Tufts, *Luis Meléndez, Eighteenth-Century Master of
the Spanish Still Life with a Catalogue Raisonné* (Columbia
MO, 1985), pp. 36-40.

2. Ibid., pp. 23-24.

3. Juan J. Luna, *Luis Meléndez* (Dallas, Meadows Art
Museum, 1985), p. 23.

4. George Kubler and Martin Soria, *Art and Architecture
in Spain and Portugal and their American Dominions* (Balti-
more, 1959) p. 299.

5. Tufts, pp. 216-217.

29 (plate 12, page 28)

J E A N S I M É O N C H A R D I N

(1699 Paris – 1779 Paris)

Kitchen Table, 1755

Oil on canvas, 15⅝ x 18¾ in. (39.8 x 47.5 cm)
Signed and dated at the lower right:
chardin/17[55?]
Gift of Mrs. Peter Chardon Brooks. 80.512

Provenance: Ange-Laurent de La Live de Jully by 1757;
Johann Anton de Peters, Paris and Cologne, 1779; Estate
sale of Mme. Johann Anton de Peters, Paris, March 9,
1779, no. 104 (bought in); J. A. Peters; Sale, Paris, Novem-
ber 5, 1787, no. 165 (bought in); M. du Charteaux et
Salavet; Sale, Paris, May 2, 1791, no. 146; Mrs. Peter
Chardon Brooks, Boston, by 1880.

Exhibitions: Paris, Salon, 1757, no. 33; Paris, Salon de la
Correspondence, 1783, no. 80; Cambridge, Fogg Art
Museum, *Still Life: Loan Exhibition Arranged by Students*,
April 4 - 30, 1931, no. 9; Toronto, Art Gallery of Ontario,
*Loan Exhibition of Paintings Celebrating the Opening of the
Margaret Eaton Gallery and the East Gallery*, no. 6; New
York, Marie Harriman Gallery, *Chardin and the Modern
Still Life*, 1936, no. 7; Milwaukee, Milwaukee Art Insti-
tute, *Still Life Painting since 1470* and Cincinnati, Cincin-
nati Art Museum, 1956, no. 13; Paris, Grand Palais,
Chardin, 1699-1779, January 29 - April 30, 1979 and Cleve-
land, Cleveland Museum of Art, June 6 - August 12, 1979,
Boston, Museum of Fine Arts, September 11 - November
19, 1979, no. 102.

Literature: Museum of Fine Arts, *Fifth Annual Report*
(Boston, 1881), p. 8; Downes, *Atlantic Monthly* 62 (Octo-
ber 1888), p. 501; H. Furst, *Chardin* (London, 1911), p. 134;
J. Guiffrey, "Tableaux français conservés au musée de
Boston et dans quelques collections de cette ville,"
Archives de l'art français 7 (1913), pp. 540-541; *Catalogue of
Paintings* (Boston, Museum of Fine Arts, 1921), p. 79, no.
190; G. Wildenstein, *Chardin* (Paris, 1933), p. 228, no. 949;
R. H. Ives Gammell, *Twilight of Painting* (New York,
1946), pl. 45; B. Denvir, *Chardin* (Paris, 1950), pl. 5; H.
Fussiner, "Organic Integration in Cézanne's Painting,"
Art Journal 15/4 (summer 1956), pp. 303-304, 310; M. Faré,
*La Nature morte en France: son histoire et son évolution du
XVIIe au XXe siècle*, (Geneva, 1962), vol. 1, p. 164; G.
Wildenstein, *Chardin* (Zurich, 1963), p. 158, no. 120, fig.
53; W. M. Whitehill, *Museum of Fine Arts Boston: A Centen-
nial History*, (Cambridge, 1970) vol. 1, p. 77 ill.; B. Scott,
"La Live de Jully," *Apollo* 97/131 (January 1973), p. 75; M.
and F. Faré, *La vie silencieuse en France* (Fribourg, 1976), p.
158; M. Fried, "Anthony Caro's Table Sculptures," *Arts
Magazine* 51/7 (March 1977), p. 97; Pierre Rosenberg, *Tout
l'oeuvre peint de Chardin* (Paris, 1983), p. 105 ill.; Pierre
Rosenberg, *Chardin: New Thoughts* (Lawrence, 1983), p.
29 fig. 13, p. 31; Philip Conisbee, *Chardin* (Lewisburg,
1985), pp. 193-195 ill.; R. Lack, ed., *Realism in Revolution:
The Art of the Boston School* (Dallas, 1985), p. 151 ill.; Mur-
phy 1985, p. 49 ill.; C. B. Bailey, *Ange-Laurent de La Live de
Jully* (New York, 1988), pp. 22-23; Norman Bryson, "In
Medusa's Gaze," in *In Medusa's Gaze: Still-Life Paintings
from Upstate New York Museums* (Rochester, University of
Rochester Memorial Art Gallery, 1991), p. 19 ill.

In the late 1740s, Chardin returned to still life,
the genre for which he became most famous,

after a hiatus of almost twenty years. A retrospective painting, *Kitchen Table* executed in 1755 displays the simple domestic objects typical of Chardin's still lifes in the 1720s and 1730s: a casserole, pieces of meat, salt shaker, copper pot and ladle, earthenware pitcher, and mortar and pestle, all sitting on a thick wooden table. Chardin, who often conceived his still lifes as pairs, painted *The Butler's Pantry Table* (Carcassone, Musée des Beaux-Arts) in 1756 to accompany *Kitchen Table*. Although the prepared foods and decorative vessels of the second canvas better represent the still lifes of the 1750s, the style of *Kitchen Table* belongs to that decade. The objects emerge from a dark ground, and, lit by a beam of light, alternate with voids of space. The brushwork is loose and relaxed.

Both *Kitchen Table* and the *Butler's Pantry* were bought by Ange-Laurent de La Live de Jully, one of the first individuals in France to collect French paintings, including some twenty still lifes. A friend of Voltaire and Rousseau and member of the Academy, La Live de Jully exhibited the two canvases in the Salon of 1757.[1] Together, the pictures contrasted preparation and presentation, the downstairs realm of the servant and the upstairs world of the master.

The still lifes of the seventeenth-century Dutch painters, which were avidly collected in France during the eighteenth century, shaped Chardin's approach to the genre. Unlike many Dutch still lifes, however, his objects do not appear as if they have been deliberately organized for viewing, but as if they have been momentarily left by the cook who will soon return to them. While they await a human presence, a kind of comraderie develops between them. We sense as Proust did the "life of inanimate objects."[2] The handles of the pot and pitcher echo one another; the shank of meat seems to share the towel's fatigue; the pitcher sends its reflection to the surface of the copper cauldron.

The Goncourts, who did much to rehabilitate Chardin's reputation in the nineteenth century, wrote, "He scarcely seems to trouble to compose his picture; he simply flings upon it the bare truth that he finds around him."[3] Yet Chardin's works are not uncomposed records of what he saw or examples of unproblematic realism or of painting as a purely mimetic enterprise. For Chardin not only appreciated these simple objects, but he also loved the texture and colors of paint.

There is a duality in his works. They record "real life," but never conceal their artifice. As one approaches the canvas, the objects seem to evaporate into a field of painted marks and as one moves away the strokes unite to describe forms and space. The edges and surfaces of shapes, moreover, are described with varying degrees of resolution or distinctness. Chardin's means, however, always exist in quiet complicity with the prosaic objects they describe, never overwhelming the harmony the painter so obviously valued in the domestic routines of the household space.[4]

1. On the commission and exhibition of these works at the Salon, see Pierre Rosenberg, *Chardin, 1699 - 1779* (Cleveland, Cleveland Museum of Art, 1979), pp. 305-306. On La Live de Jully, see B. Scott, "La Live de Jully," *Apollo* 97/131 (January 1973), pp. 72-77 and C. B. Bailey, *Ange-Laurent de La Live de Jully* (New York, 1988), pp. 22-23.

2. Marcel Proust, "Chardin and Rembrandt," in *Against Sainte-Beuve and Other Essays*, trans. John Sturrock (London, 1988), p. 129. Proust wrote the essay around 1895 but it was published posthumously.

3. Edmond and Jules de Goncourt, *French XVIII Century Painters*, trans. Rubin Ironside (New York, 1948), p. 116.

4. For an interesting appraisal of Chardin's relation to feminine labor and spaces and to household objects and routines, see Norman Bryson, *Looking at the Overlooked: Four Essays in Still-Life Painting* (Cambridge, 1990), pp. 166-170.

30 (plate 13, page 28)

JEAN SIMÉON CHARDIN

(1699 Paris – 1779 Paris)

Still Life with Tea Pot, Grapes, Chestnuts, and a Pear

Oil on canvas, 12⅝ x 15¾ in. (32 x 40 cm)
Signed and dated at lower left: *chardin/ 17 [64?]*
Gift of Martin Brimmer. 83.177

Provenance: Signol Collection; Sale Paris, April 1 - 3, 1878, no. 45; Etienne Martin, Baron de Beurnonville, Paris; Sale, Paris, May 21, 1883, no. 7; Martin Brimmer, Boston.

Exhibitions: New York, Metropolitan Museum of Art, *French Painting and Sculpture of the Eighteenth Century*, November 6, 1935 - January 5, 1936, no. 23; New York, Arnold Seligmann-Helft Galleries, *French Still Life from Chardin to Cézanne*, 1947, no. 11; New York, Metropolitan Museum of Art, *100 Paintings from the Boston Museum*, May 29 - July 26, 1970, no. 37; Paris, Grand Palais, *Chardin, 1699-1779*, January 29 - April 30, 1979 and Cleveland, Cleveland Museum of Art, June 6 - August 12, 1979, Boston, Museum of Fine Arts, September 11 - November 19, 1979, no. 119; Japan 1983 no. 24; Boston, Museum of Fine Arts, *The Great Boston Collectors: Paintings from the Museum of Fine Arts, Boston*, February 13 - June 2, 1985, no. 13.

Literature: P. Eudel, *L'Hôtel Drouot et la curiosité* (Paris, 1884), p. 334; Downes, *Atlantic Monthly* 62 (October 188), p. 501; H. Furst, *Chardin* (London, 1911), p. 134; J. Guiffrey, "Tableaux français conservés au musée de Boston et dans quelques collections de cette ville," *Archives de l'art français* 7, (1913), pp. 540-541; *Catalogue of Paintings* (Boston, Museum of Fine Arts, 1921), p. 79 ill.; *Selected Oil and Tempera Paintings and Three Pastels* (Boston, Museum of Fine Arts, 1932), ill. (np); G. Wildenstein, *Chardin* (Paris, 1933), p. 221, no. 870; M. Faré, *La Nature morte en France: son histoire et son évolution du XVIIe au XXe siècle*, (Geneva, 1962), vol. 1, p. 164; G. Wildenstein, *Chardin* (Zurich, 1963), pp. 208-209, no. 335; W. M. Whitehill, *Museum of Fine Arts, Boston: A Centennial History*, (Cambridge, 1970), vol. 1, pp. 77-78 ill.; Pierre Rosenberg, *Tout l'oeuvre peint de Chardin* (Paris, 1983), p. 108, no. 168; Philip Conisbee, *Chardin* (Lewisburg, 1985), pp. 67-68, ill.; Murphy 1985, p. 49 ill.

Although abraded, the date of the work appears to be 1764. On the replica of the Boston canvas (Algiers, Musée National des Beaux-Arts d'Alger)[1] the date 1764 is legible. Chardin pared many of his compositions down to a few objects in his later still lifes.[2] Here, he studied a white English faience tea pot similar to one that he depicted in a still life of 1750,[3] a cluster of grapes, a pear, and a few chestnuts to the left, placed on a plain surface before a dark, nondescript background. A soft hazy light washes gently over the objects revealing their forms and textures. Why Chardin simplified many of his later still lifes is not known, though they offered respite perhaps from the complicated decorative projects he undertook in the 1760s.[4]

Pierre Rosenberg has aptly observed that the later still lifes avoid temporal or anecdotal qualities.[5] Compared to his compositions in *Kitchen Table* (cat. 29) and the *Butler's Pantry*, Chardin does not choose objects or arrange them to suggest the preparation, consumption, or aftermath of a meal. Nor does he specify a particular moment in a sequence of events or a determinate space – the kitchen or dining room, for example. The setting is anonymous. Still, the objects remain visually tied, and true to Chardin's career-long fascination with animating the inanimate, bound almost empathically to one another. The pear and pot share bulging squat bodies, and the stems of the grapes and pear lean towards the vessel's spout. Though the objects and arrangement deny a human presence, Chardin places the fruit and teapot close to the viewer, draping the grapes over the table so that they appear to hang in the spectator's space.

Chardin was secretive about his working methods, but it seems likely that he painted his still lifes directly from the objects

arranged in his studio under artificial light, which, unlike variable, natural light, allowed him to explore reflections and transparencies of color at leisure, important for a painter known to work slowly and meticulously, pondering and ceaselessly reworking his compositions. As Chardin replied to a client who was frustrated by his slow pace, "I am not hurrying, because I have developed a habit of not leaving my works until, in my view, I see in them nothing more to be desired, and I shall be stricter than ever on this point."[6] (The investment of time also added perhaps to the works' cachet.) As in other later works, the brushstrokes merge, the pigments are thin, and the facture less visible when compared to the impasto surfaces of the still lifes of the 1720s and 1730s. Yet as the patch of brilliant orange brushed on the pear attests, Chardin's love of paint for paint's sake never waned.

1. Illustrated in Pierre Rosenberg, *Chardin 1699-1779* (Cleveland, Cleveland Museum of Art, 1979), p. 330.

2. The last known still life dates to 1768.

3. *White Teapot with White and Red Grapes, Apple, Chestnuts, Knife, and Bottle* (Paris, Private Collection). For an illustration see Pierre Rosenberg, *Tout l'oeuvre peint de Chardin* (Paris, 1983), no. 150.

4. On these projects for the Château de Choisy, the Russian Academy of Fine Arts, and the Château de Bellevue, see Pierre Rosenberg, *Chardin 1699-1779*, pp. 337-351.

5. Rosenberg, *Chardin 1699-1779*, p. 331.

6. Chardin was replying to Luise Ultrike of Sweden who had commissioned two domestic interiors in 1745-46. Quoted in Philip Conisbee, *Chardin* (Lewisburg, 1985), p. 88. On Chardin's slow pace also see pp. 59, 84-85, 115, 165. Chardin's painstaking methods were noted by his contemporaries Charles-Nicolas Cochin, Pierre-Jean Mariette, and Denis Diderot.

31 (plate 15, page 30)
JEAN-FRANÇOIS MILLET
(1814 Gruchy – 1875 Barbizon)

Pears

Oil on panel, 7¼ x 10 in. (18.5 x 25.5 cm)
Signed lower right: *J. F. Millet*
Gift of Quincy Adams Shaw through Quincy A. Shaw, Jr., and Mrs. Marian Shaw Haughton. 17.1519

Provenance: Mme. J.-F. Millet, Barbizon; Quincy Adams Shaw, Boston.

Exhibitions: Boston, Museum of Fine Arts, *Quincy Adams Shaw Collection*, 1918, no. 22; Boston, Museum of Fine Arts, *Jean-François Millet*, March 28 - July 1, 1984, no. 110.

Literature: Wyatt Eaton, "Recollections of Jean-François Millet with Some Account of His Drawings for His Children and Grandchildren," *Century* 38 (May 1889), p. 92; Jean Guiffrey, "Tableaux français conservés au musée de Boston et dans quelques collections de cette ville," *Archives de l'art français* n.s. 7 (1913), p. 547; Etienne Moreau-Nélaton, *Millet raconté par lui-même*, (Paris, 1921), vol. 3, p. 17, fig. 242; Carl Georg Heise, "Amerikanische Museen," *Kunst und Kunstler* 23/6 (March 1925), p. 225 ill.; Michel Faré, *La Nature morte en France*, (Geneva, 1962) vol. 1, p. 265 and vol. 2, no. 293 ill.; Griselda Pollock, *Millet* (London, 1977), p. 77; Murphy 1985, p. 199 ill.

Pears, one of only four still-life paintings by Millet, pays homage to Jean Siméon Chardin (see cats. 29-30) who inspired many of Millet's figure scenes of the late 1840s and early 1850s. Referring to *Pears* in a January 1867 letter to his friend, patron, and biographer, Alfred Sensier, Millet indicated that he had finished the picture sometime in the early to mid-1860s,[1] the period when the revival of interest in Chardin's work was at its height in Paris.[2] In its handling and arrangement, *Pears* resembles the central passage in Chardin's *Three Pears, Walnuts, Glass of Wine, and Knife* (Paris, Musée du Louvre), which belonged to Dr. Louis La Caze, who often opened his collection to artists before he donated it to the Louvre in 1869. Millet simplified Chardin's canvas, eliminating the table edge, nuts, and wineglass, and brought the three pieces of fruit forward so that they become the focal point of the canvas. The light shines brilliantly off the richly painted pieces of fruit which emerge from a dark ground. Firmly constructed, they achieve an almost sculptural effect.

The humble pieces of fruit are appropriate objects for an artist who devoted much of his life to depicting the land and peasants of rural Barbizon. As Robert Herbert has observed, an artist's choice of still-life objects often reflects his vision of society, making it as difficult to imagine Edouard Manet depicting potatoes as Millet painting an apératif.[3] *Pears* was special to Millet who refused in the 1860s to sell it to an American collector, possibly Quincy Adams Shaw, a Boston businessman whose collection of Millet paintings was the largest in late nineteenth-century America.[4] After Millet's death, Shaw bought the painting from the artist's widow.[5] Despite its modest size and unpretentious subject, the work exerts an indisputable power. It moved Wyatt Eaton, a Boston art student, to write in 1889, "I found all the tones of a landscape, in the twisted stems I seemed to see the

weather worn tree, and the modelling of the fruit was studied and rendered with the same interest that he would have given to a hill or a mountain or to the human body."[6] Meditating on Millet's painting generally, Eaton added, "One must make use of the trivial to express the sublime."[7]

1. Letter from Millet to Alfred Sensier, January 7, 1867, quoted in Etienne Moreau-Nélaton, *Millet raconté par lui-même* (Paris, 1921), vol. 3, p. 17.

2. John W. McCoubrey, "The Revival of Chardin in French Still-life Painting, 1850-1870," *Art Bulletin* 46 (March 1964), pp. 39-53 and Gabriel P. Weisberg, *Chardin and the Still-Life Tradition in France* (Cleveland, Cleveland Museum of Art, 1979), passim.

3. Robert W. Herbert, *Jean-François Millet* (Paris, Grand Palais, 1975), p. 231.

4. On Millet's refusal to sell the painting and the possibility that the American collector was Shaw, see Alexandra R. Murphy, *Jean-François Millet* (Boston, Museum of Fine Arts, 1984), p. xii.

5. Ibid.

6. Wyatt Eaton, "Recollections of J. F. Millet with Some Account of His Drawings for His Children and Grandchildren," *Century* 38 (May 1889), p. 92.

7. Ibid.

32 and **33**

JEAN-FRANÇOIS MILLET
Primroses

Pastel on green-brown wove paper
15⅞ x 18⅞ in. (40.2 x 47.8 cm) – design
17⅛ x 20⅜ in. (43.4 x 51.8 cm) – support
Signed lower right:: *J.F. Millet*
Gift of Quincy A. Shaw through Quincy A. Shaw, Jr., and Mrs. Marian Shaw Haughton. 17.1523

Provenance: Commissioned from the artist by Emile Gavet; Gavet Sale, Hôtel Drouot, Paris, June 11 - 12, 1875, no. 47; bought by Détrimont, probably for Quincy Adams Shaw, Boston.

Exhibitions: Boston, Museum of Fine Arts, *Quincy Adams Shaw Collection*, 1918, no. 49; Boston, Museum of Fine Arts, *Barbizon Revisited*, 1962, no. 75; Paris, Grand Palais, *Jean-François Millet*, October 1 - January 5, 1976, no. 197 and London, Hayward Gallery, January 20 - March 20, 1976, no. 115; Boston, Museum of Fine Arts, *Jean-François Millet*, March 28 - July 1, 1984, no. 135.

Literature: Edward Strahan, *The Art Treasures of America*, (Philadelphia, 1879), vol. 3, p. 87; "Greta's Boston Letter," *Art Amateur* 5/4 (September 1881), p. 72; Jean Guiffrey, "Tableaux français conservés au musée de Boston et dans quelques collections de cette ville," *Archives de l'art français* 7 (1913), p. 547; "The Quincy Adams Shaw Collection," *Museum of Fine Arts Bulletin* 16 (April 1918), p. 18 ill.; Elisabeth Cary Luther, "Millet's Pastels at the Museum of Fine Arts, Boston," *American Magazine of Art* 9 (May 1918), p. 266; Etienne Moreau-Nélaton, *Millet raconté par lui-même*, (Paris, 1921), vol. 3, p. 18, fig. 237; Dario Durbé and Anna Maria Damigella, *La Scuola di Barbizon* (Milan, 1969), p. 22, pl. LX; Griselda Pollock, *Millet* (London, 1977), p. 77 ill.; Yuzo Iida, *J.-F. Millet* (Tokyo, 1979), p. 130; Murphy 1985, p. 200 ill.

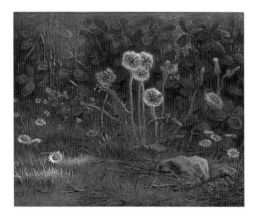

Dandelions

Pastel on buff wove paper
15⅞ x 19¾ in. (40.2 x 50.2 cm) – design
16 7/8 x 20 7/8 in. (43 x 52.9 cm) – support
Signed lower right: *J. F. Millet*
Gift of Quincy Adams Shaw through Quincy A. Shaw, Jr., and Mrs. Marian Shaw Haughton. 17.1524

Provenance: Commissioned from the artist by Emile Gavet; Gavet Sale, Hôtel Drouot, Paris, June 11 - 12, 1875, bought by Carlin; Quincy Adams Shaw, Boston.

Exhibitions: Paris, Rue St. Georges 7, *Dessins de Millet provenant de la collection de M.G.*, 1875, no. 46; Boston, Museum of Fine Arts, *Quincy Adams Shaw Collection*, 1918, no. 48; Philadelphia, Philadelphia Museum of Art, *Flower Painting*, 1963; Boston, Museum of Fine Arts, *Jean-François Millet*, March 28 - July 1, 1984, no. 136; Tokyo, Takashimaya Art Gallery, *Jean-François Millet*, August 9 - September 30, 1984 and Sapporo, Hokkaido Museum of Modern Art, October 9 - November 11, 1984, Yamaguchi, The Yamaguchi Prefectural Museum of Art, November 22 - December 23, 1984, Nagoya, Matsuzakaya, January 4 - January 29, 1985, Kyoto, Kyoto Prefectural Museum of Art, April 23 - May 19, 1985, no. 71; New York, IBM Gallery of Science and Art, *Jean-François Millet*, June 11 - July 27, 1985.

Literature: Philippe Burty, *Maîtres et petits maîtres* (Paris, 1877), p. 308; Edward Strahan, *Art Treasures of America*, (Philadelphia, 1879), vol. 3, p. 87; "Greta's Boston Letter," *Art Amateur* 5/4 (September 1881), p. 72; Jean Guiffrey, "Tableaux français conservés au musée de Boston et dans quelques collections de cette ville," *Archives de l'art français* 7 (1913), p. 547; Elisabeth Cary Luther, "Millet's Pastels at the Museum of Fine Arts, Boston," *American Magazine of Art* 9 (May 1918), p. 266; Etienne Moreau-Nélaton, *Millet raconté par lui-même*, (Paris, 1921), vol. 3, p. 18, fig. 239; Murphy 1985, p. 200 ill.

Millet made only four flowerpieces in his career, executing the first three – *Primroses*, *Dandelions*, and *Daffodils* (Hamburg, Kunstmuseum) – in 1867.[1] Most flowerpieces display the blossoms in vases. Millet, however, chose to depict them *in situ* from a closely observed viewpoint, creating images of the forest floor that are reminiscent of the *bosstilleven* of such seventeenth-century Dutch painters as Otto Marseus van Schrieck (see cat. 13).[2] In both pastels, Millet strikes a balance between science and poetry, not only describing what is immediately visible but also suggesting the atmosphere – the light, temperature, and dampness – of these small sections of the forest and meadow floor. The pastels reveal, as Griselda Pollock observes, Millet's "simple joy in nature's beauty," an aspect of his work that is often overlooked.[3] Millet's appreciation for seemingly insignificant flora and fauna emerges not only in these two pastels, but also in two statements that he made. On one occasion, he reportedly said, "There are those who say that I deny the charms of the countryside; but I find there more than charm, infinite splendors... I see very clearly the haloes around the dandelions, and the sunlight that shines down there...."[4] In 1865, he wrote to Emile Gavet, the Parisian architect who commissioned many pastels from him including *Primroses* and *Dandelions*, "We have had some superb effects of fog and hoarfrost so fairy-like it surpasses all imagination. The forest was marvellously beautiful in this attire, but I am not sure the most modest objects, the bushes and briars, tufts of grass, and little twigs of all kinds were not, in their way, the most beautiful of all. It seems as if Nature wished to give them a chance to show that these poor despised things are inferior to nothing in God's creation."[5]

Millet returned to pastel in the 1860s after abandoning the medium in the mid-1840s when he shifted from a rococo to a realist style. In the 1850s, he executed most of his drawings in black crayon. He began to introduce touches of color in 1858-59, around the time that Alfred Sensier, his agent in Paris, suggested that he brighten his works to make them more attractive to private collectors.[6]

1. The fourth picture, a pastel in the Cabinet des Dessins of the Louvre, dates to 1871-74 and displays a bouquet of daisies in a stoneware jar along with a portrait of his daughter Marguerite.

The flowers depicted in *Primroses* are not the primroses known in the United States and in Great Britain, but a related European flower, the *Primula officinalis*, which is called a primrose or cowslip. See Alexandra Murphy, *Millet* (Boston, Musem of Fine Arts, 1984), p. 197 n. 1.

2. Millet as is well known was a serious student of seventeenth-century Dutch painting. A number of sources have been suggested for *Primroses* and *Dandelions*. Théophile Silvestre compared *Dandelions* to drawings by Dürer, specifically *Large Turf* (Vienna, Albertina), but as Alexandra Murphy notes, Millet's looser handling differs from Dürer's precise drawing and even lighting. See Murphy, p. 197. Murphy does not cite the source for Silvestre's comparison. She herself suggests that Millet may have been inspired by the faience plates of the sixteenth-century artisan Bernard de Palissey; Griselda Pollock has compared *Primroses* to the works of the English pre-Raphaelites, especially John Everett Millais's *Ophelia* (London, Tate Gallery), which was exhibited in France in 1855. See Griselda Pollock, *Millet* (London, 1977), p. 77.

3. Pollock, p. 77.

4. Quoted in Pollock, p. 77.

5. Letter from Millet to Gavet, December 28, 1865, quoted in Murphy, p. 197.

6. Ibid., p. 125.

34 (plate 16, page 31)
Jean Désiré Gustave Courbet
(1819 Ornans – 1877 La Tour de Peilz)

Hollyhocks in a Copper Bowl, 1872

Oil on canvas, 23⅝ x 19½ in. (60 x 49 cm)
Signed and dated lower left: *72 G. Courbet*.
Bequest of John T. Spaulding. 48.530

Provenance: Reinach Collection (?); Galerie Bernheim-Jeune, Paris; Levesque Collection, Paris; Pearson Collection, Paris; sale at Cassirer, Berlin, October 18, 1927, no. 15; Thannhauser Collection, Lucerne; John T. Spaulding, Boston.

Exhibitions: Paris, Galerie H. Fiquet, *Quatorze oeuvres de Courbet*, November - December, 1926, no. 3; Copenhagen, Dansk Kunstmuseum, *Fransk Malerkunst fra det 19nde aarhundrede*, 1914, no. 45; Cambridge, Fogg Art Museum, *Exhibition of French Painting of the Nineteenth and Twentieth Centuries*, March 6 - April 6, 1929, no. 17; Boston, Museum of Fine Arts, *Paintings, Drawings, and Prints from Private Collections in New England*, June 9 - September 10,

1939, no. 30; Boston, Museum of Fine Arts, *The Collections of John Taylor Spaulding 1870-1948*, May 26 - November 7, 1948, no. 14; Cambridge, Fogg Art Museum, 1949; Venice, *Courbet at the XXVII Biennale di Venezia*, 1954, no. 47; Lyon, Musée de Lyon, *Courbet*, 1954, no. 52; New York, Rosenberg Gallery, *Paintings by Gustave Courbet*, January 16 - February 11, 1956, no. 17; Santa Barbara Museum of Art, *Fruits and Flowers in Painting*, August 12 - September 14, 1958; Philadelphia, Philadelphia Museum of Art, *Courbet*, December 17, 1959-February 14, 1960, and Boston, Museum of Fine Arts, February 26 - April 14, 1960, no. 81; Berne, Kunstmuseum, *Gustave Courbet*, September 22 - November 19, 1962, no. 71; Paris, Grand Palais, *Gustave Courbet, 1819-1877*, October 1, 1977 - January 2, 1978, no. 116 and London, Arts Council of Great Britain at the Royal Academy of Arts, January 19 - March 19, 1978; Japan 1989, no. 42; Japan 1992, no. 15.

Literature: Georges Riat, *Gustave Courbet, peintre* (Paris, 1906), p. 330; George H. Edgell, *French Painters in the Museum of Fine Arts: Corot to Utrillo* (Boston, 1949), p. 25 ill.; Charles Léger, *Courbet* (Paris, 1929), pp. 165, 168; Douglas Cooper, "Reflections on the Venice Biennale," *The Burlington Magazine* 96/619 (October 1954), p. 322; Robert Fernier, *La Vie et l'oeuvre de Gustave Courbet: Catalogue raisonné*, (Paris, 1977), vol. 2, no. 801 ill.; Murphy 1985, p. 64; Elisabeth Hardouin-Fugier and Etienne Grafe, *French Flower Painters of the Nineteenth Century* (London, 1989), p. 156.

In September 1871, Courbet began a six-month sentence at the Ste.-Pélagie prison for his involvement with the Paris Commune and alleged role in toppling the Vendome column, seen by the Communards as a symbol of Napoleonic imperialism.[1] Denied models and access to the outdoors at Ste.-Pélagie, he painted the pieces of fruit and bunches of flowers brought by his sister during her visits. He continued to paint still lifes at the clinic of Dr. Duval in Neuilly where in ill health, he completed his sentence. Still life offered not only a practical subject given the circumstances, but a potentially marketable one as well. Reporting the success of his flower pieces in 1863 to the architect Isabey, he wrote, "I am making a mint from flowers."[2]

Dated 1872, the Boston picture was probably executed during his stay at Dr. Duval's clinic in the winter and early spring, along with a number of other flower pieces. In all likelihood, it is the picture entitled *A Copper Vase with Hollyhocks* which appears on Charles Blondon's list of works that Courbet painted during his sentence.[3] According to Blondon, the artist's friend and sometime physician and financial advisor, the canvas belonged to Reinach – Jacques Reinach, perhaps, a financier well known in Republican circles in the early Third Republic.

Although he displayed great facility with the genre, Courbet rarely painted still lifes.

Arrangements of fruit and flowers appear in several figure paintings, but he did not engage the genre in any single-minded or sustained way until 1862-63 when he visited his friend Etienne Baudry, a wealthy landowner, collector, and amateur botanist who lived in southwest France. Inspired by Baudry's extraordinary gardens and extensive collection of books on flowers, Courbet painted approximately twenty sumptuous bouquets of brilliantly colored mixed flowers, clearly savoring their varied hues, shapes, and textures. In contrast to the earlier works, *Hollyhocks* presents a simple bouquet of muted reds, dusty violets, and soft blues. The specific qualities of the hollyhocks, perennials whose medium-size blooms grow on stalks reaching five to nine feet, are suggested. However, it is the materiality and physical presence of paint, which is thickly applied and loosely handled – almost smeared in fact – that matters in *Hollyhocks* as it did in many of Courbet's works.

At least two of the still lifes Courbet painted in 1862 and several that he executed in 1871-72 are clearly symbolic.[4] MacClintock has argued that the hollyhocks, flowers associated with autumn, death, and endings in Dutch and Flemish painting, embody the artist's broken spirit and sense of defeat.[5] Yet the tranquil colors, vivid brushwork, and evident delight in the ineffably simple – a lush spray of flowers known to bloom dependably each year, placed in a plain round pot – might also be seen as signs of renewed strength and vigor. Courbet, in fact, described his stay at Dr. Duval's clinic as among the happiest periods of his life. Now free of the dehumanizing conditions of prison life, he wrote to his family in early January, "I am in heaven. I have never been so comfortable in my life. I have a large park to walk in and beautiful room. I eat extremely well at the family table and there are guests almost daily, all old friends."[6]

1. Courbet headed the Federation of Artists and represented the sixth arrondissement during the Commune, which declared a Republic in Paris after France's defeat in the Franco-Prussian War. Courbet had called for the dismantling of the column early on, but he was not, as research has proven, involved in its actual destruction. Arrested on June 7, he was tried that summer, imprisoned at Versailles, and then sent to Ste.-Pélagie. The government later voted to make Courbet pay for the column's restoration.

2. Petra ten-Doesschate Chu, ed. *Letters of Gustave Courbet* (Chicago and London, 1992), p. 220, no. 63-8.

3. Charles Blondon, *Liste des tableaux faits en captivité par Courbet*, Bibliothèque de Besançon ms. 2030, no. 27.

4. On the symbolism of *Still Life with Poppies and Skull*, 1862 (Paris, Private Collection) and *Marigolds in a Vase*, 1862 (location unknown), see *Gustave Courbet 1819-1877* (London, 1978) pp. 141-142. On the symbolism of *Still Life with Apples*, 1871 (The Hague, Mesdag Museum) and other works from Courbet's captivity, see Werner Hoffman, *Courbet und Deutschland* (Hamburg, 1978), p. 313, and Sarah Faunce and Linda Nochlin, *Courbet Reconsidered* (Brooklyn, 1988), p. 195. Some of Courbet's contemporaries ascribed sexual and political meanings to his still lifes when they were exhibited. See Klaus Herding, *Courbet: To Venture Independence* (New Haven and London, 1991), pp. 184-185.

5. Lucy MacClintock, *From Neo-Classicism to Impressionism: French Art from the Boston Museum of Fine Arts* (Boston, 1989), p. 156.

6. Chu, *Letters*, p. 449, no. 72-2.

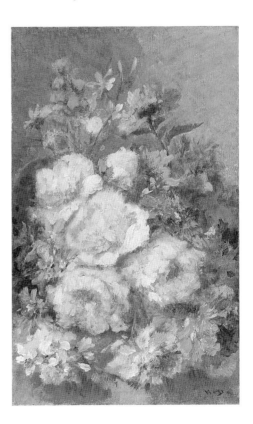

35

NARCISSE VIRGILE DIAZ DE LA PEÑA
(1808 Bordeaux – 1876 Menton)

Flowers

Oil on canvas, 15¼ x 9⅞ in. (40 x 25 cm)
Signed lower right: *N.D.*
Bequest of Ellen F. Moseley through Margaret LeMoyne Wentworth and Helen Freeman Hull.
24.236

Provenance: Ellen F. Moseley.

Exhibitions: Colorado, Colorado Springs Fine Arts Center, 1940; Boston, St. Botolph Club, 1940; New London, Connecticut College Art Gallery, November 17 - December 15, 1940.

Literature: Murphy 1985, p. 83 ill.

Born of Spanish immigrant parents, Diaz was orphaned at age ten and lost a leg in a freak accident a few years later.[1] Initially, he worked for a printer in Paris, but his friendship with the artist Jules Dupré led to a job with Dupré's uncle, a porcelain painter. At that time, he also met the artists Raffet, Cabat, and Troyon, and it was perhaps they, along with Dupré, who inspired him to begin painting. Though his formal training consisted only of a short period of study with François Suchon, an uninspired student of David, his work was sufficiently advanced by 1831 to gain him entry to the Salon where he exhibited regularly until 1859. Known primarily for his landscapes of the forest of Fontainebleau, which are rendered in jewel-like colors and often populated by gypsies, arcadian nymphs, and the like, he painted relatively few flower pieces.[2] In the latter, he generally adhered to two formats: he placed the flowers in a vase on a table,[3] or, as he does in the Boston picture, he filled much of the canvas with a spray, setting the flowers against a plain background and barely indicating the surface on which they rest. In handling and design, the Boston canvas resembles flower arrangements in the National Gallery of Scotland, the Glasgow Art Gallery and Museum, and the Koninklijk Museum voor Schone Kunsten in Antwerp. In all of these pictures, he concentrates the larger flowers towards the bottom of the bouquet and surrounds them with more delicate, smaller buds.[4] The loose, vigorous brushwork is typical of Diaz as is the interest in rendering the flowers as broad areas of color rather than in depicting their specific characteristics. As he works out toward the periphery of the bouquet, his brushwork becomes even sketchier and the furthermost blooms seem to blend imperceptibly into the background.

According to his contemporary, the critic Théophile Silvestre, Diaz rarely made preparatory drawings, but instead worked directly on the canvas and generally preferred to use pigments in their pure state.[5] Since Diaz's work has not been systematically studied, it is difficult to establish a chronology of his career and hence date Boston's *Flowers*.

However, the bright, vibrant colors, which differ from his typically darker, glistening, autumnal tones, suggest it was executed in the late sixties or early seventies.

1. For biographical information on Diaz, see E. Bénézit, *Dictionnaire critique et documentaire des peintres, sculpteurs, dessinateurs et graveurs* (Paris, 1976), pp. 560-563.

2. Of the 179 works in the Diaz retrospective, only eight appear to have been flower pieces. See *Exposition des oeuvres de N. Diaz de la Peña* (Paris, Ecole des Beaux-Arts, May 1877). There is no evidence that he painted still lifes of any sort other than flowers.

3. See for example, *Flowers in a Vase*, advertisement in *The Burlington Magazine* 115/843 (June 1973), p. LXXXVI.

4. See also *Flowers* (London, Christie's, November 28, 1972, lot 66) and *Flowers*, advertisement in *Apollo* 113/230 (April 1981), p. 33.

5. Théophile Silvestre, *Histoire des artistes vivants français et étrangers* (Paris, 1878), pp. 224-225.

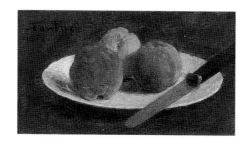

36

IGNACE-HENRI-JEAN-THÉODORE FANTIN-LATOUR

(1836 Grenoble – 1904 Orne)

Plate of Peaches, 1862

Oil on canvas, 7⅛ x 12⅝ in. (18.1 x 32 cm)
Signed and dated upper left: *Fantin/ 1862*
M. Theresa B. Hopkins Fund 60.792

Provenance: Julien Tempelaere, Paris, from the artist; Paris collector, 1900 - 1960; with Paul Rosenberg, New York 1960.

Exhibitions: Boston 1979, no. 37.

Literature: Murphy 1985, p. 95 ill.

Though he also painted portraits and imaginative compositions, Fantin is probably best known for his still lifes of fruit and flowers which he executed from the early 1860s until the end of the century. In 1841, Fantin's family moved from Grenoble to Paris where he received his first drawing lessons from his artist-father, Jean-Théodore, a specialist in portraits and genre paintings. In 1849 he registered as a copyist at the Louvre and in 1850

began studies at the Petite Ecole de Dessin with Horace Lecoq de Boisbudran, famed for his method of teaching students to draw from memory. In 1854 he entered the Ecole des Beaux-Arts but failed the first set of examinations. From then on he spent most days at the Louvre studying Old Master paintings and earning money selling his copies. Among contemporary painters, he was drawn to the work of Courbet, Manet, and Whistler whom he visited in England in 1859 and 1861. The second trip was a propitious one on two counts. He painted his first still lifes and met Edwin Edwards, a prominent lawyer and amateur artist, who along with Whistler would promote Fantin's work in England.[1]

Plate of Peaches is one of several small-format still lifes that he painted in the early 1860s. Here he seems less interested in capturing the different textures of the objects, which are all rendered with the same fluid brushstrokes, and more concerned with studying contrasts of light, shade, and color. Although it becomes almost a cliche in writing about still life to cite Chardin's importance to an artist, the emphasis given a few simple objects placed in an indeterminate but intimate space recalls Chardin's late pictures. Fantin copied a Chardin still life in 1859 and no doubt saw the twenty-five Chardin still lifes that Louis Martinet exhibited at his gallery in the summer of 1860. Fantin's style, however, differs from Chardin's. He does not display Chardin's tactile insistence, his brilliant color, or his relatively thick paint application.

1. On Fantin's life and work, the best source of information is Douglas Druick and Michel Hoog, *Fantin-Latour* (Ottawa, National Gallery of Canada, 1983).

37 (plate 14, page 29)

IGNACE-HENRI-JEAN-THÉODORE FANTIN-LATOUR

(1836 Grenoble – 1904 Orne)

Flowers and Fruit on a Table, 1865

Oil on canvas, 23⅝ x 28⅞ in. (60.0 x 73.3 cm)
Signed lower right: *Fantin - 1865*
Bequest of John T. Spaulding. 48.450

Provenance: C. de Hele, Brussels; Julien Tempelaere, Paris; Reid and Lefevre, Ltd., Glasgow; Cargill Collection, Scotland; Reid and Lefevre Ltd., London; Bignou Galerie, Paris; John T. Spaulding, Boston.

Exhibitions: New York, Museum of French Art, *Fantin-Latour: Loan Exhibition*, January - February 1932, no. 25; London, Reid and Lefevre Galleries, *Fantin-Latour*, November 1934, no. 9; New York, Bignou Gallery, *French Painters of the Romantic Period*, November 1940, no. 13; Philadelphia, Philadelphia Museum of Art, *The Second Empire: Art in France under Napoleon III*, October 1 - November 26, 1978 and Detroit, Detroit Institute of Arts, January 15 - March 18, 1979, Paris, Grand Palais, April 24 - July 2, 1979, no. VI-51; Paris, Louvre Museum, *Fantin-Latour*, November 9, 1982 - February 7, 1983, Ottawa, National Gallery of Canada, March 10 - May 22, 1983, San Francisco, Palace of the Legion of Honor, June 18 - September 6, 1983, no. 33; Boston, Museum of Fine Arts, *The Great Boston Collectors: Paintings from the Museum of Fine Arts*, February 13 - June 2, 1985, no. 50.

Literature: Gustave Kahn, *Fantin-Latour* (Paris, 1926), pl. 5; George H. Edgell, *French Painters in the Museum of Fine Arts: Corot to Utrillo* (Boston, Museum of Fine Arts, 1949), p. 47 ill.; Theodore E. Stebbins, Jr., and Peter C. Sutton, *Masterpiece Paintings from the Museum of Fine Arts, Boston* (New York, 1986), p. 70 ill.; Murphy 1985, p. 95 ill.

Round ripe peaches are piled in a shallow wicker basket next to a peach cut in half to reveal the fruit's yellow flesh and pit. To the right, a conical wicker basket disgorges bunches of grapes whose green translucent skin catches flecks of light. A smooth white ceramic bowl in the center contains some pears, an apple, and a bunch of purple grapes. A spray of chrysanthemums rises in the background.

In contrast with *Plate of Peaches*, the artist has attempted to capture the particular properties of the objects: the soft, fuzzy skin of the peaches; the hard, rutted texture of the pit, and the rough, knotty staves of wicker. The contour lines of the forms are firmer than those of the earlier work and the space more clearly defined so that the vertical wall and the horizontal surface of the table are distinguished from one another. Although the sliced peach and knife suggest the act of eating, the objects are neither arranged nor painted to evoke thoughts of a convivial meal or the pleasures of dining. The picture instead exudes a still perfection – distance from the emotional associations of the objects and the daily rituals they imply.

Several factors seem to have prompted Fantin's turn to still life in the early 1860s. He himself said that still life allowed him to experiment with different techniques and composition.[1] Given his sorry financial state, still life, which required neither elaborate and expensive props nor live models, was a practical subject, and unable to support himself on the sales of his portraits and copies after the

Old Masters, he could not ignore the promise of a substantial market for still lifes in England. While some critics in France continued to denigrate still life claiming it required less skill than figure painting, the genre was the subject of renewed interest and new-found respect by the mid-century among many artists and critics including Zacharie Astruc and Jules Castagnary.[2] Commenting on the number of still lifes at the Salon of 1863, Castagnary jokingly noted that still life was proliferating like rodents and threatening the foundations of the institution.[3] However the enthusiasm of fellow artists and critics probably gave Fantin little solace when the still life that he exhibited at the Salon of 1866 drew scant notice.[4] He waited seven years before submitting another to that annual exhibition.

1. Druick and Hoog, p. 113.

2. On the status of still-life painting at the mid-century, see Druick and Hoog, pp. 114, 129. The hierarchy of genres is discussed in the introduction to this catalogue.

3. Jules Castagnary, *Salons 1857-1870*, (Paris, 1892), vol. 2, p. 161.

4. Druick and Hoog, p. 117.

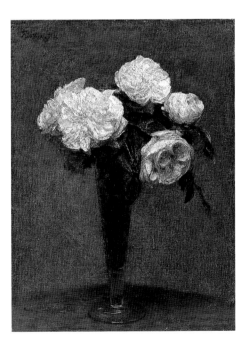

38

IGNACE-HENRI-JEAN-THÉODORE FANTIN-LATOUR

(1836 Grenoble – 1904 Orne)

Roses in a Vase, 1872

Oil on canvas, 14 x 11 in. (35.6 x 28 cm)
Signed upper left: *Fantin 72*
Frederick Brown Fund. 40.232

Provenance: with Juliein Tempelaere, Paris; Mme. Esnault-Pelterie, Paris; with C. W. Kraushaar, New York; Mrs. J. M. Sears, Boston; Mrs. J. D. Cameron Bradley, Boston.

Literature: Murphy 1985, p. 94 ill.

Fantin's images of roses were enormously popular among collectors in England, which had outstripped France to become the leading producer of roses in the world in the last decades of the nineteenth century. With its five roses in a simple glass vase, which was probably provided by Edwin Edwards, a lawyer, artist, and Fantin's agent in England, the present work is typical of Fantin's rose paintings of the 1870s when a shift in English taste prompted him to simplify his compositions. As he did in most of his flower pieces, Fantin painted the roses from different angles and in different states of bloom. Sacrificing botanical exactitude for expression, the brushwork of *Roses in a Vase* is loose and animated while a dramatic use of shade infuses the work with a sense of moodiness and mystery and gives the image the look of a scene remembered rather than one painted directly from first-hand observation. To some degree, the style of the picture is related to the romantic manner and dramatic chiaroscuro of his portraits and imaginative compositions, many of which were inspired by the music of Berlioz, Schumann, and Wagner. The looser shorter brushstrokes that describe the flowers also have affinities with Impressionist handling although Fantin kept his distance from members of that group, declining their invitation to exhibit at their first show in 1874 and steadfastly maintaining a studio practice when Monet, Pissarro, and others were engaged in plein-air painting.

It is difficult to understand why Fantin's flower pieces attracted few buyers in France.[1] Perhaps they were perceived as too traditional in their style compared to that of the avant-garde and less dazzling in their displays of alimentary plenitude and material wealth than the works of mainstream still-life painters like Blaise-Alexandre Desgoffe.

1. Druick and Hoog, p. 256.

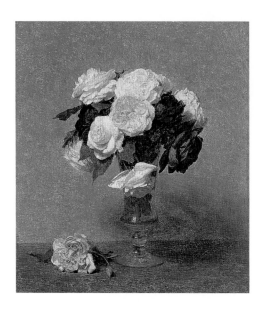

39

IGNACE-HENRI-JEAN-THÉODORE FANTIN-LATOUR

(1836 Grenoble — 1904 Orne)

Roses in a Glass Vase, 1890

Oil on canvas, 16¾ x 14⅞ in. (42.5 x 37.8 cm)
Signed lower right: *Fantin. 90*
Bequest of Alice A. Hay. 1987.291

Provenance: Alice A. Hay, New York.

Exhibitions: Japan 1989, no. 63; Japan 1992, no. 51.

From the time that he began painting still lifes, Fantin had vacillated between periods of enthusiasm for the genre and periods of despair though economic necessity kept him at his easel before his vases of flowers and bowls of fruit. By the 1890s, however, he found the constraints of the genre insurmountable. If in the 1860s he had believed in still life's infinite possibilities and in 1879 had written, "This year I find the flowers more beautiful than ever,"[1] now he complained that he had exhausted the genre and in a letter to a friend, described his flower paintings as "forced labor."[2] By this time, he was on sounder financial footing and could survive without the income from his still lifes.

The present work is a variation of *Tea and Tea Noisette Roses* of 1879 (Manchester City Art Galleries), the only still-life painting that he ever turned into a print. One senses something of the fatigue of which he complained – a certain mechanical rendering of the flowers and an unemotional rendering of light and shade. In contrast with the earlier painting, he eliminates the obtuse angle of the table top in favor of a straight line which produces a more static design. In its attention to detail and sensitivity to the nuances of color and structure of the flowers, the canvas nonetheless displays Fantin's formidable powers of observation which moved Jacques-Emile Blanche to write in 1906, "He captures the physiognomy of the flower he is copying; it is that particular flower and not another on the same stem; he draws and constructs the flower, and does not satisfy himself with giving an impression of it through bright, cleverly juxtaposed splashes of color."[3]

1. He made the comment in a letter to Otto Scholderer in the early summer of 1879. Quoted in Druick and Hoog, p. 257.

2. In a letter dated September 18, 1890, Fantin wrote to Adolphe Jullien, "I've just about completed my work for Mrs. Edwards. To have finished this forced labor will be wonderful." Quoted in Druick and Hoog, p. 338.

3. Jacques-Emile Blanche, "Fantin-Latour," *Revue de Paris*, May 15, 1906, p. 312.

40 (plate 17, page 32)

EDOUARD MANET

(1832 Paris – 1883 Paris)

Basket of Fruit

Oil on canvas, 14⅞ x 17½ in. (37.7 x 44.4 cm)
Signed lower right: *Manet*
Bequest of John T. Spaulding. 48.576

Provenance: Mme. d'Angely, Paris; Durand-Ruel, Paris until 1914; Durand-Ruel, New York until 1922; Mrs. L. L. Coburn, 1922; John Taylor Spaulding, Boston by 1931.

Exhibitions: Paris, Avenue de l'Alma, *Manet*, 1867, no. 41; Cambridge, Fogg Art Museum, *Exhibition of French Paintings of the Nineteenth and Twentieth Centuries*, March 6 - April 6, 1929, no. 59; New York, Wildenstein Gallery, *Manet*, March 19 - April 17, 1937, no. 12; Boston, Museum of Fine Arts, *Paintings, Drawings, and Prints from Private Collections in New England*, June 9 - September 10, 1939, no. 75; Boston, Museum of Fine Arts, *The John Taylor Spaulding Collection 1870-1948*, May 26 - November 7, 1948, no. 55; Boston, Museum of Fine Arts, *Impressionism: French and American*, June 15 - October 14, 1973; Tokyo, Isetan Museum of Art, *Edouard Manet*, June 26 - July 29, 1986 and Fukuoka, Fukuoka Art Museum, August 2 - 31, 1986, Osaka, Osaka Municipal Museum of Art, September 9 - October 12, 1986, no. 9; Japan 1989, no. 57; Boston, Museum of Fine Arts, *European and American Impressionism: Crosscurrents*, February 19 - May 17, 1992; Japan 1993, no. 48.

Literature: Etienne Moreau-Nélaton, *Manet raconté par lui-même* (Paris, 1926) vol. 1, p. 89, fig. 95; A. Tabarant, *Manet: Histoire catalographique* (Paris, 1931), p. 128 ill.; Paul Jamot, Georges Wildenstein, and M. L. Bataille, *Manet*, (Paris, 1932) vol. 1, no. 130; A. Tabarant, *Manet et ses oeuvres* (Paris, 1947), p. 99, no. 92; George Edgell, *French Painters in the Museum of Fine Arts: Corot to Utrillo* (Boston, 1949), p. 39 ill.; D. Rouart and S. Orienti, *Tout l'oeuvre peint d'Edouard Manet* (Paris, 1970), no. 81; Denis Rouart and Daniel Wildenstein, *Edouard Manet* (Geneva, 1975), vol. 1, no. 120; Murphy 1985, p. 175 ill.

Exasperated with the conservative juries that chose paintings for the government-sponsored Salon, Manet mounted his own exhibition in the spring of 1867. He showed *Basket of Fruit* along with forty-nine other canvases in a wooden pavilion, which he built with his own funds on the Place de l'Alma, hoping to attract the crowds from the nearby World's Fair on view that spring and summer.

Although Manet painted still lifes throughout his career, he focused on the genre during two distinct periods: 1864-69 and 1880-83. The date of the Boston canvas has been debated, but the work's proximity to still lifes executed between 1864 and 1865 suggests he painted it in those years.[1] The simple arrangement and bold sketchy handling of *Basket of Fruit* distinguish it from the highly finished academic still lifes that were much in vogue during the Second Empire. Those still lifes celebrated material wealth and consumption with lavish displays of porcelain, silver, and other luxury objects. It has been suggested that Chardin's still lifes of the 1750s and 1760s (see cats. 29-30) inspired Manet's simple designs and selection of objects.[2] The revival of interest in Chardin's work was at its height in the 1860s, and Manet, no doubt, studied his still lifes in the exhibition organized by Philipe Burty in 1860 at the gallery of Louis Martinet, the artist's first dealer. There are, however, important differences between the two painters. Although Chardin reduced the number of objects in his canvases and set them against a plain background, he nonetheless modeled his vessels and pieces of fruit, distinguished their various textures, and suggested the illusion of three-dimensional space. In contrast, Manet's schematized objects, all formed from the same fluid strokes of paint, seem to float in an indeterminate, relatively flat space, which is emphasized by the alignment of the knife with the horizontal edge of the canvas. If Chardin appealed to the viewer's sense of touch, Manet repelled it, and where Chardin manipulated paint to describe objects, Manet used paint to dissolve them.[3] The dissolution of objects is, of course, a hallmark of Manet's

figure paintings, and for that he often drew critical fire. Curiously, however, contemporaries found the sketchy handling and abbreviated forms acceptable in his still lifes which, according to Emile Zola, were generally praised.[4] Perhaps that was so because still life, as the lowest of the genres, was subject to different critical standards, or because, it posed the one theme that was, as Georges Bataille wrote, "intrinsically meaningless; thus [Manet] could approach it from a strictly painterly angles, the objects represented being a mere pretext for the act of painting."[5]

Basket of Fruit belonged to Mme. d'Angely, née Marguerite de Conflans, whom Manet painted twice in 1873. [6] Her family had long-standing ties with Manet's, and according to Moreau-Nélaton, it was in the de Conflans's home that Manet first saw Spanish paintings.[7] which were to shape many of his works in the 1860s including the Museum's *Monk in Prayer*.

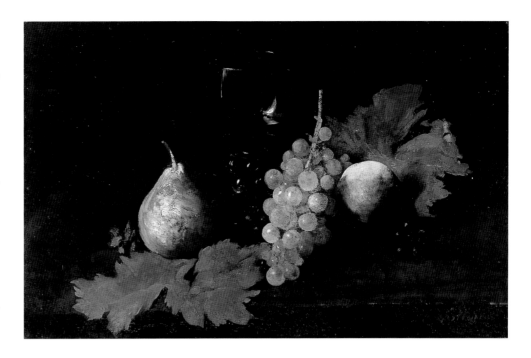

1. See Denis Rouart and Daniel Wildenstein, *Edouard Manet* (Geneva, 1975), vol. 1, nos. 80-85, 119, 121. The looser handling and flatness of the work suggest a date more towards 1866.

2. *Manet* (Tokyo, 1986), p. 154; Lucie MacClintock, *From Neo-Classicism to Impressionism: French Art from the Boston Museum of Fine Arts* (Boston, 1989), p. 165; Robert Boardingham, *Monet and His Contemporaries: Masterpieces from the Museum of Fine Arts* (Tokyo, 1992), p. 240.

3. As the two works by Chardin in this exhibition (cats. 29-30) reveal, he too often allowed paint to stand simply as paint, obviously savoring its textures and colors. Manet, however, takes this quality of paint for paint's sake to a new level.

4. George Heard Hamilton, *Manet and His Critics* (New Haven and London, 1954), p. 101.

5. Georges Bataille, *Manet*, trans. Austryn Wainhouse and James Emmons (Lausanne, 1955), p. 81.

6. *Young Woman Leaning on Her Elbows* (Northampton, Smith College Museum of Art) and *Portrait of Marguerite de Conflans* (Wintherthur, Oskar Reinhart Collection). For illustrations see Rouart and Wildenstein, vol. 1, nos. 203, 204. De Conflans possibly sat for *Young Woman with Her Hair Undone* (New York, Private Collection) also of 1873. See Rouart and Wildenstein, vol. 1, no. 206. On de Conflans and Manet, see also A. Tabarant, *Manet et ses oeuvres* (Paris, 1947), pp. 224-226.

7. Étienne Moreau-Nélaton, *Manet raconté par lui-même* (Paris, 1926), vol. 2, p. 33.

41

ANTOINE VOLLON

(1833 Lyon – 1900 Paris)

Fruit and a Wineglass

Oil on canvas, 10⅛ x 15¾ in. (25.8 x 39.9 cm)
Signed lower right: *A. Vollon*
Gift of Mrs. Josiah Bradlee. 17.3144

Provenance: Mrs. Josiah Bradlee, Boston to 1917.

Literature: Murphy 1985, p. 296 ill.

Though the critic Jules Castagnary claimed in his essay on Vollon, "he is not just a painter, he is *the* painter,"[1] Vollon was forgotten soon after his death. He began his career in Lyon, studying at the Ecole des Beaux-Arts and working as an enamelist and engraver before moving to Paris in 1859 to become a painter.[2] During his first years in the capital, he often portrayed himself or his friends Théodule Ribot and François Bonvin, leading members of the second generation of Realists, who took Vollon under their wing. While he painted landscapes, animals, and figures throughout his career, Vollon earned his reputation and his living from his still lifes, the earliest of which display humble meals and modest vessels, subject matter suggested not only by Bonvin and Ribot but also by seventeenth-century Dutch and Spanish works as well as Chardin's canvases, a source of inspiration for many painters in the 1850s and 1860s. The revival of interest in Chardin's

works was part of a general mid-century enthusiasm for still life, which, along with landscape painting, grew in stature as painters abandoned the classical themes of history painting to study contemporary life.[3]

Vollon made his public debut at the Salon of 1864. Marking the first of many official honors, the state purchased one of his submissions. Critical and commercial success soon followed. As Vollon's still lifes became popular with upper middle-class collectors in the 1870s and 1880s, he expanded his subjects to suit their tastes, painting silver decanters and oriental rugs as frequently as copper cauldrons and earthenware vessels.[4] With its elegant glass, this canvas was perhaps intended for such a patron. Vollon, according to Clarétie, always worked from the model,[5] and to that end, he kept a vast store of objects in his studio – gold and silver vessels; copper, pewter, and stoneware; textiles, and musical instruments.[6]

Contemporary critics often cited Vollon's work for its truthfulness and realism, and in this canvas, the artist's attention to the shapes, textures, and colors of his objects, rendered in tight, controlled brushstrokes, is evident. Yet as Weisberg has observed, Vollon was equally capable of dramatic, even dream-like scenes, the product of his enthusiasm for Romantic painting.[7] In this small canvas, the painter has selected, arranged, and situated his objects to create a sense of mystery. The objects emerge from an inky dark ground.

The tree leaves framing the grapes and peaches add an incongruous touch to the glass and pieces of fruit commonly found in still life. The bunch of grapes, by all accounts, should lie on the table, but it seems, instead, to hang in the air as if it were suspended from an invisible vine.

1. Jules Clarétie, *Peintres et sculpteurs contemporains*,(Paris, 1884), vol. 2, p. 201.

2. For biographical information on Vollon, see Gabriel P. Weisberg, *The Realist Tradition* (Cleveland, Cleveland Museum of Art, 1980), pp. 144-145,154-155, 311-312.

3. John W. McCoubrey, *Studies in French Still-Life Painting, Theory, and Criticism, 1660-1860* (Ph.D. diss., New York University, 1958), p. 111.

4. Weisberg, p. 154.

5. Clarétie, p. 206.

6. Louise d'Argencourt and Douglas Druick, *The Other Nineteenth Century* (Ottawa, National Gallery of Canada, 1978), p. 194.

7. Gabriel P. Weisberg, "A Still Life by Antoine Vollon, a Painter of Two Traditions," *Bulletin of the Detroit Institute of Arts* 56/4 (1978), pp. 222-229.

42

ALFRED SISLEY

(1839 Paris – 1899 Moret-sur-Loing)

Grapes and Walnuts on a Table, 1876

Oil on canvas, 15 x 21 3/4 in. (38 x 55.4 cm)
Signed lower left: *Sisley*
Bequest of John T. Spaulding. 48.601

Provenance: Durand-Ruel, Paris, from the artist, 1881; Durand-Ruel (probably New York) to John T. Spaulding, 1925.

Exhibitions: Buffalo, Albright-Knox Gallery, *Exhibition of Paintings by the French Impressionists*, October 31 - December 8, 1907, no. 76; New York, Galerie Durand-Ruel, *Still Lifes and Flower Pieces*, February 7 - 24, 1923, no. 32; Cambridge, Fogg Art Museum, *French Painting of the Nineteenth and Twentieth Centuries*, March 6 - April 6, 1929, no. 84; Boston, Museum of Fine Arts, *The Collections of John T. Spaulding 1870-1948*, May 26 - November 7, 1948, no. 77; New York, Wildenstein & Co., *Sisley*, October 27 - December 3, 1966, no. 28; Boston, Museum of Fine Arts, *Impressionism: French and American*, June 15 - October 14, 1973; Boston 1979, no. 41; Japan 1989, no. 64; Boston, Museum of Fine Arts, *European and American Impressionism: Crosscurrents*, February 19 - May 17, 1992; Japan 1993, no. 52.

Literature: Forbes Watson, "American Collections: The John T. Spaulding Collection," *The Arts* 8 (December 1925), p. 323 ill., 335; "The Collection of John Taylor Spaulding," *Bulletin of the Museum of Fine Arts* 29 (December 1931), p. 112; E. A. Jewell, *French Impressionists and Their Contemporaries* (New York, 1944), p. 192 ill.; George H. Edgell, *French Painters in the Museum of Fine Arts: Corot*

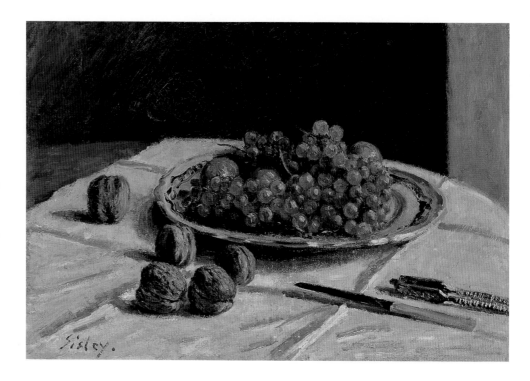

to Utrillo (Boston, 1949), p. 53 ill.; F. Daulte, *Alfred Sisley: Catalogue raisonné de l'oeuvre peint* (Lausanne, 1959), no. 233 ill.; Murphy 1985, p. 265 ill.; Christopher Lloyd, *Alfred Sisley* (Japan, 1985), p. 21 ill.; *Alfred Sisley* (London, Royal Academy of Arts, 1992), p. 174 ill.

Like many of his fellow Impressionists, Sisley was not originally destined to be an artist. At his father's behest, he studied business in London for two years, but on his return to Paris in 1862, he enrolled in the Ecole des Beaux-Arts and entered Charles Gleyre's private studio where he met Monet, Renoir, and Bazille. The four worked closely and in his pictures of 1869-70, Sisley adopted the broken brushwork that Monet and Renoir had developed in their images of La Grenouillère in the summer of 1869.

Sisley was primarily a landscape painter, and only nine of his known works are still lifes.[1] According to Durand-Ruel, who bought the present canvas from Sisley and kept it in his private collection during his life time, it was painted in 1876.[2] That date is accepted by François Daulte who catalogued Sisley's work.[3]

In the selection of objects, setting, and design, the Boston canvas is related to *Still Life with Apples and Grapes* of 1876 (Sterling and Francine Clark Art Institute, Williamstown, Mass.). Both works come from a period when Sisley and the other Impressionist painters were reevaluating their art. In his landscapes of the mid-to-late 1870s, Sisley

began to dissolve his forms in increasingly loose brushwork, to flatten the space in his canvases, and to relax his designs. In its style, however, the Boston canvas seems closer to works of the early 1870s. The three-dimensionality of the forms is more defined and the comparatively tight brushwork remains tied to a descriptive task as Sisley records the qualities and textures of his objects: the translucent skin of the grapes enlivened by the play of light, the gnarled shells of the walnuts, and the reflective silver surface of the nutcracker. The objects are also arranged with attention to geometry and firm design. Sisley paints the creases of the tablecloth in a grid pattern and places the knife, nutcracker, and two walnuts along its lines to reinforce the geometric structure. He, in addition, repeats the curve of the edge of the table in the plate and its circular pattern. Though the table is set with eating utensils, the methodical arrangement of the pieces of fruit and nuts makes it difficult to relate to them as the ingredients of a meal or foods to be consumed.

Given Sisley's evident ability with the genre, it is surprising that he painted so few still lifes. Possibly he feared they would not sell well. The marketability of his canvases was a source of concern for the impecunious Sisley who, following the collapse of his father's business during the Franco-Prussian War, depended entirely upon the sale of his pictures for his living.

1. See François Daulte, *Alfred Sisley: Catalogue raisonné de l'oeuvre peint* (Lausanne, 1959), nos. 5, 6, 7, 8, 186, 233, 234, 661, 662. The earliest still lifes date to ca. 1867 and include a dead heron (D5), a fish (D6), a pheasant (D8), and a group of apples (D7). In the 1870s, he painted a spray of flowers (D186) and in the 1880s, two still lifes of fish (D661, D662).

2. Bill of sale from Durand-Ruel to John T. Spaulding, January 2, 1925. *Grapes and Walnuts on a Table* was one of forty-five paintings that Durand-Ruel bought from Sisley in 1881. See Caroline Durand-Ruel Godfroy, "Paul Durand-Ruel and Alfred Sisley, 1872-1895," in *Alfred Sisley* (London, Royal Academy of Arts, 1992), p. 38. According to a letter to John T. Spaulding dated November 11, 1924, in the Museum files from E. C. Holston of the Durand-Ruel Gallery in New York, Paul Durand-Ruel, founder of the gallery that bore his name, kept it in his private collection during his lifetime.

3. Daulte, no. 233.

43 (plate 18, page 33)
GUSTAVE CAILLEBOTTE
(1848 Paris – 1894 Genevilliers)

Fruit Displayed on a Stand, ca. 1881-82

Oil on canvas, 30⅛ x 39⅝ in. (76.5 x 100.5 cm)
Signed at lower right: *G. Caillebotte*
Fannie P. Mason Fund in Memory of Alice Thevin.
1979.196

Provenance: A. Courtier Meaux; by descent to Mme. Brunet, Paris; by descent, private collection, Paris; sale, Paris (Ader Picard Tajan) March 22, 1979, no. 71.

Exhibitions: Paris, 251 rue St.-Honoré, *Exposition des artistes indépendants*, March 1882, no. 4; Paris, Galeries Durand-Ruel, *Exposition retrospective d'oeuvres de G. Caillebotte*, June 1894, no. 91; Houston, The Museum of Fine Arts, *Gustave Caillebotte, A Retrospective Exhibition*, October 22 - January 2, 1977 and Brooklyn, The Brooklyn Museum, February 12 - April 24, 1977, no. 59; Boston, Museum of Fine Arts, *European and American Impressionism: Crosscurrents*, February 19 - May 17, 1992.

Literature: J.-K. Huysmans, "L'Exposition des Indépendants en 1882" in *L'Art Moderne* (Paris, 1883), p. 262; Marie Berhaut, *Gustave Caillebotte* (Paris, Galerie des Beaux-Arts, 1951), p. 16, no. 133 ill.; Marie Berhaut, *Caillebotte impressioniste* (Paris, 1968), p. 42; Marie Berhaut, *Caillebotte, sa vie et son oeuvre* (Paris, 1978), pp. 56, 142 ill.; *The New Painting: Impressionism 1874-1886* (San Francisco, The Fine Arts Museums of San Francisco, 1986), p. 374 ill.; Peter C. Sutton and Theodore E. Stebbins, Jr., *Masterpieces from the Museum of Fine Arts, Boston* (New York, 1986), p. 75 ill.; J. Kirk Varnedoe, *Gustave Caillebotte* (New Haven and London, 1987), pp. 8, 18, 144, 157, 158 ill., 159.

When Gustave Caillebotte exhibited *Fruits*, painted for his friend A. Courtier Meaux, at the Exposition des Indépendants, the so-called Seventh Impressionist Exhibition in 1882, it drew different reactions. J.-K.

Huysmans, the writer and critic, praised the canvas's realism, writing that he could all but smell, taste, and feel the fruit which is arranged in neat piles on a stand and separated by pieces of paper.[1] In contrast, a caricature in *Le Charivari*, the widely read humor magazine (fig. 1), seized on the work's artifice, poking fun at Caillebotte's "bird's-eye view" and pronounced geometric order.

The caricaturist's confusion was justified. Though the title, *Fruits*, given in the exhibition *livret* suggested a conventional still-life arrangement, Caillebotte eschewed the usual mode of displaying objects on a table, in a niche, or the like.[2] At the same time the picture alluded to but hardly typified the market scene, a popular genre subject of the period. Where the likes of Léon Lhermitte,[3] Camille Pissarro, and Emile Zola, who crafted what is perhaps the most famous evocation of the nineteenth-century French market in *Le Ventre de Paris* (1873), relished the market's piles of food, unruly crowds, and noisy rituals of barter and exchange, Caillebotte insisted on order, control, and tranquillity. He detached the neat stacks of fruit from any surrounding activity or context and used the high viewpoint with which he structured his cityscapes of the early 1880s[4] to enable the viewer to master what he surveyed, affording him an intimate and focused experience in this most public of places. While Caillebotte's format may be novel within the conventions of still-life painting, *Fruits* is clearly a product of the style and fascinations that shaped many of his paintings. Throughout his short career, Caillebotte gravitated towards transitional structures and spaces – the balcony, the window, the bridge – which spanned worlds and experiences, be it public and private realms, interior and exterior spaces, one tract of land and another. In *Fruits*, he paints the fruit in the middle of its passage from country farm to domestic table.[5] Also typical of Caillebotte's work is the geometric order which the caricaturist so wittily exaggerates. Though the streets and apartments of Paris during the 1870s and early 1880s were his favored subjects, he consistently shunned the city's competing and confusing sights, sounds, and smells, seeking instead to impose order and coherency.[6]

1. J.-K. Huysmans, *L'Art Moderne* (Paris, 1883), p. 262.

2. Caillebotte had painted more traditional still-life compositions in, for example, *Still Life with Glasses, Carafes,*

Fig. 1. Caricature by Draner, "Une Visite aux impressionistes," *Le Charivari*, March 9, 1882.

and Bowls of Fruit (1879; Private Collection), and *Melon and Bowl of Figs* (1880-82; Paris, Private Collection). Both are illustrated in Marie Berhaut, *Caillebotte, sa vie et son oeuvre* (Paris, 1978), nos. 123 and 211.

3. See for example Léon Lhermitte, *The Apple Market, Landerneau, Brittany* (1878, Philadelphia, Philadelphia Museum of Art).

4. See for example, *Boulevard Seen from Above* (1880; Paris, Private Collection) and *Man on a Balcony* (1880; Paris, Private Collection). Illustrated respectively in Berhaut nos. 137 and 143.

5. The same fascination with transitional stages marks *Still Life, Display of Chickens and Game Birds* (1882; Paris, Private Collection) which displays a rack of dead animals in a butcher's window. They, too, are depicted in their passage from market to kitchen. For illustration, see Berhaut, no. 220.

6. J. Kirk Varnedoe, *Gustave Caillebotte* (New Haven and London, 1987), cf. pp. 9, 12, 18.

44 (plate 19, page 34, and cover)
PAUL GAUGUIN
(1848 Paris – 1903 The Marquesas)

Flowers and a Bowl of Fruit on a Table

Oil on canvas mounted on paperboard, 17 x 24¾ in. (42.8 x 62.9 cm)
Bequest of John T. Spaulding. 48.546

Provenance: Gustave Loiseau, Paris from Gauguin in Pont-Aven, 1894; Durand-Ruel, Paris, from Loiseau, October 6, 1922; John T. Spaulding, Boston in 1922.

Exhibitions: New York, Museum of Modern Art, *Cézanne, Gauguin, Seurat, Van Gogh*, 1929, no. 52; Cambridge, Fogg Art Museum, *French Painting of the Nineteenth and Twentieth Centuries*, March 6 - April 6, 1929, no. 44; New York, Wildenstein Gallery, *Paul Gauguin*, March 20 - April 18, 1936, no. 27; Cambridge, Fogg Art Museum,

Paul Gauguin, May 1 - May 21, 1936, no. 25; Santa Barbara, Santa Barbara Museum of Art, *Fruit and Flowers in Painting*, August 12 - September 14, 1958, no. 38; Memphis TN, Brooks Memorial Art Gallery, *Fruit and Flowers*, November 15 - 30, 1958; London, Tate Gallery, *Gauguin and the Pont Aven Group*, January 7 - February 13, 1966, Zurich, Kunsthaus, March 5 - April 11, 1966, no. 50; Cincinnati, Cincinnati Art Museum, *The Early Work of Paul Gauguin: Genesis of an Artist*, March 17 - April 26, 1971; Boston, Museum of Fine Arts, *French Paintings from the Storerooms and Some Recent Acquisitions*, May 2 - August 27, 1978; Boston, Museum of Fine Arts, *European and American Impressionism: Crosscurrents*, February 19 - May 17, 1992.

Literature: Gustave Kahn, "P. Gauguin," *L'Art et les artistes*, November 1925 (special no.), p. 52 ill.; P. Hendy, "The Collection of John Taylor Spaulding," *Bulletin of the Museum of Fine Arts*, 29/176 (December 1931), pp. 109-13 ill.; Van Wyck Brooks, trans., *Paul Gauguin's Intimate Journals* (New York, 1936), p. 68 ill.; Maurice Malingue, *Paul Gauguin* (Paris, 1948), p. 106 ill.; George H. Edgell, *French Painters in the Museum of Fine Arts: Corot to Utrillo* (Boston, 1949), pp. 73 ill., 77; Charles Estienne, *Gauguin* (Geneva, 1953), p. 81 ill.; Lee Van Dovski, *Gauguin* (Geneva, 1953), p. 81 ill.; Georges Wildenstein, *Gauguin* (Paris, 1964), no. 406; G. M. Sugana, *L'Opera completa di Gauguin* (Milan, 1972), no. 217; Murphy 1985, p. 111 ill.

In August 1893, Gauguin returned to Paris after a two-year stay in Tahiti, and in April 1894, traveled to Brittany where he had often painted before his trip to Polynesia. During a visit to the Breton fishing port of Concarneau in May, a group of sailors insulted his Javanese mistress, Annah.[1] Gauguin suffered a broken ankle in the fight that ensued and spent two months recuperating in Pont-Aven where, according to Gustave Loiseau, he executed the Boston still life. Loiseau, a painter himself, so admired the canvas during his visits to the bed-ridden artist that Gauguin eventually gave it to him.[2]

Gauguin painted independent still lifes off and on throughout his career and also incorporated prominent still-life arrangements in several of his figure paintings.[3] The existence of a crayon sketch for the still life suggests that Gauguin painted the canvas from memory and notes rather than the model.[4] Whether he based the sketch on an arrangement of actual objects or invented the image in his head is not clear.

The Boston picture, like many of Gauguin's canvases, involves a dialogue between observation and imagination, which translates pictorially into a play between decorative pattern and naturalist description, between flattened strokes of paint and the indication of volumes. The push and pull between nature and invention is seen throughout the canvas. In the vase, for example, he not only suggests the appearance of transparent glass, water, and thick green stems, but also flattens the forms so that the objects and substances seem to congeal into an irreal pattern. Because the objects and tabletop are seen from above, it seems as if there is depth in the picture, but the vertical wall behind the table contradicts the sense of space. Though he indicates shadows below the bowl and the vase, they do not model forms, but appear as distinct, almost independent shapes within the overall design. Gauguin once noted that each flower is unique. Accordingly he individuates each bloom, not, however, by recording the specific details of their natural structure and texture but by varying his color, brushstroke, and line.[5]

As he did in many of his still lifes even before his first trip to Tahiti (1891-93), he textured the composition with an exotic note in the small ceramic bowl whose design and colors make it appear vaguely non-European. In shape and hue, however, the animal on the bowl resembles the dog and fox that frequently appear in Gauguin's canvases.[6]

1. Annah was actually half-Indian and half-Malaysian, but called herself Javanese.

2. Letter in curatorial file from Gustave Loiseau to Durand-Ruel dated April 15, 1921.

3. See for example, *Te tiare farani* (1891; Moscow, Pushkin State Museum of Fine Art); *Ia orana Maria* (*Oh Hail Mary*) (1892; New York, Metropolitan Museum of Art) and *The Meal* (1891; Paris, Musée d'Orsay). In the figure paintings, the still-life groupings enhance the sense of stasis in the compositions. Degas's use of prominent still-life arrangements may have been a model for Gauguin.

4. The sketch also belongs to the Museum of Fine Arts, Boston (48.1366).

5. On Gauguin's observation about flowers and on the dichotomy in Gauguin's still lifes between naturalist observation and memory and imagination, see Robert Goldwater, *Gauguin* (New York, 1957), p. 104.

6. For paintings that incorporate animals resembling the figure on the bowl, see *The Loss of Virginity* (1890; Norfolk VA, The Chrysler Museum), *Te Faaturuma* (1891; Worcester, Worcester Art Museum), and *Tahitian Pastorals* (1893; St. Petersburg, Hermitage Museum). Though Gauguin often included images in his canvases of pots or sculptures that he had made himself, the bowl in the Boston picture does not correspond to any of his known pieces. Thus it may have been a product of his imagination or an object made by someone else. For a catalogue of Gauguin's ceramics, see Christopher Gray, *Sculpture and Ceramics of Paul Gauguin* (Baltimore, 1963).

45 (plate 20, page 35)

PAUL CÉZANNE

(1839 Aix-en-Provence – 1906 Aix-en-Provence)

Fruit and a Jug on a Table

Oil on canvas, 12⅞ x 16 in. (32.3 x 40.8 cm)
Bequest of John T. Spaulding. 48.524

Provenance: Ambrose Vollard, Paris; Eugène Blot, Paris; 1er Vente Blot, Hôtel Drouot, Paris, May 9 - 10, 1900, no. 22 (bought in); 2e Vente Blot, Hôtel Drouot, Paris, May 10, 1906, no. 19 (bought in?); Dr. Hans Wendland, Berlin and Paris (confiscated as enemy property); Vente Liquidation Wendland, Hôtel Drouot, Paris, February 24, 1922, no. 211; Gottlieb Friedrich Reber, Lausanne; Durand-Ruel, Paris; John T. Spaulding, Boston, from Durand-Ruel, May 1922.

Exhibitions: Paris, Galerie Blot, *Natures mortes et fleurs*, 1909, no. 4; Berlin, Paul Cassirer, *Sammlung Reber*, 1913, no. 19; Darmstadt, Mathildenhohe, *Sammlung G. F. Reber*, no. 11; New York, Wildenstein, *Paul Cézanne*, 1928, no. 4; Cambridge, Fogg Art Museum, *Exhibition of French Paintings of the Nineteenth and Twentieth Centuries*, March 6 - April 6, 1929, no. 8; Boston, Museum of Fine Arts, May 1931 - October 1932 (on loan from John Spaulding); Boston, Museum of Fine Arts, *Paintings, Drawings, and Prints from Private Collections in New England*, June - September 1939, no. 12; Cambridge, Fogg Art Museum, *Eighteen Paintings from the Spaulding Collection*, February 1 - September 15, 1949; Dallas, Museum of Fine Arts, *The Arts of Man*, November 15 - December 31, 1962; Boston, Museum of Fine Arts, *Impressionism: French and American*, June 15 - October 14, 1973, Boston 1979, no. 42; Japan 1983, no. 54; Yamanashi, Japan, Musée Kiyoharu Shirakaba, *Cézanne*, May 12 - July 31, 1987, no. 12; Boston, Museum of Fine Arts, *Connections: Brice Marden*, March 23 - July 21, 1991, no. 26; Boston, Museum of Fine Arts, *European and American Impressionism: Crosscurrents*, February 19 - May 17, 1992; Japan 1993, no. 54.

Literature: G. Rivière, *Le Maître Paul Cézanne* (Paris, 1923), p. 223; J. Goulinat, "Technique Picturale: L'Evolution du metier de Cézanne," *Art Vivant* March 1, 1925, p. 24 ill.; Forbes Watson, "American Collections: The John T. Spaulding Collection," *The Arts* 8/6 (December 1925), pp. 321, 334 ill.; E. Blot, *Histoire d'une collection de tableaux modernes, 50 ans de peinture* (Paris, 1934), pp. 37-38; Lionello Venturi, *Cézanne: son art – son oeuvre*, 2 vols. (Paris, 1936), vol. 1, p. 197 no. 612 and vol. 2, pl. 197; E. Jewell, *French Impressionists and Their Contemporaries* (New York, 1944), p. 58 ill.; E. Jewell, *Paul Cézanne* (New York, 1944), p. 28 ill.; L. Dame, "Spaulding Collection Willed to Boston Museum," *Art Digest* 22/17 (June 1, 1948), p. 12; S. Freedberg, "This Summer in New England," *Art News* 47/4 (Summer 1948), p. 34 ill.; Charles H. Pepper, *The Collections of John Taylor Spaulding 1870 - 1948* (Boston, 1948), pp. 5, 9; Murphy 1985, p. 48 ill.

Cézanne received a classical education in his native Aix where he counted Emile Zola, the novelist and critic, among his childhood friends. Though he wanted to paint, he attended law school at his father's behest while also studying at the Drawing Academy of Aix. His father, a prosperous businessman,

finally allowed him to study painting in Paris beginning in 1861 at the Académie Suisse. Though he attempted some ambitious canvases in the grand manner in the 1860s, his most intriguing works of that decade display violent, sometimes erotic subjects, a dark palette, and a rough application of paint. By the early 1870s under the guidance of Camille Pissarro who urged him to paint directly from nature and to discipline his work, he began to lighten his palette, refine his touch, and build his forms from small strokes of color. In the 1880s Cézanne flattened his space more markedly and developed a denser stroke which both describes the object and binds it to the surface of the canvas.

Recognizing that we are taught to see, to privilege certain things and establish particular relations between them while ignoring others, Cézanne spent much of his career resisting preconceived ways of structuring nature on the canvas, seeking to return to a pure, untutored mode of vision.[1] In this canvas, as in so many, he seems to look at each object piece by piece and in relation only to the object directly next to it but not in relation to a predetermined or overarching scheme. He builds the forms and composition slowly and sequentially, painting the chair, then the jug, and then the pieces of fruit and constructing the background from simple stroke after simple stroke. He displays in Meyer Schapiro's words "a kind of naive, deeply sincere empiricism."[2]

Cézanne not only rejects preexisting formulas for setting nature down on the canvas but also preconceived notions of the objects he depicts, painting them in such a way that they can neither appeal to our previous associations with them nor spark new ones. However, he wants only that we see the objects, not interpret them. To that end, he does not seek to capture their textures or to suggest what they might be used for – a surface to lay things on, food to eat, a vessel to fill with liquid – or when they might be used, at a meal, for example. Still he does not relate to the objects merely as abstract shapes and areas of color either for he is clearly committed to their distinctive visual qualities: the subtle changes in the color of an apple's skin, the squat shape of the Provençal jug, the elegant curves of the chair's back, the opacity of white ceramic. Unlike Monet who by the 1890s dissolved his forms in pigment, Cézanne asserted their materiality, using his strokes and touches of paint to affirm their

physical presence as objects. We are always aware that we are looking at apples not colored circles, but have no desire to eat, touch, or smell them. A middleground between anecdote and abstraction is discovered.

The pieces of fruit, after all, are unlike any that we encounter in the actual world because the canvas, in Cézanne's view, is not an extension of that world, but a separate space and order of experience. While he attempted to find a pure, unlearned way of seeing and to record that kind of direct vision on the canvas, he never lost sight of the particular qualities of representation, allowing, then, the strokes of paint to remain visible and asserting the materiality of the canvas itself. The pieces of fruit, for example, seem to sit on the plane of the canvas, but also to project forward into space. The table top slants upward rather than pierce the picture's plane. We lose our eyes in the depths of the dark blue pigment of the table cloth, but the tiny white areas of unpainted canvas remind us that the color sits on a flat, impenetrable surface.

1. My discussion is based on Meyer Schapiro's analysis of the artist in *Paul Cézanne* (New York, 1952) and T. J. Clark's lectures on Cézanne in "The Beginnings of Modernism," Harvard University, fall 1987.

2. Schapiro, p. 27.

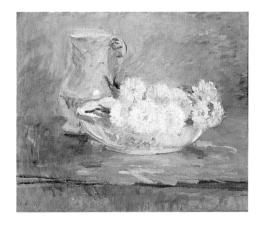

46

BERTHE MORISOT

(1841 Bourges – 1895 Paris)

White Flowers in a Bowl

Oil on canvas, 18⅛ x 25⅝ in. (46 x 55 cm)
Signed at lower left: *B Morisot*
Bequest of John T. Spaulding. 48.581

Provenance: Octave Mirbeau, Paris until 1919; Durand-Ruel, Paris and New York until 1925; John T. Spaulding, Boston.

Exhibitions: Paris, Durand-Ruel, *Berthe Morisot*, March 5 - 21, 1896, no. 161; Boston, Museum of Fine Arts, *The Collections of John Taylor Spaulding 1870-1948*, May 26 - November 7, 1948, no. 60; Columbia SC, Columbia Museum of Art, *Impressionism*, March 31 - May 8, 1960; New York, Wildenstein & Co., The National Organization for Mentally Ill Children, *Berthe Morisot*, November 1 - December 10, 1960, no. 48; San Francisco, California Palace of the Legion of Honor, *Berthe Morisot*, December 20, 1960 - January 18, 1961; Boston, Museum of Fine Arts, *Impressionism: French and American*, June 15 - October 14, 1973, no. 31; Los Angeles, Los Angeles County Museum of Art, *Women Artists, 1550-1950*, December 21, 1976 - March 13, 1977, Austin TX, University Art Museum, April 12 - June 5, 1977, Pittsburgh, Carnegie Institute, July 14 - September 5, 1977, and Brooklyn, The Brooklyn Museum, October 4 - November 27, 1977, no. 87; Boston 1979, no. 53; Boston, Museum of Fine Arts, *European and American Impressionism: Crosscurrents*, February 19 - May 17, 1992; Japan 1993, no. 59.

Literature: Forbes Watson, "American Collections: The John T. Spaulding Collection," *The Arts* 8/6 (December 1925), pp. 334-336 ill.; Arthur Pope, "French Paintings in the Collection of John T. Spaulding," *Art News* 28/30 (April 26, 1930), pp. 98, 127 ill.; George H. Edgell, *French Painters in the Museum of Fine Arts: Corot to Utrillo* (Boston, 1949), p. 66 ill.; M.-L. Bataille and Georges Wildenstein, *Berthe Morisot, Catalogue des peintures, pastels et aquarelles* (Paris, 1961), no. 182; Murphy 1985, p. 213 ill.

Morisot, who exhibited in seven of the eight Impressionist exhibitions, painted some 800 works, most of her family, her home, and her garden in Passy on the outskirts of Paris. As scholars have emphasized, Morisot's relatively narrow range of subjects reflects the restricted life of the upper middle-class woman who could not, like her male colleagues, freely move about the city's streets, café-concerts, dance halls, and other haunts in search of subjects. Given the constraints that she faced, it is surprising that Morisot painted few still lifes, a subject well-suited to the studio. When she turned to that genre, she usually focused on a few simple objects as she did in *White Flowers in a Bowl*.

Upper middle-class women generally studied drawing and sometimes watercolor along with some literature and music before they married. Many used their artistic skills to chronicle the lives of their family and friends, often pasting their imagery in albums which were passed from generation to generation.[1] True to her station in life, Morisot took drawing lessons in her teens, first with an academic painter, Geoffroy-Alphonse Chocarne, and then with Joseph-Benoit Guichard, but her decision to paint in oil, to exhibit her work publicly, and to sell it was unusual at the time.

The energetic, loose, and apparently spon-

taneous handling of *White Flowers in a Bowl* typifies her mature style, which Jean Ajalbert, reviewing her entries to the 1886 Impressionist exhibition, characterized as "telegraphic." Morisot, he wrote, "eliminates cumbersome epithets and heavy adverbs in her terse sentences. Everything is subject and verb."[2] In *White Flowers*, Morisot evidently placed little value on botanical accuracy, rendering details, or evoking specific textures, preferring instead to indicate forms with a minimum of drawing. The pitcher and bowl are so freely painted that the specific types cannot be identified, and the table seems almost an immaterial presence hardly capable of supporting what rests on it surface. Morisot's canvases reveal the process of image-making – the strokes of pigment and the canvas, which, in certain passages, remains bare – and recapitulate how we see things at a glance, perceiving the outlines and broad masses of objects.[3]

Critics less enthusiastic than Ajalbert derided Morisot's style for its sketchiness and lack of finish, a quality still highly prized in many late nineteenth-century circles. Others dismissed it as merely feminine, although her bold broken brushwork, separate strokes of color, and tonal clarity had much in common with the style of many male Impressionists – Monet and Renoir, for example – who also, on occasion, depicted familial scenes.[4] Given her interest in painting her domestic surroundings, one might surmise that the flowers came from her garden and the bowl and pitcher from her cupboard. Yet the image suggests nothing of a known or familiar environment as, for example, Chardin's canvases often do.

Though not the most daring or assertive of Morisot's still lifes, *White Flowers in a Bowl* hung in the 1896 restrospective of her work organized by Degas, Monet, Renoir, and Mallarmé at Durand-Ruel the year after her death when it belonged to Octave Mirbeau, the prominent novelist, critic, and supporter of avant-garde art. Although it is nearly impossible to identify the flowers, both the catalogue for the retrospective and the sale of Mirbeau's collection give the title *Reines-Marguerites*, a type of marigold.

1. See Anne Higonnet, *Berthe Morisot's Images of Women* (Cambridge, 1992), pp. 36-60.

2. Jean Ajalbert, *La Revue Moderne*, June 10, 1886, quoted in Charles S. Moffett, *The New Painting: Impressionism*

1874-1886 (San Francisco, Fine Arts Museums of San Francisco, 1986), p. 460.

3. This interpretation has been suggested by Charles Stuckey. See Charles F. Stuckey, *Berthe Morisot, Impressionist* (South Hadley, Mount Holyoke College Art Museum and Washington D.C., The National Gallery of Art, 1987), pp. 70, 94, 106.

4. Kathleen Adler and Tamar Garb, *Berthe Morisot* (Ithaca, 1987), pp. 57, 64-66.

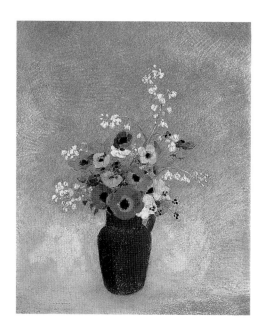

47

ODILON REDON

(1840 Bordeaux – 1916 Paris)

Large Green Vase with Mixed Flowers

Pastel on paper, 29¼ x 24½ in. (74.3 x 62.2 cm)
Signed lower left: *Odilon Redon*
Bequest of John T. Spaulding. 48.591

Provenance: M. Etienne Bignou, Paris, 1925; William A. C., Glasgow; with deHauke and Co., New York; bought by John T. Spaulding, Boston, in 1928.

Exhibitions: Paris, Musée des Arts Décoratifs, *Exposition retrospective de l'oeuvre d'Odilon Redon*, March 1926, no. 98; Glasgow, *Paintings and Pastels by Odilon Redon*, October 1926; Glasgow, *A Century of French Painting*, May 1927; New York, Paul Rosenberg and Co., *Paintings and Pastels by Odilon Redon*, February 8 - March 7, 1959, no. 22.

Literature: George H. Edgell, *French Painters in the Museum of Fine Arts: Corot to Utrillo* (Boston, 1949), p. 60 ill.; Klaus Berger, *Odilon Redon* (Cologne, 1964), p. 218; Murphy 1985, p. 236 ill.

A sickly child, Redon spent much of his youth at Peyrelebade, his family's country residence in the Gironde, separated from his parents and siblings. He detested school, but excelled in drawing and in 1858, he received

some formal training from Stanislas Gorin, a specialist in landscape watercolors who encouraged him to study Delacroix. In 1858 he met Armand Clavaud, a botanist, who played a crucial role in his intellectual and artistic formation by introducing him to subjects ranging from Darwin's and Lamarck's evolutionary theories to Hindu literature to Flaubert's and Baudelaire's writings. Though he hoped to study drawing and painting, his practically minded father steered him towards architecture. After he failed the oral entrance examinations for the architecture section of the Ecole des Beaux-Arts in 1861, he returned to Bordeaux where he studied with Rodolphe Bresdin, an eccentric but brilliant artist, who passed his skills in etching on to Redon along with an intense appreciation for Rembrandt and Dürer and a commitment to socialist politics. In 1864, Redon enrolled in the studio of the renowned academic painter Jean-Léon Gérôme in Paris but he returned to Bordeaux and Bresdin in 1865. Though he had previously worked with a variety of media and a varied palette, in the 1870s, he began to restrict himself to black and white, producing images – the majority of them etchings and charcoal drawings – which he called his "noirs" ("blacks"). The desire to recapture a pre-industrial sense of community, what Steven Eisenman has termed Redon's "romantic anticapitalism," shaped the style and themes of these pictures. Drawn from an eclectic array of sources – folktales, political caricature, and the work of Leonardo among others – the images are by turns macabre and comic, nightmarish and whimsical.[1] Redon still spent part of each year in Bordeaux, but he was by the 1880s firmly entrenched in the artistic circles in Paris where he associated with members of the literary and artistic avant-garde including J.-K. Huysmans who celebrated Redon's idiosyncratic images in his 1884 novel, *Against the Grain*, one of the manifestoes of *fin-de-siècle* French symbolism.

The direction of Redon's work changed in 1890 when he turned away from the fantastic images and reduced palette of the "noirs." Pastel and oil became his primary media, and nature his preferred subject though he sometimes depicted religious and mythological themes. Several factors probably led to the shift in Redon's art: loosened ties with the Bordeaux region and its unhappy childhood memories, growing conservativism in his politics, and fatigue from the intellectual rigors of the "noirs." The Boston pastel, which

probably dates to 1912-13, is one of numerous flowerpieces that he executed from 1890 until his death.[2] Though the flowerpiece is a conventional still-life motif and the flowers loosely resemble real ones, the palette and peculiar space of the picture make it seem otherworldly. The colors have a brilliance more vivid than any hues found in nature, and the juxtaposition of complementary colors, now the main formal device of Redon's works, produces an optical intensity so that the flowers fairly glow.[3] In the absence of any markers in the visual field, the vase, moreover, seems to float in an ambiguous space.

1. Stephen F. Eisenman, *The Temptation of Saint Redon: Biography, Ideology, and Style in the Noirs of Odilon Redon* (Chicago, 1992). For general information on Redon, see John Rewald, "Odilon Redon," in *Odilon Redon, Gustave Moreau, Rodolphe Bresdin* (New York, Museum of Modern Art, 1961), pp. 9-49 and Klaus Berger, *Odilon Redon* (Cologne, 1964).

2. Berger, p. 218.

3. The complementary colors in the picture are yellow and purple, green and red, and green and pink. Also contributing to the intensity of the colors is the absence of any modeling with light and shade and the use of pastel, which produces very rich, saturated colors.

48
ANTOINE VOLLON
(Lyon 1833 — Paris 1900)

Sitting Room

Oil on canvas, 15¾ x 10½ in. (40.1 x 26.6 cm)
Signed at lower right: *A. Vollon*
The Henry C. and Martha B. Angell Collection.
19.115

Provenance: Inglis, ca. 1890; Henry and Martha Angell.

Exhibitions: Japan 1989, no. 51; Japan 1993, no. 18.

Literature: Murphy 1985, p. 296 ill.

In a sitting room, a dog sleeps on an animal skin. A decanter and glasses, a vase of flowers, and a book rest on the table covered with a bright orange cloth while a parasol and gloves lie on the chair set before framed pictures hanging on the wall. Sunlight filters through the voile curtains covering the tall French windows. Although the scene emphasizes pleasant domesticity, the dark blue drapes and background shadows add a somber note.

The canvas contains two still-life arrangements: the more traditional combination of

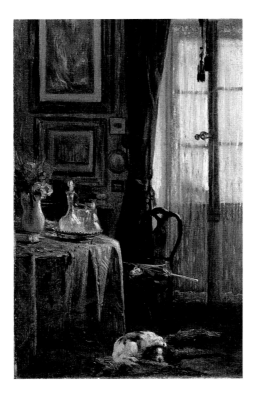

flowers and vessels on a table top and the gloves and umbrella on the chair. In most canvases, Vollon focused on the still-life objects themselves, but here he has elaborated their context and in the gloves and umbrella, perhaps referred to their owner. Other examples of his work develop the setting of his still-life objects, notably the early *Kitchen Interior* (Nantes, Municipal Museum), which was widely praised when exhibited in 1865, and *Interior of a Room* (location unknown)[1] which, like *Sitting Room*, displays a bourgeois domestic space.

Since Vollon rarely dated his work, it is difficult to establish a chronology of his career, but the loose brushwork typical of Manet and the Impressionists, which was eventually adopted by more conservative artists like Vollon, suggests a date in the 1880s or 1890s, as does the brighter palette. By the last decades of the nineteenth century, Vollon's reputation among middle-class collectors had grown, and with its oriental textiles, flowers, framed pictures, and book, *Sitting Room* was probably intended to appeal to an educated, well-heeled buyer. The picture's small size, moreover, seems suited to the dimensions of an urban apartment.

1. For an illustration see H. Shickman Gallery, New York, *The Neglected Nineteenth Century: An Exhibition of French Paintings, part II*, October 1971, no number.

49
EDOUARD VUILLARD
(1868 Cuiseaux – 1940 La Baule)

Roses in a Glass Vase, ca. 1919

Oil on canvas, 14⅜ x 18½ in. (37.2 x 47 cm)
Signed bottom left: *E Vuillard*
Bequest of Mrs. Edward Wheelwright, by exchange, and Paintings Department Special Fund. 41.107

Provenance: Georges Bernheim; Edouard Jonas in 1935.

Exhibitions: Zurich, Kunsthaus, *Bonnard-Vuillard*, 1932, no. 179.

Literature: Murphy 1985, p. 297 ill.

Vuillard's family moved to Paris when he was nine. He was set to enter Saint-Cyr, the famed military college, when a friend persuaded him to attend classes at the Gobelins school, an experience which changed his career path. His six-week stint at the Ecole des Beaux-Arts probably had a negligible effect on his formation. More important were his regular visits to the Louvre and classes at the Académie Julian where he met Paul Ranson, Maurice Denis, Paul Sérusier, and Pierre Bonnard who in the late 1880s banded together to form the Nabis. Vuillard joined the group in 1890, and like his fellow Nabis was active in theater design, book illustration, print making, and decorative arts as well as easel painting. During the 1890s, he favored flattened schematized forms and rich patterns of color but by 1900 he had adopted a looser style in which he composed objects with patches and separate strokes of paint.

Vuillard is best known for his interiors featuring family members in the Parisian apartments that he shared with his mother. He painted still lifes off and on through his career, usually depicting the same objects found in his interior scenes. In the salon or dining room, those objects become part of daily routines of sociability and domesticity, and in a number of his still lifes, he retains some reference to those household contexts through the objects' setting, their relation to the viewer, or their arrangement with one another. Vases of flowers, for example, can be found enlivening dining tables, adorning pianos, and set beside curios and books on mantlepieces in still lifes and interior scenes from all decades. In the Boston picture, however, Vuillard deliberately made the objects and setting unfamiliar. The diagonal space is slightly disorienting, and the napkins are so

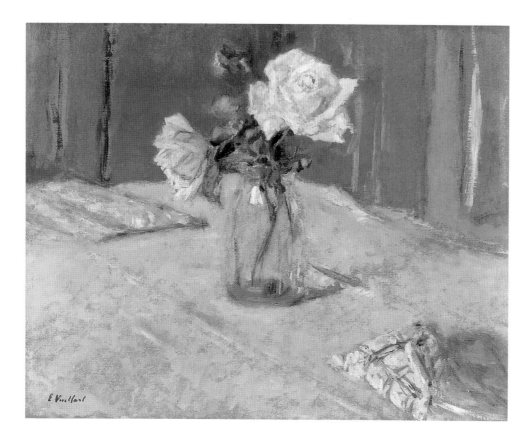

loosely painted that it is difficult to determine what they are. The viewer is drawn near to the objects, which are placed close to the picture plane, but the sketchy, abbreviated handling makes them appear far away. Here Vuillard strove perhaps to achieve the quality that he found so compelling in Chardin's still lifes. As he observed in his journal in 1890, "Chardin's still lifes, the white and grey ones, (grapes, pipe) give pleasure through their tonal harmonies and their outline shapes and not by means of the greater or lesser degree of exactitude with which they recall their models which are unknown to us."[1]

The canvas was dated 1927 when it was shown in 1932,[2] but Antoine Salomon suggested a date of 1919 is more likely.[3]

1. Quoted in Belinda Thomson, *Vuillard* (New York, 1988), p. 22.

2. *Bonnard-Vuillard* (Zurich, Kunsthaus, 1932), no. 179.

3. Letter to Lucretia Giese dated June 9, 1978, in curatorial file.

50

JEAN-BAPTISTE ROBIE

(1821 Brussels – 1910 Brussels)

Study of a Flowering Branch, 1871

Oil on panel, 21 x 13¾ in. (53.5 x 34.8 cm)
Signed lower left: *J. Robie, Mai 1871*
Fanny P. Mason Fund in Memory of Alice Thevin. 1984.169

Provenance: Wheelock Whitney & Company, New York.

Literature: Murphy 1985, p. 246 ill.

According to a contemporary chronicle, Robie worked in his father's forge during his youth but also began drawing at an early age. His skill drew the attention of one of his father's clients who asked him to paint a sign for his business, the success of which led to other commissions. Robie traveled to Paris to escape his troubled family and to learn more about fine art, but unable to support himself, he returned to his father's blacksmith shop, at which time he also began studies at the Academy of Fine Arts in Brussels. Encouraged by local picture dealer whose shop was on the way to Waterloo, he painted small portraits of Napoleon in various poses which were sold as souvenirs to English tourists en route

to visit the site of the French leader's defeat. When the market for the Napoleonic pictures declined, Robie took up flower painting, again at the picture dealer's suggestion, and eventually began selling and exhibiting those still lifes on his own, winning a gold medal for his submission to the Belgian Salon of 1848, the first of many official honors.[1] He also exhibited his still lifes in the French Salons to favorable notices. In his review of the *Salon des artistes français* of 1890, a critic wrote that Robie "continues to reign without rival in the domaine of flowers," though he wished the artist would employ his skills in other genres.[2] Robie also had a following in the United States where his pictures were exhibited as early as 1864.[3] In addition to painting, Robie published books on his trips to the Orient and on painting.[4]

Among his contemporaries, Robie's still lifes were known for their splendor and refinement.[5] Resembling the still lifes painted by French academic artists during the Second Empire, Robie's flower pieces generally display formal, often contrived arrangements which are in some instances set among opulent objects and in others in a landscape.[6] The present work departs from his usual format since he has painted a simple branch of a delicate but unostentatious flower – a branch of *sorbus*, or mountain ash[7] – displaying a nat-

uralist's sensitivity to the particular structure of the blossom that seems in the tradition of his seventeenth-century Flemish forebears. Robie's concern with aesthetic effect, however, suggests he conceived the work as more than an exercise in botanical exactitude or a casual sketch. Though the work has been called a study, it is more finished than such a title generally implies. The flowers are deliberately concentrated in the center of the canvas to create a strong focal point, while the lighting, which emphasizes the flowers and creates deep background shadows, is conspicuously staged and dramatic. Finally, Robie has blended the brushwork to produce the polished, or "licked," surface so favored by academic artists in their final canvases.

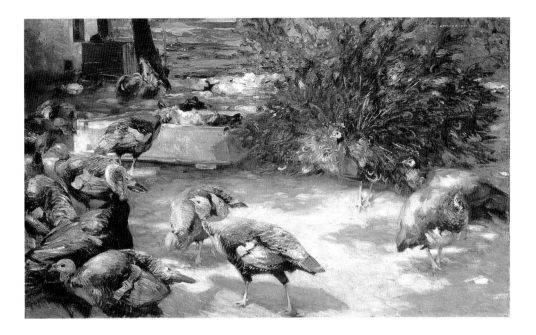

1. This biographical information comes from Edmond-Louis de Taeye, *Les Artistes belges contemporains*, (Brussels, 1894), vol. 1, pp. 171-183.

2. Paul Leroi, "Salon de 1890" *L'Art*, 49/2, pp. 224-225.

3. On Robie in the United States, see Theodore E. Stebbins, Jr., *The Life and Works of Martin Johnson Heade* (New Haven and London, 1975), pp. 119-120.

4. Including *Les Fragments d'un voyage dans l'Inde et à Ceylon* (1883) and *Les Débuts d'un peintre* (1886).

5. Camille Lemonnier, *Histoire des beaux-arts en Belgique, 1830 - 1887* (Brussels, 1887), p. 139.

6. For a selection of Robie's flower pieces see Musées Royaux des Beaux-Arts de Belgique, *Catalogue inventaire de la peinture moderne* (Brussels, 1984), pp. 524-525.

7. Thanks are due to David E. Boufford of the Harvard University Herbaria for identifying the plant.

51

MAX RUDOLF SCHRAMM-ZITTAU

(1874 Zittau – 1950 Ehrwald)

Poultry Yard

Oil on canvas, 49¼ x 79⅛ in. (125 x 201 cm)
Signed upper right: *Rudolf Schramm-Zittau*
Gift of Hugo Reisinger. 11.9

Provenance: Hugo Reisinger, New York.

Literature: Murphy 1985, p. 260 ill.

Schramm-Zittau studied at the academies in Dresden, Karlsruhe, and Munich; at the latter he worked from 1894 to 1899 with Heinrich Zügel, one of the foremost painters of animals in late nineteenth-century Germany. In the broad rendering of the forms and physical presence of the paint, the Boston canvas attests to the impact that Zügel had on Schramm-Zittau's style and bears comparison with works that Zügel painted during the 1890s. At that time, Zügel was moving from tighter, more descriptive brushwork to more loosely handled forms.[1] Schramm-Zittau used both styles in *Poultry Yard*.

Rural themes were popular in late nineteenth-century Germany where the impact of Barbizon or realist-type subjects lasted longer than in France. While this work might also be seen as a genre subject of sorts, it employs the focused gaze and tight cropping characteristic of still life. Although there is no evidence of direct influence, it descends from and might be compared to the barnyard scenes of Melchior d'Hondecoeter (see cat. 20). As with d'Hondecoeter's work, Schramm-Zittau's suggests the possibility of a narrative as the turkeys seem to rush away from the bold peacock who, fanning his brilliant tail, struts into the poultry yard. The combination of turkeys and a peacock, in fact, is somewhat incongruous. While turkeys were raised to be eaten, peacocks were more usually found roaming the estates of the wealthy who kept them as exotic pets.

The picture was given to the museum by Hugo Reisinger who was born in Wiesbaden and later settled in the United States where he married his cousin, Edmée, the daughter of Adolphus Busch, the St. Louis brewer. Reisinger, who assembled a collection of Austrian, Swiss, and German art, was instrumental in mounting exhibitions of American art for Germany and of German art for the United States.[2] In 1909, he organized an exhibition of contemporary German paintings and sculpture for New York, Chicago, and Boston, which included three of Schramm-Zittau's pictures.[3]

1. On Zügel's work, see Eugen Diem, *Heinrich von Zügel und seine Zeit* (Recklinghausen, 1986).

2. On Reisinger, see Guido Goldman, *A History of the Germanic Museum at Harvard* (Cambridge, 1989), pp. 13-14. In 1948, the museum of Germanic art at Harvard was named for the Busch and Reisinger families, which had generously supported it for many years.

3. The exhibition was shown at the Metropolitan Museum of Art, the Copley Society in Boston, and the Art Institute of Chicago. Two of Schramm-Zittau's pictures were entitled *Ducks* and the third, *Feeding Hens*. See *Exhibition of Contemporary German Art* (New York, Metropolitan Museum of Art, 1909), p. 61.

52

JAMES PEALE

(1749 Chestertown, Maryland – 1831 Philadelphia)

A Porcelain Bowl with Fruit, 1830

Oil on canvas, 16⅛ x 22¼ in. (40.9 x 56.8 cm)
Signed and dated on original canvas before relining: *Painted by . Peale in 82nd year of his Age Philad ᵃ 1830 The above was written by the old Gentleman himself A.P.* (Anna Peale)
Gift of JoAnn and Julian Ganz, Jr., Gift of Mrs. Samuel Parkman, Oliver and Emily L. Ainsley Fund. 1979.520

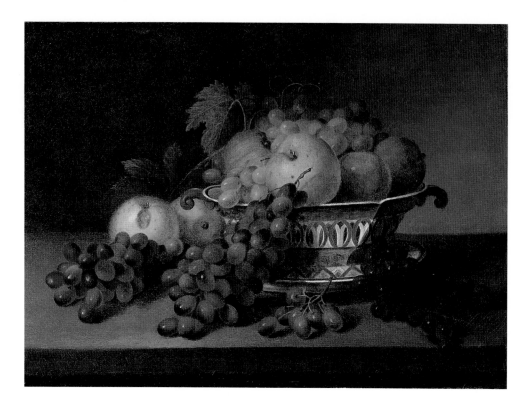

well-modeled pieces of fruit and clearly delineated geometric shapes, a nascent romantic spirit tempers its classical sobriety. Light plays over the objects and the background illuminating some passages and leaving others in darkness, giving the canvas a faintly moody quality. The bunches of grapes fall langorously from the bowl and lie expressively on the table. The lines bounding the different objects are slightly blurred and the composition is arranged along a diagonal line which moves from the lower left corner through the center of the picture. As in many of his still lifes, Peale depicted blemishes and brown spots on the pieces of fruit. Those spots not only enhance the naturalism of the image, but also insinuate the specters of death and decay, favored romantic themes, and link the canvas to the tradition of *vanitas* still lifes, which remind the viewer of the transience of life.

On the evidence of the inscription on the original canvas, the Boston still life is customarily dated to 1830. James's nephew Rubens Peale, another son of Charles, painted two copies of his uncle's composition which date to 1856 and 1860 and are in the Munson-Williams-Proctor Institute, Utica, New York and the Mead Art Museum, Amherst. In the nephew's versions, the light is more evenly distributed, the line tighter, and the composition altogether stiffer.

1. On Peale and his family, see *The Peale Family, Three Generations of American Artists* (Detroit, Detroit Institute of Arts, 1967).

2. On the differences between James's and Raphaelle's still lifes, see John I. H. Baur, "The Peales and the Development of American Still Life," *Art Quarterly* 3/1 (winter 1940), pp. 81-91.

3. William H. Gerdts, *Painters of the Humble Truth* (Columbia and London, 1981), pp. 50-51.

53 (plate 21, page 36)
CHARLES BIRD KING
(1785 Newport, Rhode Island – 1862 Washington D.C.)

Still Life on a Green Tablecloth,
ca. 1815-25

Oil on wood panel, 18¾ x 22 in. (47.6 x 55.9 cm)
Gift of Mrs. Samuel Parkman Oliver. 1978.184

Provenance: Charles Lalli, Brockton MA.

Though best known for his portraits of Indian leaders, King also painted landscapes, his-

Provenance: Anna Claypoole Peale; Sully & Earles Gallery, Philadelphia; A. D. Mondeschein, New York; Paul Lane, Tivoli, New York; James Ricau Piermont, New York until 1973; Mr. and Mrs. Julian Ganz, Jr.

Exhibitions: Providence, Rhode Island School of Design, *Twenty Five American Paintings from the Revolution to the Civil War*; 1942 - 1943, no. 3; Norfolk VA, The Hermitage Foundation and the United Virginia Bank Gallery, *Nineteenth-Century American Still Life Paintings*, February 19 - March 30, 1973, no. 1; Santa Barbara CA, The Santa Barbara Museum of Art, *American Paintings, Watercolors, and Drawings from the Collection of JoAnn and Julian Ganz, Jr.*, June 23 - July 22, 1973, no. 51; Los Angeles, Los Angeles County Museum of Art, *American Paintings from Los Angeles Collections*, May 7 - June 20, 1974, no. 2; Beijing, Zhongguo Meishuguan, *American Paintings from the Museum of Fine Arts, Boston*, September 1 - 20, 1981 and Shanghai, Shanghai Bowuguan, October 20 - November 19, 1981, no. 9.

A member of the illustrious Peale family which played a prominent role in the cultural and intellectual life of post-colonial America, Peale grew up in Annapolis, Maryland, and received his artistic training from his older brother Charles Willson Peale who had studied in London with Benjamin West. After serving in the Continental Army under George Washington, he moved to Philadelphia where he joined his brother's portrait studio, painting miniatures while Charles handled the commissions for larger-scale canvases. Though he exhibited a still life in 1795 at the Columbianum Exhibition in Philadelphia, he painted few if any still lifes during the next twenty years. His reputation as one of the first professional still-life painters in the United States, a distinction he shares with Charles's son Raphaelle, rests on the works that he executed between 1819 and 1831 and exhibited at Charles's museum in Baltimore, the Pennsylvania Academy of Fine Arts, and the Boston Athenaeum.[1] Why Peale turned to still life so late in his career is not known, but it may well have been Raphaelle's example that inspired him.[2] William Gerdts has argued that still-life painting held little economic incentive prior to the second decade of the nineteenth century. By that time the number of exhibitions mounted in the United States began to increase, thus providing painters with more opportunities to display their works to the public, an important consideration in the case of still life which was usually painted on speculation not commission.[3]

Peale favored pieces of fruit or vegetables or combinations thereof and in general placed them in wicker baskets, directly on a table or shelf, or in a ceramic bowl as he does in the present work. He painted a number of his still lifes in a classical style, emphasizing solid simple forms and balanced rectilinear designs. While the present canvas displays

tory subjects, genre scenes, and still lifes. He grew up in Newport, trained in New York, and later studied in London with Benjamin West from 1805-12. He painted his first still life, a fairly conventional gamepiece, during his time in West's studio.[1] When he returned to the United States, he settled in Washington D.C.[2]

According to documentary evidence, King produced at least eighteen still lifes, though only a handful of these have been located.[3] Among King's contemporaries, the only still-life painters of any note belonged to the illustrious Peale family: Raphaelle Peale, who pioneered the genre in the United States, his uncle James Peale (cat. 52), and his cousin Margaretta Angelica. King probably knew the Peales' still lifes which were exhibited in Philadelphia and Baltimore where King himself had worked after returning to the United States. Like those of Raphaelle and James Peale, King's tabletop fruit pieces display a selection of crisply articulated objects simply arranged in a balanced composition on a table illuminated against a plain background. Raphaelle Peale, moreover, portrayed cut-glass goblets and decanters similar to the ones that King painted in *Still Life on a Green Tablecloth*.[4] King's canvas, however, differs in important respects from the Peales' still lifes. His colors, though subdued, are somewhat richer and warmer and his objects more numerous and tightly grouped, creating a sense of greater abundance. While the Peales' still lifes can seem reserved and even aloof, King's arrangement intimates conviviality. He has poured some wine or port into the glass, displayed a pineapple, a well-known symbol of welcome, in the porcelain bowl, and prepared the orange to be eaten, even placing a slice near the glass as to offer it, however tentatively, to the viewer. The pieces of fruit, goblets, and bowl, all so insistently round, come forward in space and the pineapple's leaves move freely, adding a note of spontaneity and informality to the composition. Though hardly puritanical, the attitudes toward wealth and display that inform King's still life differ from those that would shape the mid-century works of artists like Severin Roesen (cat. 55). Where Roesen and others explored themes of plentitude and profusion, King's composition speaks to the values of restraint and measure.

1. The still life is in the collection of the IBM Corporation in Armonk, NY.

2. The best source of information on King is Andrew J. Corsentino, *The Paintings of Charles Bird King (1785-1862)* (Washington D.C., 1977).

3. For a list of the still lifes, see Corsentino, pp. 186-188. Most are tabletop works.

4. See for example, *A Dessert* (1814; Collection of JoAnn and Julian Ganz, Jr.) and *Still Life with Liqueur and Fruit* (ca. 1814; Eleanor Searle Whitney McCollum, Houston TX).

54
JOHN F. FRANCIS
(1808 Philadelphia – 1886 Jeffersonville, Pennsylvania)

Still Life with Apples and Chestnuts, 1859

Oil on canvas, 25 x 30 in. (63.5 x 76.2 cm)
Signed and dated lower left: *J.F. Francis Pt 1859*
Gift of Mrs. Maxim Karolik for the M. and M. Karolik Collection of American Paintings, 1815-1865. 47.1145

Provenance: found in Philadelphia; Victor Spark, New York until 1944; M & M. Karolik.

Exhibitions: Brockton MA, Brockton Art Center, *The Good Things in Life: Nineteenth-Century American Still Life*, March 8 - April 29, 1973; Mansfield OH, The Mansfield Art Center, *The American Garden*, March 17 - April 14, 1991, no. 6.

Literature: M. and M. Karolik Collection of American Paintings, 1815 to 1865 (Boston, Museum of Fine Arts, 1949), pp. 264-265 ill.; Alfred Frankenstein, *After the Hunt* (Berkeley and Los Angeles, 1953), p. 135, pl. 106; *American Paintings in the Detroit Institute of Arts* (Detroit, Detroit Institute of Arts, 1991) vol. 1, p. 100.

From the time of James Peale's death in 1831 until the mid-century, few Americans painted still lifes. John Francis was one of a small number of American artists who came to prominence for his work in the genre at this time. He initially earned his living as an itinerant portrait painter whose business took him to rural Pennsylvania, Ohio, and Tennessee, and he exhibited works at the Artist's Fund Society in 1840 and the Pennsylvania Academy of Fine Arts in Philadelphia where he was listed as a resident.[1] Several factors probably influenced his decision to give up portraiture in the early 1850s to focus on still lifes: the market for such works, a product of rising incomes and higher standards of living,[2] and the promise of a sedentary lifestyle. Moreover, still life, unlike portraiture, eliminated the possibility of demanding sitters.

Francis's still lifes fall into three categories:

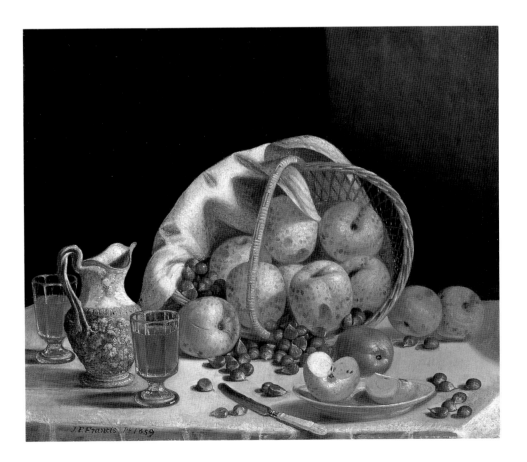

luncheon pictures, dessert images, and canvases, like the present one, which feature large market baskets filled with fruit. Unlike the refined prepared foods and opulent vessels of the luncheon and dessert pictures which suggest a special occasion or an upper-class meal, the common rustic basket and the abundance of newly picked fruit of the third category of pictures evoke images of nature and the countryside's orchards and fields. The image, however, does not lead the viewer to contemplate the process of and labor involved in growing, harvesting, and selling food. Instead, the cut apple, knife, and glasses of cider seem the makings of an impromptu meal, one that takes places perhaps during an afternoon excursion in the country.

The Boston canvas derives from *Still Life with Yellow Apples* (Detroit Institute of Arts) which Francis painted in 1858. Save for the addition of two walnuts to the left of the knife in the Boston canvas, the two pictures are virtually identical. Both works were preceded by smaller, simpler images of apple-filled baskets.[3] As he does in the present work, Francis often depicted his fruit with brown spots and worm holes. But the associations of disease and decay that those features might suggest in other still lifes are negated by the abundance of food, the sunny palette, and the ordered arrangement, all of which combine to evoke visions of plenitude and well-being and fantasies of a simple, uncomplicated rural existence. It is easy to imagine this work hanging in the dining room of a well-appointed urban house.

1. On Francis, see Alfred Frankenstein, *After the Hunt* (Berkeley and Los Angeles, 1953), pp. 135-137; *A Catalogue of Paintings by John F. Francis* (Lewisburg PA, 1958); William H. Gerdts and Russell Burke, *American Still-Life Painting* (New York, 1971), pp. 60-61; William H. Gerdts, *Painters of the Humble Truth* (Columbia and London, 1981), pp. 99-101; *A Suitable Likeness: The Paintings of John F. Francis 1832 - 1879* (Lewisburg PA, Packwood House Museum, 1986).

2. On the relation between improved standards of living and the still-life market, see Gerdts, p. 60.

3. On the earlier paintings, see *American Paintings in the Detroit Institute of Arts* (Detroit, Detroit Institute of Arts, 1991), vol. 1, pp. 99-100.

55 (plate 22, page 37)
S EVERIN R OESEN
(ca. 1814 Cologne? – ?)

Still Life – Flowers in a Basket

Oil on canvas, 30 x 40¼ in. (76.2 x 102.2 cm)
M. and M. Karolik Fund. 69.1228

Provenance: Vose Galleries, Boston.

Exhibitions: Brockton MA, Brockton Art Center, *The Good Things in Life: Nineteenth-Century American Still Life*, March 8 - April 29, 1973.

Literature: Judith Hansen O'Toole, *Severin Roesen* (Lewisburg, 1992), fig. 37.

In a wicker basket on a dark marble slab, Roesen has painted a variety of flowers including lilacs, peonies, morning glories, primroses, and tulips.

Roesen painted about three to four hundred still lifes during his career, but little is known of his life. Evidence suggests that he trained as a porcelain painter in Germany and that he exhibited a still life at an art club in Cologne in 1847 before he fled Germany's political turmoil in 1848. For the next nine years, he lived, exhibited, and developed a following among collectors and artists in New York. In 1857, he left for Pennsylvania, eventually settling in Williamsport in 1862. A downturn in the New York art market, the result of trouble in the City's economy, apparently prompted the move. Pennsylvania offered not only a sizeable German community but also potential clients who had prospered by the booming lumber industry. It appears that Roesen remained in Williamsport until 1872. What happened to him after that remains a mystery, but reports that he returned to New York or that he died in a Philadelphia almshouse have proven unfounded.[1]

According to anecdotal evidence, Roesen painted portraits, but only his still lifes have survived. These consist of flowers and fruit and combinations thereof usually placed on a white or dark marble slab against a plain background. With its bright colors, crisp drawing, and wealth of detail, the Boston canvas is typical of Roesen's style. His training as a porcelain painter probably influenced his approach to still life,[2] but his work is clearly an extension of the fruit and flower pieces of late seventeenth- and early eighteenth-century Dutch artists like Jan van Huysum, Rachel Ruysch, and Maria van Oosterwijck. He may have known those still lifes first hand or through the work of Jacob Preyer who kept that tradition of still-life

painting alive in nineteenth-century Düsseldorf.

Roesen's work defies a chronology. He dated only about two dozen of his paintings and those display discernible pattern in the choice of objects.[3] It is unlikely that Roesen painted directly from the model since it is difficult, even impossible to replicate his arrangements with actual objects and he often combined flowers and fruits that bloomed at different times of the year. William Gerdts has speculated that Roesen used popular prints or botanical drawings as models or studies that he himself made.[4]

It is unsurprising that Roesen's work attracted buyers and many imitators since the ground had been laid in the United States for an art such as his. Dutch still lifes had been exhibited in New York, Philadelphia, and Boston and the art of the Düsseldorf school had shaped the taste and style of American collectors and painters.[5] Moreover, Roesen's images of natural abundance, it has been argued, probably struck a chord with the growing American middle class who might well have understood them as emblems of their own prosperity, plenitude, and well-being.[6]

1. The most recent discussion of Roesen's biography can be found in Judith Hansen O'Toole, *Severin Roesen* (Lewisburg, 1992), pp. 13-22.

2. Ibid., p. 23. O'Toole points out that porcelain painters were often also trained in oil painting.

3. On Roesen's style and the problem of chronology, see Lois Goldreich Marcus, *Severin Roesen: A Chronology* (Lycoming County Historical Society and Museum, 1976).

4. William H. Gerdts, *Painters of the Humble Truth* (Columbia and London, 1981), pp. 87-88.

5. Ibid., pp. 88-89.

6. Ibid., p. 87. For an interesting response to this argument, see Norman Bryson, "In Medusa's Gaze," in *In Medusa's Gaze: Still-Life Paintings from Upstate New York Museums* (Rochester, Memorial Art Gallery, 1991), pp. 18-19. Bryson argues that "Abundance, with Roesen, is essentially plural or multiple: the idea of prosperity emerges fully only when objects are seen to replicate identically and in great numbers. It is as though the mid-century's sense of the industrial object, based on mechanical repetition and seriality, had been ingrained so deeply that nature itself could seem abundant only if it exhibited the same scale and rhythmic pattern." Bryson distinguishes Roesen's still lifes from the images of abundance in Netherlandish still life where, he asserts, each object is depicted as individual and unique one. Bryson's characterization of Dutch still life is painted perhaps with too broad a brush since some Dutch and Flemish artists also multiplied virtually identical fruits.

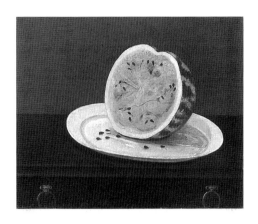

56
Anonymous American

Watermelon, 1855

Oil on canvas, 22 x 27½ in. (55.9 x 69.8 cm)
Gift of Maxim Karolik for the M. and M. Karolik
Collection of American Paintings, 1815-1865. 48.410

Provenance: Victor Spark, New York.

Exhibitions: Hartford, Wadsworth Atheneum, *Forty-Two Karolik Paintings*, May 15 - July 14, 1963; Beijing, Zhong-guo Meishuguan, *American Paintings from the Museum of Fine Arts, Boston*, September 1 - 20, 1981 and Shanghai, Shanghai Bowuguan, October 20 - November 19, 1981, no. 23.

Literature: *M. and M. Karolik Collection of American Paintings, 1815-1865* (Boston, Museum of Fine Arts, 1949), pp. 64-65 ill.

In the mid-nineteenth century, folk painting, the problematic term commonly used to denote works by unschooled or little-trained professionals,[1] found a committed clientele in the lower- to upper-middle classes – trades-men, merchants, doctors, and lawyers eager to decorate their houses with pictures that provided permanent records of the people they knew, objects they used, and places they lived. Though they were less expensive than canvases by trained artists, folk paintings nonetheless served as tangible evidence of their owners' economic well-being.

In this painting the awkward attempt to model forms, to develop space three-dimen-sionally, and to imitate the colors and tex-tures of the various objects indicate that its painter, who is unknown, was aware of but little practiced in the academic methods basic to American artistic training in the nine-teenth century. At the same time the clumsy negotiation of the table, oddly shaped plate, and watermelon as well as the skewed table top contribute to the work's charm. Though

the artist did not deliberately intend them, the distortions in the space of the picture and shapes of the objects also give the work a peculiarly modern appeal. Those distortions, which are typical of folk art generally, explain in part the revival of interest in studying, col-lecting, and exhibiting this art beginning in the 1920s when aesthetic sensibilities shaped by exposure to the works of Cézanne and other Post-Impressionist and Cubist artists were receptive to the folk painter's stark, direct style. Paradoxically the current popu-larity of folk paintings has put them beyond the financial reach of the very kinds of people for whom they were originally made.

Although European still lifes rarely feature watermelons, they were common in both folk and fine art in the United States. They were, for example, a favored fruit among members of the Peale family, appearing in still lifes by Raphaelle and James Peale as well as pictures by Margaretta Angelica Peale and Sarah Miriam Peale. The watermelon's desir-ability as a still-life object was two-fold. With its mottled green rind, pink flesh, and dark brown seeds, it offered the painter a variety of colors and textures. Moreover, watermelon was a popular American food. The seeds of the watermelon, which originated in Africa, were brought to the United States by slave traders as well as slaves and cultivated throughout the country. Although derogato-ry associations between African-Americans and watermelons became commonplace in the later decades of the nineteenth century, they were rare at the time this still life was painted.[2] The watermelon, instead, was con-sumed by members of all classes during the summer when its cool, wet pulp proved most refreshing. In addition to eating the water-melon flesh, people pickled the rind, particu-larly in New England, and boiled the fruit to make sugar and molasses.[3]

1. On the problems of the various terms which include provincial, naive, and primitive, see John Michael Vlach, *Plain Painters* (Washington and London, 1988), pp. xiii-xiv.

2. *M. and M. Karolik Collection of American Painting, 1815-1865* (Boston, Museum of Fine Arts, 1949), p. 64. The date 1855 is faintly scratched on the wooden stretcher of the picture, a date supported by the condition of the canvas and the paint.

3. Information on the history of the watermelon was provided by William Watson, executive director of the National Watermelon Promotion Board. On the deroga-tory associations between African-Americans and water-melons see Peter H. Wood and Karen C. C. Dalton, *Winslow Homer's Images of Blacks* (Austin, 1989), p. 122 n. 192.

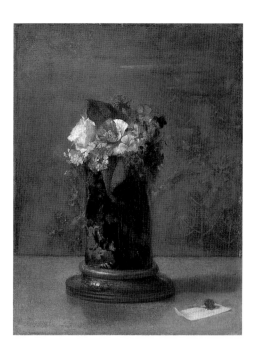

57
JOHN LA FARGE
(1835 New York – 1910 Providence, Rhode Island)

Vase of Flowers, 1864

Oil on gilded panel, 18¼ x 14 in. (47 x 35.6 cm)
Signed lower right on calling card: *J. LaFarge/1864*
Gift of Louisa W. and Marian R. Case. 20.1873

Provenance: James Brown Case, Boston before 1907.

Exhibitions: Worcester MA, Assumption College, *John La Farge*, December 7, 1956-January 4, 1957, no. 1; Washing-ton D.C., National Museum of American Art, *John La Farge*, July 10-October 12, 1987 and Pittsburgh PA, Carnegie Museum of Art, November 7, 1987-January 3, 1988, Boston, Museum of Fine Arts, February 24-April 24, 1988, no. 10.

Literature: Wolfgang Born, *Still Life Painting in America* (New York, 1947), p. 41, pl. 109; R. B. Katz, *La Farge as Painter and Critic*, Ph. D. diss., Radcliffe, 1951, p. 68, fig. 17; Kathleen A. Foster, "The Still-Life Paintings of John La Farge," *The American Art Journal* 11/3 (July 1979), p. 18 ill.

Though best known for his murals and stained glass, La Farge was also a prolific painter, frequently of still lifes.[1] One of the best educated and most eclectic of American nineteenth-century artists in his choice of sources, subjects, and media, he came from a cosmopolitan and prosperous family of French emigrés. He received some instruc-tion in drawing and painting while growing up in New York, but seemed destined – at least in his family's mind – to be a lawyer. During an 1856 visit to relatives in Paris, he studied briefly with Thomas Couture, one of

the reigning academic painters of the day, whose work nonetheless influenced a number of important avant-garde artists including Edouard Manet. Back in the United States, he settled on a career as an artist and enrolled in William Morris Hunt's school in Newport RI., in 1859. La Farge painted his first still life that same year. With its expensive and crisply delineated objects, *Still Life: Study of Silver, Glass, and Fruit* (ex-Collection of Charles D. Childs) had something in common with the canvases of Severin Roesen (cat. 55) and John Francis (cat. 54), two of mid-century America's most popular still-life painters. After that one attempt to imitate contemporary trends, La Farge developed his own approach to the genre, usually favoring a few simple objects and flowers painted in a loose, sketchy manner like that of the Boston panel. Here he suggests flowers of varied colors and shapes but does not clearly describe or differentiate between them. He derived his painterly style from a variety of sources including the work of his teacher Couture, Théodore Chassériau, Gustave Moreau, and Barbizon painters like Diaz. His style also realized Hunt's teaching that the painter should seek "an impression of the whole thing" rather than belabor details.

La Farge typically mixed references to different schools and periods of art. The slightly flattened space and asymmetrical arrangement of the Boston panel reveals his enthusiasm for Japanese culture, a fascination dating to the early 1860s when he began collecting Japanese prints. The painting in the background, most likely a section of a screen, also invokes Japanese models, though it cannot be connected to any known example.[2] While the colors of the vase parallel those of the screen, its shape does not correspond with any kind of Japanese or Chinese porcelain or ceramic ware and more nearly resembles a classical column.

In previous pictures, La Farge had set his flowers before a window opening onto a tract of land or water to make the setting more natural.[3] In the Boston panel, however, he uses that device to an opposite effect, intensifying the sense of artifice by depicting a landscape painting whose features are sketchily indicated on a surface of gold leaf, which La Farge has applied to the panel, making it as much a rare and valuable object as a still-life painting. The otherworldly gold along with the elliptical handling, hazy light, and exotic objects, create an air of mystery which is

heightened by the intimation of a story. A calling card bearing La Farge's name rests beneath a wilting red bachelor's button, one of the few flowers in the work that La Farge has painted with any specificity. Together card and flower offer the tantalizing ingredients of a narrative whose plot remains beguilingly obscure.

To critics more disposed to Roesen's botanical exactitude or Francis's images of abundance, La Farge's esoteric references, handling, and spare arrangements were an enigma. An anonymous critic writing for the (New York) *Tribune* in 1864 dismissed them as mere "blots of color."[4] To James Jackson Jarves, the American collector of Italian Gothic and Early Renaissance painting and a committed advocate of La Farge's work, however, his paintings of flowers "were an exhibition of the flowers' highest possibilities of being rather than their present material organization. However beautiful this may seem to the eye, La Farge makes his subject present a still more subtle beauty to the mind, which finds in it a relationship of spirit as well as matter. This phase of art is rare in any school."[5]

1. On La Farge's still lifes, see Kathleen A. Foster, "The Still-Life Paintings of John La Farge," *The American Art Journal* 11/3 (July 1979), pp. 4-37 and on La Farge's career generally, Royal Cortissoz, *John La Farge* (New York, 1911) and Henry Adams et al., *John La Farge* (Pittsburgh, The Carnegie Museum of Art and Washington, D.C., National Museum of American Art, 1987).

2. My thanks to Ping Foong of the Department of Asiatic Art for looking at the objects in the picture.

3. For example *Flowers in a Persian Porcelain Water Bowl* (ca. 1861; Washington D.C., Corcoran Gallery of Art).

4. Quoted in Foster, p. 19.

5. James Jackson Jarves, "Museums of Art, Artists, and Amateurs in America," *Galaxy* 10 (July 1870), p. 54. Quoted in Theodore E. Stebbins, Jr., Carol Troyen, and Trevor J. Fairbrother, *A New World: Masterpieces of American Painting 1760-1910* (Boston, Museum of Fine Arts, 1983), p. 280.

58

MARTIN JOHNSON HEADE

(1819 Lumberville, Pennsylvania – 1904 St. Augustine, Florida)

Vase of Mixed Flowers, ca. 1865-75

Oil on canvas, 17¼ x 13¾ in. (43.8 x 35 cm)
Signed lower right: *M. J. Heade*
Bequest of Martha C. Karolik for the M. and M. Karolik Collection of American Paintings, 1815-1865. 48.427

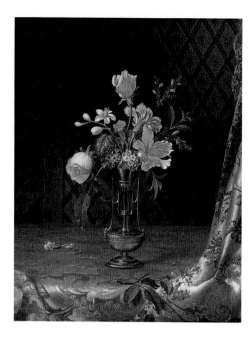

Provenance: With A. F. Mondschein, New York.

Exhibitions: New York, M. Knoedler & Co., *Commemorative Exhibition: Paintings by Martin J. Heade and Fitz Hugh Lane from the Private Collection of Maxim Karolik and the M. and M. Karolik Collection of American Paintings from the Museum of Fine Arts, Boston*, 1954, no. 12; Hamilton, Ontario, The Art Gallery of Hamilton, *The Realist Tradition in American Painting*, March 11 - April 23, 1961; College Park MD, University of Maryland, *Martin Johnson Heade*, September 14 - October 23, 1969 and Boston, Museum of Fine Arts, July 9 - August 24, 1969, New York, Whitney Museum of American Art, November 10 - December 21, 1969, no. 23.

Literature: Charles M. Skinner, *Catalogue of Works of Art of William B. Bement* (Philadelphia, 1884), n.p. ill.; Wolfgang Born, *Still Life Painting in America* (New York, 1947), fig. 71; Robert G. McIntyre, *Martin Johnson Heade* (New York, 1948), pl. 16; M. & M. Karolik Collection of American Paintings, 1815-1865 (Cambridge MA, 1949), p. 307 ill.; Richard B. K. McLanathan, *Martin J. Heade as Represented in the M. & M. Karolik Collection of American Paintings, 1815-1865* (Boston, 1955), fig. 3; *American Paintings in the Museum of Fine Arts, Boston* (Boston, 1969), vol. 1, no. 506 and vol. 2, fig. 326; Theodore E. Stebbins, Jr., *The Life and Works of Martin Johnson Heade* (New Haven and London, 1975), pp. 116-117 and no. 143; Doreen Bulger, Marc Simpson, and John Wilmerding, eds., *William M. Harnett* (New York, Metropolitan Museum of Art, 1992), p. 77 ill.

Today Heade is probably best known for his pictures of orchids, magnolias, water lilies, and other flowers in which he focused on one, two, or three blooms.[1] Painted life size in a natural setting, their forms are often sexually suggestive. Throughout his life, however, he also painted more conventional flower pieces in keeping with Victorian taste. With its simple arrangement of flowers in a delicate vase set on a covered table, the present

work, which probably dates to the late 1860s or early 1870s, typifies those canvases.

Though Heade deliberately selected flowers that allowed him to work with different shapes, textures, and colors, the arrangement does not appear contrived, and though the flowers may not be overtly erotic, Heade nonetheless recognized their expressive possibilities. Thus the rose seems to reach upwards and tentatively open its leaves outward, while the stamens shoot out from the fully open leaves of the azalea. Heade probably also chose the flowers with an eye towards their symbolism since he was well aware of the vogue in Victorian America for assigning meanings to various flowers, particularly ones associated with the traits and character of women. Contemporary viewers familiar with the language of flowers might therefore have read the heliotrop and orange blossom as signs of devotion and purity respectively and equated the rose with love. The carnation, on the other hand, conventionally signified disdain and heather indicated solitude – neither desirable qualities in women in that period.[2]

1. The best source of information on Heade is Theodore E. Stebbins, Jr., *The Life and Works of Martin Johnson Heade* (New Haven and London, 1975).

2. On the vogue for flower symbolism and on the meanings of the flowers in the Boston canvas, see Stebbins, pp. 116-126.

59 (plate 25, page 40)

MARTIN JOHNSON HEADE

(1819 Lumberville, Pennsylvania – 1904 St. Augustine, Florida)

Orchids and Hummingbird, ca. 1875-85

Oil on canvas, 14⅛ x 22⅛ in. (35.9 x 56.2 cm)
Signed lower right: *M.J. Heade*
Gift of Maxim Karolik for the M. and M. Karolik Collection of American Paintings, 1815-1865. 47.1164

Provenance: With David David, Philadelphia; with A. F. Mondschein, New York, 1944; with Newhouse Galleries, New York, 1944; with Macbeth, New York; Stephen C. Clark, New York; with Macbeth, New York, 1946; Maxim Karolik.

Exhibitions: New York, M. Knoedler & Co., *Commemorative Exhibition: Paintings by Martin J. Heade and Fitz Hugh Lane from the Private Collection of Maxim Karolik and the M. & M. Karolik Collection of American Paintings from the Museum of Fine Arts, Boston*, 1954, no. 23; Philadelphia, Philadelphia Museum of Art, *A World of Flowers*, 1963, p. 155 ill.; New York, American Federation of Arts, *A Century of American Still Life Painting*, October 1966-November 1967, no. 27; College Park MD, University of Maryland, *Martin Johnson Heade*, September 14 - October 23, 1969,

Boston, Museum of Fine Arts, July 9 - August 24, 1969, New York, Whitney Museum of American Art, November 10 - December 21, 1969, no. 36.

Literature: Wolfgang Born, *Still Life Painting in America* (New York, 1947), fig. 72; Robert G. McIntyre, *Martin Johnson Heade* (New York, 1948), p. 10; *M. & M. Karolik Collection of American Paintings, 1815-1865* (Cambridge, MA, 1949), pp. 308-309 ill; Richard B. K. McLanathan, *Martin J. Heade as Represented in the M. & M. Karolik Collection of American Paintings, 1815-1865* (Boston, 1955) fig. 13; Theodore E. Stebbins, Jr., *The Life and Works of Martin Johnson Heade* (New Haven and London, 1975), pp. 143, 145 and no. 222 ill.; Ella M. Foshay, "Charles Darwin and the Development of American Flower Imagery," *Winterthur Portfolio* 15 (winter 1980), pp. 299-300 ill.

Heade conceived the two principal motifs of his hummingbird and orchid pictures separately. He first painted hummingbirds during a trip to Brazil in 1863-64, while his fascination with orchids came somewhat later, during an 1870 trip to Jamaica where he sketched the flower. In 1871, back in his New York studio, he put bloom and bird together, painting more than twenty five hummingbird and orchid pictures over the course of his career, all according to a similar format consisting of birds and flowers in the foreground set in a lush, often misty tropical forest. Heade's orchids, which are painted life-size, are noteworthy for their botanical exactitude, and in all likelihood, he based his paintings on sketches of actual orchids which were grown by collectors in New York and Boston. His hummingbirds, by contrast, are usually composites of various birds.[1]

While *Vase of Mixed Flowers* (cat. 58) catered to Victorian taste, Heade's orchids ignored the era's strict sexual mores. The resemblance between the flower's labellum and the female genitalia, the orchid's renown as an aphrodisiac, and the meaning of its name – orchis is the Greek work for testicle – may explain why the Victorian world avoided the flower, neither depicting it in contemporary prints or paintings nor mentioning it in contemporary books on flower symbolism. Here as in many of the pictures, Heade exploits the sensual qualities of the bloom, bringing it close to the picture plane where twisting and undulating on its stem, it opens its petals to the viewer. Though he exhibited his orchid pictures widely in the 1870s and 1880s, period critics all but ignored them, at a loss perhaps for acceptable ways of describing them.

In depicting the orchids in their natural setting – growing from trees or the ground in

the tropical forests where they were most plentiful – Heade invented a new kind of flower picture, one completely outside the conventions favored by his American contemporaries. Ella Foshay has linked Heade's approach to the increasing importance of John Ruskin's naturalist aesthetics as well as Darwin's evolutionary theories with their emphasis on natural rather than divine origins.[2] Yet to reduce Heade's pictures to scientific treatises or to appreciate them merely for their sexual suggestiveness is to miss their complexity. As Theodore Stebbins observes, the old categories – still life, landscape, romantic, realist – are of little help in interpreting Heade's pictures. In their place, he proposes the terms that Hawthorne devised to describe his writing: "a neutral territory, somewhere between the real world and fairyland, where the Actual and the Imaginary may meet, and each imbue itself with the nature of the other."[3]

1. The best source of information on the orchid and hummingbird pictures is Theodore E. Stebbins, Jr., *The Life and Works of Martin Johnson Heade* (New Haven and London, 1975), pp. 126-154. Heade was versed in ornithology and referred to Gould's *A Monograph of the Trochilidae, or Family of Hummingbirds*, 5 vols. (London, 1849-1861) in his notebook on hummingbirds.

2. Ella M. Foshay, "Charles Darwin and the Development of American Flower Imagery," *Winterthur Portfolio* 15 (winter 1980), pp. 299-314.

3. Quoted in Stebbins, p. 148.

60

JAMES REEVE STUART

(1834 Beaufort, South Carolina – 1915 Madison, Wisconsin)

Sword, Pistols, and Teacup

Oil on canvas, 20 x 24 in. (50.8 x. 61 cm)
Bequest of Martha C. Karolik for the M. and M. Karolik Collection of American Paintings, 1815-1865. 48.478

Provenance: John Levy, New York until 1944; M. and M. Karolik, Newport, RI.

Exhibitions: Bloomfield Hills MI, Cranbrook Academy of Art Museum, *Genre, Portrait, and Still-Life Painting in America: The Victorian Era*, August 26 - September 30, 1973; St. Louis, St. Louis Art Museum, *Currents of Expansion: Painting in the Midwest 1820 - 1940*, February 18 - April 10, 1977, no. 55.

Literature: *M. and M. Karolik Collection of American Paintings, 1815 - 1865* (Boston, Museum of Fine Arts, 1949), pp. 482-483 ill.

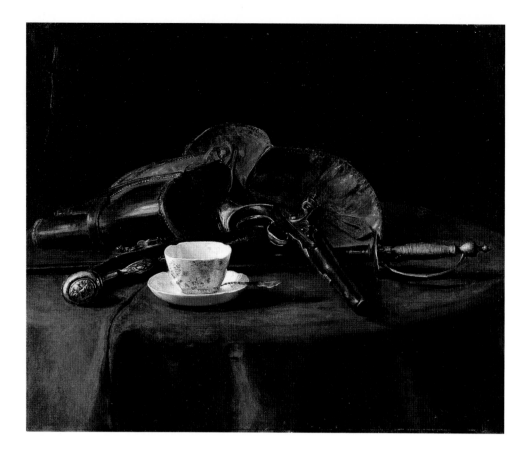

61 (plate 23, page 38)

JOHN FREDERICK PETO

(1854 Philadelphia – 1907 Island Heights, New Jersey)

Old Time Letter Rack, 1894

Oil on canvas, 30 x 25 in. (76.2 x 63.5 cm)
Signed and dated lower right: *John F. Peto/94*
Bequest of Maxim Karolik. 64.411

Provenance: Dr. Ill, New Jersey, about 1894; Edward Ill, Southampton, L.I.; Maxim Karolik, 1952.

Exhibitions: Philadelphia, Pennsylvania Academy of Fine Arts, *150th Anniversary Exhibition*, January 15 - March 13, 1955, no. 177; Ogunquit ME, Museum of Art of Ogunquit, *Eighth Annual Luminist and Trompe l'Oeil Painters*, 1960, no. 21; La Jolla, La Jolla Museum of Art, *The Reminiscent Object*, July 11 - September 19, 1965 and Santa Barbara, Santa Barbara Museum of Art, September 28 - October 31, 1965, no. 44; Brockton MA, Brockton Art Center, *The Good Things in Life: Nineteenth-Century American Still Life*, March 8 - April 29, 1973; Washington D.C., *Important Information Inside*, January 16 - May 23, 1983 and Fort Worth, Amon Carter Museum, July 15 - September 18, 1983, no. 184.

Literature: Alfred Frankenstein, *After the Hunt* (Berkeley and Los Angeles, 1953), pp. 17 note 12, 108 ill.; Alfred Frankenstein, "Harnett, Peto, Haberle," *Artforum* 4/2 (October 1965), p. 29 ill.; John Canaday, "Painters Who Put the Real World into Sharp Focus," *Smithsonian* 12/7 (October 1981), p. 75 ill.

Stuart has depicted a porcelain teacup, saucer, and spoon; a pair of early eighteenth-century Queen Anne flintlock holster pistols; a sword, and a brown leather pistol case against a dark brown background.

Stuart, who came from a wealthy Southern family, attended the University of Virginia in 1852 and enrolled at Harvard in 1853 but did not graduate. During his time in Cambridge, he frequently visited the Boston studio of Joseph Ames, a specialist in portraits. In the late 1850s, he traveled to Germany to study art and became only the third American to enter the Royal Academy of Art in Munich when he enrolled in 1860. When the Civil War depleted his family's resources, Stuart was forced to return to the United States. He opened his first studio in Atlanta, moved to Memphis and then St. Louis before settling in Madison, Wisconsin, in 1872 where he taught at Milwaukee College and the University of Wisconsin, but earned a living mainly from portrait painting.[1] Since Stuart's work has not been systematically studied, it is not known whether he painted many still lifes. Though he lived some distance from the centers of American artistic life on the East coast, the selection of objects and realistic style of the Boston canvas suggests his aware-

ness of contemporary currents in American still-life painting, particularly the tabletop still lifes of William Harnett who in the later nineteenth century often depicted valuable man-made objects, reflecting the Victorian vogue for collecting small objects, bric-a-brac, and antiques.[2]

Because so little is known of Stuart's life, one can only speculate on his motives for selecting the particular objects that appear in the Boston canvas. At first glance, it seems that he chose them for their opposite meanings and associations. Thus the delicate feminine teacup representing the domestic sphere evokes images of genteel social occasions, while the guns and sword signal the masculine arenas of fighting and hunting. It is also possible that the objects were family heirlooms belonging either to Stuart, who came from an aristocratic family, or to a client. In this view, the still life becomes a kind of portrait of an individual enacted through the "sitter's" possessions.

1. For biographical information about Stuart, see Porter Butts, *Art in Wisconsin* (Madison, 1936), pp. 216-219.

2. William H. Gerdts, *Painters of the Humble Truth* (Columbia and London, 1981), pp. 153-154.

Peto, the son of a gilder of picture frames and dealer in Philadelphia, was virtually unknown during his life time. He exhibited irregularly in the annual exhibitions of the Pennsylvania Academy of Fine Arts, where he studied briefly and became friends with William Harnett whose trompe l'oeil still lifes probably inspired Peto's. He continued to paint after he moved in 1889 to Island Heights, a resort area in New Jersey, but rarely showed his works outside the town. Due to his self-imposed exile from the professional art world, much about the artist's life and artistic beliefs remains a mystery beyond basic biographical facts gleaned mostly from public records and anecdotal information provided by family and friends.[1]

His earliest known rack picture dates to June 1879, and it is the one format in which he seems to have preceded Harnett who executed his first rack image two months later. Peto painted rack pictures until 1885, and again from 1894 to 1904. The later pictures are generally bolder in design because he reduced the rack to two crossed lines inside a square and broadened the width of the tapes. While there are scattered examples of rack paintings in earlier nineteenth-century American art,[2] inspired in all likelihood by rack

paintings from seventeenth- and eighteenth-century Dutch, German, and French art, today it is Peto's name which is most often linked with the format in the United States. Although he executed several of his earlier canvases for specific individuals or as signs for businesses,[3] the objects in his later canvases, including the present work, are more autobiographical. While many rack pictures by Peto and others incorporated photographs of well-known individuals, Alfred Frankenstein proposed that Peto's use of Lincoln's portrait, which appears in many of his later paintings, had significance beyond observing a pictorial convention or paying homage to Lincoln's role in American politics. He has argued that Peto identified Lincoln with his recently deceased father who often told his son stories of his service in the Civil War.[4] The envelopes are also related to Peto's life for their postmarks record the places where the artist lived and visited – Philadelphia, Island Heights, and Laredo, Ohio, the home of Peto's wife. The fourth postmark is barely legible, but Frankenstein read it as Shickshinny, Pennsylvania,[5] a town where some of Peto's friends resided.

Although the references in this and other later works are more personal, the value and meaning of the discarded paraphernalia in Peto's life is inscrutable. That seems intentional on the painter's part for he has left the cover of the book blank, made the aged clippings illegible, and torn the addresses from the envelopes. Thus, he simultaneously invites us into and bars us from his private world. Moreover, the objects that he includes – a mass produced photograph, a ticket, envelopes, newspaper clippings, and a calling card – are all related on some level to transmitting information and facilitating interaction. Paradoxically, the way that they are rendered in this work occludes communication.

In its repertory of objects and its design, the Boston canvas resembles *Old Letter Rack* (New York, Museum of Modern Art) also of 1894. That canvas, like many by Peto, was originally given to Harnett, though Peto's style differs markedly from Harnett's style of trompe l'oeil.[6] The edges of Peto's objects are soft and painterly, the colors, muted and powdery, and the space and volumes, relatively flat. Where Harnett aimed to conceal the medium in order to achieve an image that appeared photographically real, Peto revealed that conceit, distinguishing the painter's skills and materials from those of the engraver,

typographer, and photographer whose work is so abundantly represented in the images of the painting.

1. On Peto's life and work, see Alfred Frankenstein, *After the Hunt* (Berkeley and Los Angeles, 1953), pp. 83-111 and John Wilmerding, *Important Information Inside* (Washington, National Gallery of Art, 1983).

2. On the history of rack paintings in earlier American art, see William H. Gerdts, "A Deception Unmasked: An Artist Uncovered," *American Art Journal* 18/2 (1986), pp. 4-23.

3. On Peto's clients, see Wilmerding, p. 205.

4. Frankenstein, p. 207.

5. Alfred Frankenstein, memo to Museum file, January 2, 1953.

6. On the attribution of Peto's works to Harnett, see Frankenstein, pp. 3-24.

62 (plate 24, page 39)

JOHN FREDERICK PETO

(1854 Philadelphia – 1907 Island Heights, New Jersey)

The Poor Man's Store

Oil on canvas and wood, 35½ x 25⅝ in.
(90.2 x 65.1 cm)
Signed and dated upper left: *J.F. Peto/ 85*
Gift of Maxim Karolik for the M. and M. Karolik Collection of American Paintings, 1815-1865. 62.278

Provenance: Family in East Orange, N.J.; Mrs. Raymond Dey, New Jersey about 1940; John Kenneth Byard, Silvermine CT; Miss Mary Allis, Fairfield CT about 1943; Albert Duveen, New York; Maxim Karolik in 1951.

Exhibitions: Northampton, Smith College Museum of Art, *John F. Peto*, March 1 - 24, 1950, Brooklyn, Brooklyn Museum of Art, April 11 - May 21, 1950, and San Francisco, California Palace of the Legion of Honor, June 10 - July 11, 1950, no. 4; New York, Wildenstein and Co., *Landmarks of American Art, 1679 - 1950*, 1953, no. 32; New York, American Federation of Arts Travelling Exhibition, *Harnett and His School*, 1953-54; Detroit, Detroit Institute of Arts, *Painting in America*, April 23 - June 9, 1957, no. 140; Toronto, Art Gallery of Ontario, *American Painting from 1865 - 1905*, 1961 and Winnipeg, Winnipeg Art Gallery, Vancouver, Vancouver Art Gallery, New York, Whitney Museum of American Art, no. 51; Hartford, Wadsworth Atheneum, *Forty-Two Karolik Paintings*, 1963; Flushing Meadow, Gallery of Better Living Center - World's Fair, *Four Centuries of American Masterpieces*, April 15 - October 31, 1964; New York, Metropolitan Museum of Art, *Nineteenth Century America*, April 16 - September 7, 1970, no. 181; Philadelphia, Philadelphia Museum of Art, *Three Centuries of American Art*, April 1 - September 30, 1976, no. 359; Washington D.C., National Gallery of Art, *Important Information Inside*, January 16, 1983 - May 29, 1983 and Fort Worth, Amon Carter Museum, July 15 - September 18, 1983, no. 86; Boston, Museum of Fine Arts, *The Great Boston Collectors: Paintings from the Museum of Fine Arts*, February 13 - June 2, 1985, no. 94

Literature: Alfred Frankenstein, *After the Hunt* (Berkeley and Los Angeles, 1953), pp. 101-102 ill.; E. P. Richardson, *Painting in America* (New York, 1956), pp. 322-3 ill.; T. N. Maytham, "Some Recent Accessions," *Bulletin of the Museum of Fine Arts* 60/322 (1962), pp. 137-138 ill.; *100 Paintings from the Boston Museum* (Greenwich, 1970), pp. 129, 131 ill.; Milton W. Brown, *American Art to 1900* (New York, 1977), p. 541 ill.; Theodore E. Stebbins, Jr., and Peter C. Sutton, *Masterpiece Paintings from the Museum of Fine Arts, Boston* (New York, 1986), p. 118 ill.; Olaf Hansen, "The Senses of Illusion," in Thomas W. Gaehtgens and Heinz Ickstadt eds., *American Icons: Transatlantic Perspectives on Eighteenth and Nineteenth Century American Art* (Santa Monica, 1992), pp. 281-282 ill.

Poor Man's Store, among the most famous of all American trompe l'oeil still lifes, is one of the few extant works from Peto's years in Philadelphia. Peto painted an earlier version of *Poor Man's Store* and exhibited it at the Pennsylvania Academy of Fine Arts in 1880. That canvas is now lost, but the description of it in the *Philadelphia Record* suggests it was almost identical to the Boston canvas, though the later work does not include a copy of the *Record*, the detail that probably caught the reviewer's attention. It was said of the earlier work:

> Mr. John F. Peto contributes to the present annual exhibition of the Pennsylvania Academy of the Fine Arts a study of still life, entitled the "Poor Man's Store," which cleverly illustrates a familiar phase of our street life, and presents upon canvas one of the most prominent of Philadelphia's distinctive features. A rough, ill-constructed board shelf holds the "Poor Man's Store" – a half dozen rosy-cheeked apples, some antique gingerbread, a few jars of cheap confectionary "Gibralters" and the like, and, to give all a proper finish and lend naturalness to the decorative surroundings of the goods, a copy of The Record has been spread beneath.[1]

For the writer, the painting's appeal turned on its typical subject and realistic style. Yet unlike other reactions to trompe l'oeil paintings, the *Record*'s reviewer did not believe that he was seeing an actual store-front, for unlike John Haberle and William Harnett (cats. 64-63), Peto never completely deceived.[2] Instead, he generally structured his work with two voices: the declarative, explicit one that insists on the plausibility of communicating facts and certainty (trompe l'oeil's usual mode of address) and an elliptical one in which images are rendered to

allow for interpretation, multiple meanings, and ambiguity. Thus a spectral jar hides in the shadows behind the gingerbread horse on the upper shelf and a candy cane seems to float in thin air in the background of the lower one. The words "good board" on the sign below the window mean several different things: the availability of lodging, the material from which the window is supposedly made, and the actual wooden plank attached to the painted window. While many trompe l'oeil artists conceal the means they use to make their pictures, crafting a perfect illusion, Peto includes references to the process of conversion, of turning one thing into another. Sugar is spun into striped confections; dough is shaped to resemble a horse. A cloth canvas becomes a window, and a window a storefront. The glass jar on the lower shelf bares a streak of white, reading as a glint of light one moment and as a daub of paint the next.

1. Quoted in Alfred Frankenstein, *After the Hunt* (Los Angeles and Berkeley, 1953), p. 102.

2. For some typical reactions to trompe l'oeil painting in which the viewer initially believes the painting is a real object, see Paul J. Staiti, "Illusionism, Trompe L'Oeil, and the Perils of Viewership," in Doreen Bolger, Marc Simpson, and John Wilmerding eds., *William M. Harnett* (New York Metropolitan Museum of Art and Fort Worth, Amon Carter Museum, 1992), p. 32. Staiti argues that reactions to trompe l'oeil differed according to class, with those who considered themselves members of the elite maintaining their ability to distinguish the painting as a painting and dismissing trompe l'oeil as mere entertainment for the masses.

63 (plate 26, page 41)

WILLIAM MICHAEL HARNETT

(1848 Clonakilty, County Cork, Ireland – 1892 New York)

Old Models

Oil on canvas, 54 x 28 in. (137.2 x 71.1 cm)
Signed and dated at lower left: *WMHarnett/ 1892*
The Hayden Collection. 39.761

Provenance: William M. Harnett Estate; Harnett Estate Sale, Thomas Birch's Sons, Philadelphia, February 23 - 24, 1893, no. 27; with Knoedler, New York, fall 1893; A. Ludwig Collection Sale, Fifth Avenue Art Galleries, February 1 - 2, 1898, no. 93; William J. Hughes, Washington D.C.; with the Downtown Gallery, New York, 1939.

Exhibitions: Philadelphia, Earle's Galleries, *Paintings of the late W. M. Harnett*, 1892, no. 20; New York, M. Knoedler & Co., *Harnett*, 1893; St. Louis, St. Louis Exposition and Music Hall, *Thirteenth Annual Exhibition*, 1896, no. 221; London, Tate Gallery, *American Painting from the Eigh-*

teenth Century to the Present Day, 1946, no. 97; New York, Downtown Gallery, *Harnett Centennial Exhibition*, April 13 - May 1, 1948, no. 20; Washington D.C., Corcoran Gallery, *De Gustibus: An Exhibition of American Paintings Illustrating a Century of Taste and Criticism*, 1949, no. 32; San Francisco, California Palace of the Legion of Honor, *Illusionism and Trompe l'Oeil*, May 3 - June 12, 1949; New York, Whitney Museum of American Art, *American Painting*, 1954, no. 40; New York, American Federation of Arts, *American Painting in the Nineteenth Century*, 1953, no. 40; Berlin, Schloss Charlottenburg, *Amerikanische Malerei des 19. Jahrhundert*, 1953; Cincinnati, Cincinnati Art Museum, *Recent Discoveries in American Art*, 1955, no. 46; Washington D.C., St. Albans School, *St. Albans School's 50th Anniversary Celebration*, 1959, no. 20; Toronto, The Art Gallery of Ontario, *American Painting from 1865 to 1905*, January 5 - February 5, 1961 and Winnipeg, Winnipeg Art Gallery, February 17 - March 12, 1961, Vancouver, Vancouver Art Gallery, March 29 - April 23, 1961, New York, The Whitney Museum of American Art, May 17 - June 18, 1961, no. 31; Detroit, Detroit Institute of Arts, *Arts and Crafts in Detroit: The Movement, the Society, the School*, November 24 - January 16, 1977, no. 230; Boston, Museum of Fine Arts, *A New World: Masterpieces of American Painting, 1760-1910*, September 7 - November 13, 1983, Washington D.C., Corcoran Gallery of Art, December 6, 1983 - February 12, 1984, Paris, Grand Palais, March 16 - June 11, 1984, no. 73; New York, The Metropolitan Museum of Art, *William M. Harnett*, March 14 - June 14, 1992, Fort Worth, Amon Carter Museum, July 18 - October 18, 1992, San Francisco, The Fine Arts Museums of San Francisco, November 14 - February 14, 1993, and Washington D.C., The National Gallery of Art, March 14 - June 13, 1993, pl. 49.

Literature: "The Old Cupboard Door by William Michael Harnett," *Bulletin of the Museum of Fine Arts* 38/225 (February 1940), pp. 17-18 ill.; Alfred Frankenstein, *After the Hunt* (Berkeley and Los Angeles, 1953), pp. 15, 89 n. 57, 92-93, 95, 108, 174-175, and pl. 82; Albert T. Gardner, "Harnett's Music and Good Luck," *Metropolitan Museum of Art Bulletin* 25/5 (January 1964), p. 163 ill.; William Fleming, *Arts and Ideas* (New York, 1974), pp. 418 ill. - 419; Carol J. Oja, "The Still-Life Paintings of William Michael Harnett," *The Musical Quarterly* 63/4 (October 1977), pp. 513-515 ill, 523; Milton W. Brown, *American Art to 1900* (New York, 1977), p. 543 ill.; Nathan Goldstein, *Painting, Visual and Technical Fundamentals* (Englewood Cliffs, 1979), pl. 14; Bernard Dunstan, "Looking at Paintings," *American Artist* 44/461 (December 1980) pp. 74-75 ill.; Edward J. Sozanski, "Sleight of Hand from a Master Illusionist," *Antiques World* 3/5 (March 1981), pp. 44 ill. - 45; Alain Masson, "Le Sentiment de la profondeur dans la peinture et au cinema," *Revue de l'Université de Moncton* 15/2-3 (April - December 1982), pp. 70-71 ill.; Theodore E. Stebbins, Jr., and Peter C. Sutton, *Masterpiece Paintings from the Museum of Fine Arts, Boston* (New York, 1986), p. 119 ill.; Rudolf Arnheim, *To the Rescue of Art* (Berkeley, Los Angeles, and Oxford, 1992), pp. 70-71 ill., 72-73.

Harnett, the leading late nineteenth-century trompe l'oeil painter in the United States, came to Philadelphia in 1849 with his family, perhaps to escape the potato famine in his native Ireland. He trained as an engraver, but in 1875 he began to concentrate on painting,

which he had studied in night classes at the Pennsylvania Academy of the Fine Arts and later at the National Academy of Design and the Cooper Union in New York. His work, consisting mostly of tabletop still lifes featuring "masculine" objects such as smoking paraphernalia and drinking accessories, sold well enough to allow him to travel to Europe in 1880. After a few lackluster months in London where his work attracted little attention, he went to Frankfurt and then Munich, enrolling in the Royal Academy of Fine Arts in 1881. By this time, the Munich School's signature bold, dramatic brushwork and dark palette were giving way to a more refined, meticulous style well suited to Harnett's trompe l'oeil. Harnett spent his years in Munich perfecting his ability to capture fine detail and to paint smooth, polished surfaces that betrayed little evidence of the human hand. He also varied the formats of his still lifes and included more opulent objects. In 1885, he enjoyed some moderate critical success when he showed *After the Hunt* (San Francisco, The Fine Arts Museums of San Franciso) at the Paris Salon. After he returned to the United States in 1886, he kept mostly to himself, rarely submitting works to established exhibitions. Though he had many followers, he apparently took no students.[1]

Old Models, which Harnett had intended to send to the World's Columbian Exposition in Chicago in 1893, was the last still life that he painted before his untimely death at the age of forty-four. With its worn instruments, torn sheet music, tattered books, and aging Dutch jar, *Old Models* effuses an air of nostalgia, a common theme in Harnett's still lifes.[2] Muted colors and glowing tones enhance its retrospective cast, as do the multiple allusions of the work's title. Not only were the objects aged models, but they had also appeared in earlier pictures, making them previous models. The striking chiaroscuro, fine brushwork, and carefully observed detail of *Old Models*, moreover, recall the canvases and panels of the Old Masters, particularly seventeenth-century Dutch trompe l'oeil painters like C. N. Gijsbrechts (cat. 11), one of the originators of the cupboard door format.[3]

Old Models also alludes to older forms of behavior, modes of production, and values. At a time when many Americans were leaving rural farms to find jobs in the city, Harnett painted a Dutch jar displaying a simple agrarian scene. He depicted a violin and horn, the handmade works of individual

craftsmen, though machine-made goods were becoming the norm. And as more Americans were working longer hours, his instruments, sheet music, and books – not the latest pulp novels aimed at a mass audience but the classics, Homer's *Odyssey*, Shakespeare's tragedies, and an unidentified volume of Renaissance literature – espouse the values of leisure and reflection. That Harnett's style and objects are in many ways anachronistic does not mean that they were idiosyncratic; they might be seen as instances of what Eric Hobsbawm has termed the "invention of tradition," that fabrication and celebration of an idealized past in late nineteenth-century Europe and America intended to counter the economic, social, and political changes of that time.[4]

Though Harnett did not regularly exhibit his works, many of them hung in business establishments, making them accessible to a wide and varied audience. While ordinary viewers might feel estranged from the experiences and values his pictures embodied, they by all reports delighted in his deceptions, which, as Paul Staiti observes, allowed them to explore complex questions about perception.[5] Harnett, however, resented those who dismissed his still lifes as merely clever technical feats, contending "In painting from still life I do not closely imitate nature. Many points I leave out and many I add."[6] Though the highly realistic style suggests the picture corresponds with some material, verifiable fact, the arrangement is highly artificial. The angles of the bugle and sheet music, for example, deny the forces of gravity, and the violin's ability to remain on the ledge without falling forward seems almost magical since its tip does not rest against the frame of the door. It is hard to imagine, moreover, that there is enough room on the ledge to accommodate the lower part of the violin's bow and the rounded body of the jug, yet the objects stay in place. The still life, then, becomes a mimetic rendering or faithful reproduction of sheer contrivance, even utter fantasy.

1. Harnett's works fell out of favor in the 1890s when the vogue for sunny, outdoor themes painted in an Impressionist manner became fashionable but were recovered by the New York art dealer Edith Halpert and the critic Alfred Frankenstein in the 1930s and 1940s. See Alfred Frankenstein, *After the Hunt* (Berkeley and Los Angeles, 1953), pp. 3-96.

2. For information on the objects that Harnett has depicted, see Theodore E. Stebbins, Jr., Carol Troyen,

and Trevor J. Fairbrother, *A New World: Masterpieces of American Painting 1760-1910* (Boston, Museum of Fine Arts, 1983), pp. 287-288.

3. The discussion of the multiple meanings of "old models" is based on Paul Lubin, "Permanent Objects in a Changing World: Harnett's Still Lifes as a Hold on the Past," in Doreen Bolger, Marc Simpson, and John Wilmerding eds., *William M. Harnett* (New York, Metropolitan Museum of Art and Fort Worth, The Amon Carter Museum, 1992), pp. 49-59. On Harnett's old-fashioned style and his distance from the artistic mainstream, see Stebbins et al., p. 288.

4. Eric Hobsbawm, "The Invention of Tradition," in Eric Hobsbawm and Terence Ranger eds. *The Invention of Tradition* (Cambridge and New York, 1983), pp. 1-41. The parallel is suggested by Lubin, p. 53.

5. Paul J. Staiti, "Illusionism, Trompe l'Oeil, and the Perils of Viewership," in Bolger et al., pp. 31-47.

6. From an interview with Harnett entitled "Painted like Real Things" published in the *New York News* ca. 1889-90.

64
JOHN HABERLE
(1856 New Haven – 1933 New Haven (?))

The Slate, ca. 1890-94

Oil on canvas, 12 x 9⅜ in. (30.4 x 23. 8 cm)
Signed upper left: *Haberle*
Henry H. and Zoë Oliver Sherman Fund. 1984.163

Provenance: Mrs. Avis Gardiner, Stamford CT until 1965; O. Kelley Anderson, New York until 1984.

Exhibitions: New Britain CT, New Britain Museum of American Art, *Haberle*, January 6 - 28, 1962; La Jolla, La Jolla Museum of Art, *The Reminiscent Object*, July 11 - September 19, 1965 and Santa Barbara Museum of Art,

September 28 - October 31, 1965, no. 66; Katonah, The Katonah Gallery, *Plain Truths: American Trompe l'Oeil Painting*, June 7 - July 20, 1980, no. 18; Tulsa OK, Philbrook Art Center, *Painters of the Humble Truth: Masterpieces of American Still Life*, September 27 - November 8, 1981 and Oakland, CA, The Oakland Museum, December 8, 1981 - January 24, 1982, Baltimore, Baltimore Museum of Art, March 2 - April 25, 1982, New York, The National Academy of Design, May 18 - July 4, 1982, no. 48; Springfield MA, Museum of Fine Arts, *John Haberle: Master of Illusion*, June 15 - August 11, 1985 and Stamford CT, Whitney Museum of American Art, Fairfield County, September 10 - November 6, 1985, Fort Worth TX, Amon Carter Museum, November 29, 1985 - January 19, 1986, no. 23.

Literature: Alfred Frankenstein, "Fooling the Eye," *Artforum* 12/9 (May 1974), p. 34 ill.; W. Draeger, "Trompe-l'oeil – Anmerkungen zu seiner Entwicklung," *Du* 6 (1980), p. 49 ill.

The Boston canvas is one of three paintings in which Haberle depicted a blackboard covered with various chalk-drawn scrawls, scratches, and doodles.[1] The words "Leave Your Order Here" indicate that the slate was modeled on ones commonly used in grocery stores, though it bears an eclectic array of images and words.[2] Beneath the stenciled message are images of a tic-tac-toe game, a stick figure, and a cat, as well as some words and phrases handwritten in chalk: "but the cat can" followed by "Painting/ 'A Bachelor's Drawer'/ is *FOR RENT*/ Inquire of/ John Haberle/ Studio/ New Haven/ Ct."

Haberle lived most of his life in New Haven where at age fourteen he was apprenticed to a lithographer. After practicing that trade in Montreal, Quebec, and Providence, he returned to New Haven in 1880 to work as an illustrator and preparator at the Peabody Museum at Yale. In 1887, he studied at the National Academy of Design and began painting trompe l'oeil still lifes. In those works, he playfully deceived the viewer with images of dollar bills, postage stamps, photographs of pin-up girls, torn packages, playing cards, tickets, and other bits of ephemera so realisitically rendered that at first glance they appear to be real rather than painted objects. What exactly drew Haberle to trompe l'oeil is not known, though it clearly involved the same kind of meticulous attention to detail that the scientific drawings by which he earned his living did. Haberle painted few trompe l'oeil still lifes after the mid-1890s when his failing eyesight made the exacting work of trompe l'oeil painting almost impossible.[3]

Late nineteenth-century trompe l'oeil still

lifes, now viewed as important examples of American realism, were little valued in their own day when the institutions that shaped aesthetic practice favored more painterly, suggestive styles derived from Impressionism.[4] By contrast, trompe l'oeil still lifes found their audience among middle and lowbrow- viewers who enjoyed their technical wizardry.[5] While trompe l'oeil still lifes occasionally hung in some of the officially sanctioned exhibitions like those of the National Academy of Design, they more often appeared on the walls of well-traveled business establishments – restaurants, saloons, shops, and the like. A Frederick McGrath, for example, showed his collection of Haberle paintings in the Boston liquor store Conway and Co.[6]

The Slate, however, is more than a technical tour de force. As if anticipating Magritte's intellectual peregrinations in *This is not a Pipe* (1926; Private Collection) or *Two Mysteries* (1966; Private Collection), its collection of words and drawings explore the distance between the representation of an object and the object itself.[7] At first, *The Slate* appears to claim that representation is an unproblematic exercise, that a one-to-one correspondence between an image and a thing can be established. Yet Haberle simultaneously asserts and denies that proposal. The expert trompe l'oeil claims the equivalency of the painted image and the object on which it is modeled, but the drawings of the stick-figure and the cat, composed of the most abbreviated and simple forms, only approximate their models and can never be confused with them as the blackboard might be. Greater distance occurs between Haberle's painted words and the things and ideas to which they refer. Beneath the drawing of the grinning feline is the spectrally rendered phrase, "but the cat can." That phrase probably alludes to an article entitled "Fooled the Cat," which Haberle coupled with "A Newspaper Critic Pronounces a Picture a Fraud, but Retracts," in his *Bachelor's Drawer* (1890-94; New York, Metropolitan Museum of Art). Those articles referred to the success of Haberle's pictorial deceptions, yet no cat would be fooled by Haberle's drawing in *The Slate* nor would it understand any relation between itself and the word cat. And what, if anything, could this particular chalk-drawn cat do? What is the relation between the name "John Haberle" left in large script on the slate to some actual person, and does that Haberle differ

from the one who has etched his name in crude block letters in the illusionistic wooden frame? Words and names are deceptive, their meanings are shifting rather than certain and secure. "Bachelor's Drawer" explicitly refers to the painting that Haberle completed in 1894, but when coupled with the words "for rent," it perhaps takes on vaguely scatalogical meanings, referring to the availability of a man's underwear and by implication what it contains.[8] Representations are also evanescent and contingent as the juxtaposition "painting" and "for rent" indicate. With the stroke of an eraser, the present images will vanish and a new tenant will take possession of the space.

The Slate appears to be a real slate, but it is not. The cat and stick figure only resemble the things to which they refer, and the words only indicate objects, individuals, and ideas. You might "leave your order here" as the message directs, but will the words and images communicate your desires and intentions? In the end, the only truthful or certain image on this blackboard is the tic-tac-toe game because it is not based on anything outside itself. It is what it is.

1. The two related pictures are entitled *The Slate*. One is in a private collection and the other in the Fine Arts Museums of San Francisco. They are illustrated in Gertrude Grace Sill, *John Haberle: Master of Illusion* (Springfield MA, Museum of Fine Arts, 1985), figs. 18 and 27 respectively.

2. Sill, p. 50.

3. Ibid.

4. On the reevaluation of late nineteenth-century trompe l'oeil still lifes, see Elizabeth Johns, "Harnett Enters Art History," in *William M. Harnett*, Doreen Bolger, Marc Simpson, and John Wilmerding eds. (Fort Worth, The Amon Carter Museum and New York, The Metropolitan Museum of Art, 1992), p. 107.

5. For a good discussion of the class of the audience for such pictures and their high illusionism, see Paul J. Staiti, "Illusionism, Trompe l'Oeil, and the Perils of Viewership," in *William M. Harnett*, pp. 31-47

6. On the advertisement, see Alfred Frankenstein, *After the Hunt* (Berkeley, 1953), p. 120. The text read, "Policemen and firemen will be interested in the free exhibition of Haberle's famous realistic paintings which will be opened to the public on Monday, June 29, at Conway & Co's., 48 School Street, Boston. This exhibition is the private collection of Mr. Frederick McGrath and cost $10,000. The exhibition will continue several days."

7. Though Haberle may not have been equipped with the tools of semiotic theory, his trompe l'oeil pictures of counterfeit money evidence his fascination with the relation between images and actual objects, originals and

copies, the real and the fake. On the pictures of money, see Frankenstein, pp. 116-117.

8. *Bachelor's Drawer* is illustrated in Frankenstein, fig. 98. The imagery depicted in *Bachelor's Drawer* refers on the one hand to the bachelor's pleasures – a pipe, pictures of pin-up girls, playing cards and theater tickets – and on the other, to the end of such diversions: a verse parody of marriage vows and a booklet, "How to Name the Baby." On the iconography of *Bachelor's Drawer*, see Theodore E. Stebbins, Jr., Carol Troyen, and Trevor J. Fairbrother, *A New World: Masterpieces of American Painting 1760-1910* (Boston, Museum of Fine Arts, 1983), p. 289.

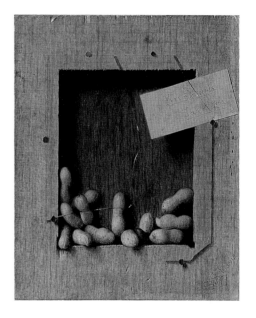

65
DE SCOTT EVANS
(1847 Boston, Indiana – 1898 at sea)

Free Sample – Take One

Oil on canvas, 10 x 11⅛ in. (30.7 x 25.9 cm)
Signed lower right: *S.S. David*
Emily L. Ainsley Fund. 1984.86

Provenance: James Maroney Inc., New York.

Literature: Nannette V. Maciejunes, *A New Variety, Try One: De Scott Evans or S. S. David* (Columbus OH, Columbus Museum of Art, 1985), p. 8.

Peanuts are stacked in a shallow wooden niche covered with a piece of broken glass. A card with the penciled message "Free Sample – Take One" is wedged beneath the glass. Imitating the look of wood, glass, paper, and nuts, Evans explores the distinction between objects in the material world and objects in the painted one. He signed the canvas "S.S. David," one of his many pseudonyms.[1]

The son of a doctor, Evans grew up in the

Midwest and taught at several schools in the region before traveling to France in 1877 where he studied with the famed academic artist Adolphe William Bouguereau. He returned to the United States the next year and became codirector of the Cleveland Academy of Fine Arts. In 1887 he moved to New York and died eleven years later when the ship he was taking to Paris sank.[2]

Known primarily in his day for his images of elegant upper-class women, Evans painted a number of trompe l'oeil still lifes including numerous versions of *Free Sample – Take One* and several other canvases in which he placed almonds rather than peanuts in the niche.[3] Nuts, usually in combination with other objects, had appeared in still lifes since the seventeenth century, but ordinary varieties like peanuts only came of age as a subject in the 1880s when they were given pride of place in the canvases of American artists, notably Joseph Decker, John Haberle, and John Frederick Peto.[4] (Peanuts, in fact, were not widely grown or consumed in the United States until the early twentieth century.) It is believed that Evans executed his peanut images in the late 1880s or early 1890s, shortly after he arrived in New York. At that time, many American still-life artists were painting in a trompe l'oeil style, but Evans, like Haberle, carried the conceit further than usual by extending the painted wood grain to the tacking edges of the canvas. Thus the painting, which is not meant to be framed, resembles an actual piece of wood cut from a larger plank.[5] To heighten the sense of actuality, Evans added knicks and chips to the wood and textured the top and bottom edges of the board to create the illusion of the rough end grain.

At first glance, the commonplace nature of the object combined with the teasing humor of the trompe l'oeil style suggest this is merely a charming and ingenious canvas intended to delight the viewer. However, the possible meanings of the image are not as simple or straightforward as such a description assumes. The piece of glass over the recessed area evokes the age-old idea of painting as a window on the world, but cracked and broken, it simultaneously "shatters" that claim. Evans contests the time-honored differences between painting and sculpture by making the canvas into an object. He also disputes the boundaries which ordinarily separate painted from real space by making it seem as if the modeled nuts and the shallow

niche project into the viewer's domain. Though the artist makes every effort to create the sense of an actual object existing in actual space, the glass-covered niche is – paradoxically – the product of his imagination since it corresponds with no known receptacle for displaying or dispensing peanuts. Thus the painter doubly deceives the viewer, using the trompe l'oeil style to make him believe in the reality of a fiction. (Haberle and Decker, by contrast, placed their peanuts in jars and bins.) Normally a piece of glass placed over an object implies its value and uniqueness and hence its need for protection, but Evans appears to satirize that notion by protecting nothing more than lowly peanuts, which look and taste virtually the same and can be infinitely substituted for one another. Finally, the image is as contentious as it is amusing. While the handwritten note encourages the viewer to sample one of the peanuts, the jagged edges of the broken glass threaten bodily harm to the person who takes up the offer. Should he successfully remove one of the peanuts, he runs the probable risk that the entire stack will come tumbling down. In the end, Evans leaves the viewer wondering whether a previous spectator, irritated with the glass that denied him what the note invited him to take, broke the pane.

1. Evans used a variety of names. He was born David Scott Evans, Jr., and signed his early works D. S. Evans or D. Scott Evans. During his year in Paris, he changed his first name to "De Scott." He signed most of his trompe l'oeil still lifes with the names Scott David, Stanley S. David, or S. S. David. William Gerdts and Russell Burke were the first to sort out the problem of Evans's pseudonyms. They theorize that Evans signed his trompe l'oeil still lifes with pseudonyms in order to avoid the critics' scorn for this kind of painting, reserving De Scott Evans for his more serious, ambitious works. See William H. Gerdts and Russell Burke, *American Still-Life Painting* (New York, 1971), p. 168. Nannette Maciejunes, arguing that the still lifes are Evans's best and most creative works, contests Gerdts and Burke's theory and suggests the possibility that the still lifes are by another hand. See Nannette V. Maciejunes, *A New Variety, Try One: De Scott Evans or S. S. David* (Columbus OH, Columbus Museum of Art, 1985), pp. 11, 18.

2. In addition to the discussions of Evans by Gerdts, Burke, and Maciejunes, one should consult Nancy Troy, "From the Peanut Gallery: The Rediscovery of De Scott Evans," *Yale University Art Gallery Bulletin* 36/2 (spring 1977), pp. 37-43.

3. On the other versions of *Free Sample – Take One*, see William H. Gerdts, *Painters of the Humble Truth* (Columbia and London, 1981), p. 203 and Maciejunes, p. 32 fn. 9.

4. See Decker's *Hard Lot*, 1886 (destroyed); Haberle's *Fresh Roasted*, 1887 (Private Collection), and Peto's

Peanuts – Fresh Roasted, Well Toasted (Private Collection). On these and other peanut paintings, see Gerdts and Burke, p. 168 and Maciejunes, p. 7.

5. Gijsbrechts and other early trompe l'oeil painters did the same.

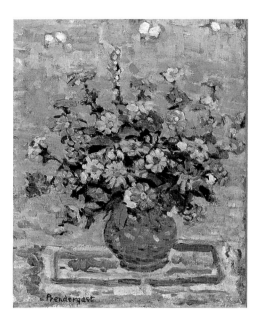

66

MAURICE B. PRENDERGAST

(1859 St. John's, Newfoundland – 1924 New York)

Flowers in a Blue Vase, ca. 1910-13

Oil on canvas, 19 x 16 in. (48.2 x 40.6 cm)
Signed lower left: *Prendergast*
Bequest of John T. Spaulding. 48.589

Provenance: Kraushaar, New York; John T. Spaulding in 1925.

Exhibitions: New York, Kraushaar Art Galleries, *Catalogue of a Memorial Exhibition of Paintings and Watercolors by Maurice Prendergast*, February 16 - March 4, 1925, no. 19 or no. 23; Boston, Museum of Fine Arts, *The Collections of John Taylor Spaulding 1879 – 1948*, May 26 - November 7, 1948, no. 66; Boston, Pucker Safrai Gallery, *Twentieth Century Still Life: An Intimate View*, April 29 - June 10, 1979.

Literature: W. M. Ivins, Jr., "A Note on Aesthetic Theory," *The Arts* 8 (December 1925), p. 310 ill.; H. H. Rhys, "Maurice Prendergast: The Sources and Development of His Style," Ph.D. diss. Harvard University, 1952, p. 167; Carol Clark, Nancy Mowll Mathews, and Gwendolyn Owens, *Maurice Brazil Prendergast, Charles Prendergast: A Catalogue Raisonné* (Williamstown, Williams College Museum of Art, 1990), p. 275 ill.

Most of Prendergast's still lifes date to the period 1910-1913, and of those canvases fourteen display pieces of fruit and household objects while the rest are flower pieces,

which like the Boston canvas display a single bouquet in a vase.[1] The reasons for Prendergast's turn to still life in 1910 are not known, but it was probably connected to his decison at that time to come to terms with the work of Cézanne for whom still life had played such a crucial role. Though Prendergast had spent time in France before, he became seriously interested in Cézanne's works during a trip to Paris in 1907. Writing to a friend in the United States, he tentatively offered that of all the art that he had seen during that visit, "Cézanne will influence me more than the others. I think so now."[2] It took him about three years to put those words into practice. Although Prendergast is generally recognized as one of the first Americans to support the work of European modernists, by the 1910s, he was but one of a number of Americans who were seriously considering Cézanne. At that time, many artists in the United States began to paint in a Cézannesque manner and American collectors including Alfred Barnes started buying Cézanne's still lifes.[3] To Prendergast's regret, there was only one Cézanne in the Boston area where he lived most of his life. Nothing is known about the canvas except that it was owned by a private collecter named Sumner and it was not a still life. In a letter to the painter, dealer, and writer Walter Pach, Prendergast expressed his hope that Sumner would purchase one of Cézanne's fruit pieces.[4]

In *Flowers in a Blue Vase*, Prendergast combines his new-found interest in Cézanne, expressed here in the passages of color that describe the background, with the daubs of color that he adapted from Neo-Impressionism. Like many who studied Cézanne's style, Prendergast domesticated it. Thus his space is more regularized, his composition more static, and his brushstrokes looser and less controlled than Cézanne's. There is also less blending of forms in his canvases, which, in general, lack the French artist's subtlety.

Prendergast, who spent much of his life in Boston before moving to New York, never exhibited his still lifes, and kept all of them save one which he gave to the painter William Glackens.[5] After 1913, he basically abandoned the genre, returning to the subject that he had favored since the beginning of his career – figures in the out-of-doors.

1. Illustrations of Prendergast's still lifes can be found in Carol Clark, Nancy Mowll Mathews, and Gwendolyn Owens, *Maurice Brazil Prendergast, Charles Prendergast: A Catalogue Raisonné* (Williamstown, Williams College Museum of Art, 1990), nos. 300-326.

2. Letter from Maurice Prendergast to Mrs. Oliver Williams, October 10, 1907, quoted in Nancy M. Mathews, "Maurice Prendergast and the Influence of European Modernism," in Clark et al., p. 36.

3. On Barnes's two still lifes, see John Rewald "Dr. Albert C. Barnes and Cézanne," *Gazette des Beaux-Arts* 111/1428-1429 (January/ February 1988), p. 173.

4. Letter from Prendergast to Walter Pach, December 6, 1909, quoted in Mathews, p. 38.

5. Glackens owned *Apples and Pears on the Grass*. For an illustration see Clark et al., no. 307.

67 (plate 27, page 42)
FRANK WESTON BENSON
(1862 Salem, Massachusetts – 1951 Salem)

The Silver Screen, 1921

Oil on canvas, 36¼ x 44 in. (92.1 x 111.7 cm)
Signed and dated lower right: *F.W. Benson/ 1921*
A. Shuman Collection 1979.615

Provenance: F. L. Dunne, Boston, 1921; Alice M. Dunne, Boston, by 1938; Mr. and Mrs. John Dorsey, Wellesley MA; with Vose Galleries, Boston, 1979.

Exhibitions: Washington, Corcoran Gallery of Art, *Eighth Exhibition of Contemporary Oil Paintings*, 1921; Philadelphia, Pennsylvania Academy of Fine Arts, *Paintings, Watercolors and Etchings by Frank W. Benson*, and Cleveland, The Gage Gallery, 1922, no. 8; Boston, Museum of Fine Arts, *Ten American Impressionists: Frank W. Benson, Edmund C. Tarbell*, 1938, no. 39; Rockland ME, Farnsworth Museum, *Paintings by Frank W. Benson*, July 6 - September 9, 1973; Durham, University of New Hampshire, University Art Galleries, *Frank Weston Benson and Edmund C. Tarbell*, March 19 - April 26, 1979, no. 35; Boston, Museum of Fine Arts and New York, American Federation of Arts, *The Boston Tradition: American Paintings from the Museum of Fine Arts, Boston* and Des Moines IA, Des Moines Art Center, November 25, 1980 - January 7, 1981, Houston, Museum of Fine Arts, February 6 - March 29, 1981, New York, Whitney Museum of American Art, April 21 - June 14, 1981, Philadelphia, Pennsylvania Academy of Fine Art, June 26 - August 16, 1981, no. 74; Boston, Museum of Fine Arts, *The Bostonians: Painters of an Elegant Age, 1870-1930*, June 11 - September 14, 1986 and Denver, The Denver Art Museum, October 25 - January 18, 1987, Evanston IL, Terra Museum of American Art, March 13 - May 10, 1987, no. 79; Columbus OH, Columbus Museum of Art, *Boston Impressionists*, February 20 - April 23, 1988; Springfield MA, Springfield Museum of Fine Arts, *French and American Impressionism from New England Museums*, September 25 - November 27, 1988, no. 26.

Literature: Ulrich W. Hiesinger, *Impressionism in America: The Art of Ten American Painters* (Munich, 1991), p. 206 ill.

A bowl of fruit, a Chinese jar with a pierced wood cover,[1] a porcelain bowl, and a glass candlestick rest on an American gateleg table, dating to around 1700, covered with oriental fabric and a kimono before a silver Japanese screen.

Benson, a leading member of the Boston School known primarily for his idealized figure subjects and sporting pictures, came to still-life painting relatively late in his career. *Silver Screen* was the first of eleven still lifes painted between 1921 and 1936. In the 1910s when painters in New York were working in variations of Cubism and Expressionism, Benson, like many Boston artists, favored a more traditional style, combining solid draughtsmanship with Impressionist-type brushwork. As the years progressed, his forms showed firmer construction, his line more definition, and his brushwork greater control. The thick build up of paint, notably in the kimono where it is applied with a palette knife, is also typical of his later imagery. The kimono, Japanese screen, and Chinese jar recall Boston's historic ties with the East, which dated back to the eighteenth-century China Trade and had made nineteenth-century Boston one of the leading centers in the world for the study of East Asian art. It was fashionable among the city's well-to-do to combine orientalia with American furnishings and to drape tables with oriental textiles.[2] Exotic objects also figured in several other still lifes by Benson and in the richly appointed rooms of his interior genre scenes. Although issues arising from mass immigration, and the growing labor and women's movements engaged numerous artists, particularly in New York, Benson characteristically preferred elegant scenes of tranquility and understated wealth, recording a privileged way of life that was becoming anachronistic,[3] a situation alluded to perhaps in the closely keyed tonal shades which give the picture a crepuscular, nostalgic quality.

1. The jar appears to be an example of famille-rose ware with a painted overglaze enamel design from the Kangxi period (1662-1722) of the Qing dynasty (1644-1912). It could also be slightly later from the Yongzheng period (1723-1735). My thanks to Ping Foong of the Asiatic Department in the Museum of Fine Arts for this information.

2. Edgar Mayhew and Minor Meyers, *A Documentary History of American Interiors* (New York, 1980), p. 243.

3. Trevor J. Fairbrother, *The Bostonians: Painters of an Elegant Age, 1870-1930* (Boston, Museum of Fine Arts, 1986), p. 69.

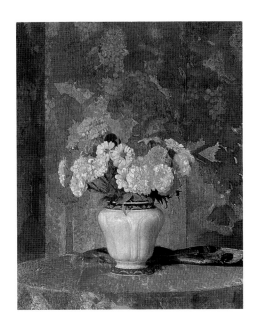

68

HERMANN DUDLEY MURPHY

(1857 Marlborough, Massachusetts – 1945 Lexington, Massachusetts)

Zinnias and Marigolds, 1933

Oil on canvas, 30 x 25 in. (76.2 x. 63.5 cm)
Signed lower left: *H. Dudley Murphy*
The Hayden Collection. Prov. 43.30

Provenance: The artist, Lexington, MA.

Exhibitions: New York, National Academy of Design, *109th Annual Exhibition,* 1934; Boston, Guild of Boston Artists, *Murphy,* 1943, no. 44; Boston, Guild of Boston Artists, *60th Anniversary Celebration,* November 5 - 23, 1974; Boston, The Copley Society, *A Centennial Exhibition,* April 28 - June 9, 1979, no. 28; Boston, Museum of Fine Arts, *The Bostonians: Painters of an Elegant Age, 1870 - 1930,* June 11 - September 14, 1986, and Denver, The Denver Art Museum, October 25, 1986 - January 18, 1987, Evanston IL, Terra Museum of American Art, March 13 - May 10, 1987, no. 83.

Literature: Michael David Zellman, *American Art Analog,* vol. 2: *1842-1874* (New York, 1986), p. 631 ill.

A prominent member of the Boston school, Murphy was a contemporary of Edmund Tarbell, Frank Weston Benson (see cat. 67), and William Paxton. After training at the School of the Museum of Fine Arts, he worked as a mapmaker for the Nicaragua Canal survey and then as an illustrator for newspapers, books, and magazines. In 1891 he traveled to Paris where he studied at the Académie Julian under Benjamin Constant and Jean-Paul Laurens. Returning to Boston six years later, he established a studio and in addition to painting, he taught life drawing at the Harvard School of Architecture (1902-37) and at the Worcester Art Museum School (1903-07). A member of various organizations including the National Academy of Design and the Copley Society, he exhibited widely in the United States. Shows of his work were held at the Museum of Fine Arts, Boston, the Detroit Institute of Arts, and the Art Institute of Chicago among others. From early on in his career, Murphy made his own frames and in 1903, he went into business with the painter and frame-maker Charles Prendergast, the brother of Maurice Prendergast (see cat. 66) and W. Alfred Thulin. That business, which proved highly successful, was eventually bought by the Vose Galleries of Boston.[1]

Murphy's work can be divided into three periods. From the late 1890s to 1910, he painted mostly figure subjects and in the second decade of the twentieth century, he focused more on landscapes. While his contemporaries Tarbell, Benson, and Paxton were investigating variations of Impressionism and his Parisian teachers Constant and Laurens worked in a highly academic style, Murphy was most influenced by Whistler's tonal hues. Beginning in the 1920s, he concentrated on flower pieces, the works that ultimately established his reputation. *Zinnias and Marigolds,* executed in 1933, is typical of his flower still lifes which generally feature a spray of flowers in a simple vase set against a solid background, in this case a Japanese screen composed of large dark blossoms on a muted gold field. In combining orientalia with more ordinary still-life objects Murphy follows a vogue among Boston still-life painters in the 1920s (see cats. 66 and 67). Well-modeled and brightly lit, the simple, elegant porcelain vase and vibrant orange and yellow blossoms, whose casual arrangement suggests they have been freshly picked from a backyard summer garden, contrast with the flattened silhouettes and subtle hues of the screen. Although the subject and realist style of Murphy's flower pieces are conservative compared to the work of avant-garde artists of the period and to his own earlier canvases, they were well received by his contemporaries in Boston. That *Zinnias and Marigolds* was one of two paintings Murphy exhibited in the National Academy of Design Exhibition of 1934 suggests he felt strongly about the picture, which was later bought by the Museum of Fine Arts with funds designated for the purpose of supporting the work of local artists, a commitment the Museum had made at its founding in the late nineteenth century.

1. On Murphy see Dora M. Morrell, "Hermann Dudley Murphy," *Brush and Pencil* 5/2 (November 1899), pp. 49-57; William A. Coles, *Hermann Dudley Murphy, 1857-1945* (New York, Graham Gallery, 1982); *Hermann Dudley Murphy: Boston Painter at Home and Abroad* (New York, Graham Gallery, 1985); Erica Hirshler, "Hermann Dudley Murphy," in *The Bostonians: Painters of an Elegant Age, 1870-1930* (Boston, Museum of Fine Arts, 1986), pp. 219-220. A list of Murphy's numerous affiliations, exhibitions, and prizes can be found in Coles 1982. Murphy did not make the frame for *Zinnias and Marigolds.*

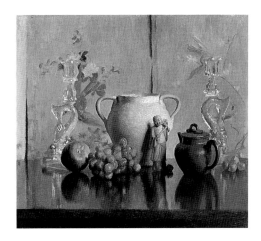

69

GRETCHEN W. ROGERS

(1881 Boston – 1967 New Haven)

Still Life, ca. 1923

Oil on canvas, 19¼ x 21¼ in. (48.9 x 54 cm)
Gift of the artist. 1986.59

Exhibitions: Washington D.C., Corcoran Gallery of Art, *Ninth Exhibition of Contemporary American Oil Paintings,* December 16, 1923 - January 20, 1924, no. 48; Boston, Museum of Fine Arts, *The Bostonians: Painters of an Elegant Age, 1870-1930,* June 11 - September 14, 1986 and Denver, The Denver Art Museum, October 25, 1986 - January 18, 1987, Evanston IL, Terra Museum of American Art, March 13 - May 10, 1987, no. 82.

Two glass dolphin candlesticks[1] are placed on either side of a teapot, a porcelain pot, grapes, and a *blanc-de-chine* figurine. A Japanese screen stands behind the table. The frame of this particular work is based on a design by the architect Stanford White.

Rogers grew up in Boston and trained at the Museum School from 1900 to 1907 where she studied with Edmund Tarbell, one of the leaders of the Boston School of painters. In addition to still life, Rogers also painted portraits, genre scenes, and landscape. She exhib-

ited canvases at the Art Institute of Chicago, the Detroit Institute of Arts, the Pennyslvania Academy of Fine Arts, and the Panama-Pacific Exposition of 1915 where her canvas, *Woman in a Fur Hat* (1915; Boston, Museum of Fine Arts), won a silver medal. For reasons that are not known, Rogers gave up painting at the end of the Depression.[2]

In the later 1910s, Boston witnessed a revival of still-life painting though what constellation of economic, social, and artistic factors led to the genre's resurgence has been little studied.[3] Like many Boston still lifes and genre paintings, Rogers's canvas with its Japanese screen and Chinese figurine reflects the vogue for orientalia in Boston, a city whose ties to the East dated to the eighteenth-century China Trade.[4] Rogers admits the viewer to a refined and elegant space whose autumnal tones augur a world that is disappearing: a quiet, ordered, balanced realm of simple, tasteful objects untouched by the social and economic changes that accompanied immigration and industrialization and the conspicuous displays of wealth brought on by the booming economy of the 1920s. With its traditional style and classical design, Rogers's picture is much like the city in which she painted it. Though nineteenth-century Boston had played a leading role in shaping the cultural, political, and economic life of the United States, by the early 1900s it was becoming a provincial, conservative city due in large part to the attitudes of the aristocratic Brahmins. In the face of growing disparities between classes, heightened ethnic tensions, and a changing economy, this ruling elite held to tradition, heritage, and history.[5] Since they dominated Boston's cultural scene, their posture inevitably shaped the ways in which many Boston artists, most of whom came from this caste, perceived themselves and their art. The leaders of the Boston School like Benson and Tarbell and their disciples saw themselves as the guardians of skill, craftsmanship, and beauty. Yet the values that strengthened them stifled others who left Boston for New York where galleries and collectors were more receptive to their efforts to explore various currents of modernism and the implications that changes in American life had for their art. Boston's conservativism notwithstanding, Rogers no doubt benefited by the support that Boston had traditionally given women artists who were offered the same educational opportuni-

ties as men and encouraged to sell and exhibit their work as professionals.[6]

1. The candlesticks are made of press-molded Sandwich glass and were mass produced during the nineteenth century. My thanks to Jeffrey H. Munger, associate curator of European Decorative Arts, for this information.

2. On Rogers, see Trevor J. Fairbrother et al., *The Bostonians: Painters of an Elegant Age, 1870-1930* (Boston, Museum of Fine Arts, 1986), p. 224.

3. Trevor Fairbrother offers the beginnings of an explanation when he contends that "...it marked a reaffirmation of the cult of the beautiful, and of that belief that art belongs to a realm of privilege and refinement, a closed world." He implies without explicitly stating that the painters and patrons of Boston still lifes intended their style and subjects to affirm their sense of themselves in a world in which their place and power were threatened. See Fairbrother, p. 88.

4. Frank Weston Benson (see cat. 67), Edmund Tarbell, Adelaide Cole Chase, and Hermann Dudley Murphy all painted still lifes with orientalia around this time.

5. On the Brahmins' conservatism and its deleterious effects on the city, see Theodore E. Stebbins, Jr., "The Course of Art in Boston," in Fairbrother, pp. 4ff. Stebbins draws on the analysis of Frederick Jaher. See Jaher, *The Urban Establishment* (Urbana, 1982). Erica Hirshler contends that Boston's conservatism need not be viewed in a negative light, arguing that the Boston painters were not fearfully retreating from modern painting and modern life, but proudly asserting the values of craftsmanship, harmony, and beauty. She also links those attitudes with the Colonial Revival. See Erica Hirshler, *Lilian Westcott Hale (1180-1963): A Woman Painter of the Boston School*, Boston University, Ph.D. diss., 1992, pp. 189ff.

6. On the status of women artists in Boston, see Hirshler, pp. 1-35.

70

Samuel John Peploe
(1871 Edinburgh – 1935 Edinburgh)

Still Life with Roses in a Glass Vase

Oil on canvas, 24 x 20 in. (61 x 51 cm)
Signed lower right: *peploe*
Bequest of John T. Spaulding. 48.586

Provenance: John Taylor Spaulding.

Exhibitions: Boston, Museum of Fine Arts, *The Collections of John Taylor Spaulding 1870-1948*, May 26 - November 7, 1948, no. 63.

Literature: Murphy 1985, p. 225 ill.

After abandoning a career in law, Peploe studied painting at the Edinburgh College of Art in 1893 and then in Paris in 1894 at the Académie Colarossi and the Académie Julian with the figure painter Adolphe William Bouguereau.[1] Though Bouguereau was con-

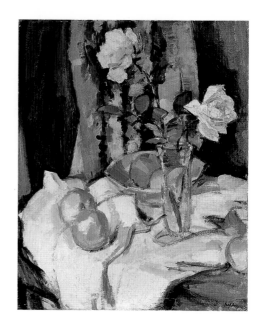

sidered one of the most successful academic artists of his day, an unimpressed Peploe dismissed him as a "damned old fool."[2] Peploe's dissatisfaction with Bouguereau's teaching is unsurprising since he favored avant-garde painting from the very beginning of his career. Early on he imitated the broad strokes and darker palette of Manet's work from the 1860s, and in the first decade of the twentieth century he adopted the brighter colors and simplified forms of the Fauves. Peploe returned to Paris where he lived from 1910 to 1913 and once again responded to developments in avant-garde painting, particularly Cubism. From 1911 on, his Fauve-like canvases displayed more architectonic designs composed of flattened forms built from planes of color and often outlined in darker hues. By the 1920s, when he painted the Boston canvas, he had turned to domesticating the work of Cézanne. In this particular work, the folds of white cloth, as well as the pieces of fruit, recall Cézanne's still lifes as does the delineation of the objects in terms of planes and shortened brushstrokes. Unlike Cézanne, however, Peploe rarely dissolved his forms into one another. Save for the passage in the center of the picture, where the glass vase, flower stems, and background seem to meld together, the other objects are clearly separated and placed in distinctly different points in space.

The slender glass vased filled with roses or other flowers was one of Peploe's favored motifs and appears in canvases from all phases of his career.[3] Although he painted figures

and landscapes, he preferred still life to both. In 1929, he explained his penchant for the genre: "There is so much in mere objects, flowers, leaves, jugs, what not – colors, forms, relations – I can never see that mystery coming to an end."[4]

Peploe was often linked with J. D. Fergusson, Leslie Hunter, and F. C. B. Cadell. Though they worked only informally with one another and never formed an official group or school, these artists were dubbed the Colorists due to the similarity of their styles. Today Peploe's work, and that of his fellow Colorists, may seem more derivative than original, but it is generally held to have opened the door to modern painting in Scotland.

1. On Peploe see, Stanley Cursiter, *Peploe* (London, 1947); T. J. Honeyman, *Three Scottish Colourists* (Edinburgh, 1950), pp. 49-70; *Three Scottish Colourists* (Glasgow, Scottish Arts Council Gallery, 1970); *S. J. Peploe, 1871-1935* (Edinburgh, Scottish National Gallery of Modern Art, 1985); and Keith Hartley, *Scottish Art Since 1900* (London, 1989), pp. 13-18, 157-158. With the exception of Hartley's work, the literature on Peploe is largely anecdotal.

2. Quoted in Honeyman, p. 53.

3. For illustrations of two pictures from the 1920s that are particularly close to the Boston canvas, see Christie's, Glasgow, December 11, 1986, lot 210 and Christie's, Glasgow, December 7, 1989, lot 332.

4. Quoted in Guy Peploe, "S. J. Peploe, Painter in Oils," in *S. J. Peploe, 1871-1935*, p. 12.

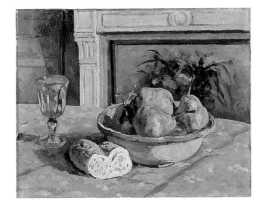

71

ALBERT ANDRÉ
(1869 Lyon – 1954 Laudun)

Bowl of Pears, Bread, and a Glass on a Table

Oil on canvas, 16⅞ x 21⅞ in. (43 x 55.5 cm)
Signed upper left: *Albert André*
Anonymous Gift. 38.778

Provenance: Durand-Ruel, Paris; Mrs. J. Montgomery Sears, Boston, 1921; Mrs. J. D. Cameron Bradley, Boston, 1937.

Exhibitions: Paris, Galerie Durand-Ruel, *André*, 1913, no. 51.

Literature: Muriel Ciolkowska, "Albert André," *International Studio* 76/310 (March 1923), p. 457 ill.; Murphy 1985, p. 4 ill..

André spent his youth in Lyon, designing silk patterns with his brothers. In 1889, he moved to Paris where he studied at the Académie Julian. Struck by the five pictures that André exhibited at the Salon des Indépendants in 1894, Renoir introduced himself to the young painter, thus beginning a lifelong friendship, and brought him to the attention of Durand-Ruel who became his exclusive dealer. André painted a number of portraits of Renoir, published a monograph on his work in 1918, and oversaw the inventory and dispersal of Renoir's studio after his death.

According to a letter from the artist, he executed this particular work in 1910.[1] André painted still lifes off and on throughout his career, but worked in other genres as well. While Renoir's influence can be detected in some of André's pictures – particularly his nudes, which show the stamp of Renoir's classical bathers – the *intimiste* canvases and cityscapes of his friends Vuillard and Bonnard, as well as the canvases of Cézanne played a more critical role in shaping his style and choice of subjects. The muted tones of the setting in the Boston picture recall Vuillard's interiors while Cézanne's influence can be seen in the short brushstrokes that describe various objects and in the faceting of the glass. Though it is easy to discuss André's work in terms of its sources and influences, he did not simply copy his models though he did perhaps domesticate them. His space, for example, usually displays greater stability than Cézanne's, and more than Cézanne and Vuillard, he defined the contours of his objects and developed their volumes.

In addition to writing on Renoir, André published monographs on Manet and Degas. He also illustrated books and served as curator at the Bagnols-sur-Cèze Museum where he built a collection of contemporary pictures, many by friends that he had made over the years.

1. Letter dated January 19, 1940, in Museum files.

72 (plate 31, page 45)
JEAN METZINGER
(1883 Nantes – 1956 Paris)

Fruit and a Jug on a Table

Oil on canvas, 45⅝ x 31⅞ in. (116 x 81 cm)
Signed lower left: *Metzinger*
Fanny P. Mason Fund in Memory of Alice Thevin. 57.3

Provenance: Anonymous dealer, Paris; Marlborough Fine Art Ltd., London by 1955.

Exhibitions: New York, Guggenheim Museum, 1955; London, Marlborough Fine Art Ltd., *Nineteenth and Twentieth Century European Masters*, November - December 1955, no. 46; Des Moines, Des Moines Art Center, *American and European Paintings of the Nineteenth and Twentieth Centuries*, 1958; Iowa City, The University of Iowa Museum of Art, *Jean Metzinger in Retrospect*, August 31 - October 13, 1985 and Austin TX, University of Texas, The Archer M. Huntington Art Gallery, November 10 - December 22, 1985, Chicago, The David and Alfred Smart Gallery at the University of Chicago, January 21 - March 9, 1986, Pittsburgh, Carnegie Institute, The Museum of Art, March 29 - May 25, 1986, no. 99.

Literature: Murphy 1985, p. 188 ill.

On a table, Metzinger has painted several pieces of fruit, a wineglass, bottle, and pitcher. A piece of fabric – a curtain perhaps – sweeps from the background under the objects, emerging as a table cloth in the foreground. The table is set against a black door or window.

Metzinger studied at the local art academy in Nantes and moved to Paris in 1903 after dealers responded enthusiastically to the canvases he exhibited in the Salon des Indépendants of that year. Like the work of most of his contemporaries, his painting developed in relation to a variety of avant-garde styles. The mosaic-like surfaces of his early pictures owe much to Neo-Impressionism which attracted renewed attention in 1904 and 1905 when the works of Seurat, Signac, Cross, and Luce were widely exhibited in Paris. Towards the end of the decade, he began to loosen his brushwork and facet his forms as he explored the work of Cézanne and the Cubist canvases of Braque and Picasso. Although he experimented with Picasso and Braque's analytic Cubism in 1910, he usually preferred to depict recognizable forms and to distinguish between figure and ground. In 1912, he and Albert Gleizes set forth their understanding of the movement in *Du Cubisme*, which was reprinted fifteen times in its first year of publication.[1]

Metzinger painted relatively few still lifes before 1916. He inscribed the back of the present work with the words "Peint par moi, 1916 Metzinger," but the painting's curvilinear forms and broad, flattened, superimposed planes suggest a date of 1918 or 1919. The still lifes of 1916 and 1917, by contrast, display greater faceting, more angular shapes, and evident tension between figure and ground, and in all likelihood Metzinger dated the work some years after he had painted it.[2] The objects in the Boston canvas – a table seen from an elevated viewpoint supporting pieces of fruit, glasses, and other vessels – are typical of Cubist still lifes in general and the stenciled lettering of synthetic Cubism in particular. The letters "BANYU" are the first part of a brand name of a particular kind of liquor and are meant to suggest a label pasted on the bottle.

In his still lifes of 1916-20, Metzinger did not seek to evoke a particular place like the café of analytic Cubism, the qualities of the objects he depicted, or their associations, but instead focused on the means of painting. In this still life one of his more abstract compositions, he experimented, for example, with different ways of representing objects, rendering the bottle and glass with superimposed planes of color, and reducing some objects like the pitcher to a few key characteristics, in this case the handle and lip. As many Cubist painters did, Metzinger also played with identities, turning a curtain into a table cloth, conflating a door and a window, and manipulating paint to suggest wood grain in the base of the table. He, in addition, worked with a range of paint effects: the smooth inky surface of the door or window in the background, the scumbled passages that describe the wall and rug, and the grainy surface of the yellow pitcher which he produced by mixing pumice with his pigment.

1. The best source of information on Metzinger's work is Joann Moser, *Jean Metzinger in Retrospect* (Iowa City, The University of Iowa Museum of Art, 1985).

2. On the dating of the work, see Moser, p. 45.

73 (plate 29, page 44)
GEORGES BRAQUE
(1882 Argenteuil – 1963 Paris)

Still Life with Peaches, Pears, and Grapes, 1921

Oil on canvas, 12⅜ x 25¾ in. (31.3 x 65.3 cm)
Signed and dated on lower left: *G. Braque/ 21*
Gift by Contribution. Res. 32.21

Provenance: Fukishima Collection, Paris until 1931; Pierre Matisse Gallery, Paris, 1931.

Exhibitions: Cambridge, Harvard University, Dunster House, *Exhibition of Contemporary French Painting*, March 10 - April 1, 1936, no. 18; Cambridge, Fogg Art Museum, April - May 1937; Boston, Institute of Modern Art, *Sources of Modern Painting*, March 2 - April 9, 1939, no. 10; Boston, Institute of Modern Art, 1942; Winchester MA, Winchester Art Association, 1944; Cambridge, Massachusetts Institute of Technology, 1950; Boston, Museum of Fine Arts Museum School, 1951; Brookline MA, Brookline Public Library, *An Exhibition of Original French Paintings*, 1951; Cambridge, Fogg Art Museum, *Twentieth-Century Art Exhibition*, 1952; Boston, 1979, no. 69.

Literature: W. G. Constable, ed., *Summary Catalogue of European Paintings* (Boston, 1955), p. 7; Marco Valsecchi and Massimo Carrà, *L'opera completa di Braque* (Milan, 1971), pp. 94-95 ill.; Maeght, ed., *Catalogue de l'oeuvre de Georges Braque: peintures 1916 – 1923* (Paris, 1973), n.p. ill.; Murphy 1985, p. 32 ill.

In 1917, after recuperating from a severe head wound suffered in the War, Braque returned to the formal investigations he had undertaken in analytic and synthetic Cubism (1910-14). For the next decade or so, he occasionally painted the human figure, but focused mainly on still life. The objects of the café – the playing cards, glasses, pipes, and bottles – continued to fascinate him, but he now painted pieces of food and household vessels, objects that had been part of still life's vocabulary since the genre's beginnings in the late sixteenth century. Braque's gesture to tradition, though less pronounced than that of other painters, is consistent with the *rappel à l'ordre* that characterized much of French culture in the years following the War. In the post-War still lifes, Braque softened his contour lines, employed more delicate colors, and often used a horizontal format to flatten the picture's space and heighten its decorative qualities. As the fleshy peaches, nestled in their womb-like enclosure of white paint attest, Braque also displayed a new appreciation of sensuality.

Far from rendering the unique qualities of the food and vessels, or painting them to evoke a familiar domestic space or ritual as

Chardin often had, Braque used his still-life objects to meditate on the act of painting itself and the character of his pigment and canvas. He offered no single idea about the painter's endeavors, but instead, posed questions, created puzzles, and even played an occasional joke. Appropriately, he placed the objects in *Still Life with Peaches, Pears, and Grapes* not on a table, but on a canvas whose right side and right upper corner are visible. The canvas, which rests on an easel whose lower edge is legible, presents a veritable chronology of Cubism, the movement which Braque, in tandem with Picasso, initiated. Vestiges of analytic Cubism's fragmented, soberly colored planes flicker in the background, while the patterned patches resembling wallpaper and the strips simulating the texture of wood in the middle ground recall the papiers collés of the synthetic period. Blurring the distinction between the painted and the real object, the strips of wood evoke the conceit of trompe l'oeil painting, but the two strokes of paint brushed atop the imitation wood reveal the means that sustain the artist's trick, alerting the viewer to his ruse and underscoring the fact that painting is an act of construction – an artifice – not the mere reproduction of reality. Throughout his career, Braque insisted on the difference between the world inside the picture and the world outside its frame. Pictorial experience had its own distinctive qualities, among them the flatness of the canvas. Thus, the spectral silhouettes of the pear and the object next to it, so reminiscent of the photographic negative, assert the two-dimensional surface as do the peaches which lie on, rather than illusionistically pierce, the vertical canvas. If the trompe l'oeil painter seduced the viewer with expertly crafted equivalences of actual objects, Braque stressed the uncertainties of producing and transmitting meanings, deliberately obfuscating the identities of the objects that he painted. One viewer's wedge of cheese is another's slice of pie, while yet another might see the object above the suggested pot as simply a yellow rectangle beneath a white triangle. Is the object next to the pear a bottle, a slightly misshapen piece of fruit, or something else?

74 (plate 30, page 44)

GEORGES BRAQUE

(1882 Argenteuil – 1963 Paris)

Still Life with Plums and a Glass of Water, 1925

Oil on canvas, 9⅛ x 28¾ in. (23.2 x 73.1 cm)
Signed at lower left: *G. Braque/ 25-*
Gift of Mr. and Mrs. Paul Rosenberg. 57.523

Provenance: Mr. and Mrs. Paul Rosenberg, New York from 1925.

Exhibitions: New York, Rosenberg Gallery, *Marguerite and Paul Rosenberg: Private Collection,* November 19 - December 19, 1953; Boston, Museum of Fine Arts, *Recent Acquisitions,* June 1957.

Literature: N. Mangin, *Catalogue de l'oeuvre peint de Georges Braque, 1924-1927* (Paris, 1968), p. 55 ill.; Massimo Carrà, *L'Opera completa di Braque* (Milan, 1971), no. 276 ill.; Murphy 1985, p. 32 ill.

The Boston canvas is one of a number of small horizontal still lifes that Braque painted in the 1920s. Well worked surfaces, sensuous color, and a more naturalistic description of the objects replace the harder edged, fragmented shapes and planes of his cubist style. The realistic style of these works might be viewed as an instance of the *rappel à l'ordre,* the term Jean Cocteau devised to designate the impulse in post-war France to define and assert a French tradition. In painting, that tendency manifested itself in a return to figuration and a renewed interest in a classical style.[1] It has also been suggested that Braque painted these pictures mainly for the American market and therefore opted for a less obdurate, more accessible manner.[2] Finally these small still lifes probably offered him respite from larger, more complex works in which he continued to explore the possibilities of Cubism.

Though the picture is not extraordinarily complicated, the horizontal format poses interesting pictorial problems. The shape causes the painter to spread the image across the canvas and encourages the viewer to process information in a linear way. Nonetheless Braque clearly strove to produce an independent picture as opposed to an ornamental border or decorative frieze of objects like those often featured in the classical reliefs which the horizontal format recalls. (Such reliefs were one of the precursors of the independent still life.) As we can see from *Still Life with Plums,* the shape also challenged Braque to suggest a sense of depth without sacrificing the lateral movement of the image

or the essential flatness of the support. The table tips at an oblique angle creating the sense of space before the wall which clings to the picture plane. By repeating similar shades of gray in the glass and onion, Braque pulls the eye from one to the other and by tilting one of the onions toward the pile of purple fruit enhances the flow of movement horizontally which carries through the drapery. Black, which he uses beneath the glass and fruit and between the pieces of fruit, has the ability both to suggest depth and reinforce the flatness of the support. Intermingled with the bright purple hues of the fruit, the black makes these objects appear as if they have some kind of substance or strange volume but does not make them seem three-dimensional.

1. John Golding, "Braque and the Space of Still Life," in *Braque, Still Lifes and Interiors* (London, The South Bank Centre, 1990), p. 15.

2. Jean-Louis Prat, *G. Braque* (Martigny, Fondation Pierre Gianadda, 1992), p. 112.

75

JUAN GRIS

(1887 Madrid – 1927 Boulogne-sur-Seine)

Still Life with a Mandolin, 1925

Oil on canvas, 28¾ x 36¼ in (73 x 92 cm)
Signed and dated lower left: *Juan Gris 25*
Gift of Joseph Pulitzer, Jr. 67.1161

Provenance: Galerie Simon, Paris, 1925; Dr. G. F. Reber, Lausanne, 1925; Paul bey Adamidi Frasheri, Geneva; Galerie Kleinmann, Paris; G. David Thompson, Pittsburgh, by 1960; Galerie Beyeler, Basel; Joseph Pulitzer, Jr., St. Louis, aquired February 21, 1961.

Exhibitions: Zurich, Kunsthaus, *Juan Gris,* April 2 - 26, 1933, no. 136; Paris, Galerie Charpentier, *Natures mortes françaises,* 1951, no. 54; Zurich, Kunsthaus, *Thompson Collection,* October 15 - November 27, 1960 and Düsseldorf, Kunstmuseum, December 14, 1960 - January 29, 1961, no. 54; The Hague, Gemeentemuseum, *Collectie Thompson uit Pittsburgh,* February 17 - April 9, 1961, no. 53; St. Louis, Washington University Gallery of Art, *Juan Gris, Paintings and Drawings from St. Louis Collections,* March 13 - April 8, 1966; Cambridge MA, *The Pulitzer Collection, Accessions 1958 - 1971,* November 15 - January 3, 1972 and Hartford, Wadsworth Atheneum, February 1 - March 26, 1972, no. 179; Madrid, Biblioteca Nacional, *Juan Gris,* September 20 - November 24, 1985, no. 91.

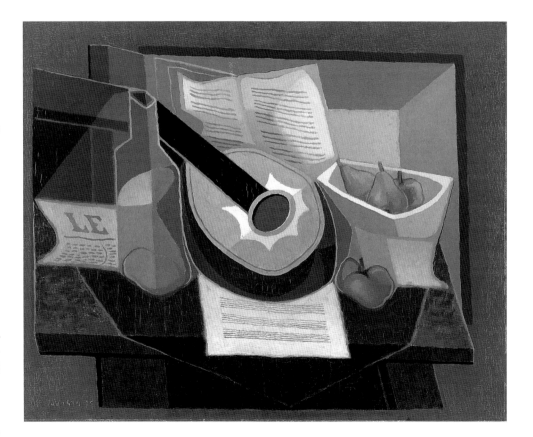

Literature: Douglas Cooper, ed., *Letters of Juan Gris, 1913-1927* (London, 1956), no. CCX; C. Chetham et al., *Modern Painting, Drawing, and Sculpture Collected by Louise and Joseph Pulitzer Jr.,* (Cambridge MA, 1971), vol. 3, no. 179 ill.; Juan Antonio Gaya-Nuno, *Juan Gris,* trans. by Kenneth Lyons (London and Boston, 1975), p. 233 ill.; Douglas Cooper, *Juan Gris, Catalogue raisonné de l'oeuvre peint,* (Paris, 1977), vol. 2, no. 531 ill.; Murphy 1985, p. 124 ill.

On a slanted table partially covered with a dark green cloth, Gris has depicted a sheet of music beneath a mandolin, which rests below a book. A page with the word "le" written across the top is placed next to a bottle composed of subtle shades of brown and gray on the left side of the table. A compotier filled with pears painted in shades of aqua sits to the right, another piece of food at its foot. Two dark brown rectilinear shapes are painted to the left of a window in the background.

Like many artists associated with Cubism, Gris explored the style mainly through still life, which, according to Gertrude Stein, was for Gris "not a seduction but a religion."[1] Though he was influenced by the Cubism of Picasso and Braque whom he met shortly after arriving in Paris in 1906, he was more inclined than they to maintain recognizable forms, to separate figure and ground, and to experiment with a wider range of color during the movement's early years. His work provided an important model for the transition from analytic to synthetic Cubism. In the post-war years, he continued to paint in a style derived from Cubism, but by the early 1920s, he turned away from the multiple planes and fragmented objects that had characterized his pictures of the previous decade in favor of more broadly conceived forms like those in the present work.

In *Still Life with a Mandolin,* Gris creates a world which differs markedly from the one we envisage lying outside the window he paints in the background. At the foot of the compotier inside the picture a pear metamorphoses into a squat shape resembling a tomato or pepper and the table's upper left corner appears to merge with a door frame. There is a suggestion of a glass or siphon inside the bottle, not outside were we would expect such objects to be. The table top is almost parallel with the picture plane. Angular edges distort the shape of the compotier which leans toward the mandolin. In the world outside the window, objects appear three dimensional and a pear differs from a tomato. Yet as Gris explained to Amédée Ozenfant in 1921,

he did not intend his pictorial world to replicate the actual world: "No glass manufacturer would be able to make any bottle or water-jug which I have painted because they have not, nor can they have any equivalent in a world of three dimensions. They can only have an equivalent in the world of the intellect. And these objects certainly do have such an equivalent because you yourself describe them as a triangular water-bottle, an oval or a square bottle. Thereby proving that you have understood them."[2]

Inside the picture frame, Gris also suggests new relations between writing, music, and painting.[3] Though we usually understand texts, sounds, and images – all of which are represented or alluded to in the canvas – as different modes of experiencing and constructing the world, Gris blurs the boundaries that separate them. The lines of the book are grouped to resemble the staffs of the musical score – music is made into a text and a text into music. The word "le" which in Gris's still lifes normally precedes "Journal" or "Matin," the titles of two Parisian newspapers, now seems to modify not another word but the image of a bottle. Words and images can be put together in Gris's world because they share certain characteristics. Different patterns of curved and straight lines compose letters which create words just as a certain pattern of curved and staight lines creates the image of the bottle, here reduced to a mere silhouette outlined in white. Much as our recognition of letters and words involves learning to identify them, representation depends on the visual habits of the viewer to connect various arrangements of lines and colors with known objects – to read a square of blue as sky, a page covered with blocks of five lines as a musical score, and the small dashes of gray beneath "le" as words. Both words and pictures begin as mere marks – like those gray daubs beneath "le" – which are manipulated into recognizable forms. Commenting on his working method, Gris wrote in 1921, "I try to make concrete that which is abstract...I mean I start with an abstraction in order to arrive at a true fact."[4] True facts aside, the ability of pictorial signs to communicate meaning is just as fragile as that of verbal signs. The stroke of a pen or a paintbrush can alter the identity of either. By modifying a line, a pear can be transformed into another piece of fruit.

1. Gertrude Stein, *Picasso* (London, 1948), p. 13.

2. Letter to Amédée Ozenfant dated around March 25, 1921, in Douglas Cooper, ed., *The Letters of Juan Gris, 1913-1927* (London, 1956), p. 104.

3. A number of Gris's canvases from the mid-1920s include references to various art forms – the painter's palette, the sculptor's bust, and the musician's score. See for example *The Bust* (1925; Private Collection), *The Painter's Table* (1925; Private Collection), *The Musician's Table* (1926; Private Collection). Illustrations of these works can be found in Douglas Cooper, *Juan Gris, Catalogue raisonné de l'oeuvre peint,* (Paris, 1977), vol. 2, nos. 523, 532, 559.

4. Juan Gris, [untitled article], *L'Esprit Nouveau* no. 5 (February 1921), pp. 533-34 cited in D.-H. Kahnweiler, *Juan Gris: His Life and Work,* trans. Douglas Cooper, 2nd ed. (New York, 1969), p. 191.

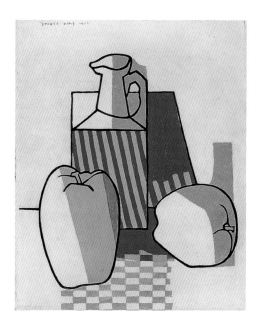

76

S T U A R T D A V I S
(1892 Philadelphia – 1964 New York)

Apples and Jug, 1923

Oil on composition board, 21¾ x 17¾ in. (65.8 x 45.1 cm)
Signed upper left: *Stuart Davis 1923*
Gift of the William H. Lane Foundation. 1990.390

Provenance: Acquired from the artist by the William H. Lane Foundation, MA, before 1954.

Exhibitions: New York, Museum of Modern Art, *Stuart Davis,* October 17, 1945 - February 3, 1946; Andover, Addison Gallery, *William H. Lane Foundation,* November 20 - December 14, 1953; Fitchburg MA, Fitchburg Museum, *Contemporary American Paintings from the William H. Lane Foundation,* December 12, 1953 - January 20, 1954; Poughkeepsie NY, Vassar College Art Museum, *Twentieth-Century Paintings Lent by the William H. Lane Foundation,*

March 3 - March 26, 1954; Norwich CT, Slater Memorial Museum, *Exhibition of Paintings from the Collection of William H. Lane*, October 10 - October 31, 1954; Lincoln MA, De Cordova Museum, *William H. Lane Foundation Exhibit*, November 14, 1954 - January 13, 1955; Wellesley MA, Wellesley College Art Museum, *Exhibition of William H. Lane Foundation*, October 15 - November 15, 1955; South Hadley MA, Mount Holyoke College, *William H. Lane Foundation Exhibit*, May 9 - June 3, 1956; Worcester, Worcester Art Museum, *American Paintings since the Armory Show*, July 1 - September 10, 1957; Norwich CT, Slater Memorial Museum, *William H. Lane Foundation Exhibit*, October 1 - October 31, 1957; New York, The Downtown Gallery, *Abstract Painting in America 1903-1923*, March 27 - April 21, 1962; Brooklyn, The Brooklyn Museum, *Stuart Davis: Art and Theory*, January 21 - March 19, 1978 and Cambridge, Fogg Art Museum, April 15 - May 28, 1978, no. 53; Boston, Museum of Fine Arts, *The Lane Collection: Twentieth-Century Paintings in the American Tradition*, March 13 - August 7, 1983 and San Francisco, Fine Arts Museums of San Francisco, November 1 - December 1, 1983, Fort Worth, Amon Carter Museum, January 7 - March 5, 1984, no. 78; New York, Metropolitan Museum of Art, *Stuart Davis*, November 18, 1991 - February 16, 1992 and San Francisco, San Francisco Museum of Modern Art, March 24, 1992 - May 26, 1992, no. 52.

Literature: E. C. Goossen, *Stuart Davis* (New York, 1959), pp. 18-20 ill.

Stuart Davis, one of the leading practitioners of early American modernism, left school at fifteen to study with Robert Henri, leader of the Ashcan school, a group of artists known for their gritty scenes of urban life done in a quasi-realist manner. Although urban forms and rhythms would remain the touchstone of Davis's art throughout his life, he had by the early teens abandoned his teacher's style to explore European modernism, which he first studied at the Armory Show held in 1913. Early in his career, the palette and handling of Matisse, Gauguin, and Van Gogh shaped his work, but by the late teens, he was exploring variations of Cubism and collage and integrating everyday objects into his canvases.

In the summer of 1923, he traveled to New Mexico to spend several months with John Sloan for whom he had worked as an illustrator at *The Masses,* a well known magazine of the period. During that time, he painted both New Mexico's landscapes and a group of still lifes including *Apples and Jug*. While many of those still lifes display objects from the twentieth-century kitchen, such as percolators, lightbulbs, and matches, the Boston canvas displays simple vessels and pieces of fruit, objects that could be found in still lifes dating back to the seventeenth century. Evoking images of nature and of the potter's manual labor, the apples and jug contrast with the picture's decidedly modern, machine-like

style. Here, as in all of the New Mexico still lifes, the objects are rendered with schematized flattened shapes, most shown frontally and bounded with strong black outlines. The style suggests the influence of Fernand Leger's simple but well-defined forms and Juan Gris's planar shifts as well as the bold, emphatic style of advertising. Some notes that Davis made for himself in 1920 explain his fascination with commercial imagery. Hoping to perfect an anonymous, unsentimental style that conjured up the tone and energy of modern American mass culture and consumption, he wrote, "Don't emotionalize. Copy the nature of the present – photography and advertising, tobacco cans and bags and tomato can labels."[1] Although the geometric shapes and blocks of color seem almost as if they have been mechanically stenciled on the canvas, the short feathery brushstrokes and slight wobble of the dark outlines reveal the individual, human hand.

1. Stuart Davis, "Notebook, 1920-22," December 4, 1920, Private Collection, quoted in Lowery Stokes Sims, *Stuart Davis* (New York, Metropolitian Museum of Art, 1991), p. 151.

77
STUART DAVIS
(1892 Philadelphia – 1964 New York)

Medium Still Life, 1953

Oil on canvas, 45 x 36 in. (114.3 x 91.44 cm)
Signed upper right: *Stuart Davis*
Gift of the William H. Lane Foundation. 1990.396

Provenance: The artist; Mr. and Mrs. Daniel Saidenburg, New York; Downtown Gallery, New York; William H. Lane Foundation, 1961.

Exhibitions: New York, Whitney Museum of American Art, *1953 Annual Exhibition of Contemporary American Painting*, October 15-December 5, 1953; New York, Downtown Gallery, *Stuart Davis Exhibition of Recent Paintings*, March 3-March 27, 1954; Detroit, Detroit Institute of Arts, *Annual Exhibition for Friends of Modern Art*, April 20-May 16, 1954; Houston TX, Contemporary Art Museum, September, 1954; Lincoln NE, University of Nebraska, University Galleries, *Nebraska Art Association Sixty-Fifth Annual Exhibition*, February-March, 1955; Iowa City, University of Iowa Museum of Art, *17th Annual Fine Arts Festival - Contemporary American Painting*, June 16-August 14, 1955; New York, Downtown Gallery, *The Recurrent Image*, January 31-February 25, 1956; Southampton N.Y., Parrish Art Museum, *What Americans are Painting*, July 2-July 21, 1956; New York, Federation of Jewish Philanthropies, January 1957; Minneapolis, Walker Art Center, *Paintings by Stuart Davis*, March 30-May 19, 1957 and Des Moines, Des Moines Art Center, June 9-June 30, 1957, San Francisco, San Francisco Museum of Art, August 6-Sep-

tember 8, 1957, New York, Whitney Museum of American Art, September 25-November 17, 1957, no. 30; New York, Downtown Gallery, *Gallery Artists: A Group Show*, February 1962; Durham NH, University of New Hampshire, University Art Galleries, *An Exhibition of Paintings from the William H. Lane Foundation*, February 13-March 15, 1963; New York, Downtown Gallery, *28th Annual Exhibition*, September 22-October 17, 1963; Springfield MA, George Walter Vincent Smith Art Museum, *Twentieth Century American Paintings Lent by the William H. Lane Foundation*, November 8-December 6, 1964; Washington, D.C., National Collection of Fine Arts, *Stuart Davis Memorial Exhibition*, May 28-August 29, 1965, Chicago, Art Institute of Chicago, June 30-August 29, 1965 and New York, Whitney Museum of American Art, September 14-October 17, 1965, Los Angeles, University of California, Art Galleries, October 31-November 28, 1965; Paris, Musée d'Art Moderne, *Stuart Davis: 1894-1964*, February 15-March 14, 1966 and Berlin, Amerika Haus, April 22-May 21, 1966, London, American Embassy Gallery, June 7-June 24, 1966; Storrs CT, William Benton Museum of Art, *Selections from the William H. Lane Foundation*, March 17-May 24, 1975, no. 18; Utica NY, Munson-Williams-Proctor Institute, *Paintings from the William H. Lane Foundation*, April 8-May 27, 1979; Brunswick ME, Bowdoin College Museum of Art, *Paintings from the William H. Lane Foundation: Modern American Masters*, October 10-November 23, 1980; Lincoln MA, De Cordova Museum, *Modern American Masters from the William H. Lane Foundation*, March 1-April 26, 1981; Boston, Museum of Fine Arts, *The Lane Collection: 20th-Century Paintings in the American Tradition*, April 13-August 7, 1983 and San Francisco, Museum of Modern Art, October 1-December 1, 1983, Fort Worth, Amon Carter Museum, January 7-March 5, 1984, no. 84.

Literature: E. C. Goossen, *Stuart Davis* (New York, 1959), no. 59 ill.; Karen Wilkin, *Stuart Davis* (New York, 1987), pp. 183 ill, 194.

By the late 1920s, Davis was painting abstract pictures, notably the *Egg Beater* series of 1927 whose non-objective forms were based on an arrangement of a rubber glove, a small fan, and an eggbeater.[1] In the next few years, he also began developing his ideas about picture-making including his concept of color-space, a tenet of his practice until his death. According to that formulation, color did not describe a form but created space while each juxtaposition of color established new and unique spatial relationships. Though they were infinitely varied, his canvases after 1930 generally display planes and shapes of saturated color deployed in a spatial configuration derived from Cubism. However abstract they might appear, Davis insisted that his paintings were inspired by the world around him – the city, jazz music, and modern technology in particular.

The 1950s and early 1960s were productive years for Davis. The advent of Color Field painting and the use of images from mass

culture by Robert Rauschenberg and Jasper Johns created a receptive climate for his abstractions and vernacular sources. Yet it was not so much the outside world that engaged Davis during this period for, as Karen Wilkin has argued, his paintings were now largely rooted in canvases from previous decades.[2] Along with *Something on the Eight Ball* (1953-54; Philadelphia, Philadelphia Museum of Art) and *OHW! in San Pao* (1951; New York, Whitney Museum of Art), *Medium Still Life* reprises two abstract paintings of 1927 which were based on objects from the modern kitchen, *Percolators* (New York, Metropolitan Museum of Art) and *Matches* (Norfolk, Chrysler Museum). Though *Medium Still Life* incorporates many of the shapes found in the earlier pictures, the canvas is less crowded, the colors more vibrant, and the shapes larger.

It is sometimes claimed that still life is the genre most conducive to formal investigations since the common, ordinary objects it features usually entail no complex meanings and their arrangements no narrative, thus freeing the painter to focus on the properties of his materials and aspects of his technique. It would be misleading, however, to reduce Davis's abstract still lifes to such terms. Though he did not record the appearance of his objects, their qualities, properties, and capabilities were as important in determining the forms of his canvas as formal and technical matters were. His works grew from the clean, sleek lines of modern objects and took their rhythms from their energy and dynamism – the bubbling sounds of the percolator, the spark of the newly lit match, the glow of lightbulbs, and so on. If, moreover, some still life painters deliberately removed their objects from the contexts which gave them meaning and to which they gave meaning – William Harnett's *Old Models* (cat. 63) is a case in point – Davis's still lifes often include signs of the contexts or worlds in which the objects were used. *Hot Still-Scape in Six Colors-7th Avenue Style* of 1940 (Boston, Museum of Fine Arts) is perhaps the best example of this tendency in Davis's work, but even the highly abstract *Medium Still Life* incorporates elements which suggest a setting – a rectangular shape in the center of the canvas that evokes the lines of a tall building, while the small squares in the upper right hand corner recall a street.

Davis's canvases are striking for their simplicity and economy, but they were products of a painstaking and sometimes lengthy process. He often made preliminary sketches and drew the design on the canvas in charcoal as one can see in *Medium Still Life* where some of the underdrawing remains visible. He also frequently isolated various areas with masking tape in order to focus on individual details, a practice which also allowed him to create clean, smooth edges.

1. On the *Egg Beater* series, see Lowery Stokes Sims, *Stuart Davis* (New York, Metropolitan Museum of Art, 1991), pp. 188-190.

2. Karen Wilken, *Stuart Davis* (New York, 1987), pp. 194ff.

78

HANS HOFMANN
(1880 Weissenberg – 1966 New York)

Green Bottle, 1921

Oil on canvas, 17⅞ x 23⅞ in. (45.4 x 60.7 cm)
Gift of William H. and Saundra B. Lane. 1983.697

Provenance: the artist; given to William H. Lane, 1953.

Exhibitions: Andover, Addison Gallery of American Art, *Hans Hofmann*, January 2 - February 9, 1948; Fitchburg MA, Fitchburg Art Museum, *Contemporary American Paintings from the Collection of the William H. Lane Foundation*, December 12, 1953 - January 20, 1954; Poughkeepsie, Vassar College Art Gallery, *Twentieth Century American Paintings Lent by the William H. Lane Foundation*, March 3 - 26, 1954; Norwich CT, Slater Memorial Museum, *Collection of Paintings Loaned by the William H. Lane Foundation*, October 10 - 31, 1954; Lincoln MA, De Cordova Museum, *American Pantings from the William H. Lane Foundation*, November 14, 1954 - January 13, 1955; Northampton MA, Smith College Museum of Art, *Twentieth Century Americans from the William H. Lane Foundation*, April 15 - May 15, 1955; Wellesley MA, Wellesley College Museum, *American Paintings from the William H. Lane Foundation*, October - November 1955; South Hadley MA, Mount Holyoke College Art Museum, *Contemporary American Painters from the William H. Lane Foundation*, May 9 - June 3, 1956; Norwich CT, Slater Memorial Museum, *Notable American Contemporaries Loaned by the William H. Lane Foundation*, October 1 - 31, 1957; South Hadley MA, Mount Holyoke Art Museum, *American Paintings Lent by the William H. Lane Foundation*, October 10 - November 2, 1959; Norwich CT, Slater Memorial Museum, *William H. Lane Foundation Exhibition*, November 2 -22, 1960; Boston, Museum of Fine Arts, *The Lane Collection: Twentieth Century Paintings in the American Tradition*, April 13 - August 7, 1983 and San Francisco CA, San Francisco Museum of Modern Art, September 22 - December 4, 1983, Fort Worth TX, Amon Carter Museum, January 7, 1984 - March 5, 1984 and Worcester MA, Worcester Museum of Art, September 12, 1984 - January 20, 1985, no. 32; New York, Whitney Museum of American Art, *Hans Hofmann*, June 20 - September 16, 1990, Miami, Center for the Fine Arts, November 1990 - January 1991, and Norfolk, The Chrysler Museum, February 1991 - April 1991, no. 16.

Literature: Frederick S. Wight, *Hans Hofmann* (Berkeley and Los Angeles, 1957), p. 34 ill. - 35; Cynthia Goodman, *Hans Hofmann* (New York, 1986), p. 23 ill.

Painted in Munich where he grew up and founded the Hans Hofmann School for Modern Art in 1915, *Green Bottle* reveals the

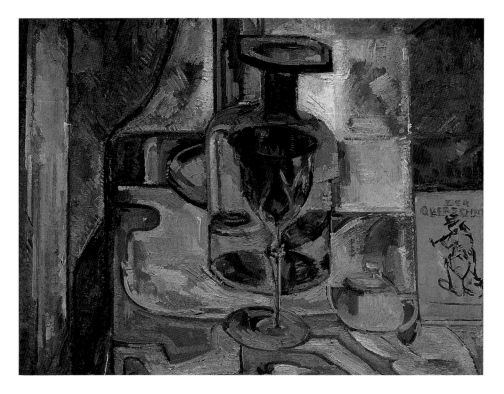

painter's grounding in European modernism, particularly in Matisse's patterns of color (which are evident in the table) and also in Cubist design. Hofmann came to know the works of the European avant-garde first in Munich through his teacher, Willi Schwarz, and through exhibitions at the Secession Gallery. He lived in Paris from 1904 to 1914, years which saw the formation of Fauvism and Cubism. Whether *Green Bottle* is representative of Hofmann's work in the early twenties is difficult to determine since almost all of the canvases that he painted before leaving Germany in 1930 disappeared during the two world wars.[1] According to the recollections of the painter and his students, however, Matisse's use of color and Cubism's distillation of space and form were among Hofmann's principal interests at this time. As his paintings, writings, and teaching in the United States attest, they continued to be important reference points for his work throughout the rest of his career.[2]

Green Bottle suggests that even in the early 1920s,[3] when Cubism's relative contemporaneity hindered critical distance and perspective, Hofmann's approach to its terms was neither adulatory nor strictly derivative. This is most evident at the center of the picture where he has depicted a bottle, wineglass, and palette. He did not simply fragment his forms to suggest their intersection or flatness, a standard manuver for Cubism's followers, but instead achieved that end by subtly manipulating color and distorting shapes. The stem of the glass, for example, appears both to fold into the bottle and to exist in a separate plane, an illusion Hofmann realized by adroitly varying the tones of green used for the two objects so that their forms move in and out of one another. The viewer's sensation of each form, moreover, changes in relation both to its own parts and to those of the objects near it, depending upon the particular passages that the viewer's eye selects and conjoins. On the one hand, the red bowl of the glass moves away from the bottle – as red will generally do when juxtaposed with green. Yet when the viewer's eye links the bowl with the base of the glass and the lip or stopper of the bottle as it inevitably does since all three are aligned along the same axis and described with similar shapes and colors, the bowl appears to return to the plane in which the bottle stands. If at one moment an object seems off-kilter, at another, it returns to some semblance of order. Thus the stem

of the wine glass appears off center in relation to the base of the glass, but it neatly bisects the bottle. Also evident in *Green Bottle* is Hofmann's favored means for creating a dynamic surface, the push and pull of colors, which became a touchstone of his later work. On the right side of the canvas, passages of blue, ordinarily a cool color that recedes, seem to come forward while red, a warm color that normally moves to the surface, appears to move backward in space.

Still life was a staple subject for Cubist painters and in *Green Bottle*, Hofmann painted objects that his Parisian counterparts frequently used: the bottle and glass referring to café culture and the palette and copy of *Der Querrschnitt*, an art magazine, alluding to the studio. Hofmann was perhaps less engaged by the epistemological issues that other Cubist painters raised. *Green Bottle* and subsequent pictures offer little evidence of the word games, shifting identities, and multiple viewpoints that fascinated Picasso, Braque (cats. 73-74), and others. Nonetheless Clement Greenberg contended in 1961 that no other artist had matched Hofmann's exploration of the formal problems Cubism had posed and no painter had done more than Hofmann – through his paintings and his teaching – to convey their significance to others.[4]

1. The work that Hofmann did in Paris was destroyed during World War I while his German work was burned in a Munich warehouse fire during World War II.

2. The works that survive include three early canvases done in a Neo-Impressionist manner, a few landscapes on paper resembling Kandinsky's Murnau landscapes done after he returned to Munich, one that suggests Oskar Kokoshka's work of 1910, and a design for a ceiling featuring female nudes that recalls Cezanne. None of Hofmann's work from Paris survives, but his student, Vaclav Vytlacil, recalls they were examples of early Cubism. On Hofmann's pre-American work, see Cynthia Goodman, *Hans Hofmann* (New York, 1986), pp. 14-23 and idem, *Hans Hofmann* (New York, Whitney Museum of American Art, 1990), pp. 12-21.

3. The date 1921 was given to William H. Lane by the artist.

4. Clement Greenberg, *Hofmann* (Paris, 1961) reprinted in Goodman 1990, p. 125.

79 (plate 28, page 43)

H E N R I M A T I S S E
(1869 Le Cateau-Cambrésis – 1954 Nice)

Vase of Flowers

Oil on canvas, 23⅞ x 29 in. (60.5 x 73.7 cm)
Signed lower right: *Henri Matisse*
Bequest of John T. Spaulding. 48.577

Provenance: Collection of Georges Bernheim, Paris; M. Knoedler and Co., New York; John T. Spaulding, Boston, from Knoedler, 1929.

Exhibitions: New York, M. Knoedler & Co., *A Century of French Painting*, November 12 - December 8, 1928, no. 45; Cambridge, Fogg Art Museum, *Exhibition of French Painting of the Nineteenth and Twentieth Centuries*, March 6 - April 6, 1929, no. 62; Boston, Museum of Fine Arts, *Collection of Modern French Paintings Lent by John T. Spaulding*, May 27, 1931 - December 31, 1931; Boston, Museum of Fine Arts, *The Collections of John Taylor Spaulding, 1870 - 1948*, May 26 - November 7, 1948, no. 56; Cambridge, Fogg Art Museum, *Eighteen Paintings from the Spaulding Collection*, February 1 - September 15, 1949; Denver, Denver Art Museum, *Ten Directions by Ten Artists*, 1954; Boston, Museum of Fine Arts, *Matisse*, November 1 - 27, 1955, no. 63; Boston, Institute of Contemporary Art, *Twentieth Anniversary Exhibition*, January 9 - February 10, 1957, no. 4; New York, Acquavella Galleries, *Matisse*, November 2 - December 1, 1973, no. 35; Framingham MA, Danforth Museum, *Inaugural Exhibition*, May 24 - September 30, 1975; Washington D.C., National Gallery of Art, *Matisse: The Early Years in Nice, 1916-1930*, November 2, 1986 - March 29, 1987, no. 135; Nagoya, City Art Museum, *Matisse Retrospective*, August 24 - September 29, 1991 and Hiroshima, Hiroshima Museum of Art, October 5, 1991 - November 4, 1991, Kasama, Kasama Nichido Museum of Art, November 9 - December 8, 1991, no. 52.

Literature: George H. Edgell, *French Painters in the Museum of Fine Arts: Corot to Utrillo* (Boston, 1949), pp. 8, 91; Philip Hendy, "The Collection of John T. Spaulding," *Bulletin of the Museum of Fine Arts* 29/176 (December 1931), pp. 112-113 ill.; Alfred Barr, *Matisse: His Art and His Public* (New York, 1951), p. 557; Mario Luzi, *L'opera de Matisse dalla rivolta 'fauve' all' intimismo 1904 - 1928* (Milan, 1971), no. 414; Pierre Schneider, Massimo Carrà, and Xavier Derying, *Tout l'oeuvre peint de Matisse, 1904 - 1928* (Paris, 1982), no. 414; Murphy 1985, p. 184 ill.

In 1917 to escape the northern winters, Matisse began spending part of each year in Nice or the surrounding area, living in hotels until 1921 when he settled in an apartment on the Place Charles-Félix in the older section of the city. During the late teens and 1920s, the years known as his Nice period, Matisse retreated from the difficult issues of modernist painting that had engaged him for more than two decades to paint pictures of contented women and sunny interiors, opulent patterns and vibrant colors, hedonistic images that seem to fulfill the ambition he had espoused in 1908: "What I dream of is an

art of balance, of purity and serenity devoid of troubling or depressing subject matter, an art which might be for every mental worker, be he businessman or writer, like an appeasing influence, like a mental soother, something like a good armchair in which to rest from physical fatigue."[1] Matisse's style also changed at this time as he gave more body to his forms, deepened his space, and created images that the viewer could more easily understand. The shift in style and subject makes sense within the context of the period. Order and harmony, serenity and balance – to use the terms that he proposed in 1908 and formally and thematically realized in his pictures of the 1920s – were key to the *rappel à l'ordre* that shaped French culture and politics in the post-war period.[2]

In most of his Nice period paintings, Matisse depicted the various rooms in which he lived. The Boston canvas displays the window and wall in one of the two rooms facing the sea in his apartment on the Place Charles-Félix.[3] The striped cloth beneath the window was probably one of the many pieces of fabric that along with numerous objects he brought from Paris to enliven his quarters. The window facing the sea, the striped fabric, and beige wallpaper with darker brown arabesques appear in several canvases of 1923 and 1924 including *Woman Playing the Violin before an Open Window* (New York, Mrs. W. Leicester Van Leer Collection), *The Three O'Clock Session* (Private Collection), *Woman before a Drawn Curtain* (Collection of Henry Ford II), and *The Morning Session* (Private Collection).[4] In the latter two canvases a vase of flowers similar to that of the Boston canvas rests on a table before the window.

Both whimsical and restrained, charming and austere, the Boston canvas seems a marriage of opposite tones. The artist delights in the playful red and white stripes, the cheery view of the palm trees and boat, and the lively brushwork that describes the vase and flowers. At the same time, he emphasizes order, harmony, and discipline in the design and palette. While the four related paintings display larger sections of the room as well as figures and pieces of furniture, in the present work he focuses on the vase of flowers and the area immediately around it. As he narrows his gaze and shifts from a genre image to a still life, his rendering of the wall changes. He tempers this pleasant scene with a sense of classical rigor by accentuating the pattern of squares and rectangles, horizontal

and vertical lines, and he also compresses the space so that the frame, ledge, shutters, and curtain seem to be in the same plane. He makes the wall and window seem more abstract and compared to their depiction in the related pictures, emotionally distant by schematizing their forms and inserting them in a strict rectilinear grid. At the same time, the differences in the rendering of the wall change its function in the picture. In contrast with the related canvases, the room is not merely a setting or backdrop for the objects but as much the subject of the picture as the vase of flowers is.

1. Quoted in Alfred Barr, *Matisse: His Art and His Public* (New York, 1951), p. 122. For a rebuttal of the commonly held view that Matisse's Nice period works are essentially conservative ones, see Dominique Fourcade, "An Uninterrupted Story," in *Henri Matisse: The Early Years in Nice, 1916-1930* (Washington D.C., The National Gallery of Art, 1987), pp. 47-57. See also Kenneth E. Silver, "Matisse's *Retour à l'Ordre*," *Art in America* 75/6 (June 1987), pp. 111-123, 167-169. Silver convincingly rejects Fourcade's argument.

2. On the relation between Matisse's work and the *retour à l'ordre*, see Silver.

3. On the layout of Matisse's apartment see Jack Cowart, "The Place of Silvered Light: An Expanded, Illustrated Chronology of Matisse in the South of France, 1916-1932," in *Matisse* 1987, p. 30.

4. For illustrations of these works see *Matisse* 1987, pls. 125, 146, 148, 149.

80

JAMES ENSOR
(1860 Ostende – 1949 Ostende)

Still Life with Sea Shells

Oil on panel, 17¼ x 21⅝ in. (44.5 x 55 cm)
Signed lower right corner: *Ensor 1923*
Gift of G. Peabody Gardner. 60.124

Provenance: Private Collection, Paris; Swetzoff Gallery, Boston until 1959; G. Peabody Gardner, Boston.

Exhibitions: Boston, Swetzoff Gallrey, *James Ensor*, May 19 - June 13, 1959, no. 5; Miami, Miami Art Center, *The Artist and the Sea*, March 20 - April 18, 1969, no. 14.

Literature: Murphy 1985, p. 93 ill.

The picture displays a collection of shells, which includes a sea urchin, small turbo, mussel, and conch as well as what appears to be a small doorway to the left, a fan, a teacup with Japanese figures, and a small seated nude in the upper right corner.

Like many of his works from the twentieth century, *Still Life with Sea Shells* has

antecedents in pictures painted in the 1880s and 1890s when Ensor, one of the leading exponents of Belgian modernism, executed his most powerful and innovative canvases. Early on, he often painted shells alongside other forms of sea life or food,[1] but in his 1895 *Shells* (Brussels, Private Collection), which in palette and handling anticipates the Boston canvas, he focused on the shells themselves placed in a pile. Like many of his later images, *Still Life with Sea Shells* exhibits a rococo sensibility that had occasionally appeared in his works in the 1880s and 1890s, but became more pronounced after 1900. The soft colors and delicate style of the present work differ from the morbid and satirical subjects and generally bold palette that characterized his work in the late nineteenth century.

With its Japanese porcelain cup and exotic shells, the Boston canvas is part of a lineage of Northern still lifes which, dating back to the seventeenth century, had often incorporated such objects. However, if orientalia and shells in the canvases of artists like Willem Kalf evoked visions of material wealth and far-off lands, for Ensor they brought back memories of his parents' curio shop in Ostende where tourists visiting the nearby beaches stopped to buy souvenirs. As Ensor's statements reveal, these objects were sources of both delight and terror. Recalling the visual pleasure that they gave him as a child, he wrote "in my parents' shop I had seen the wavy lines, the serpentine forms of the beautiful seashells, the iridescent lights of mother-of-pearl, the rich tones of chinoiserie."[2] They also fed his imagination: "I was even more fascinated by our dark and frightening attic, full of horrible spiders, curios, seashells, plants and animals from distant seas, beautiful chinaware, rust and blood-colored effects."[3]

The shells may also have had latent psychological meanings for Ensor as apples had for Cézanne,[4] functioning as motifs in which he sublimated his ambivalent, often hostile feelings for women, sentiments which are well in evidence in his imagery and his writings and like the statements quoted above shift between adulation and curious aversion.[5] Like apples, shells had time-honored erotic connotations, with their apertures and curvilinear shapes suggesting associations with the female body. The small seated nude figure in the corner of the picture above the shells implies such a connection as does an

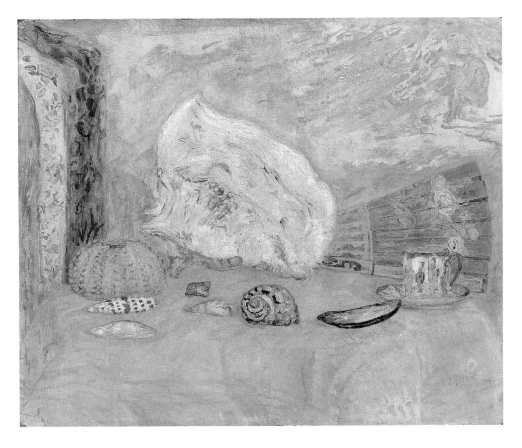

YASUO KUNIYOSHI

(1893 Okayama – 1953 New York)

Flowers, 1932

Oil on canvas, 30 x 20 in. (76.2 x 50.8 cm)
Signed and dated lower left: *Yasuo Kuniyoshi 32*
Gift of the William H. Lane Foundation. 1990.421

Provenance: acquired by the William H. Lane Foundation, May 1954.

Exhibitions: New York, Downtown Gallery, *Yasuo Kuniyoshi, Recent Paintings*, February 7 - 25, 1933; New York, Salons of America, *Spring Salon*, May 2 - 20, 1933; New York, Weyhe Gallery, October 1934; Philadelphia, Philadelphia Museum of Art, March 1934; Washington, D.C., American University, May 1946; Palm Beach FL, The Society of Four Arts, December 1946; Fitchburg MA, Fitchburg Art Museum, *Lane Foundation, Twentieth-Century Paintings*, April 4 - May 10, 1965, no. 11; Storrs CT, The William Benton Museum of Art, *Selections from the William H. Lane Foundation*, March 17 - May 25, 1975, no. 46; Framingham MA, Danforth Museum, *Selections from the William H. Lane Foundation*, April 2 - June 4, 1978.

Literature: *Yasuo Kuniyoshi* (Okayama, 1991), p. 105 ill.

Kuniyoshi came to the United States in 1906 at the age of thirteen, planning only a long visit but remaining for the rest of his life. He settled first in Seattle and then in Los Angeles where he attended the Los Angeles School of Art and Design at the suggestion of a high school teacher who sensed his talent for drawing. In 1910 he moved to New York and

oil painting of 1925 where he depicts numerous shells on a table beneath a deluge of nude female bodies cascading from the sky.[6] While Ensor had painted small statuettes of nude women in other still lifes,[7] the figure in the Boston canvas seems closer to nature, more human than sculptural. In its pose, the figure recalls the seated nude adolescent girl in *Children Dressing* (1886; Private Collection), Ensor's only painting of a full-length nude female. However, Ensor submerged the figure as if he wanted to veil what he brought to life and though the head of the figure appears to be that of a female, the body lacks identifiable sexual characteristics. In *Still Life with Sea Shells*, the ambiguous space, disproportionate scale of the objects as well as the odd appearance of the decorated doorway to the left and the strangely placed, veiled figure suggest the condensed and conflated images typical of the dream. As if he wants to impose order and control on the potentially charged images, Ensor places the smaller shells in a neat pattern. The pleasure that he may well deny himself in depicting the female nude or the anxieties he might confront in doing so seem transferred to the conch shell whose

luxuriant open shape composed of pink aqueous paint contrasts with the hard surfaces, tight forms, and closed shapes of the smaller shells.

1. See for example, *Still Life with Fish and Shells* (1888; Private Collection); *Still Life with Blue Pitcher* (1890-91; Stuttgart, Staatsgalerie), and *The Ray* (1892; Brussels, Musées Royaux des Beaux-Arts de Belgique).

2. Quoted in John Farmer, *Ensor* (New York, 1976), p. 10.

3. Ibid., p. 9.

4. On the private, psychological meanings of the apples in Cézanne's still lifes, see Meyer Schapiro, "The Apples of Cézanne," in *Modern Art* (London, 1978), pp. 1-38.

5. For a discussion of Ensor's attitudes towards and statements about women, see Diane Lesko, *James Ensor* (Princeton, 1985), pp. 68-75, 146-158.

6. The picture is illustrated in Paul Haesaerts, *James Ensor* (New York, 1959), p. 325. The deluge of female bodies is related to the scene which Ensor painted in *Andromeda* (1925; Brussels, Private Collection).

7. See for example, *Bric-á-Brac* (1896; location unknown), illustrated in Haesaerts, p. 313, and *The Antiquarian* (1902; Brussels, Collection of the Crédit Communal de Belgique).

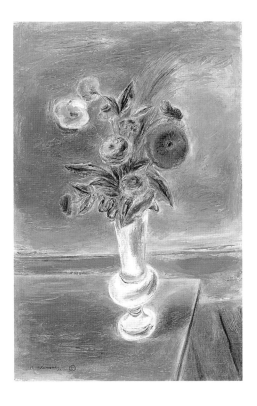

for the next decade took art classes at various institutions in the city beginning with Robert Henri's school and the National Academy of Design. In 1914, he entered the Independent School, also in New York, whose curriculum emphasized current trends in modern painting. Two years later he transferred to the Art Students League where he worked under Kenneth Hayes Miller whom he credited with giving him direction and focus.[1] During his student years, he supported himself by photographing paintings and illustrations.

Recalling the flattened space and schematic figural style of folk painting, Kuniyoshi's works of the late teens and early 1920s have a fantastic, imaginary quality. After two trips to Europe in 1925 and 1928, he developed a more naturalistic style, and he spent the rest of his career trying to reconcile that impulse with varying degrees of abstraction.[2] In the Boston canvas, he strikes a balance between describing the particularities of the flowers and creating an image which is engaging for its pictorial qualities. He tilts the table forward so that we look down on the central motif; he sets the edge of the table, the direction of the wall, and lines of the floorboards at slightly different angles; and he compresses the space, and animates every part of the canvas with vibrant, expressive brushwork. Kuniyoshi painted similar flowers in the same white vase in two other paintings, *Bouquet and Stove* (1929; Wichita KS, Wichita Art Museum) and *Flowers in a Vase* (1930; location unknown,)[3] but in contrast with those related pictures, he eliminated the setting in the present work so that the viewer focuses exclusively on the central motif. He also made the relation between the surface of the table and the foot of the vase more ambiguous so that the vase appears to lurch forward.

Kuniyoshi painted many still lifes throughout his career. In 1944, writing what he intended as his autobiography, he explained his attraction to the genre: "Still life is a difficult thing to paint. I find it more difficult to start than figures or landscape. You have to deal with...lifeless things. To make them alive is harder.... But I've learned a great deal... from painting still life because you can work as hard as you want to and as long as you want and still keep the same position."[4]

1. Lloyd Goodrich, *Yasuo Kuniyoshi* (New York, Whitney Museum of American Art, 1948), p. 10.

2. On this issue, see John L. Ward, *American Realist Painting, 1945-1980* (Ann Arbor and London, 1989), pp. 10-13.

3. For illustrations of these two pictures, see *Yasuo Kuniyoshi* (Okayama, 1991), pp. 94, 100.

4. Quoted in Bruce Weber, "Yasuo Kuniyoshi's Symbolic Still Lifes: Mind at Work," in *Yasuo Kuniyoshi: Artist as Photographer* (Bard College and the Norton Gallery and School of Art, 1983), p. 28.

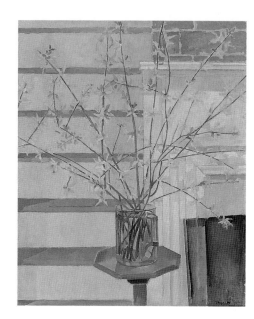

82

CHARLES SHEELER

(1883 Philadelphia – 1965 Irving-on-Hudson, New York)

Spring Interior, 1927

Oil on canvas, 30 x 25 in. (76.2 x 63.5 cm)
Signed at lower right: *Sheeler 1927*
Gift of the William H. Lane Foundation. 1990.441

Provenance: The artist; Juliana Force (?); Whitney Museum of American Art, New York, 1931; Downtown Gallery, New York; William H. Lane in 1954.

Exhibitions: MacDowell Club, February - March, 1937; New York, Museum of Modern Art, *Charles Sheeler: Paintings, Drawings, Photographs*, 1939; San Francisco, Palace of Fine Arts, *Golden Gate International Exposition: Art*, May 10 - October 16, 1940; New Britain CT, New Britain Museum of American Art, *17 Important Paintings from the Permanent Collection of the Whitney Museum*, January 15 - 28, 1941; Trenton, New Jersey State Museum, *Modern Paintings*, January - March, 1947; Norwich CT, Slater Memorial Museum, *Collection of Paintings Loaned by the William H. Lane Foundation*, October 10 - 31, 1954; Lincoln MA, De Cordova Museum, *American Paintings from the William H. Lane Foundation*, November 14, 1954 - January 13, 1955; Wellesley MA, Wellesley College Museum, *American Paintings from the William H. Lane Foundation*, October - November, 1955; Deerfield MA, Hilson Gallery, Deerfield Academy, *Arthur G. Dove, Charles Sheeler from the William H. Lane Foundation*, February 12 - March 11, 1956; New York, Downtown Gallery, *Sheeler from the Collection of the William H. Lane Foundation*, April 3 - 28, 1956, no. 14;

South Hadley, MA, Mount Holyoke College Art Museum, *Contemporary American Paintings from the William H. Lane Foundation*, May 9 - June 3, 1956; Worcester MA, Worcester Art Museum, *American Painting since the Armory Show from the William H. Lane Foundation*, July 1 - September 10, 1957; Cambridge MA, Radcliffe College Graduate Center, *Exhibition of Contemporary Paintings from the William H. Lane Foundation*, October 1 - 31, 1957; Manchester NH, Currier Gallery of Art, *American Art from the William H. Lane Foundation*, November 1 - December 14, 1958; Cambridge MA, Hayden Gallery, M.I.T., *Charles Sheeler: A Retrospective Exhibition from the William H. Lane Foundation*, January 5 - November 9, 1959; South Hadley MA, Mount Holyoke Art Museum, *American Paintings Lent by the William H. Lane Foundation*, October 10 - November 2, 1959; Katonah NY, Katonah Art Gallery, *Charles Sheeler Exhibition Lent by the William H. Lane Foundation*, April 24 - May 24, 1960; Norwich CT, Slater Memorial Museum, *William H. Lane Foundation Exhibition*, November 2 - 22, 1960; Allentown PA, Allentown Art Museum, *Charles Sheeler, Retrospective Exhibition*, November 17 - December 31, 1961, no. 11; Iowa City, University of Iowa Art Galleries, *The Quest of Charles Sheeler*, March 17 - April 4, 1963; Washington D.C., National Collection of Fine Arts, *Charles Sheeler*, October 10 - November 24, 1968, Philadelphia, Philadelphia Museum of Art, January 10 - February 16, 1969, New York, Whitney Museum of American Art, March 11 - April 27, 1969, no. 47; Manchester NH, Currier Gallery of Art, *Selection of Paintings by Arthur G. Dove and Charles Sheeler from the William H. Lane Foundation*, April 7 - 20, 1972; Amherst, Amherst College Art Museum, *Twentieth Century American Art from the William H. Lane Foundation*, October 10 - November 11, 1973; Andover, Addison Gallery of Art, Phillips Academy, *William H. Lane Foundation Exhibition*, November 20, 1973 - January 24, 1974; Storrs CT, William Benton Museum of Art, *Selections from the William H. Lane Foundation*, March 17 - May 24, 1975; Utica NY, Munson-Williams-Proctor Institute, *Paintings from the William H. Lane Foundation*, April 8 - May 27, 1979; Brunswick ME, Bowdoin College Museum of Art, *Paintings from the William H. Lane Foundation: Modern American Masters*, April 8 - May 27, 1979; Boston, Museum of Fine Arts, *The Lane Collection*, April 13, 1983 - August 7, 1983 and San Francisco, San Francisco Museum of Modern Art, October 1 - December 1, 1983, Fort Worth TX, Amon Carter Museum, January 7, 1984 - March 5, 1984, no. 45; Boston, Museum of Fine Arts, *Charles Sheeler: Paintings and Drawings*, October 13, 1987 - January 3, 1988 and New York, Whitney Museum of American Art, January 28 - April 17, 1988, Dallas, Dallas Museum of Art, May 15 - July 10, 1988, no. 33.

Literature: Constance Rourke, *Charles Sheeler: Artist in the American Tradition* (New York, 1938), pp. 76 ill., 142, 144; Robert Coates, "A Sheeler Retrospective - A Sisley Centennial," *New Yorker*, October 14, 1939, p. 56; Wolfgang Born, *Still Life Painting in America* (New York, 1947), p. 132; Dorothy Adlow, *Christian Science Monitor*, April 20, 1956; Lillian Dochterman, *The Stylistic Development of the Work of Charles Sheeler*, Ph.D. diss., University of Iowa, 1963, p. 46; Susan Fillin-Yeh, *Charles Sheeler and the Machine Age*, Ph.D. diss., City University of New York, 1981, p. 60 ill.

In his earliest works, Sheeler imitated the Impressionistic brushwork of his teacher, William Merritt Chase, with whom he studied at the Pennsylvania Academy of the Fine Arts from 1903 to 1906. Though he took two trips to Europe in 1904 and 1905, he only seriously considered the work of modernist painters, particularly Cézanne, during a third visit to Italy and France in 1908-09. That experience prompted him to reevaluate the role of structure in his own paintings, and upon his return to the United States, he began to formulate his ideas in a series of modest tabletop still lifes. During the next decade Sheeler evolved the style for which he is best known: spare, economical shapes made from thin layers of paint and deployed in a flattened space. That style was shaped not only by contemporary modernist handling but also by the lines and surfaces of the machine and skyscraper as well as photography, which he took up in 1912.[1]

In addition to still lifes and urban and industrial subjects, Sheeler painted rural landscapes, barns, and houses and beginning in 1919, domestic interiors, which became one of his major themes. Along with two pictures both entitled *Gladioli*, *Spring Interior* is one of three flowerpieces that Sheeler painted in 1927 and one of a number of pictures in which he situated a still-life arrangement in an interior setting.[2]

The Boston canvas displays a vase of forsythia before a section of the fireplace and adjacent wall in Sheeler's house in New Salem, New York, where he moved in 1926. The branches of flowers in an unassuming glass mug rest atop a late eighteenth-century candlestand, which belonged to the artist's growing collection of early American furnishings and first appeared in a still life of 1925.[3] The table, mug, common forsythia, and restrained architectural features typify Sheeler's preference in the 1920s for plain, understated objects.

The painting's array of techniques, visible underdrawing, and complex structure undermine Constance Rourke's claim that Sheeler executed *Spring Interior* "rapidly, without preliminary study."[4] As he did in both versions of *Gladioli*, Sheeler varies his handling in the Boston canvas. The background exhibits virtually no signs of the brush but the paint of the mantlepiece is thick and worked. Each of the forsythia's petals is rendered with a single daub of paint while the pigment describing the brickwork is so thinly applied that it

resembles watercolor. Pencil underdrawing and bare canvas forms the mortar between the bricks. Unlike the anonymous, machine-like surfaces Sheeler favored in his skyscrapers and industrial objects, the surfaces of *Spring Interior* seem more artisanal in keeping with its natural and domestic objects.

Spring Interior exudes a cheery optimism with its spray of brilliant yellow forsythia, a flower synonymous with the arrival of spring. Moreover, the picture's straightforward geometric shapes and clearly articulated pattern of horizontal and vertical lines create an agreeable sense of order. But as Carol Troyen and Erica Hirshler observe, a variety of perplexing optical illusions tempers the impression of warm domesticity.[5] The depiction of simple and familiar objects in an unstable arrangement may owe in part to the still lifes of Cézanne, who had also plied the difference between what the eye sees and the mind knows.[6] Behind the screen of forsythia, the moldings on the fireplace appear to move both forward and backward in space. The upper horizontal edge of the fireplace screen lies flat against the fireplace while its left vertical edge tilts slightly, suggesting that the wing of the screen juts away from the wall. Even more confusing is the wall structure to the left of the fireplace. The lower section recedes implying that the brown horizontal lines are steps or shelves but the brown slats in the upper half create a pattern of flat bands on a wall that is flush with the fireplace. In later works, Sheeler would use such optical illusions to disturbing effect, but as Troyen and Hirshler argue, the presence of the brilliant forsythia and simple innocent objects make those visual tricks more amusing than unsettling.[7]

1. On Sheeler's work two good sources are Carol Troyen and Erica E. Hirshler, *Charles Sheeler: Paintings and Drawings* (Boston, Museum of Fine Arts, 1987) and Karen Lucic, *Charles Sheeler and the Cult of the Machine* (Cambridge, 1991).

2. *Gladioli* (Mr. and Mrs. Richard C. Hedreen, Seattle) and *Gladioli* (*Summer Flowers*) (Collection of Glenn C. Janss, Sun Valley, Idaho).

3. Troyen and Hirshler, p. 106.

4. Constance Rourke, *Charles Sheeler, Artist in the American Tradition* (New York, 1938), p. 142.

5. Troyen and Hirshler, p. 112.

6. In about 1925, Sheeler wrote an essay on still-life painting in which he set out the history of the genre and discussed the work of Cézanne and other still-life painters whom he admired. Unpublished typescript, Watson

Forbes Papers, microfilm D56. 1092-1094, Archives of American Art, Washington, D.C.

7. Troyen and Hirshler, p. 115.

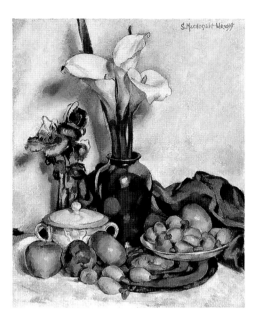

83
STANTON MACDONALD-WRIGHT
(1890 Charlottesville, Virginia – 1973 Los Angeles)

Still Life with Arum Lilies and Fruit,
1923

Oil on canvas, 22 x 18 in. (55.9 x 45.7 cm)
Signed upper right: *S. Macdonald-Wright*
Bequest of John T. Spaulding. 48.575

Provenance: John Taylor Spaulding, Boston.

Exhibitions: Cleveland, Cleveland Museum of Art, *Sixth Exhibition of Contemporary American Painting*, 1926; Boston, Museum of Fine Arts, *The Collections of John Taylor Spaulding 1870-1948*, May 26 - November 7, 1948, no. 54.

Wright left school at age fourteen and enrolled at the Art Students League in Los Angeles the next year.[1] In 1907, he traveled to Paris, where he absorbed various currents of European modernism and studied at the Académie Julian, the Ecole des Beaux-Arts, and the Sorbonne. He is best known for his fairly abstract Synchromist paintings of the second decade of the twentieth century. Synchromism, which he developed with Morgan Russell, an American whom he met in Paris, was primarily concerned with the properties of color and their effects on one another. Discouraged by the lack of critical support and

poor sales of his paintings, Wright returned to New York in 1916 and in 1919 moved to Southern California where he spent the rest of his life, save for occasional stays in Japan. In the 1920s, he returned to more realistic subject matter and expanded his palette beyond the pure colors that had been the focus of his Synchromist works. In 1948 he explained the transformation in his art: "At that time, having entirely outgrown the 'academism' of my earlier intellectualist (sic) method, I began to search for a procedure or style, a 'way' which would serve me in my mature years as well as Synchromism had served me in my youth."[2] It took Wright some thirty-five years to find that "way." Dissatisfied with the direction of his own work and of American painting generally, he rarely exhibited during those decades, supporting himself mainly through teaching.[3]

In a letter to the Museum, Wright wrote that he painted *Still Life with Arum Lilies and Fruit* in 1923 in New York, but added that the objects were more typical of California.[4] Although Wright claimed that he had found Synchromism too limited, the Boston canvas displays evidence of that style in the prismatic colors of the shadows and the concentric circles of the blue and red cloth placed beneath the bowl. It differs from earlier works, however, in its richer, more varied palette, thicker paint application, and use of line, which Wright had previously eschewed in favor of creating forms through color. While Wright explained changes in his art in purely personal terms, his depiction of a more traditional subject in a more realistic style is consistent with general trends in European and American painting in the 1920s.

1. On Wright, see *Stanton Macdonald-Wright* (Los Angeles, Los Angeles County Museum of Art, 1956); *Stanton Macdonald-Wright, A Retrospective Exhibiton* (Los Angeles, UCLA Art Galleries, 1970); *The Art of Stanton Macdonald-Wright* (Washington D.C., National Collection of Fine Arts, 1976).

2. Quoted in *The Art of Stanton Macdonald-Wright*, pp. 12-13.

3. See Wright's comments in John Alan Walker, "Interview: Stanton Macdonald-Wright," *American Art Review* 1/2 (January - February 1974), p. 63.

4. Letter dated December 1963 in Museum files.

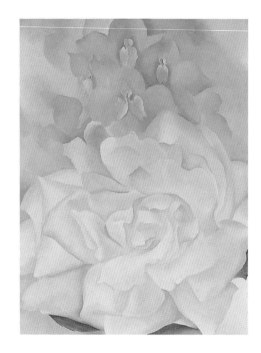

84
GEORGIA O'KEEFFE
(1887 Sun Prairie, Wisconsin – 1986 Santa Fe, New Mexico)

White Rose with Larkspur No. 2, 1927

Oil on canvas, 40 x 30 in. (101.6 x 76.2 cm)
Signed on verso: *Georgia OKeeffe*
Henry H. and Zoë Oliver Sherman Fund. 1980.207

Provenance: the artist.

Exhibitions: New York, The Intimate Gallery, *O'Keeffe Exhibition*, January - February 1928, no. 17.

Literature: *The Museum Year: 1979-80*, p. 80 and cover; "La Chronique des arts: principales acquisitions des musées en 1980," *Supplément à la Gazette des Beaux Arts*, no. 1346 (March 1981), p. 44 ill.; Katherine Hoffman, *An Eduring Spirit: The Art of Georgia O'Keeffe* (Metuchen NJ, 1984), insert T; Lisa Mintz Messinger, *Georgia O'Keeffe* (New York, Metropolitan Museum of Art, 1986), p. 61; Charlene Breedlove, "The Cover," *Journal of the American Medical Association* 255/24 (June 27, 1986), p. 3338 and cover ill.; Theodore E. Stebbins, Jr., and Peter C. Sutton, *Masterpiece Paintings from the Museum of Fine Arts*, Boston (New York, 1986), p. 138 ill.; Nicholas Callaway ed., *Georgia O'Keeffe: One Hundred Flowers* (New York, 1987), no. 42.

O'Keeffe began her training with John Vanderpoel in 1905 at the Art Institute of Chicago and continued at the Art Students League in 1907, winning first prize for her work in William Merritt Chase's still-life class.[1] Forced to curtail her studies for financial reasons, she taught and worked as a commercial artist for the next few years but exposure to the theories of Arthur Wesley Dow renewed her

interest in painting. Dow urged his students to focus on the evocative properties of line, color, and mass rather than the description of a particular object. In 1916, O'Keeffe's work came to the attention of Alfred Stieglitz, a critical figure in the history of early American modernism and later O'Keeffe's husband. In 1917, he gave O'Keeffe a solo exhibition at his gallery, "291," and in 1918 she left her teaching job at West Texas State Normal School for New York. By that time she was developing her signature style of economical shapes, simple lines, and smooth surfaces.[2]

Though she painted both landscapes and pure abstractions, O'Keeffe is probably best known for her still lifes, particularly for her large-scale flower pictures, which she began painting in 1924. By the end of her life, she had made over 200 flower pictures, executing most of them between 1918 and 1932 and generally favoring one or two blooms of inflated size as she did in *White Rose with Larkspur No. 2*.[3] Like many of O'Keeffe's flower paintings, the extraordinary proportion of the flower in the Boston canvas gives it an almost hypnotic, hallucinatory power, which is enhanced by the centripetal force of the petals, whose rhythmic circular pattern pulls the eye towards the blossom's inner recesses. By using pale delicate colors and smooth motionless surfaces to render the vital growing flower, O'Keeffe created an image of intriguing opposites, one that is simultaneously sensual and innocent, energized and controlled, natural and abstract.

Responding to several factors, critics characterized her flower still lifes as evocations of her sexuality. Certainly the relative scarcity of women artists brought the issue of her gender to the fore, and the flowers themselves also encouraged such a reading since their swelling rounded forms, crevices, and openings so readily suggested the physical qualities of the female body. O'Keeffe's reputation as a sexually liberated woman probably also shaped the reception of her pictures. Finally, increasing fascination with and openness about sexual issues in 1920s America, particularly in avant-garde circles, not only enabled critics to discuss her flowers as examples of erotica in a public forum but also perhaps prompted them to do so.[5]

For her part, O'Keeffe contended that such interpretations said more of the critics' interests than her intentions: "Well – I made you take time to look at what I saw and

when you took time to really notice my flower you hung all your own associations with flowers on my flower as if I think and see what you think and see of the flower – and I don't."[6]

1. O'Keeffe won the prize for *Dead Rabbit with Copper Pot* (1908; New York, Art Students League).

2. Surveys of O'Keeffe's life and work include Laurie Lisle, *Portrait of an Artist* (Albuquerque, 1986); Sarah Whitaker Peters, *Becoming O'Keeffe: The Early Years* (New York, 1991), and Charles C. Eldredge, *Georgia O'Keeffe: American and Modern* (New Haven and London, 1993). Peters and Eldredge include extensive bibliographies.

3. For a selection of the flower paintings, see Nicholas Callaway ed., *Georgia O'Keeffe: One Hundred Flowers* (New York, 1987).

4. See for example, Lewis Mumford, "O'Keefe [*sic*] and Matisse," *O'Keeffe Exhibition* (New York, Intimate Gallery, 1928). The essay was reprinted from *The New Republic*, March 2, 1927, pp. 41-42; Louis Kalonyme, "Georgia O'Keeffe: A Woman in Painting," *Creative Art* 2/1 (January 1928), pp. 35-40; Marsden Hartley, "Georgia O'Keeffe: A Second Outline in Portraiture," *Georgia O'Keeffe: Exhibition of Paintings, 1935* (New York, An American Place, 1936). It should be noted that the sexual angle was not unique to the flower paintings, but had also been used to interpret previous works.

5. As noted by Anna C. Chave, "O'Keeffe and the Masculine Gaze," *Art in America* 78/1 (January 1990), p. 119.

6. Georgia O'Keeffe, "About Myself," in *Georgia O'Keeffe, Exhibition of Oils and Pastels* (New York, An American Place, 1939). Chave argues that O'Keeffe was fully aware of the eroticism of her flowers, but deplored "the degrading forms those readings took." See Chave, p. 120.

85 (plate 32, page 46)

GEORGIA O'KEEFFE

(1887 Sun Prairie, Wisconsin – 1986 Santa Fe, New Mexico)

Deer's Skull with Pedernal, 1936

Oil on canvas, 36 x 30 in. (91.4 x 76.2 cm)
Gift of the William H. Lane Foundation. 1990.432

Provenance: the artist; Downtown Gallery, New York; William H. Lane Collection in 1953.

Exhibitions: New York, An American Place, *Georgia O'Keeffe: New Paintings*, February 5-March 17, 1937; Philadelphia, Pennsylvania Academy of the Fine Arts, *134th Annual Exhibition of Contemporary American Painting*, February-March, 1939; New York, Museum of Modern Art, *Georgia O'Keefe*, May 14-August 25, 1946; Andover, Addison Gallery of American Art, *Paintings from the William H. Lane Foundation*, November 20-December 14, 1953; Fitchburg, Fitchburg Art Museum, *Contemporary American Paintings from the William H. Lane Foundation*, December 12, 1953-January 10, 1954; Poughkeepsie, Vassar College Art Gallery, *Twentieth Century American Paintings. Lent by the William H. Lane Foundation*, March 3-26, 1954; Lincoln, De Cordova Museum, *American Paintings from the William H. Lane Foundation*, November 14,

1954-January 13, 1955; Northhampton, Smith College Museum of Art, *Twentieth Century Americans from the William H.Lane Foundation*, April 15-May 15, 1955; Wellesley, Wellesley College Museum, *American Paintings from the William H. Lane Foundation*, October-November, 1955; South Hadley, Mt. Holyoke College Art Museum, *Contemporary American Painters from the William H. Lane Foundation*, May 9-June 3, 1956; New York, Whitney Museum of American Art, *The Museum and Its Friends*, April 30 - June 15, 1958, no. 123; Worcester, Worcester Art Museum, *Georgia O'Keeffe*, October 4 - December 4, 1960, no. 17; New York, Whitney Museum of American Art, *The 1930s: Painting and Sculpture in America*, October 15 - December 1, 1968, no. 80; New York, Whitney Museum of American Art, *Georgia O'Keeffe*, October 8 - November 29, 1970, Chicago, Art Institute of Chicago, January 6 - February 7, 1971, San Francisco, San Francisco Museum of Art, March 15 - April 30, 1971, no. 84; Storrs CT, William Benton Museum of Art, *Selections from the William H. Lane Foundation*, March 17 - May 25, 1975; Framingham, Danforth Museum, *Selections from the William H. Lane Foundation*, April 2 - June, 4 1978; Bowdoin ME, Bowdoin College Museum of Art, *Paintings from the William H. Lane Foundation: Modern American Masters*, October 10-November 23, 1980; Lincoln, De Cordova Museum, *Selections from the William H. Lane Foundation*, 1980; Boston, Museum of Fine Arts, *The Lane Collection*, April 13 - August 7, 1983 and San Francisco, San Francisco Museum of Modern Art, October 1 - December 1, 1983, Fort Worth, Amon Carter Museum, January 7, 1984 - March 5, 1984, no. 63.

Literature: Henry McBride (Review of an American Place Show), *New York Sun*, February 13, 1937, p. 31; "Georgia O'Keeffe Who 'Makes Death Beautiful,'" *Art Digest* 11 (March 1, 1937), p. 13 ill.; Elizabeth McCausland (Review of An American Place Show), *Springfield Sunday Union and Republican*, February 14, 1937, p. 6; Sam A. Lewisohn, *Painters and Personality* (New York, 1937), p. 255, pl. 122; Journal of the American Association of University Women, 45/2 (January 1952); *New York Times Book Review*, October 10, 1954 (cover illustration); *Keene Reformer*, August 15, 1973 ill.; Doris Bry and Nicholas Callaway eds., *Georgia O'Keeffe: In the West* (New York, 1989), no. 39; Elizabeth Montgomery, *Georgia O'Keeffe* (New York, 1993), p. 101 ill.

O'Keeffe began spending summers in New Mexico in 1929 and settled there permanently after Alfred Stieglitz's death in 1946. She based her studies of bones on objects she found in the New Mexican desert, here depicting a deer's skull hanging on a weathered cedar tree before the Pedernal, the mesa visible from her home at Ghost Ranch.[1] O'Keeffe rejected interpretations of her bone still lifes as modern *vanitas* images,[2] maintaining that the bones connoted life not death: "The bones are as beautiful as anything I know," she wrote. "To me they are strangely more living than the animals walking around – hair, eyes and all, with their tails switching. The bones seem to cut sharply to the center of something that is keenly alive on the desert even though it is vast and empty and

untouchable – and knows no kindness with all its beauty."[3] On another occasion, she insisted that they were "symbols of the desert, but nothing more."[4]

O'Keeffe's objections notwithstanding, the critics' response cannot be ignored. She has rendered the stark skeletal remains with such force and monumentality that thoughts of death and decay seem inescapable. Moreover, O'Keeffe's bone studies inevitably call up images of the solitary animal carcass lying in the mid-eastern desert or skulls scattered on the western plains, standard symbols of nature's destructive powers among nineteenth-century orientalist painters and chroniclers of the American west. Though such widely known images influence the viewer's assessment of *Deer's Skull*, O'Keeffe does not slavishly reproduce their meanings. The brilliant white bones, the cloudless blue sky, the perfectly balanced design, and smooth quiet surfaces produce a sense of equanimity and permanence, tempering the feelings of doom, fear, and guilt that previous images of human or animal bones were intended to induce.

1. For a survey of O'Keeffe's paintings of New Mexico, see Doris Bry and Nicholas Callaway, eds., *Georgia O'Keeffe: In the West* (New York, 1989), no. 39.

2. On the *vanitas* readings of O'Keeffe's bone studies, see for example, Henry McBride in "New York Criticism," *Art Digest* 6 (January 15, 1932), p. 18 and Ralph Flint, "1933 O'Keeffe Show a Fine Revelation of Varied Powers," *Art News* 31 (January 14, 1933), p. 9.

3. Georgia O'Keeffe, "About Myself," *Georgia O'Keeffe: Exhibition of Oils and Pastels* (New York, An American Place, 1939), n.p.

4. Quoted in Dorothy Sieberling, "Horizons of a Pioneer," *Life*, March 1, 1968, p. 42. O'Keeffe's still lifes are often notable for the disorienting relation between figure and ground. Charles Eldredge argues, however, that the disproportionate scale makes sense in the desert pictures, writing "The large scale, bright light, and clear air of the region permit the viewer to see, proverbially, 'forever,' and the juxtaposition of faraway and nearby is an integral part of desert vision." See Charles C. Eldredge, *Georgia O'Keeffe: American and Modern* (New Haven and London, 1993), p. 203.

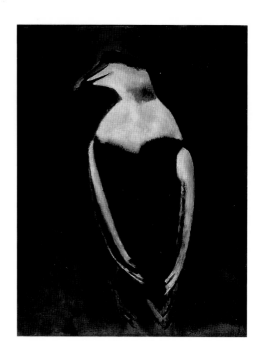

86

(EDMUND) MARSDEN HARTLEY

(1877 Lewiston, Maine – 1943 Ellsworth, Maine)

Black Duck, 1940-41

Oil on masonite, 28¼ x 22 in. (71.8 x 55.9 cm)
Signed at lower right: *M.H. 40/41*
The Hayden Collection. Prov. 43.32

Provenance: W. Kelekian, New York.

Exhibitions: New York, Museum of Modern Art, *Feininger and Hartley*, 1944, p. 85; Chicago, Arts Club, *Hartley Memorial*, 1945, no. 52; Canada, Toronto Art Gallery, *Contemporary Art*, 1949, no. 87; Lincoln MA, DeCordova Museum, *Birds of Nature and the Nature of Birds*, 1957; Boston, Shore Gallery, *Hartley*, March 7 - 24, 1962, no. 37; Beijing, Zhongguo Meishuguan, *American Paintings from the Museum of Fine Arts, Boston*, September 1 - 30, 1981 and Shanghai, Shanghai Bowuguan, October 20 - November 19, 1981, no. 57.

Literature: Russell Lynes, "The Museum in My Head," *Architectural Digest*, 39/1 (January 1982), p. 22, 26 ill.

In the early 1930s, Hartley, one of the foremost practitioners of early American modernism, began fashioning himself as a painter of New England. He was motivated in part by his ties to the area – he grew up in Maine – and in part by pragmatism since American scene and regionalist subjects dominated American art at that time. To announce his new identity, Hartley entitled his 1932 show at the Downtown Gallery in New York, "Pictures of New England by a New Englander" and wrote a poem, "Return of the Native," to accompany the exhibition. Yet typically, Hart-

ley's affections and allegiances were ever changing. He yearned for the city in the country, craved solitude in the face of urban crowds, and longed for the United States when in Europe. Despite his avowed intention to chronicle New England, he traveled and lived in Europe, Mexico, the American southwest, and New York during the next five years. He returned to Maine in 1937 after an absence of nearly forty years. By that time, he was emotionally, physically, and financially spent.[1]

Hartley executed several drawings and paintings of dead birds in the late 1930s. He made the first of them in Nova Scotia, following the deaths of Alty and Donny Mason, who, along with their parents, had become Hartley's surrogate family. Though the boys' deaths may have been the original impulse for such early pictures as *Labrador Ducks* (1936; Private Collection), bird images served other functions and interests.[2] As Hartley grew more infirm, their simplicity proved practical. They also allowed him to continue to investigate natural motifs, the touchstone of his art even at its most abstract and mystical moments. Hartley's admiration for the pictures of John James Audubon and the gamepieces of the seventeenth-century Dutch painters Jan Weenix and Melchior d'Hondecoeter may also have informed his bird images.[3]

The almost monochromatic palette of *Black Duck* is typical of Hartley's later canvases when failing eyesight led him to use more muted colors. The Boston canvas is one of two images of this bird. In contrast to the later picture of 1941 (now in the Detroit Insitute of Arts),[4] Hartley sharpens the design in the Boston canvas so that the duck's beak is more pointed and the transition from light to dark feathers on the breast more pronounced and dramatic. By eliminating much of the detail, the bird becomes abstract and enigmatic. It is not clear whether the duck is dead or alive or whether we are seeing his back or front, and the position of the limp, misshapen foot is ambiguous. Moreover, the duck, which stands upright, seems almost human. With its aquiline nose, distinctive profile, black body, and white shoulders, head, and wings, the *Black Duck* has reminded some viewers of John Singer Sargent's infamous *Mme. X* (1884; New York, Metropolitan Museum of Art). Though the visual similarities are compelling, it will probably never be known whether Sargent's canvas, which was acquired by the

Metropolitan Museum in 1916, lurked in Hartley's subconscious when he painted the *Black Duck*. However his transformation of the common duck into an aristocratic, mysterious, and detached figure is evident.

1. For a good overview of Hartley's work, see Barbara Haskell, *Marsden Hartley* (New York, Whitney Museum of Art, 1987).

2. On the symbolism of these early works, see Gerald Ferguson ed., *Marsden Hartley and Nova Scotia* (Halifax, Mount Saint Vincent University Art Gallery, 1987), pp. 152-154.

3. Marsden Hartley, "John James Audubon, as Artist," in Marsden Hartley, *On Art*, Gail R. Scott ed. (New York, 1982), pp. 251, 253. My thanks to Janet Comey for this reference.

4. The Detroit canvas, entitled *Black Duck no. 1* is signed and dated M.H./ '41.

There is some confusion over the kind of duck that Hartley has depicted in the canvas. In a letter dated June 12, 1943, to W. G. Constable, curator of paintings at the Museum of Fine Arts, Hartley said "As for the Black Duck painting which is now in the possession of the Boston Museum, there is little to say. The ducks come down from Labrador by the thousands to escape the cold of that region and settle down in our coves...." However, it is the Eider not the Black Duck which comes down from the north in the winter. The Black Duck lives in New England year round. The letter is in the curatorial files of the Museum of Fine Arts.

87

GINO SEVERINI

(1883 Cortina – 1966 Paris)

Cupids Carrying the Themes of the Picture, 1929

Oil on canvas, 45⅞ x 35⅛ in. (116.5 x 89.3 cm)
Signed lower right: *G. Severini*
Tompkins Collection. Res. 32.16

Provenance: Léonce Rosenberg, Paris until 1931.

Exhibitions: Paris, Galerie Bonjean, 1931; Rome, *Seconda quadriennale d'arte nazionale*, 1935; Boston, Institute of Modern Art and New York, Wildenstein & Co., *Sources of Modern Paintings*, 1939, no. 17.

Literature: Pierre Courthion, *Gino Severini* (Milan, 1930), n.p. ill.; Maurizio Fagiolo Dell'Arco, "Severini e il gruppo degli 'Italiani di Parigi,'" in *Gino Severini* (Florence, Pitti Palace, 1983), p. 30 ill.; Murphy 1985, p. 262 ill.

In 1906, Severini moved to Paris and over the next several years settled into the world of the Parisian avant-garde. During that time, he painted mainly scenes of the city in a divisionist style inspired by Neo-Impressionism. Despite his new-found ties with Paris, he

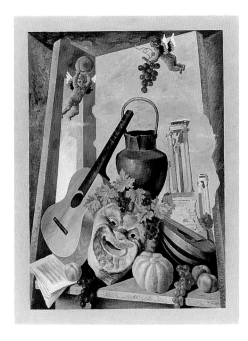

maintained contact with Italian artists, and in 1910, joined Carlo Carrà, Umberto Boccioni, Giacomo Balla, and F. T. Marinetti to form a group known as the Futurists, signing his name to the manifesto published that year in Milan, which outlined the movement's goals. For much of the next decade, Severini continued to paint images of urban life – dance halls, crowds, and city streets – as well as portraits and apparently non-objective works. Now, however, he combined the fragmented planes of Cubism with Futurism's dynamic force lines, which were intended to embody movement and speed, the centerpieces of the group's art and theory. He also executed collages in the manner of Juan Gris.

Cupids Carrying the Themes of the Picture, however, is a product of a shift that took place in Severini's art in the late teens. Alongside a new concern with the integrity, rather than the fragmentation of forms came a fascination with motifs rooted in Italian history and art. The mask reflects Severini's interest in the *commedia dell'arte*, a subject he painted in various guises throughout the 1920s, and the pieces of fruit are traditional still-life objects. The architectural ruins evoke, of course, classical antiquity and the lute and guitar have roots in Italian still-life painting dating back to the seventeenth century. As this picture demonstrates, Severini did not completely reject avant-garde painting. The flattened but dynamic space of his Cubo-Futurist works shapes the picture's design and traces of his divisionist style appear in the stippled clouds. The witty reversal of sky and

wall seems almost a quotation from Magritte, and the plain modern arches, which contrast so neatly with the foliated capitals and fluted columns of the ruins, pay homage to Giorgio de Chirico's metaphysical works.

Severini painted a number of still lifes incorporating classical motifs in 1928-29, but *Cupids Carrying the Themes of the Picture* is especially close to a gouache in the Fogg Art Museum, Cambridge, and a canvas in the Galleria Nazionale d'Arte Moderna in Rome. Both pictures display putti carrying still-life objects before a backdrop of classical and de Chiricesque architecture.[1] Severini also included variations of this scene in *Flowers and Masks*, an album of sixteen gouaches published in London in 1930.[2]

Severini's revival of the past was not unique. Painters throughout Europe, including Picasso, de Chirico, and Carrà, depicted traditional subjects in the 1920s, responding to the *rappel à l'ordre*, which swept the continent following the War. That return to the past had ominous overtones in Italy, where the Fascist regime called upon artists to further its goals by celebrating the country's national heritage.[3] Yet Severini's canvas with its whimsical putti, humorous story, and witty painted frame hardly displays the kind of propagandistic pedantry that characterized the work of artists who responded to Mussolini's appeal. This light-hearted view of history is equaly far from the strident tones of the 1910 Futurist manifesto. There Severini and his colleagues had urged artists to expunge the past from their canvases, writing that the "eye must be freed from its veil of atavism and culture, so that it may at last look upon Nature and not upon the museum as the one and only standard,"[4] and claiming further that "…all subjects previously used must be swept aside in order to express our whirling life of steel, of pride, of fever, and of speed."[5]

1. For an illustration of the picture in Rome, see *Gino Severini* (Florence, Pitti Palace, 1983), p. 122.

2. For illustrations, see *Severini* (Milan, 1987), pp. 115, 117.

3. Kate Flint, "Art and the Fascist Regime in Italy," *Oxford Art Journal* 3/2 (October 1980), pp. 49-54. On the *rappel à l'ordre* generally, see Kenneth E. Silver, *Esprit de Corps: The Art of the Parisian Avant-Garde and the First World War, 1914 - 1925* (Princeton, 1989).

4. "Futurist Painting: Technical Manifesto," dated April 11, 1910, in Herschel B. Chipp, *Theories of Modern Art* (Berkeley and Los Angeles, 1968), p. 292.

5. Ibid., p. 293.

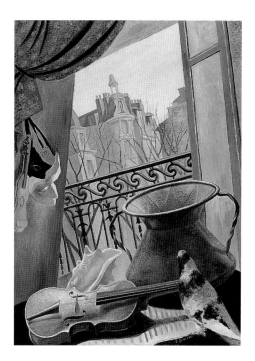

88

GINO SEVERINI

(1883 Cortina – 1966 Paris)

Balcony in Paris, 1930

Oil on canvas, 39⅜ x 28¾ in. (100 x 73 cm)
Signed lower right: *G. Severini*
Tompkins Collection. Res. 32.17

Provenance: Purchased from the artist, 1931.

Exhibitions: Venice, *XVII Biennale*, 1930; Paris, American Women's Club, *Living Italian Painters*, 1931, no. 8; Boston, Society of Independent Artists, 1932.

Literature: Murphy 1985, p. 262 ill.

In 1920 Severini wrote *Du Cubisme au classicisme* in which he argued that painting was in a state of chaos because artists had lost contact with traditional techniques and with science. As if to remedy the situation, he himself began studying mathematics and early theories of proportion around that time. In 1923, he returned to Catholicism and the next year, painted the first of many fresco cycles, several of them for churches.

Although many of his canvases from the 1920s and 1930s pay homage to Italy's past, Severini modernizes those references in *The Balcony*. The domestic setting transforms the *commedia dell'arte* mask and the instruments, which in *Cupids Carrying the Themes of the Picture* evokes the pictures of Baschenis and Caravaggio, into personal possessions arranged before an open window in an individual's

dwelling. Although Severini visited Italy regularly, his life revolved around Paris where he had settled with his family. With its double French windows and view of the typically Parisian apartment blocks across the way, the scene is clearly located in the painter's adopted rather than native country. The picture, moreover, recalls the balcony scenes of such modern French painters as Manet, Caillebotte, and Matisse.

The Balcony is related to a gouache in the Rijksmuseum Kröller-Müller, Otterlo[1]; a gouache in the Beaverbrook Art Gallery, Frederickton, New Brunswick[2]; and two paintings of 1930 and 1933, whose locations are unknown.[3] Those four pictures display many of the same objects as the Boston canvas, as well as a similar curtained window and balcony, but their horizontal formats and relatively stable rectilinear designs contrast with its vertical format and diagonal orientation.

1. For an illustration, see *Gino Severini* (Florence, Pitti Palace, 1983), p. 124.

2. For an illustration, see Editorial, "The Singularity of Gino Severini," *Apollo* 97/135 (May 1973), p. 457.

3. For illustrations, see *Gino Severini, "Entre les deux guerres"*, (Rome, Galleria Giulia, 1980), p. 73 and *Gino Severini, "Processo e difesa di un pittore d'oggi," L'Arte* 34/4 (November 1931), p. 495.

89 (plate 34, page 48)
GIORGIO MORANDI
(1890 Bologna – 1964 Bologna)

Still Life of Bottles and Pitcher, 1946

Oil on canvas, 9⅞ x 17¾ in. (25 x 45.2 cm)
Signed lower center: *Morandi*
Tompkins Collection. 61.662

Provenance: Pietro Rollino, Rome by 1946; Lorenzelli Galleries, Milan until 1961.

Exhibitions: Providence RI, Rhode Island School of Design, *Recent Still Life in Painting and Sculpture*, February 18 - March 30, 1966, no. 47; Cambridge, Busch-Reisinger Museum, *Giorgio Morandi, 1890-1964*, January 12-February 10, 1968 no. 3; Vancouver, Vancouver Art Gallery, *Paintings and Etchings by Giorgio Morandi*, October 1 - 31, 1977, no. 26; Boston, Pucker Safrai Gallery, *Beginnings '79*, April 29 - June 10, 1979; San Francisco, San Francisco Museum of Modern Art, *Morandi Retrospective*, September 23 - November 1, 1981, New York, Guggenheim Museum, November 19, 1981 - January 17, 1982, and Des Moines IA, Des Moines Art Center, February 1 - March 14, 1982, no. 33.

Literature: Gnudi Cesare, *Morandi* (Florence, 1946), p. 64, no. 49; Daniel Robbins, "Recent Still Life," *Art in America*

54/1 (January - February 1966), p. 57 ill.; Murphy 1985, p. 212 ill.

Though his works were widely collected and exhibited, Morandi was considered an outsider, even an anomaly in the history of modern art during his lifetime because his pictures could not be easily linked with any trend in painting or group of painters. Early in his career, he associated with other artists in Italy, exhibiting with the Futurists in 1914 and participating in Giorgio de Chirico's *scuola metafisica* in 1918-19. After those brief episodes, however, he neither belonged to a particular movement nor subscribed to a specific school of painting. By the 1920s, he was producing mostly still lifes and landscape, and the simple compositions, schematic shapes, and tonal colors that would characterize his work until the end of his life were already in evidence. The human figure disappeared entirely from his imagery by the end of the 1930s. Save for a few brief trips, he spent his entire life in Italy, mostly in Bologna. His knowledge of Cézanne and the Cubists, who influenced his application of paint and conception of space, came mainly from reproductions in books and magazines since little of their art was shown in Italy.

In work after work, Morandi depicted the same bottles, containers, and glasses; these he kept in his studio, set on a table against a plain background. His unstinting, almost obsessive investigation of these objects over a period of forty years stands in opposition to the value given to change and novelty in modern society. Refusing any hint of narrative which might allow us to apprehend his objects in terms of our daily, creatural habits, he does not invite us to think about what the bottles were used for or where they came from. The schematic shapes and simple arrangements, in some senses, evoke the telegraphic language and imagery of mass culture. Yet to be fully appreciated, Morandi's pictures demand careful sustained scrutiny which differs markedly from the cursory attention we normally accord such imagery.[1] While the application of paint is visible, Morandi eschewed bravura, expressionistic brushwork in favor of hushed, motionless strokes of pigment placed painstakingly on the canvas. He asks us to ponder the paint surface, the depiction of space, subtle changes in color, form, and texture. We see a beam of light congealing into a single stroke of white paint on the bottle to the right,

extraordinarily subtle modulations of white paint enlivening the surfaces of the two bottles to the left, and multiple shades of gray in the background. It might be argued that looking is the true subject of the painting, and the bottles only a pretext for that act.

Morandi's canvases involve intriguing dialogues. His compositions often simultaneously suggest both the intimate and the infinite. His objects, which he usually grouped together in the center of the canvas, relate to one another in a familial way, but in many of his pictures including the Boston canvas, the back edge of the table appears like a horizon line in a landscape, and the pale background takes on the character of a limitless sky. Moreover, his silhouetted shapes, which seem physically present and concrete no matter how abstract they become, as well as his simple designs and beguiling, deliberate awkwardness seem as indebted to the examples of Giotto, Piero della Francesco, and other early Renaissance painters as they are to Cézanne and other moderns.

1. This idea is discussed by Kenneth Baker in his, "Redemption through Painting: Late Works of Morandi," in *Giorgio Morandi* (Des Moines, Des Moines Art Center, 1981), pp. 43-44. On Morandi's resistance to Mussolini's use of representation for propagandistic purposes, see Francesco Arcangeli, *Giorgio Morandi*, 2nd. ed. (Milan, 1968), p. 202.

90 (plate 35, page 48)
MAX BECKMANN
(1884 Leipzig – 1950 New York)

Still Life with Three Skulls, 1945

Oil on canvas, 21¾ x 35¼ in. (55.2 x 89.5 cm)
Signed lower right: *beckmann/ A 45*
Gift of Mrs. Culver Orswell. 67.984

Provenance: Paul Cassirer, Amsterdam, bought from the artist, May 29, 1945; Curt Valentin, bought September 10 or October 31, 1946; Mrs. Lois Orswell, bought November 19, 1946.

Exhibitions: Boston, Institute of Modern Art, *Twentieth-Century Art in New England*, May 6 - June 30, 1948, no. 34; Boston, Pucker Safrai Gallery, *Beginnings '79*, April 29 - June 10, 1979; Frankfurt am Main, Stätischen Galerie, *Hinter der Bühne – Backstage – Max Beckmann*, 1990, no. 5.

Literature: B. Reifenberg and W. Hausenstein, *Max Beckmann* (Munich, 1949), p. 80; M. Beckmann, *Tagebücher, 1940 – 1950* (Munich, 1955), pp. 109, 116; Erhard Göpel and Barbara Göpel, *Max Beckmann, Katalog der Gemälde*, (Bern, 1976), vol. 1, p. 415 and vol. 2, p. 251 ill.; Stephan Lackner, *Max Beckmann* (New York, 1977), p. 35 ill.; Nathan Goldstein, *Painting, Visual and Technical Fundamentals* (Englewood Cliffs NJ, 1979), p. 176 ill.; *Max Beck-*

mann – Retrospective (St. Louis, St. Louis Art Museum, 1984), p. 26-27 ill.; Murphy 1985, p. 14 ill.; Carla Schulz-Hoffmann, *Max Beckman* (Munich, 1991), p.152 ill.

In a bold modern style composed of flattened space, schematic forms, and vibrant colors, Beckmann has painted still-life objects whose roots lie in the seventeenth century: three skulls in the center, a candle with a blackened wick to the left, a bottle to the right and five playing cards – the king of spades to the left, the four of hearts, the ace of hearts, a jack and a nine of diamonds to the right beneath the bottle. Adding an incongruous note to the ensemble, a floppy hat rests on its crown before the skulls. The objects are assembled before a backdrop that resembles stained glass.

Although the picture's combination of a modern style and traditional objects typifies the artist's still lifes, it is perhaps his most vivid and intense work in the genre.[1] The objects are obviously drawn from the *vanitas* tradition, with the skulls, extinguished candle, and the playing cards all reminding the viewer of the ephemerality of life.[2] In the present work, however, Beckmann does not merely modernize an historic theme. As the date beneath the signature, "A 45," indicates, he executed this canvas in Amsterdam during the final stages of the War and of the Nazi regime. He sought refuge in that city in 1937, leaving Germany the day after the infamous "Degenerate Art Exhibition," which featured ten of his canvases, opened in Berlin. During his years in Amsterdam, Beckmann was almost completely cut off from his life in his native country, and for much of the time he scrounged for basic necessities like food and fuel. He described that period of his life to a friend: "…I have had a truly grotesque time, full to the brim with work, Nazi persecutions, bombs, hunger.…"[3] In the selection of objects, the predominance of black, and the ponderous application of paint, the still life embodies the grim sentiments conveyed by those words. The red-brown of the table recalls the color of dried blood and the dusky gray bottle resembles a chimney. The playing cards evoke associations of judgment and skill but also of irrationality and chance, seemingly contradictory qualities that aptly describe the calculated insanity of war.

Beckmann began this still life in January 1945[4] and completed it in mid-April, at which time, he briefly described it in his diary: "Skull is truly finished. Quite a funny picture – as everything on the whole is getting pretty funny and increasingly spooky. Quappi well again – Otherwise – can anything still interest me? Don't think so. Basically nothing will ever be as impossible as this current state of poverty and disillusion."[5] Given the gruesome images and the horrors they symbolize, the description at first seems odd, but on further reflection, the black humor that Beckmann ascribed to the work emerges. The tone of the oranges and greens seems simultaneously spritely and vibrant but also acidic and repellent. The large skulls set at jaunty angles press towards and seem to smile or leer at the viewer. In contrast with the grim implications and historic roots of the other images, the floppy hat brings the viewer back to the humdrum realities of everyday life. As he indicated in a letter of August 1945, he found the return to the ordinary routines of human interaction following the atrocities of war disconcerting and even offensive given the ease with which it was apparently effected: "The world is rather kaput, but the spectres climb out of their caves and pretend to be normal and regular humans again who excuse themselves to each other instead of eating one another or sucking each other's blood. The entertaining folly of war evaporates, distinguished boredom sits down again on the dignified old overstuffed chairs."[6]

1. Other favored motifs included flowers, musical instruments, candles, and fruit.

2. On the *vanitas* still life, see Christian Klemm, "Weltdeutung – Allegorien und Symbole in Stilleben," in *Stilleben in Europa* (Münster and Baden-Baden, 1980), pp. 190-217; Carla Schulz-Hoffmann has compared *Skulls* to A. B. van der Schoor's *Vanitas*, 1660/1670, in the collection of the Rijksmuseum in Amsterdam (A 1342). Beckmann might well have studied the painting during his visits to the museum. See Carla Schulz-Hoffmann, "Bars, Fetters, and Masks: The Problem of Constraint in the Work of Max Beckmann," in *Max Beckmann – Retrospective* (St. Louis, St. Louis Art Museum, 1984), p. 27; There are also striking parallels between Beckmann's canvas and Cézanne's still lifes of skulls both in the prominence given the skeletal remains and the bold handling.

3. Letter from Beckmann to Stephan Lackner dated August 27, 1945. Quoted in Stephan Lackner, "Exile in Amsterdam and Paris 1937-1947," in *Max Beckmann-Retrospective*, p. 155.

4. Max Beckmann, *Tagebücher 1940 – 1950* (Munich, 1955), p. 104.

5. Ibid., p. 116. Quappi was Beckmann's wife. My thanks to Yule Heibel for translating this passage.

6. Lackner, p. 155.

INDEX and CONCORDANCE

Concordance:

Acc. no.	Cat. no.
80.512	29
83.177	30
89.499	5
89.503	14
90.82	25
90.202	22
07.501	20
11.9	51
13.458	6
13.459	7
17.1519	31
17.1523	32
17.1524	33
17.3144	41
19.115	48
20.1873	57
24.236	35
27.465	9
32.16	87
32.17	88
32.21	73
38.778	71
39.40	27
39.41	28
39.42	19
39.761	63
40.232	38
41.107	49
41.744	21
43.30	68
43.32	86
44.585	23
46.59	4
47.1145	54
47.1164	59
48.410	56
48.427	58
48.450	37
48.478	60
48.524	45
48.530	34
48.546	44
48.575	83
48.576	40
48.577	79
48.581	46
48.586	70
48.589	66
48.591	47
48.601	42
49.1789	16
50.561	2
50.2728	12
54.1606	10
56.883	8
57.3	72
57.523	74
58.357	11
59.193	18
60.124	80
60.792	36
61.662	89
62.172	15
62.278	62
63.1628	26
64.411	61
64.1947	17
67.752	1
67.984	90
67.1161	75
69.1059	24
69.1228	55
1978.184	53
1979.196	43
1979.520	52
1979.615	67
1980.207	84
1983.697	78
1984.86	65
1984.163	64
1984.169	50
1986.59	69
1987.291	39
1990.390	76
1990.396	77
1990.421	81
1990.432	85
1990.441	82
1990.622	13
1993.566	3